NIGHT MAGIC

It was night and suddenly I felt like dancing
I took a cab to show me to the disco scene
He said, OK, you wanna see those crazy people
Hustling at the door to get into studio 54

Well, I was in and everybody was "Traveling"
The fashion queens, the models and the movie stars
Andy snapping, Margaux dancing with Scavullo
Liza dancing on the floor and Bianca walking the dog

Who's in, who is out?
Tell me, tell me, tell me
Who is in, who is out?
Famous and trashy

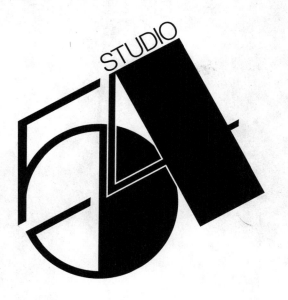

NIGHT MAGIC

It was night and suddenly I felt like dancing
I took a cab to show me to the disco scene
He said: OK, you wanna see those crazy people
Hastling at the door to get into studio 54

Well, I was in and everybody was "Travolting"
The fashion queens, the models and the movie stars
Andy snapping, Margaux dancing with Scavullo
Liza dancing on the floor and Bianca walking through the door

Who is in, who is out?
Tell me, tell me, tell me
Who is in, who is out?
Famous and trendy

Excerpt from "Fashion Pack (Studio 54)" [song title]
By Anthony Monn and Amanda Lear

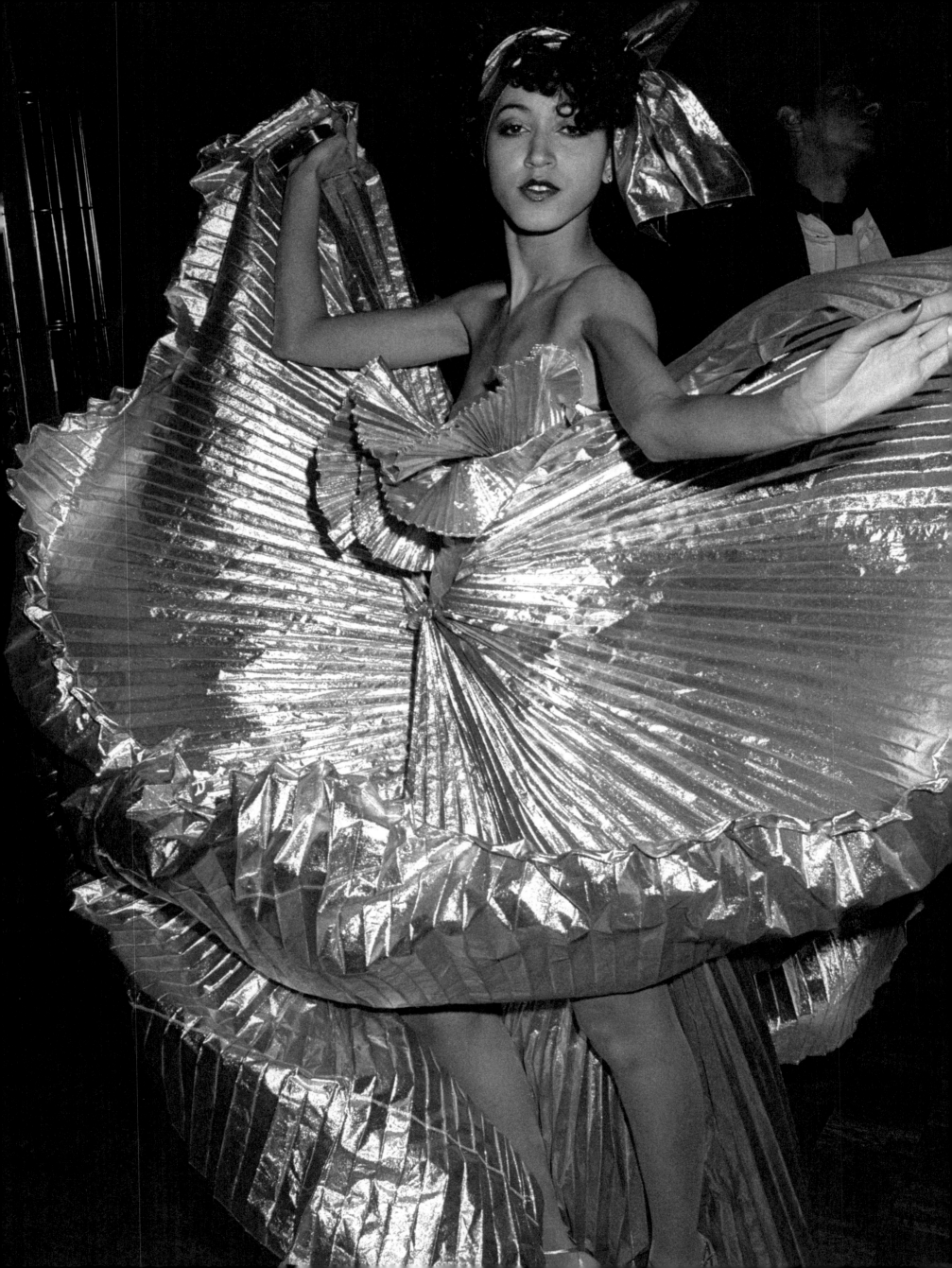

NIGHT MAGIC

Matthew Yokobosky

Brooklyn Museum *Rizzoli* **Electa**

Foreword

Anne Pasternak

Shelby White and Leon Levy
Director
Brooklyn Museum

Though open for only three years—from April 26, 1977, to February 4, 1980—Studio 54 is arguably the most iconic nightclub of all time. Set in a former opera house in Midtown Manhattan, with the stage innovatively repurposed as a dance floor, Studio 54 afforded all patrons the opportunity to be themselves, to be free, to be a star. *Studio 54: Night Magic* traces the nightclub's radiant history, with its trailblazing aesthetics, explosive creativity, and social freedoms. The disco scene that defined it brought people from all strata, heritages, and lifestyles together. Conceived by Brooklyn-born creative geniuses Ian Schrager and Steve Rubell, Studio 54 emerged out of a turbulent, gritty period of New York City's history, defined by a much-publicized recession of 1975 and more broadly by the post-Vietnam War era—a time that nevertheless brought one of the most liberating and artistic periods in that history.

The exhibit was built on a passionate belief in the important stories Studio 54 can tell us today. Without the enthusiasm and devotion of the wonderful Ian Schrager, this exhibition would never have happened. We extend our most profound gratitude for his role in turning this exhibition from a dream to a reality. Throughout the development of the show, Ian provided constant connections and guidance, as he opened numerous doors for Matthew Yokobosky, Senior Curator, Fashion and Material Culture. In turn, Matthew spent countless hours in deep research, especially with primary source accounts. His interviews, conversations, and fresh scholarship shaped the exhibit's fascinating story. I thank Matthew for his passionate commitment to the project, and the joy and insights he brought. Our tremendously dedicated Brooklyn Museum team also contributed in innumerable ways to the exhibit's success, and I am grateful, as always, to them. We are very thankful to the many creatives, friends, and lenders to the exhibit, acknowledged at the end of this catalogue, without whom this project would not be possible.

As ever, we are grateful to our Board of Directors, led by Barbara M. Vogelstein, for its constant support. Likewise, we have been blessed to work with Perrier, our major sponsor, and Spotify, who have been model partners. We would also like to thank MGM and Elliott Azrak for their kind permission to use the Studio 54 logo and trademark.

Created by Brooklynites, and celebrated as a place of freedom, creativity, and liberation, Studio 54 is a story we are thrilled to tell at the Brooklyn Museum. As Truman Capote said at the height of Studio's popularity in February 1979: "[Studio 54] is everything the way it ought to be. It's very democratic. It's all kinds of colors. All kinds of sizes. Boys and boys together. Girls and girls together. Girls and boys together. Poor people. Rich people. Taxi drivers. Anything you want. It's all mixed up together and that's what I like about it." And that is what the Brooklyn Museum likes about Studio 54 too.

Miestorm, *Rollerena*, 1977.
Courtesy of the artist.
© Miestorm

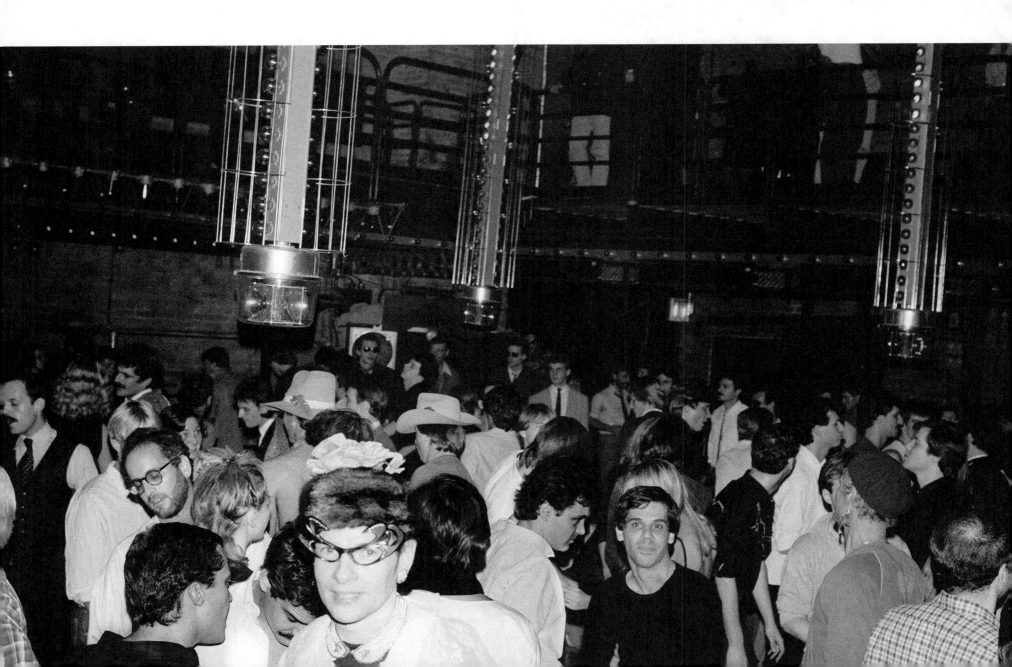

New York in the 1970s

When Studio 54 opened on April 26, 1977, it was a jewel amid broken bottles. The 1970s were years of great social, political, and economic upheaval in the United States. Nationwide protests for the rights of the LGBTQ+ community, African Americans, women, and other marginalized groups were unrelenting. New York City, plagued by a stagnant economy, barely escaped bankruptcy after being initially refused federal assistance by President Gerald Ford (memorialized in the *Daily News* headline "Ford to City: Drop Dead").

Although the city had celebrated successes, such as the completion of the World Trade Center in 1973, many neighborhoods were in disrepair and awash in graffiti. Crime was rampant amid the dilapidated backdrop.

The emergence of discos in the 1970s coincided with the rise of the movements for the rights of all people, including gays and Black Americans. Some clubs were members-only or by-invitation-only, allowing them to prescreen clientele, to operate without a cabaret assembly license, and to create a safe space for men to dance together, since it was still against state law. Before opening Studio 54, while Steve Rubell and Ian Schrager were running their Queens nightclub the Enchanted Garden, they would frequently visit a number of gay- and Black-friendly clubs to take notes and eye the competition.

Not long after Studio 54 opened, New York experienced a crippling two-day blackout. Ironically, on July 15, 1977, the day after the blackout, the New York State Department of Commerce, in collaboration with graphic designer Milton Glaser, launched the "I ♥ NY" campaign. New York was beginning to rebrand, and Studio 54 brought the spotlight back to Gotham's glamour and creative energy.

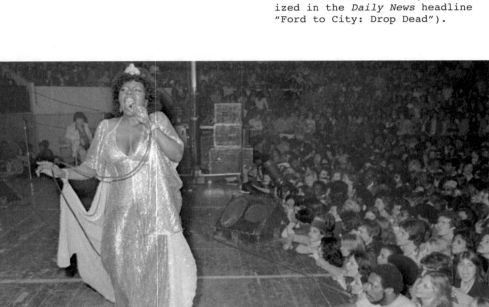

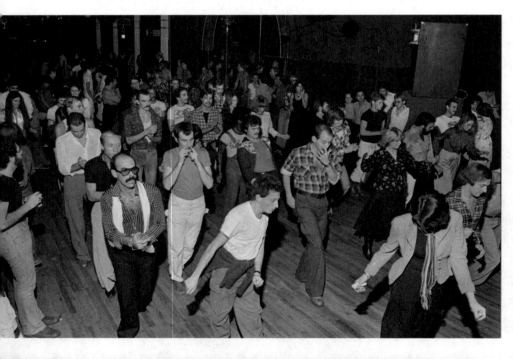

Top: Allan Tannenbaum (American, born 1945). *Gloria Gaynor/ Disco Convention*, 1975. Courtesy of the artist. © Allan Tannenbaum

Middle: Allan Tannenbaum (American, born 1945). *Infinity Disco*, November 1975. Courtesy of the artist. © Allan Tannenbaum

Top: Allan Tannenbaum (American, born 1945). *World Trade Center View of Tribeca*, circa 1974. Courtesy of the artist. © Allan Tannenbaum

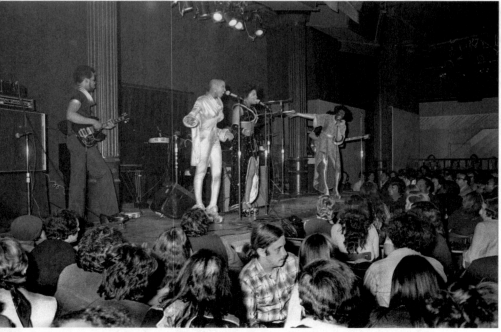

Bottom: Allan Tannenbaum (American, born 1945). *Labelle at Bottom Line*, 1974. Courtesy of the artist. © Allan Tannenbaum. Labelle wardrobe by Larry LeGaspi

Bottom: Michael Hanulak (American, 1937–2011). *Prostitute and Pimp*, 1974. Gelatin silver print, 9 1/4 x 12 1/2 in. (23.5 x 31.8 cm). Brooklyn Museum, Purchased with funds given by the Horace W. Goldsmith Foundation, Harry Kahn, and Mrs. Carl L. Selden, 1994.129.1. © Michael Hanulak

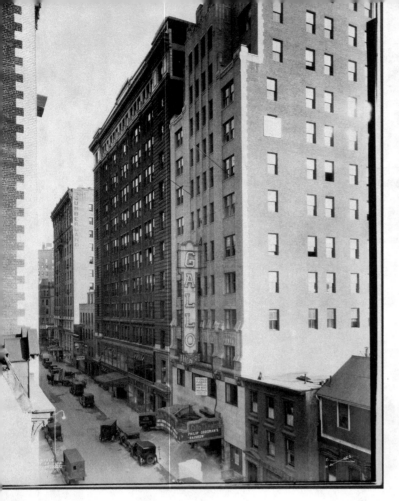

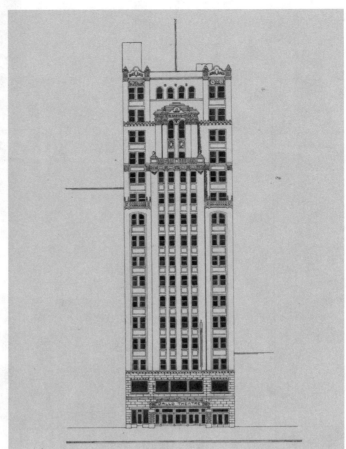

M E M O R A N D U M

March 19, 1977

TO: Ron Doud

FROM: Ian Schrager

1. Coordinate size of D.J. Booth re: lighting controllers and sound equipment.

2. Food.

3. Expense reimbursement.

4. Paint out entering hallway.

5. Silver paint will be expensive and require two coats. —Paul

6. Seating in sloping room should be high and elegant. WPA

7. Can you chalk out where everything will be?

8. Certificates of flamability for all materials.

Voyeuristic Architecture

In early 1977, seasoned nightclub owners Steve Rubell and Ian Schrager partnered with businessman Jack Dushey to acquire the property at 254 West Fifty-fourth Street that would become Studio 54. Even before it became Studio 54, the building had been used as a performance space. Originally built as the Fortune Gallo Opera House in 1927, it subsequently housed a succession of theaters in the 1930s and became Columbia Broadcasting Company's Studio 52, a television studio. Because the theater building had an eighty-four-foot-high fly space (an empty space above the stage where flying scenery could be attached and housed), as well as a proper proscenium arch to hide the behind-the-scenes apparatus, changes of scenery could be frequent, seamless, and magical.

Over the next several months, Schrager and Rubell assembled a unique team of designers who worked outside the usual coterie of nightclub design professionals. Because they were transforming a theater into a discotheque, they needed experts to design sets, lighting, and sound.

Top: Gil Lesser (American, 1935–1990). *Ian Schrager and Steve Rubell during construction of Studio 54*, 1977. Gelatin silver print, 5 x7 in. (12.7 x 17.8 cm). Courtesy of Ian Schrager Archive

Bottom: Adam Scull (American). *Ian Schrager and Steve Rubell during construction of Studio 54*, 1977. Photo by © Adam Scull/PHOTOlink.net

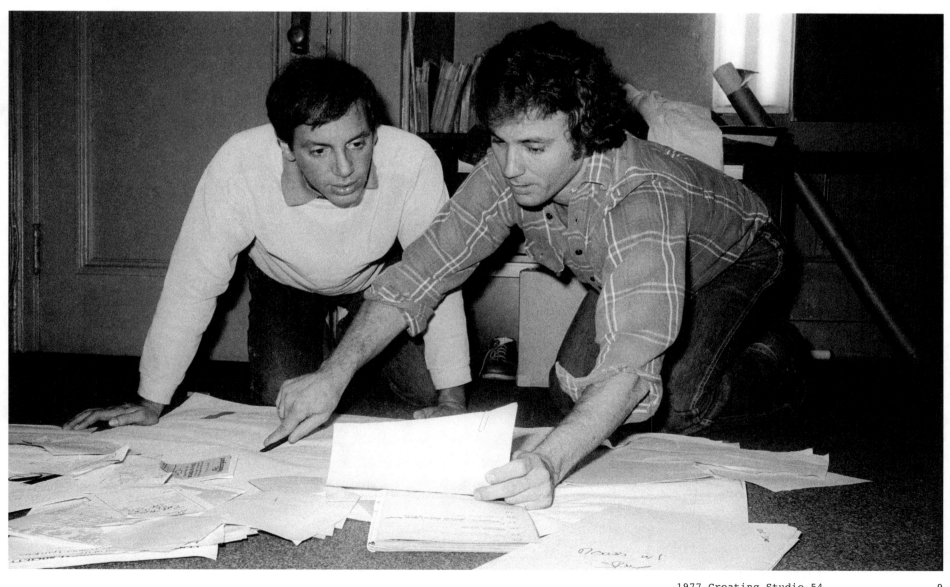

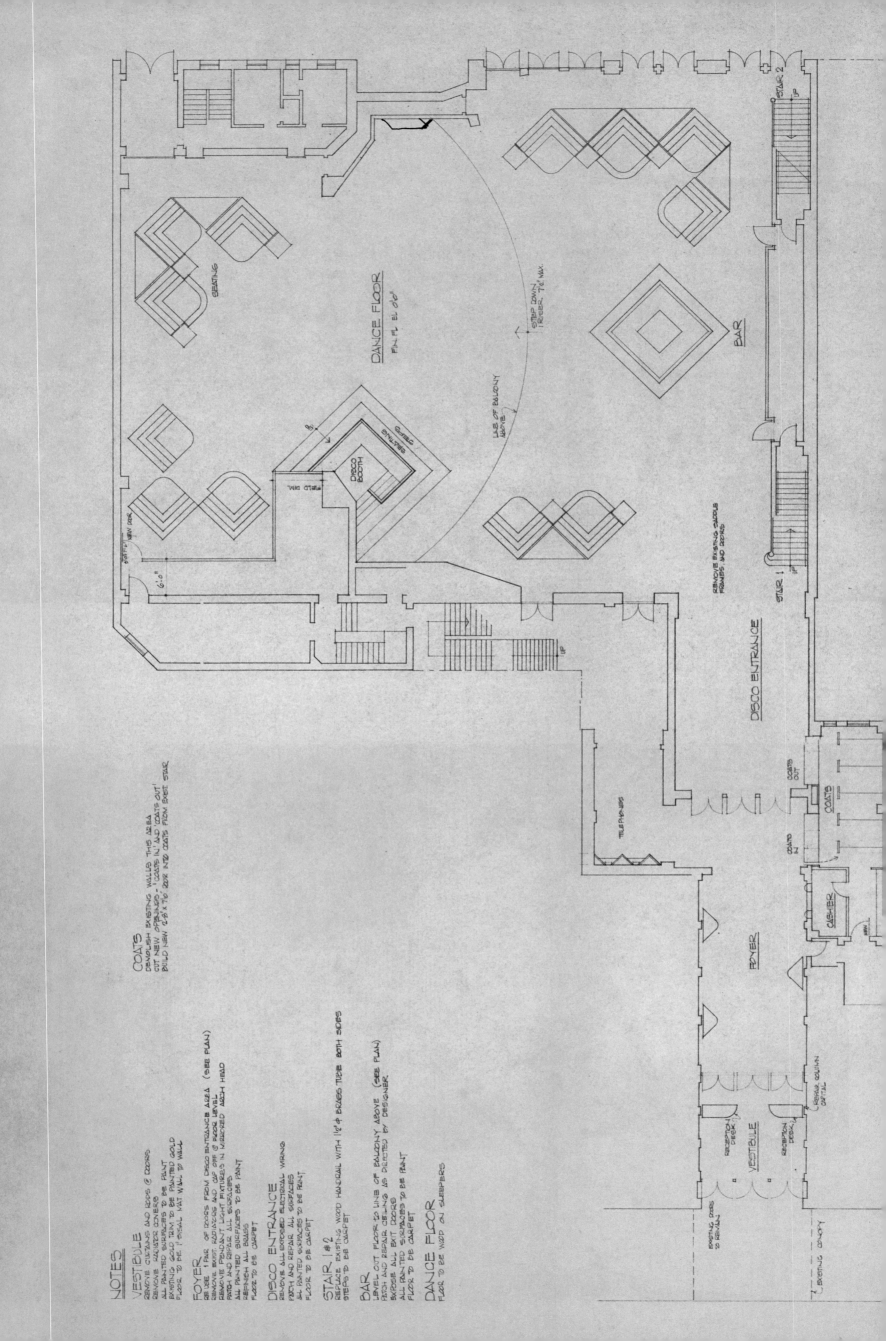

NOTES

VESTIBULE
REMOVE CURTAINS AND RODS & DOORS
REMOVE RADIATOR COVERS
ALL PAINTED SURFACES TO BE PAINT
EXISTING GOLD TRIM TO BE PAINTED GOLD
FLOOR TO BE 1" SISAL MAT WALL TO WALL

FOYER
SEE USE 1 PAIR OF DOORS FROM DISCO ENTRANCE AREA (SEE PLAN)
REMOVE EXIST. RADIATORS AND CAP OFF @ FLOOR LEVEL
REMOVE PENDANT LIGHT FIXTURES IN MIRRORED ARCH HEAD
PATCH AND REPAIR ALL SURFACES
ALL PAINTED SURFACES TO BE PAINT
REFINISH ALL BRASS
FLOOR TO BE CARPET

DISCO ENTRANCE
REMOVE ALL EXPOSED ELECTRICAL WIRING
PATCH AND REPAIR ALL SURFACES
ALL PAINTED SURFACES TO BE PAINT
FLOOR TO BE CARPET

STAIR #2
REPLACE EXISTING WOOD HANDRAIL WITH 1¼"Ø BRASS TUBE BOTH SIDES
STEPS TO BE CARPET

BAR
LEVEL OUT FLOOR TO U/S OF BALCONY ABOVE (SEE PLAN)
PATCH AND REPAIR CEILING AS DIRECTED BY DESIGNER
BVROSE ALL EXIT DOORS
ALL PAINTED SURFACES TO BE PAINT
FLOOR TO BE CARPET

DANCE FLOOR
FLOOR TO BE WOOD ON SLEEPERS

COATS
DEMOLISH EXISTING WALLS THIS AREA
CUT NEW OPENINGS, 1' COATS IN 1 AND 1 COATS OUT'
BUILD NEW 2'6"x 7'0' DOOR INTO COATS FROM EXIST STAIR

DANCE FLOOR
FIN FL 0'0"

STEP DOWN
1 RISER, 7'6" MAX.

U/S OF BALCONY ABOVE

BAR

SEATING

DISCO
BOOTH

SEATING

SEATING

FIELD DIM.

6'-0"

6'-0"

NEW DOOR

STAIR 2

UP

STAIR 1

UP

REMOVE EXISTING SADDLE
FRAMES AND DOORS

DISCO ENTRANCE

TELEPHONES

COATS
OUT

COATS
IN

COATS

CASHIER

FOYER

VESTIBULE

RECEPTION
DESK

RECEPTION
DESK

EXISTING DOORS
TO REMAIN

REMOVE COLUMN
CAPITAL

EXISTING CANOPY

UPPER PART OF DANCE FLOOR

ERECT NEW BDGG. 1¼" PIPE RAIL
36" HIGH · SEE DETAIL

LOUNGE

WOMEN

POWDER ROOM

SHELF

SHELF

MIRROR

MEN

VESTIBULE

SHELF

STAIR 4

STAIR 5

LOGE

EXIT

EXIT

FLUSH RADIATOR GRILLES

UP

IN

WOMEN

POWDER ROOM

LOUNGE

NOTES

LOUNGE
REMOVE EXPOSED ELECTRICAL WIRING
REMOVE EXISTING RADIATOR GRILLES AND INSTALL FLUSH ONES
MIRROR WALLS BETWEEN RADIATOR MOLDINGS AS DIRECTED BY DESIGNER
ALL OTHER PAINTED SURFACES TO BE PAINT
FLOOR TO BE CARPET

POWDER ROOM
MIRROR OPPOSITE WALLS BETWEEN MOLDINGS AS DIRECTED
INSTALL 2 COMB SHELVES
REMOVE OLD DOOR
FIX CEILING HATCH
ALL EXPOSED PAINTED SURFACES TO BE PAINT
FLOOR TO BE CARPET

WOMEN
REMOVE EXISTING SINK TOP
REPLACE WITH MARBLE TOP AND BACKSPLASH
RE-PLASTIC LAM. DOORS UNDER SINK TOP
QUIET FAN MOTOR
SPRAY PAINT EXIST. STALLS
FLOOR TO BE CERAMIC TILE

VESTIBULE
REMOVE MOLDING ALL WALLS
MIRROR ALL WALLS (NOT DOORS)
INSTALL 2 COMB SHELVES
CEILING TO BE PAINT
FLOOR TO BE CARPET

MEN
INSTALL NEW MARBLE SINK TOP AND BACKSPLASH (SEE DRAWING) WITH CABINET BELOW
REMOVE CURTAIN AND ROD
VINYL ABOVE TILE LINE AND CEILING
SPRAY PAINT EXISTING STALLS
MIRROR WALL IN FRONT OF SINK AS DIRECTED
FLOOR TO BE CERAMIC TILE
IN VENETIAN BLIND PR. WINDOW

STAIRS 5 & 4
STEPS TO BE CARPET
REPLACE EXISTING WOOD HANDRAILS WITH 1¼" Ø BRASS PIPE RAIL

LOGE
CARPET EXISTING CONC. STEPS AND PLATFORMS
ERECT NEW WALL AS SHOWN TO BLOCK OFF UPPER PART OF BALCONY
ERECT NEW BRASS RAILINGS

Ron Doud (American, 1949–1983).
Studio 54 blueprints, 1977. 6
pieces of paper, each 24 x 36 in.
(61 x 91.4 cm). Courtesy of Ian
Schrager Archive

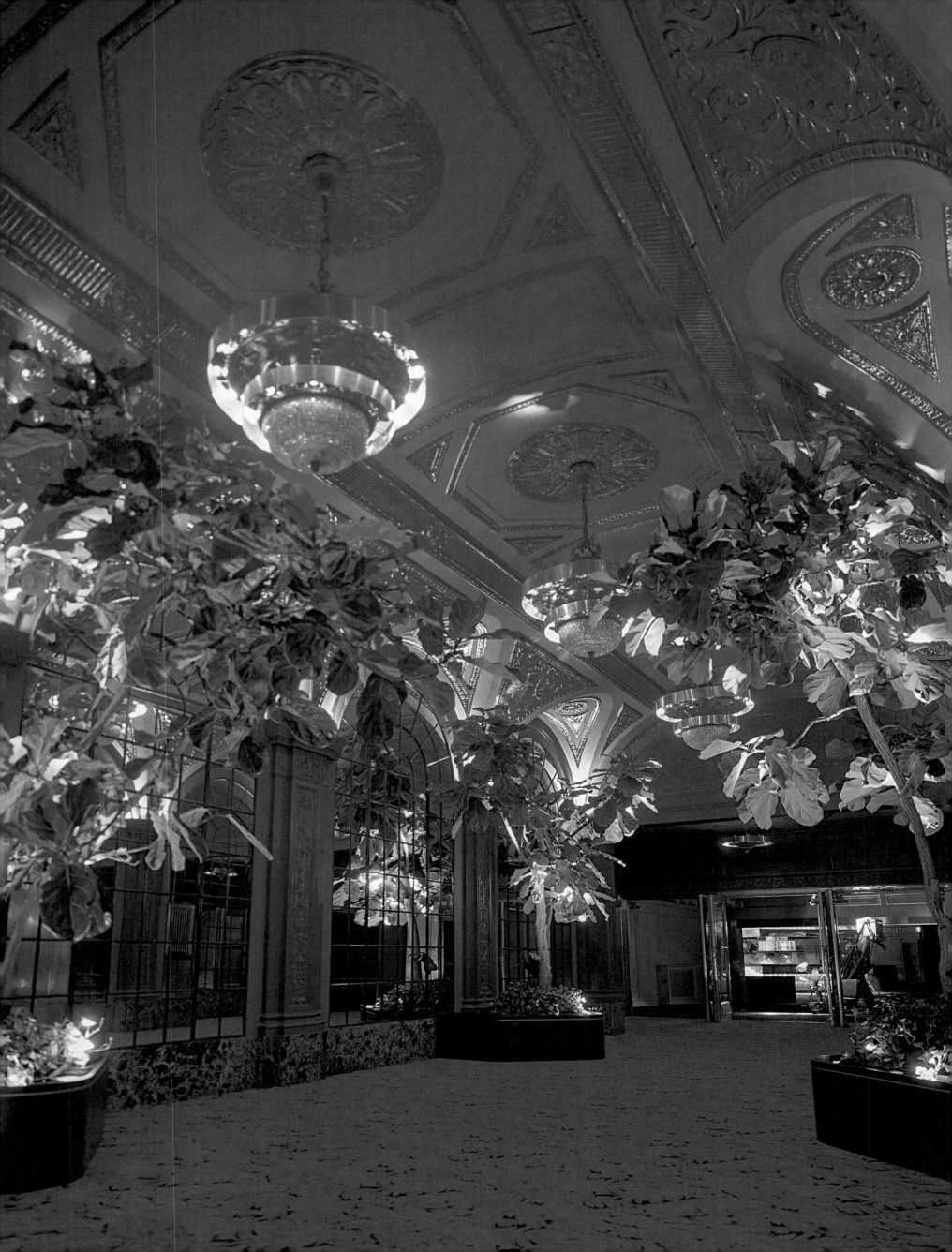

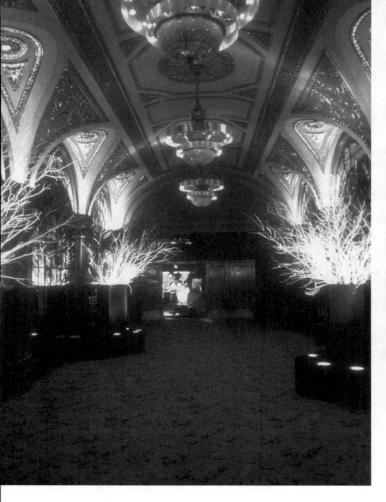

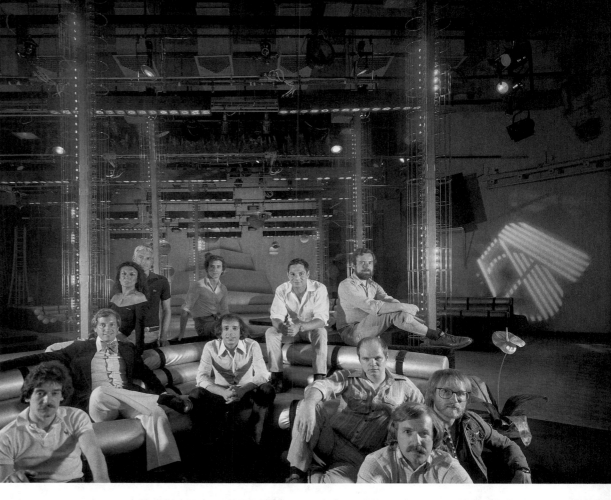

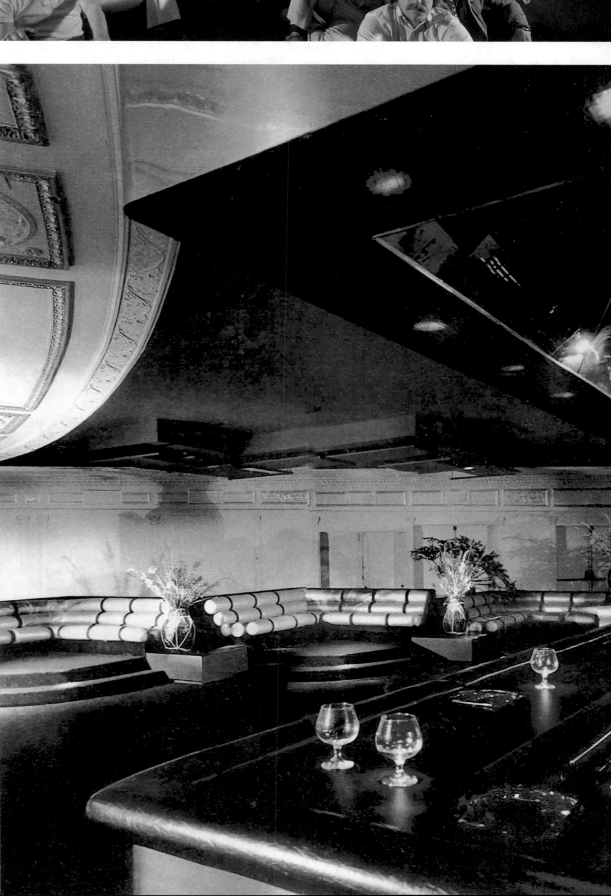

In this Polaroid taken around
the time of the opening of
Studio 54 for *New York* magazine,
Schrager and Rubell are
surrounded by architectural
lighting designer Brian
Thompson, interior landscaper
Renny Reynolds, promoter Carmen
D'Alessio, architect Scott
Bromley, designer Ron Doud,
lighting designer Paul Marantz,
scenic designers Dean Janoff and
Richie Williamson, and club
manager Richard DeCourcey. Not
pictured are graphic designer Gil
Lesser and audio designer Richard
Long, who played critical roles
in the club's success.

Creating Lightning in a Bottle

Studio 54 has been called
lightning in a bottle, and
truly it was. Jules Fisher and
Paul Marantz, who had designed
lighting for Tony Award—winning
productions, nightclubs, and
rock concerts, were brought
in to create a kinetic light
experience. Fisher and Marantz
then suggested the artist duo
known as Aerographics (Richie
Williamson and Dean Janoff), whom
they had met on a stage production
for the New York rock band Kiss.
Audio was engineered by Richard
Long, who had been responsible for
the sound system at the New York
club Le Jardin and many others.
Together these talents created
a space in which patrons in the
balcony, as well as from bars and
seating areas, could watch the
dynamic light, scenery, dancing,
and fashions moving across the
dance floor.

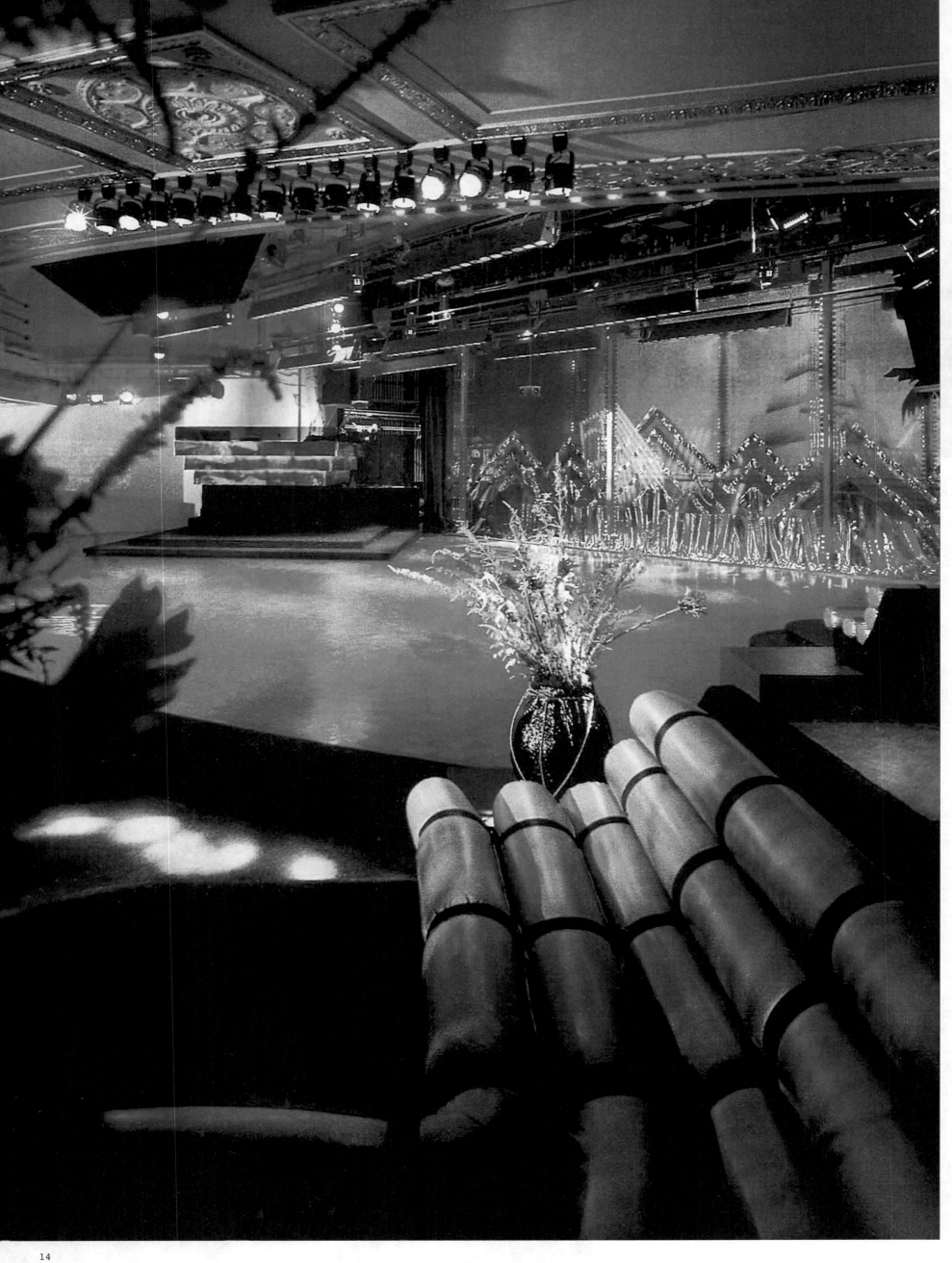

Top: Adam Scull (American). *Bar at Studio 54*, 1977. Courtesy of the artist. Photo by © Adam Scull/PHOTOlink.net

Bottom: Adam Scull (American). *Dance Floor at Studio 54*, 1977. Photo by © Adam Scull/ PHOTOlink.net

Opposite: View of bar from the banquettes showing Aerographics. © James Ardiles-Arce.

The exhilarating combination of high-end interior design, the original theater architecture, and changing, state-of-the-art sets, lighting, and sound created a sophisticated, often surprising environment that had never before been seen in a New York nightclub. And, unlike most nightclubs of the time, Studio 54 was run like a theatrical business. During the daytime, the parquet floor would be polished. On Thursdays, the lights were dusted and gels replaced, and on Fridays the speakers were vacuumed. There were light, sound, and theatrical drop presets. DJs had set "mood" music to begin the evenings. By 10 p.m., everything was inspected and had to be perfect before the doors would open.

"Thursdays lights cleaned, Friday speakers cleaned
Everything perfect when doors opened at 10 . . . it was a magicbox, everybody dressed, every flower had a light
There was an opening scene, a sequence to the evening . . . building the night
The music would go down . . . and up . . . pulsing, the lights would pulsate . . .
Sometimes we would turn off the A/C . . . get hot, smokey and sweaty . . . then turn the A/C back on . . . 'play with the weather' . . . could change over 5 minutes
The evening would play it by ear, playing with the crowd . . .
Sometimes Karin would script an event . . . but had to sure not to lose the room . . .
Sometimes a special song would come on and people, even coat check girls, would come running onto the dance floor . . .
Steve loved the Stones . . . Michael Jackson . . . Diana Ross."
—Michael Overington

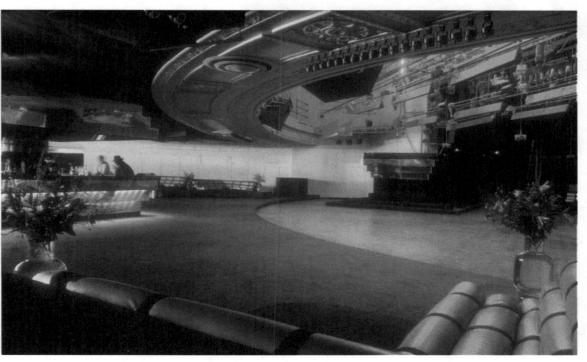

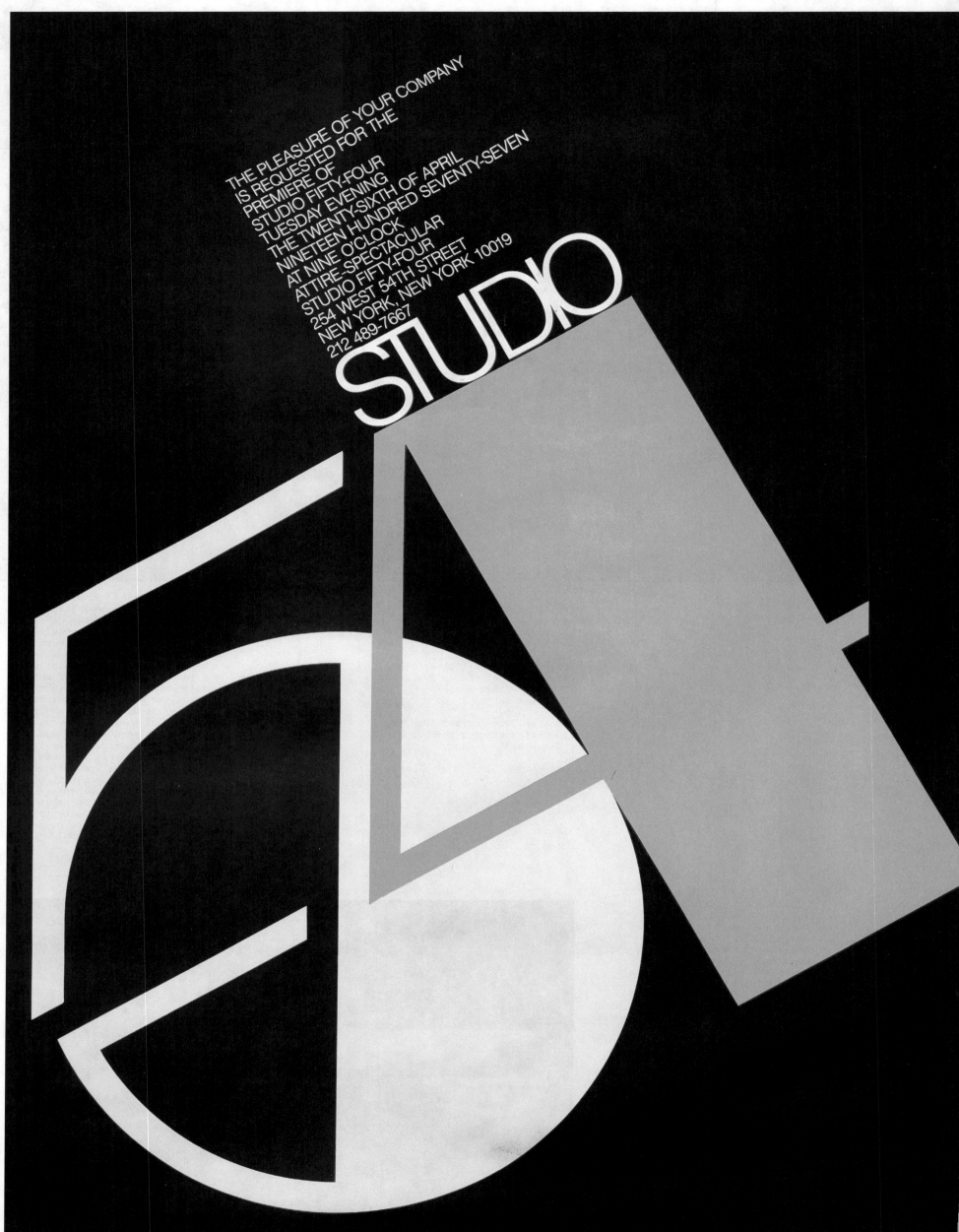

THE PLEASURE OF YOUR COMPANY
IS REQUESTED FOR THE
PREMIERE OF
STUDIO FIFTY-FOUR
TUESDAY EVENING
THE TWENTY-SIXTH OF APRIL
NINETEEN HUNDRED SEVENTY-SEVEN
AT NINE O'CLOCK
ATTIRE-SPECTACULAR
STUDIO FIFTY-FOUR
254 WEST 54TH STREET
NEW YORK, NEW YORK 10019
212 489-7667

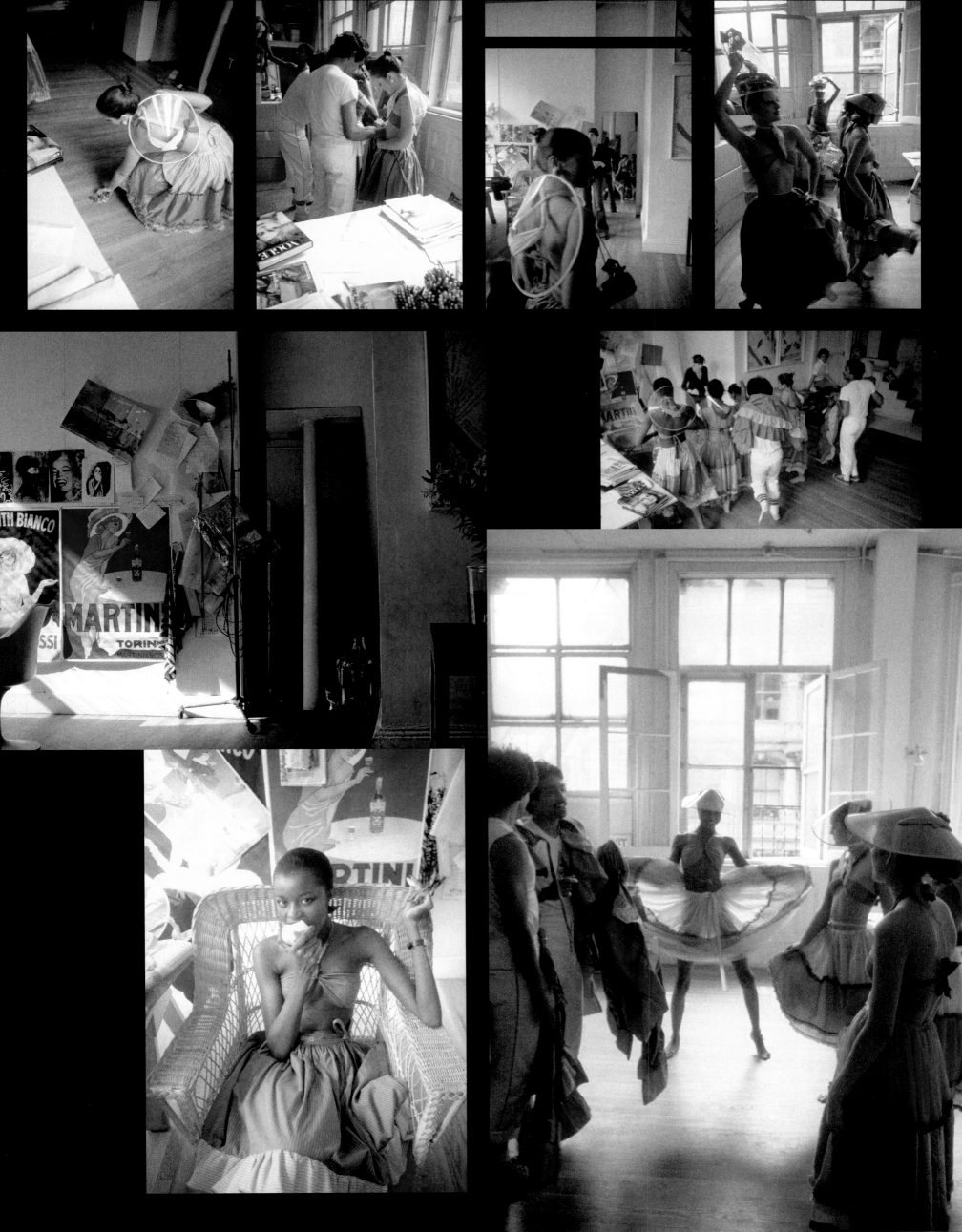

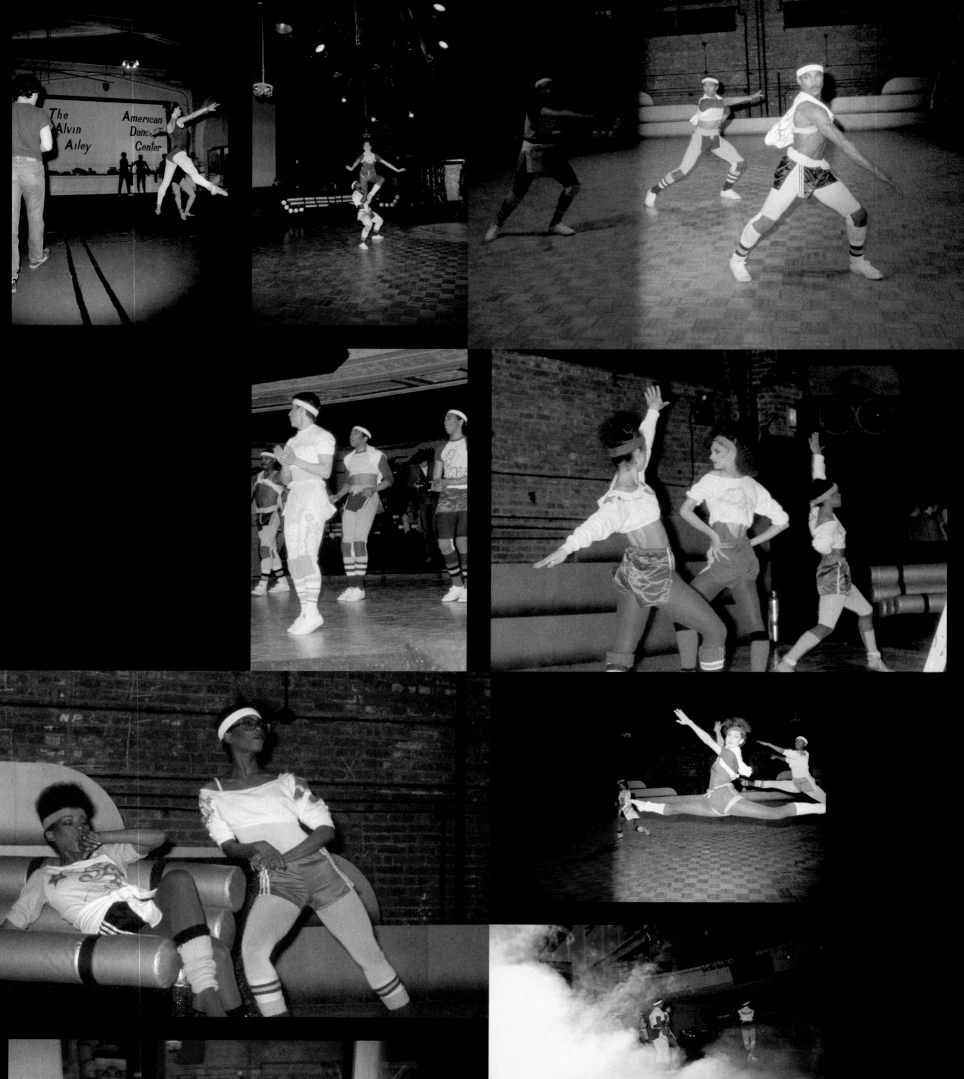
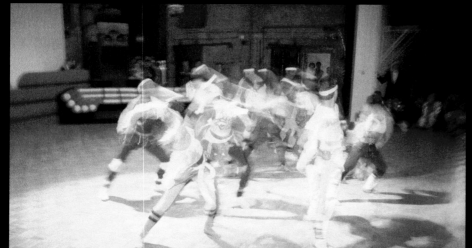

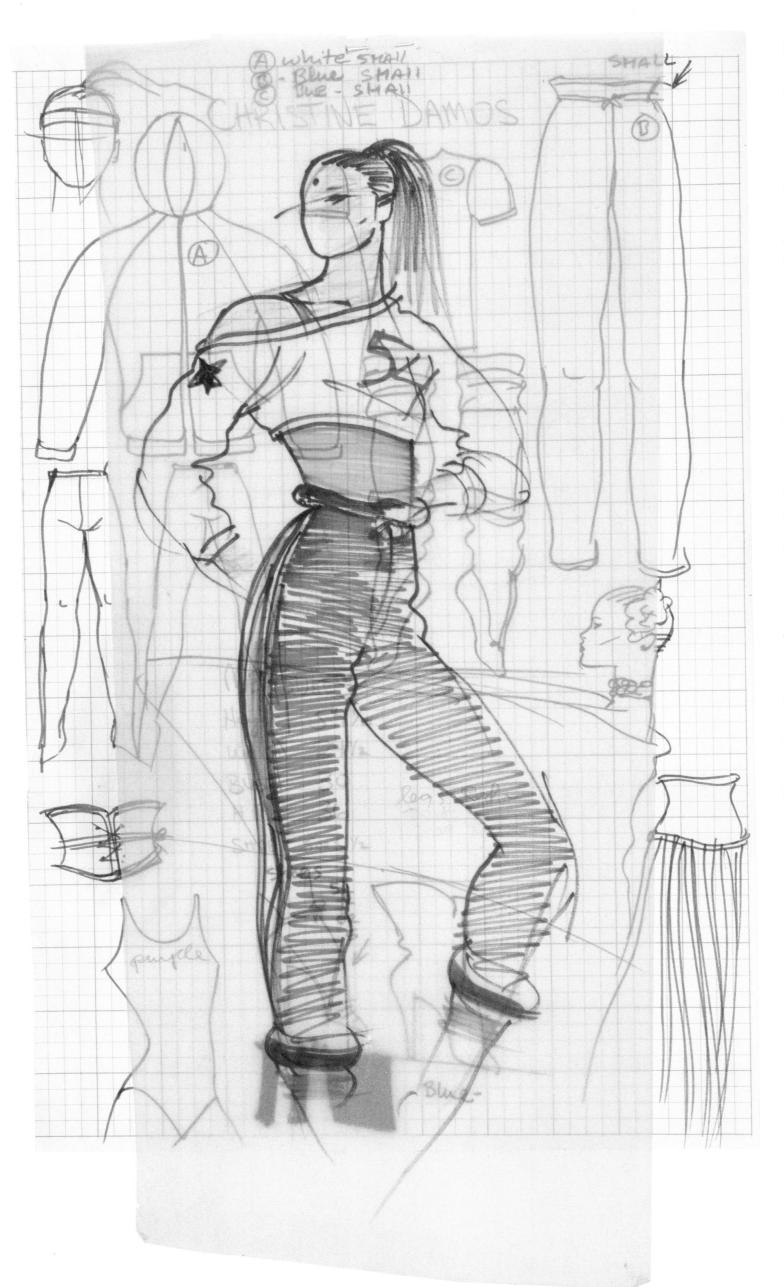

Page 17: Juan Ramos (American, born Puerto Rico, 1942–1995). *Fittings and Rehearsal for Alvin Ailey Performance*, 1977. 35mm color slide. Courtesy of Paul and Devon Caranicas. © The Estate and Archive of Antonio Lopez and Juan Ramos

Page 18: Juan Ramos (American, born Puerto Rico, 1942–1995). *Dress Rehearsal for Alvin Ailey Performance*, 1977. 35mm color slide. Courtesy of Paul and Devon Caranicas. © The Estate and Archive of Antonio Lopez and Juan Ramos

Antonio Lopez (American, born Puerto Rico, 1943–1987). *Christine Damos Dressing Sheet and Measurements*, 1977. Ink and pencil on graph paper, fabric swatch, vellum overlay. © The Estate of Antonio Lopez and Juan Ramos. (Photo: Jonathan Dorado)

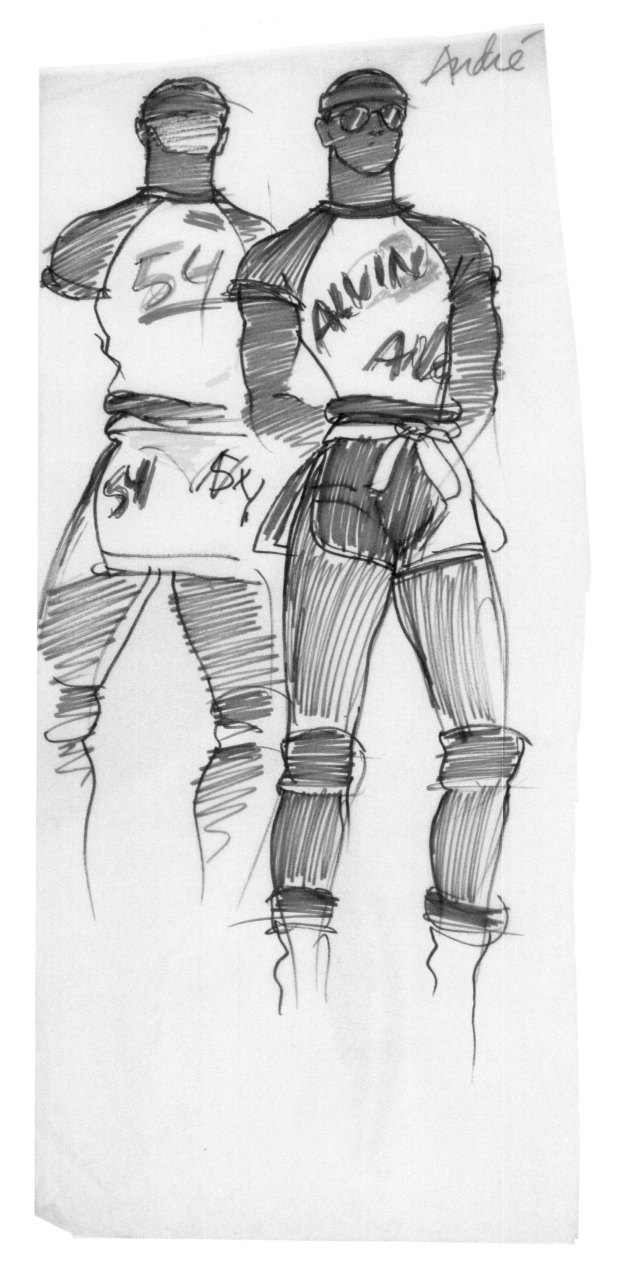

André

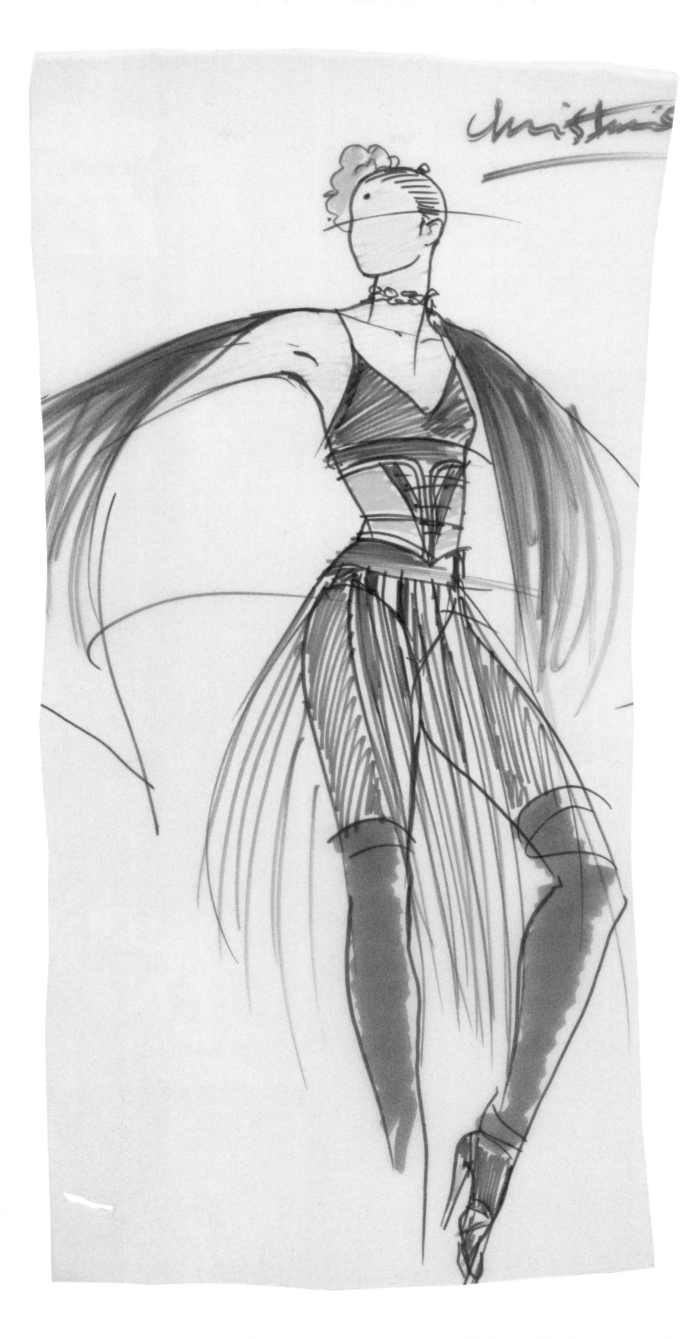

Pages 23-25: Juan Ramos (American, born
Puerto Rico, 1942-1995). Alvin Ailey
performance, opening night of Studio
54, April 26, 1977. 35mm color slide.
Courtesy of Paul and Devon Caranicas.
© The Estate and Archive of Antonio Lopez
and Juan Ramos

Antonio Lopez (American, born Puerto
Rico, 1943-1987). Christine, 1977. Ink on
vellum, 19 3/4 x 10 in. (50.2 x 25.4 cm).
© The Estate of Antonio Lopez and Juan
Ramos. (Photo: Jonathan Dorado)

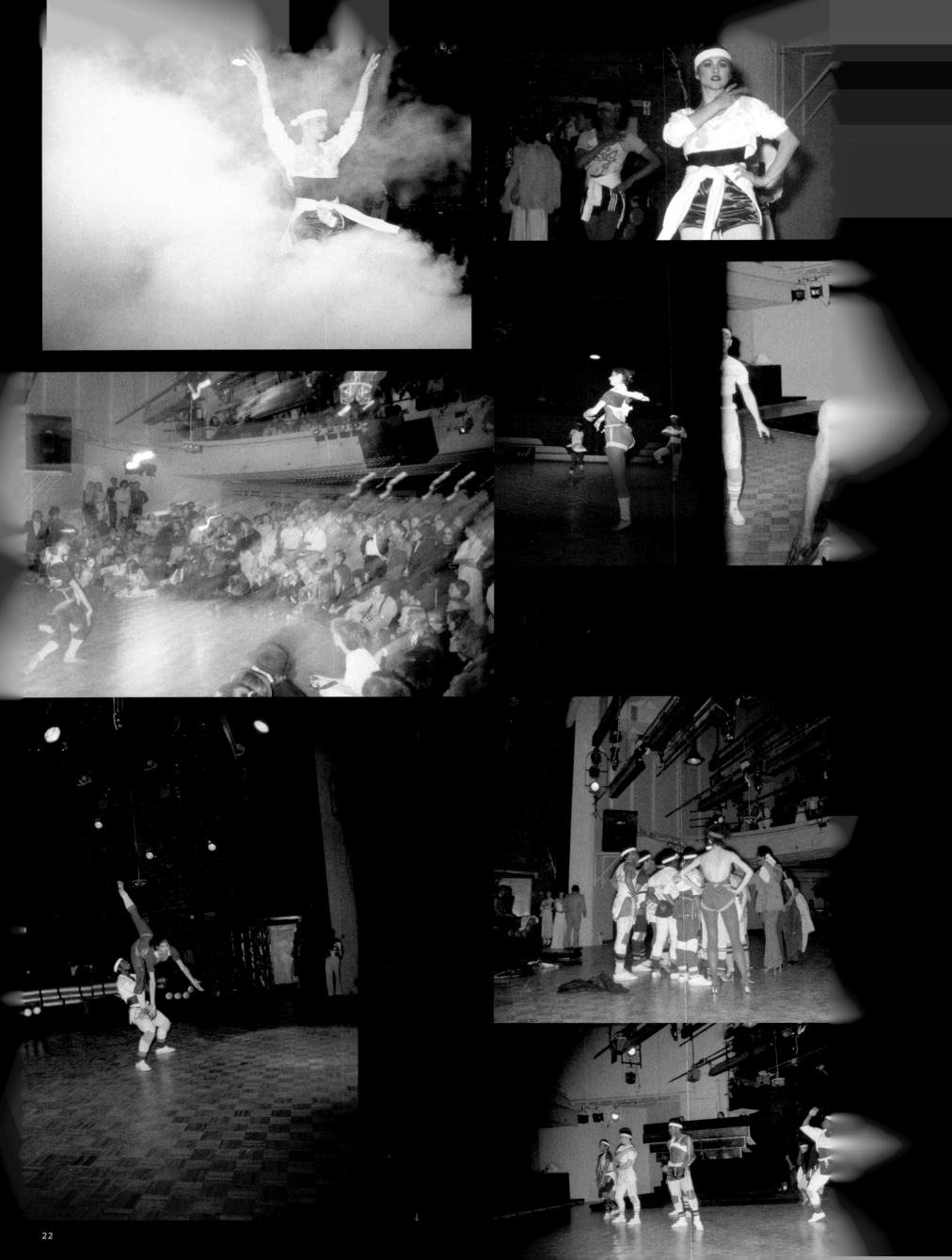

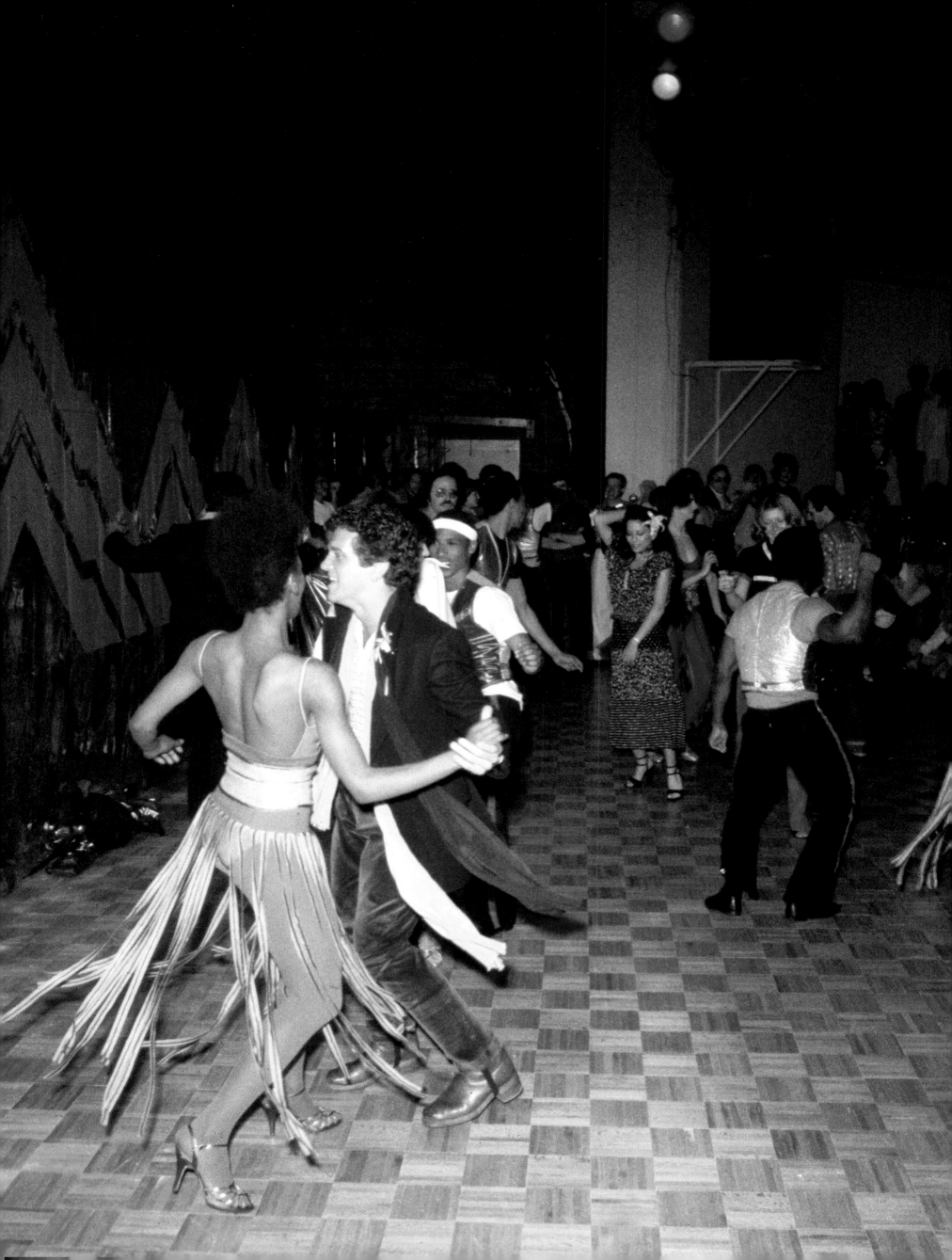

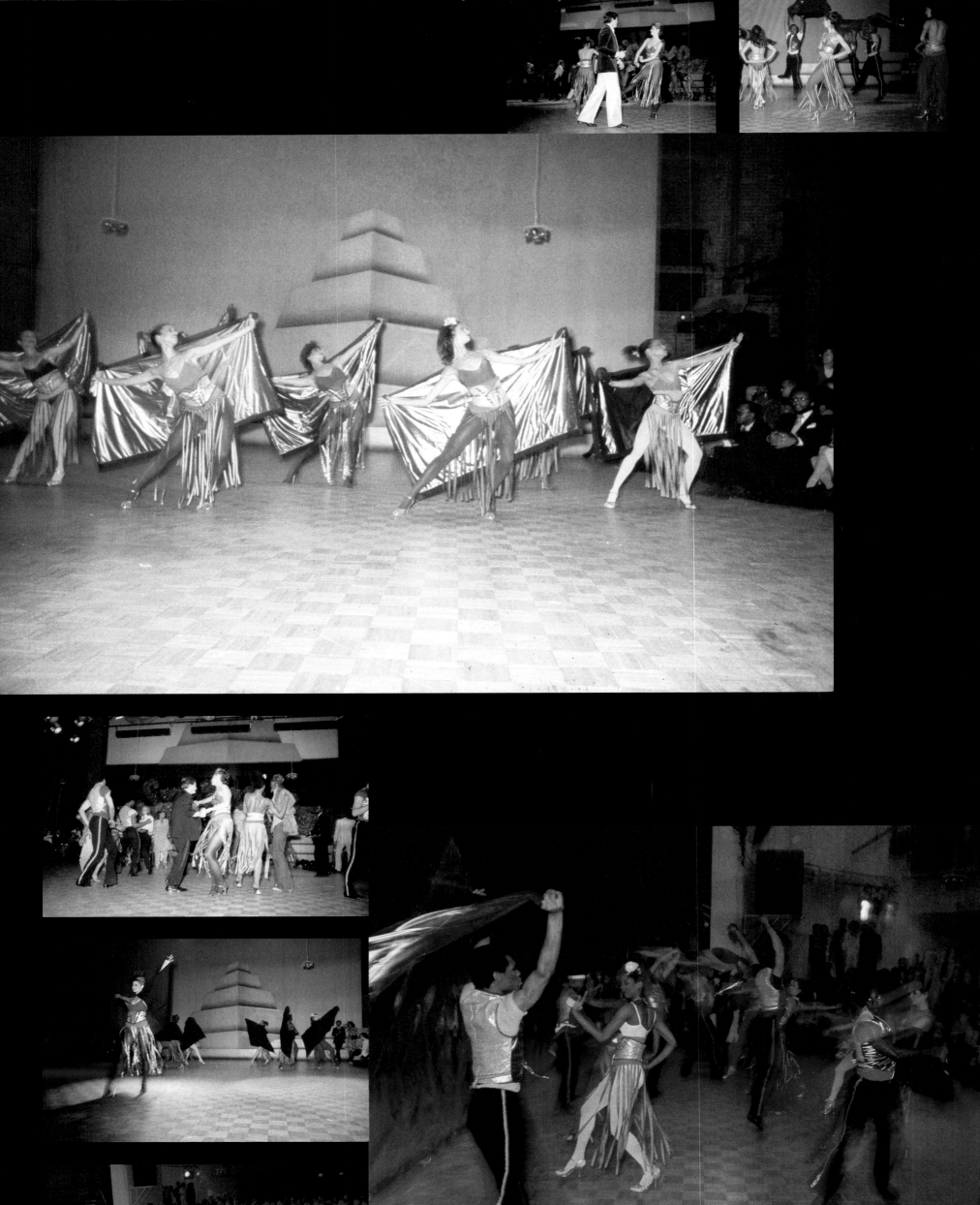

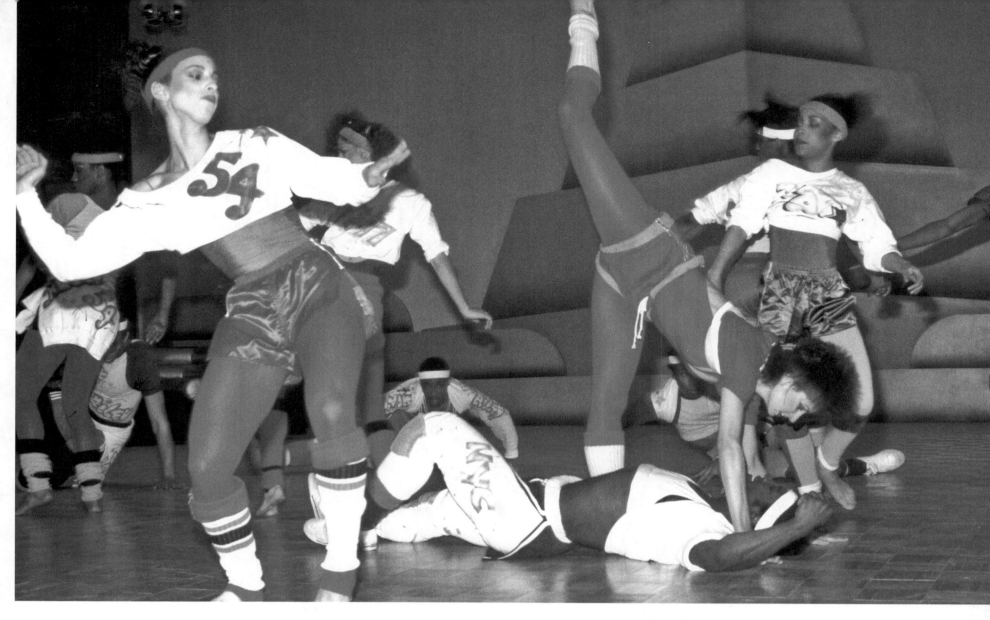

Studio 54 Premiere

From a Fiorucci press release: Dearest friend, today is music time, and we are introducing you to American avant-garde music with a journey to New York, . . . on Tuesday, April 26, Studio 54 will be inaugurated, in the most lively metropolis, as a temple of disco. If you want to experience technological advancements of show lights, you can't miss this appointment with the laser . . . The Fiorucci show in New York will be a Busby Berkeley parade: Antonio Lopez, the well-known fashion illustrator currently designing for Fiorucci, has sketched his looks for the show in a sequence of sixteen images. . . .

Antonio Lopez April 26, 1977 Diary Entry Grey and cold. up at 9:30 a.m. New York City N.Y.C Quick shower — taxi 23rd street $3 — bought breakfast $3 Got to the studio at 10 a.m. David and Scott were having coffee — Grace sewing — started to put clothes into garment bags. At 10:15 John came. He drove

us to Studio 54 — the place a Mess. Almost impossible to move. Wendy and Marcell were working on some of the girls. We spend two hours cleaning rooms upstairs and setting up dressing rooms. Don helped me. G.O. sent glasses. Leonard came and helped — got shopping bags. The dress rehearsal started at 2:30. Channel 11 came then channel 4 — a mess — we broke for lunch - Asia No. 1 Juan and Paul, Leonard, Don and Russel Beal, he left early to buy film at B. Arkins $25.00 — back to work — got more organized — the girls looks great and the guys incredible — the place opened at 9 — a real mess — people shoving to get in from 9-3 a.m. I got a lot of them in. The show started at 10:30 p.m. Very good — after champagne for all the dancers and roses. I love those kids. Toscani took photos for Elle, Italian Vogue — we stayed till 2 a.m. David Wolfson and Donna, Peter Hale and us left together. Taxi to Empire Diner. Breakfast. Taxi home to bed at 4 a.m.

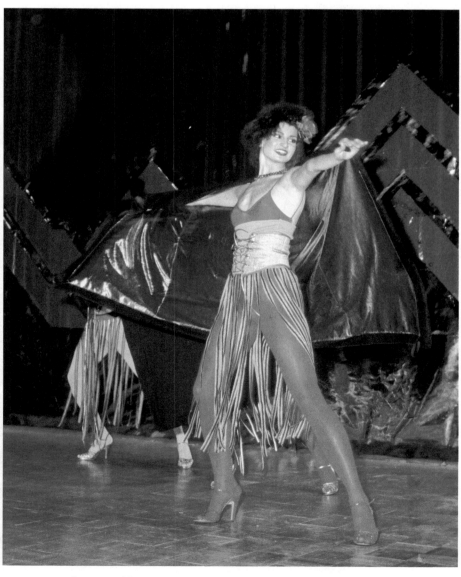

Tuesday, April 26, 1977: Premiere of Studio 54

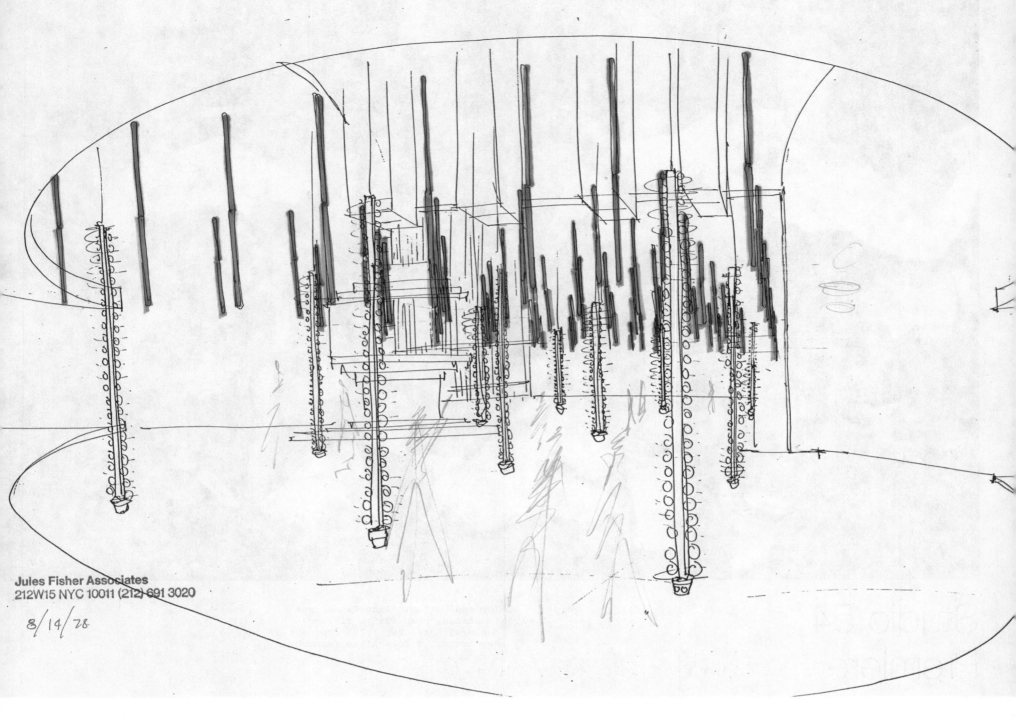

Jules Fisher Associates
212 W15 NYC 10011 (212) 691 3020

8/14/78

Top: Jules Fisher (American, born 1937). *Concept sketch for Studio 54* (lighting design), 1978. Ink on paper. Courtesy of Jules Fisher and Paul Marantz

Bottom: Dustin Pittman (American). *New Year's Eve*, 1979. Courtesy of the artist. © Dustin Pittman

Opposite, top: Adam Scull (American). View of the chase poles lowering into the crowd, 1977. Courtesy of the artist. Photo by © Adam Scull/ PHOTOlink.net

Opposite, bottom: Adam Scull (American). Constructing the chase poles, 1977. Courtesy of the artist. Photo by © Adam Scull/PHOTOlink.net

Kinetic Lighting

To renovate the existing space into a nightclub, the stage was dismantled to make room for a parquet dance floor, but the proscenium, air-conditioning, and theatrical rigging were retained. Feeling that light-up dance floors and mirror balls were passé, Schrager asked Jules Fisher and Paul Marantz to design "kinetic" lighting.

Marantz and Fisher decided to "make it bright," in contrast to the typically dark discos of the time. Twelve "chase poles" festooned with red and yellow bulbs were wired together in groups and switched to fool the eye into seeing moving light. The poles themselves could move up and down in the theater, while the red and yellow lights could flash in faster or slower progressions. The lowering of the poles right into the moving throng below and the timing of the lights were done manually.

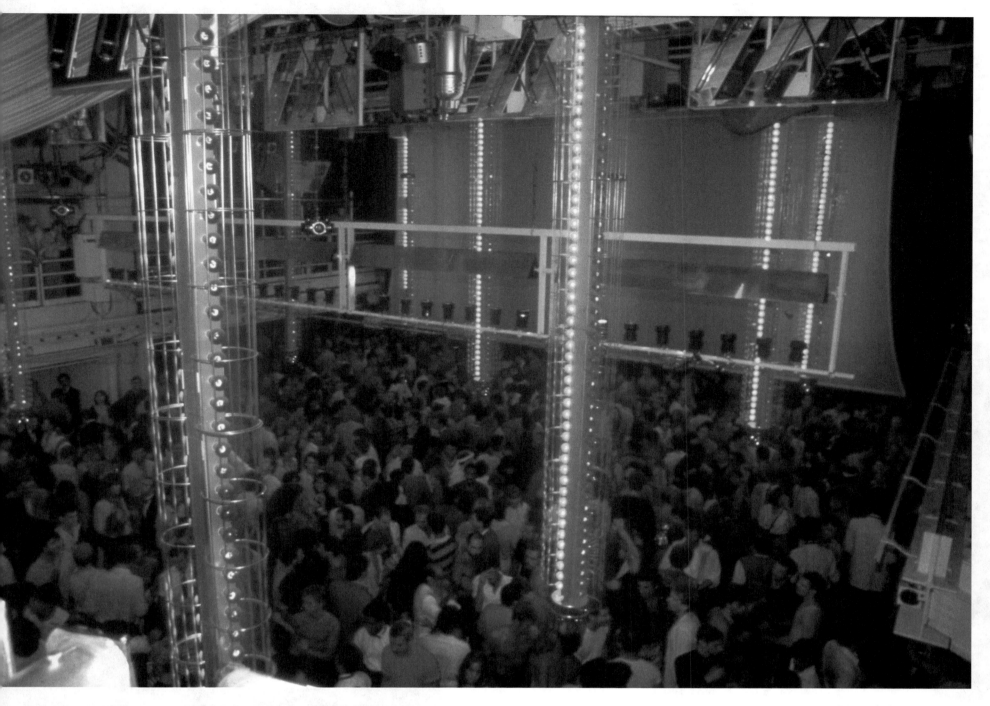
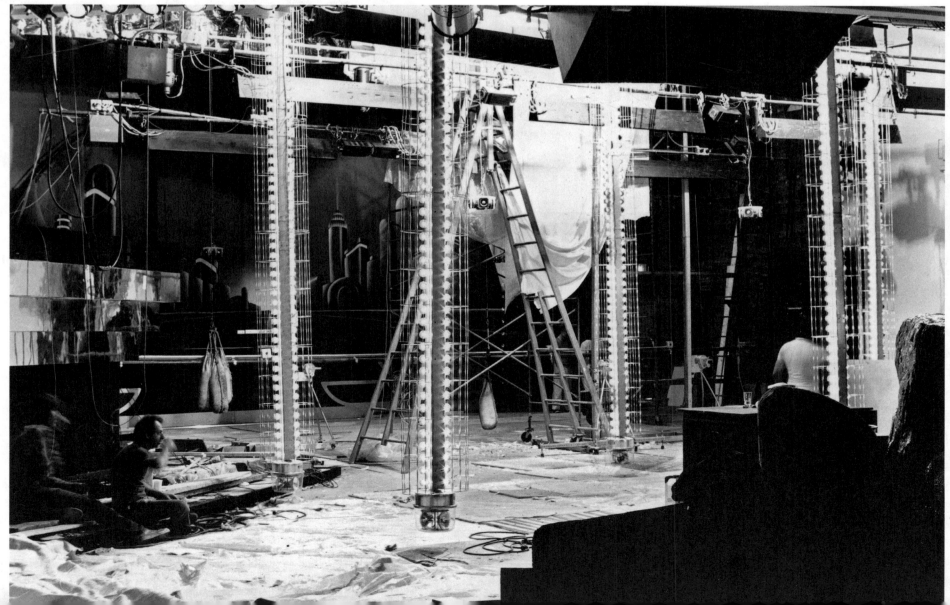

Opening Night Door List

There were more than 6,000 names on the door list for Studio's opening night.

Studio 54 Opening Door List, 1977. Typed paper, 11 × 8 1/2 in. (27.9 × 21 cm). Courtesy of Ian Schrager Archive

Edwin Bolwell - N.Y. Post
Anna Bond - Eyewitness News
Peter Boyle
Tim Boxer
Bill Bradley
Maureen Brennan
Ruth Brine - Time
Andrea Bruzzi
Mel Brooks
David Browde - WNEW-TV News
Arvin Brown
Mr. and Mrs. David Brown
Yul Brynner
Martin Burden
Anthony Burgess
Dick Burgheim, People
Guy Burgos
Michael Butler
Dick Button
Louis Calta, N.Y. Times
Virginia Capers
Patricia Carbine MS
Jeffrey Cohen - After Dark
Dick Cavett
Wm. Chapman
Ilka Chase
Richard Chaney (Voice)
Robert Christmont (Voice)
Mr. and Mrs. John Clark (Lynn Redgrave)
Frances K. Clines N.Y. Times
Harold Clurman
Frank Coffey, WPIX-TV Claudia Cohen
Bob Colacello

Mr. and Mrs. Alex Cohen
Gary Cohen (Cashbox)
Joe Cohen (Variety)
Steven Cohen
Cy Coleman
Nancy Collins
Pat Collins WCBS-TV
Betty Comden
Bill Como (After Dark)
Mr. and Mrs. Wyatt Cooper
Richard Corkery (Daily News)
John Corporan (WPIX-TV)
John Corry (N.Y. Times)
Mr. and Mrs. Irwin Cory
Joe Coscia - Eyewitness News
Tom Courtney
Pete Coutros - Daily News
Jim Cranberry - Wall St.
Campbell Crawford - WOR-TV
Joan Crawford
Sarah Crienron - Chelsea-Clinton
Mr. and Mrs. Hume Cronyn
Mrs. Russell Crouse
John Cullin
Bill Cunningham
Charlotte Curtis - N.Y. Times
Peter Cutros - N.Y. News

Arlene Dahl
Mr. and Mrs. Ossie Davis
Paul DeMaria - Daily News
Sandy Dennis

Celeste Holm

Linda Hopkins
Fred Hughes
Chris Huizenga (After Dark)

Bianca Jagger
Judy Jeannin (The Record)

Laurie Johnson (N.Y. Times)

Ed Joyce (WCBS 'TV News)

Mr. and Mrs. Garson Kanin

Bob Kaus (Cash Box)
Mari Kajiwara
Norman Kean Harry Katz

Kathey Kector (Viva)

David Kernan

Richard Kiley

Dong Kingman
John Kinney + photog.
Howard Kissel (WW)
Calvin Klein
Stewart Klein (Channel 5)

Judy Kemesurd (N.Y. Times)

Peter Knobler (Crawdaddy)

Joe Koennen
Ronald Kolodze
Roman Kozak (Billboard)

Albin Krebs (N.Y. Times)

Jack Kroll (Newsweek)

Jerry Krupnick - Star Ledger

Bill Laffler - UPI

Reg Laile - WOR-TV News

Bob Lape - Eyewitness News

Tom Lask - N.Y. Times

Nartine Latour (Mademoiselle)

Ernest Leogrande (Daily News)

John Leonard (N.Y. Times)

Leo Lerman (Vogue)

Kiki Levathes, (Daily News)

Mr. and Mrs. Stuart Levin

Mitchell Levitas (New York Times)

Dan Lewis, (Bergen Record)

Judy Licht (Ch 5)

Viveca Lindfors

Pia Lindstrom (Newscenter 4)

Roz Lipps (Celebrity Service)

John Lithgow
Antonio Lopez
Dorothy Louden

Jim Lowe (WNEW)

Pat Lowry (Women's Wear)

Lawrence Luckenbill

Mr. & Mrs. Sidney Lumet

Jeff Lyons

Shirley Machaine

Tom Madaras - WNBC-TV

Ted Majeski - UPI Newspictures
David Kelman
Millicent Martin

Ron Martin - N.Y Post

Janet Maslin - Newsweek) Sylvia Mezzola
Christopher Mau - Disco Dini McConnell
Fred McDarrah - Voice

Julie H. McKenzie

Ken McMillan
Mickey McMillan McMorran- People's
Judy Mallecker (New Yorker)

Mr. and Mrs. Craig Stevens

Michelle Stevenson Time
Rod Stewart
Mr. and Mrs. Jerry Stiller
Judith Stockman
Norma McClain Stoop (After Dark)

Lee Strasberg

Ms. Geraldine Stutz

Anita Summer

Andre Talley - W.W.D
Alan Tanenbaum - SOHO NEWS

Howard Thompson - N.Y. Times

Ronald Tindiglia - Eyewitness News

Lily Tomlin

Tom Topor - N.Y. Post

Mimi Torchin - Cue

Constance Towers

Neal Travis - N.Y. Post

Pauline Trigere

George Trow - New Yorker
Priscilla - Tucker - New York Mag
Peter Tufo
Phillys Twed

Liv Ullmann
Robin Ullmann

Lawrence Van Gelder - N.Y. Times

Mr. and Mrs. Carlton Varney

Joe Vecctuone - N.Y. Times

Gwen Verdon

Ben Vereen
Michael Vollvracht
Diana Vreeland

Allan Wallach - Newsday

(N.Y. Post)

...rold Prince

(N.Y. Post)

...Star Ledger
...James Reinsh
...Magazine
...NCNY
...lumn Rec...
- Newsday
...Daily News
...liff Robertson
...chard Rodgers
...N.Y. Times
...wsweek
- WPIX-TV News
...N.Y. Post
...ly News
...al Ruddy

Hubert Saal - (Newsweek)

Marilyn Sachs - (HOST)

Donald Sadler
Joan Sands
John Savage

Michael Schau - Where

Sydney Schauberg - N.Y. Times

Mort Scheinman - WWD

Gerald Schoenfeld
Adrian Scott
Mr. & Mrs. George C. Scott

Vincent Seglior (After Dark)

Michele Shay

Carol Shelley

Reid Shelton

Eugenia Sheppard

Mr. and Mrs. Ed Sherrin

Ned Sherrin

Bobby Short

Paul Shrye

Marvin Siegal, N.Y. Times (Week-end)

Mike Sigman (Record World)

Betty Silva

Liz Smith

Paulette Smith (Womensweek)

Robert Smith (Circus)

Steve Sondheim

Susan Sopor (Newsday)

John Dexter

Jim Dimino - Cue

Dr. Barbardee Dimondstin

Bob Dishy

Tom Dolan - Eyewitness News

Mr. and Mrs. Melvin Douglas

Alfred Drake

Ross Drake (People)

Mr. and Mrs. Wm. Dufty
M/Mrs Tony Duke
Hoh. G.B. Duke

Frank Dunlop

Bob Duvall

Jennifer Edelman
Adam Edwards - National Star Photo

Henry Edwards - Times
Britt Ekland
Hector Elizondo

Ruth Ellington

Don Erickson, ESQUIRE

Edward Evanko
Joe Eula

Clarence Fanto - WCBS-TV news

Jules Feiffer

Norm Fein - Newscenter 4

Clay Felker

Ted Fetter - NCNY

Geraldine Fitzgerald

Chet Flippo - Rolling Stone

Don Flynn - Daily News

5.

Alex Fondes

Joan Fontaine

Larry Fralberg

Gerald Freedman
Gabarch Freedman - T. Coole T.U.
Don Friedman - People

Mr. and Mrs. Martin Gabel

James Galley

Arthur Gelb

Bernie Gersstein

Ruth Gilbert - New York Magazine

Nikki Giovanni

Mort Glankoff

Peter Glenville

Paulette Goddard

Sylvianne Gold N.Y. Post

Milton Goldman

William Goldman

Barbara Goldsmith - Harpers Bazaar

Richard Goldstein - Voice
Michael Gomes
Morton Gottlieb

Cary Grant

Mr. & Mrs. Adolph Green

Robert Green - Playboy
Mrs Warren Greene
Tammy Grimes

Jack Guilford

6.

Kenneth Haigh

Harry Haines (Pat. News)

Mr. and Mrs. Sam Hall

Halston

Pete Hamill (Daily News)

Marvin Hamlisch

Mrs. Dorothy Hammerstein

Bill Hampton
Uwe Harden
Sheldon Harnick

Leonard Harris

Radie Harris

Rosemary Harris

William Harris (SOHO Weekly)

Kitty Carlisle Hart
Rose Hartman - Viva
Elvind Harum

Harry Haun, (NEWS)

R. Couri Hay

Eileen Heckart

John Heffernan
Margtte Her
Cynthia Heimel (SOHO WEEKLY)
Margaux Hemingway
Mary Henderson NCNY

Garrit Henry (Voice)

Ed Herman

Frances Herridge (N.Y. Post)

Vy Higginson (UNique, N.Y.

Anthony Hiss (New Yorker)

Jan Hockenfield (Post)

Dustin Hoffman

Geoffrey Holder

9.

Mabel Mercer

Wm. Merchant

Frank Meyer - Variety

Peter Michelmore - N.Y. Post

Charles Micher - Newsweek

Bob Micklin - Newsday

Stan Mieses - NEA

Sylvia Miles

Ed Miller - Seventeen

John Miller - WCBS-TV
Ed Mintz - Lively Arts
Arthur Mitchell

Mr. and Mrs. J. Minskoff

Ed Mintz (Lively Arts)

Irvin Molotzky - NY Times

Mark Monsky - WNEW-TV

Carmen Moore - Voice

Melba Moore

Sally Moore (People)
Daniel Moreno
Bruce Morrow - Newscenter 4
Joan Marie
Zero Mostel

Scott Manl

Rosemary Murphy
Robert Murray - Vogue
Don Murray

Joe Namath

Elyse Nass

Larry Nathanson (N.Y. Post)

Don Nelson (news)

1

Enid Nemy (N.Y. Times

Mr. & Mrs. Mike Nichols
M/Mrs. Miller Nicholas
Louis Niele AFTER DARK

Ralph Novak PEOPLE

Peter Ochiogrosso - SOHO WEEKLY

Pat O'Haire - DAILY NEWS

Diane Oliver - Celeb. Service

Dick Oliver - Daily News

Lou O'Neill, Jr. - Post

Gerry Orback Michael Orlando
Chrishan Orlov
Chip Orton

Al Pacino

Patrick Pacheco)AFTER DARK)

Betsy Palmer

Robert Palmer N.Y. Times

Joe Papp

Nick Paradise WRNO

Jerry Parker NEWSDAY

Estelle Parsons

Marianne Partridge (Voice)

Pamela Payton-Wright

Seymour Peck (New York Times)

Mr. and Mrs. Leif Pedersen

Mr. and Mrs. Austin Pendleton

Lester Persky

Kurt Peterson

Lionel Phillips WCBS-TV
Anne Pinkerton - W.W.D
Robin Platler News-week Photo

(miller)

14.

Mr. and Mrs. Eli Wallach

Bob Wahls (News)
Andy Warhol
Bob Wiener

Mr. and Mrs. Jack Weston

Jane Weston - N.Y. Times

Ross Wetzsteon - Village Voice

Mr. and Mrs. Robert Whitehead

Alan Whitney - N.Y. Post

Ron Whyte - Soho Weekly
Charles Wieland
Earl Wilson
John Wilson
Fred Winshop -UPI

Eugene Wolsk

Donna Wood

Gretchen Wyler

Roland Yoell WOR-TV NEWS

Chuck Young Ran. Notes/Rolling Stone

Tina Yvan

Bill Zakariasen News

Mark Zweigler After Dark

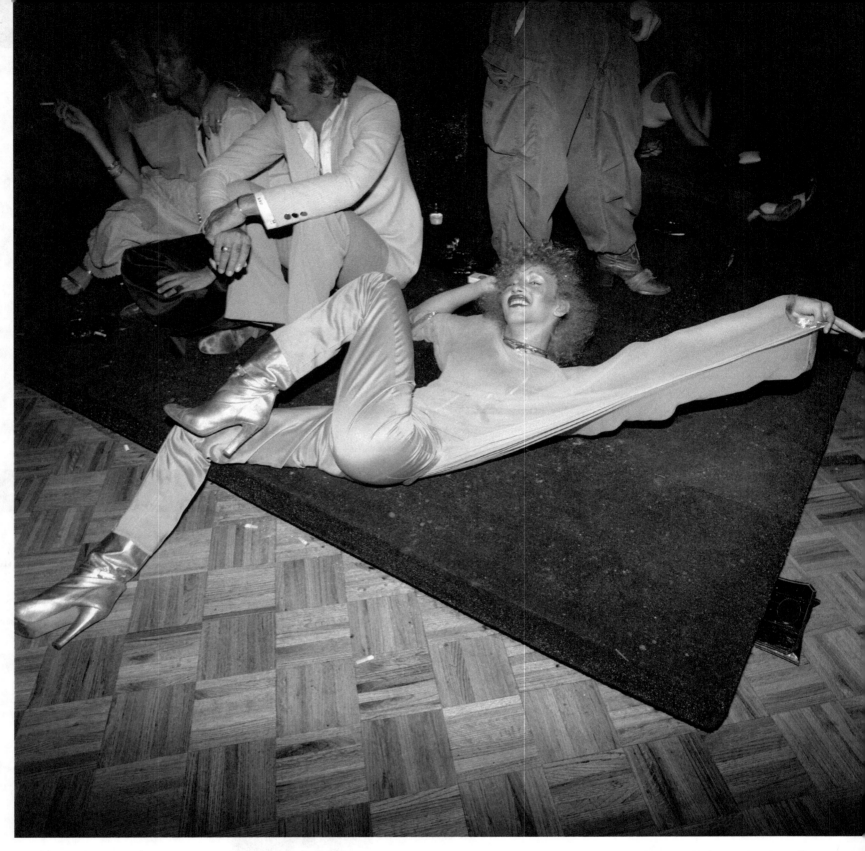

Bottom: Meryl Meisler (American,
born 1951). *Turquoise Ring*, 1977.
Archival color pigment print,
9 11/16 x 14 in. (24.6 x 35.6
cm). Courtesy of the artist.
© Meryl Meisler

Opposite, top: Meryl Meisler (American, born 1951). *Stretched on Floor (Silver Boots)*, 1977; printed 2019. Gelatin silver print, 14 x 14 in. (35.6 x 35.6 cm). Courtesy of the artist. © Meryl Meisler

Right: Allan Tannenbaum (American, born 1945). *Halloween Tits Lamé Skirt*, 1977. Courtesy of Allan Tannenbaum

Below: Anton Perich (American, born Croatia, 1945). *Two Men on Couch*, circa 1978. Color photograph, 20 x 24 in. (50.8 x 61 cm). Courtesy of the artist. © Anton Perich

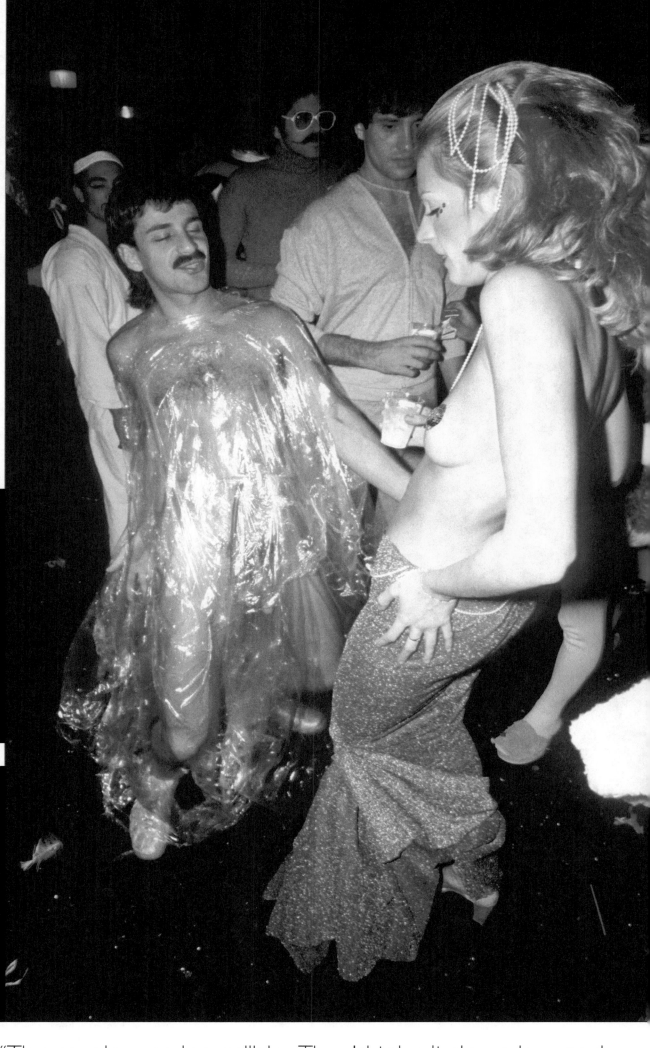

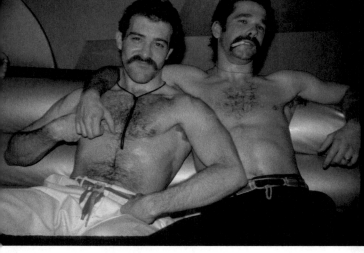

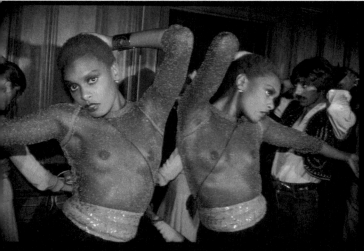

Bottom: Anton Perich (American, born Croatia, 1945). *Untitled*, circa 1978. Color photograph, 20 x 24 in. (50.8 x 61 cm). Courtesy of the artist. © Anton Perich

Opposite, bottom: Dustin Pittman (American). *Two Dancers*, 1977. Courtesy of the artist. © Dustin Pittman

"The music was incredible. They'd take it down low and give your ears a rest, and then bring it back up. The music was 'constructed'—they'd play cartoons and opera and mix in the disco."

—Edward Tricomi, 2018

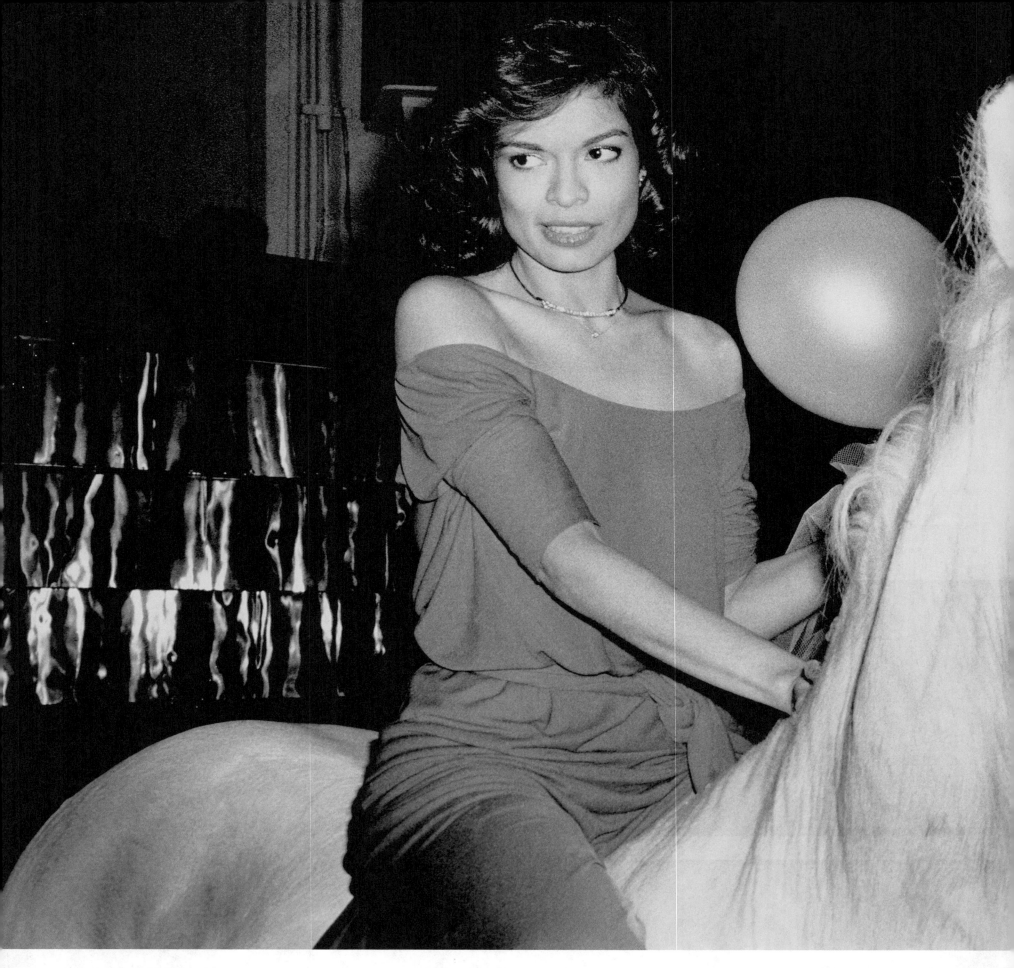

Birthday Party
Bianca Jagger Style

One of the most fabled spectacles at Studio 54 was Bianca Jagger, wearing a clinging red Halston dress, astride a white horse. Referencing the classic story of Lady Godiva, two actors from the Broadway production of *Oh! Calcutta!* (notorious for its scenes of total nudity) and a white horse were hired for the evening. Both actors were nude with body-painted, illusionistic clothes: the woman rode the horse, which was led in by the man. Jagger enthusiastically leapt onto the horse in front of several photographers, and the resulting images were splashed across newspapers worldwide over the following days. The provocative image would come to characterize Studio 54 as a sexually progressive and artistic environment that embraced a renewed sense of freedom following political and economic strife.

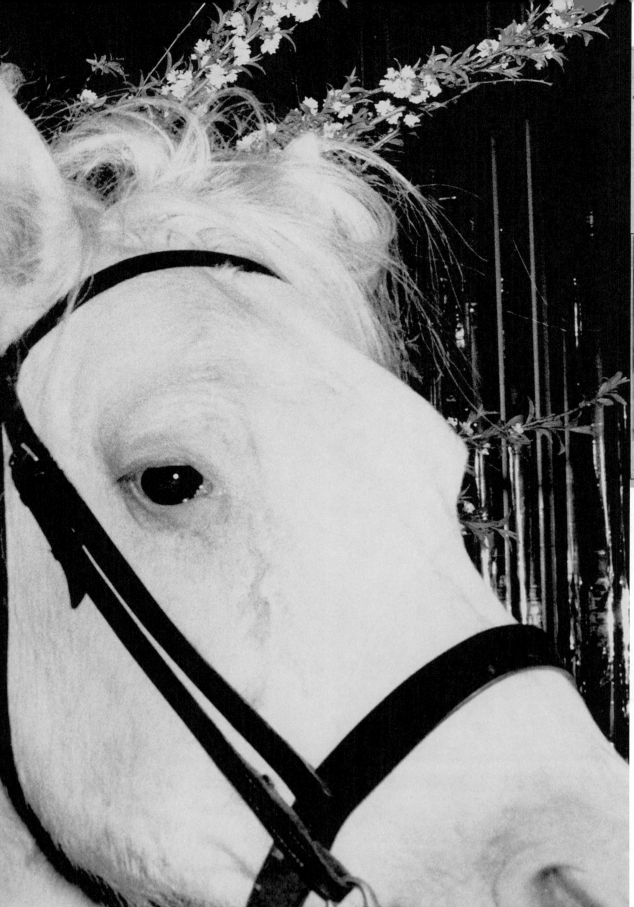

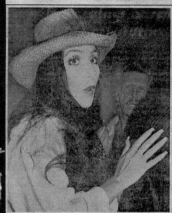

On April 27, 1977, a photo of
Cher at Studio's opening the
previous night made the front
page of the *New York Post*.

Rose Hartman (American, born
1937). *Bianca Jagger*, May 2,
1977. Courtesy of the artist.
© Rose Hartman

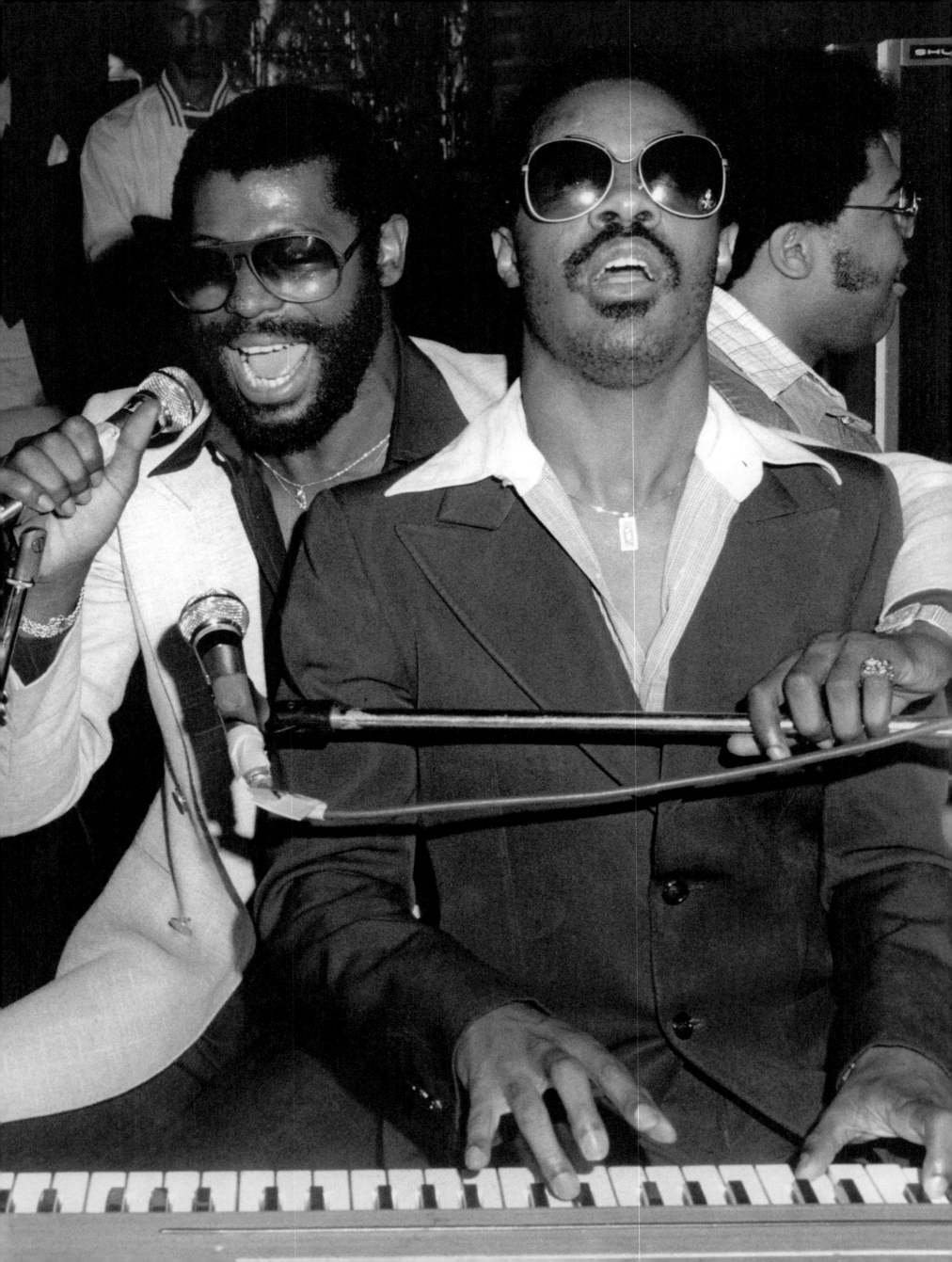

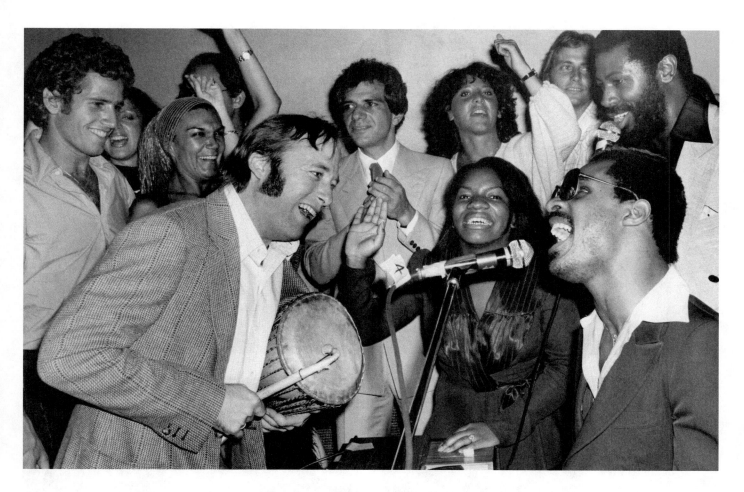

Opposite: Russel Turiak, Stevie Wonder, and Teddy Pendergrass. Image courtesy of Russel Turiak

Top: Stevie Wonder (at piano) jams with Steven Stills (with drum), Stephanie Mills and Teddy Pendergrass (behind Wonder) for his New York secretary, Mary Ann. New York Daily News Archive/ Getty Images

"If you didn't go one night, you felt like you missed something."

—Edward Tricomi, 2018

Politician Bella Abzug and her Supporters

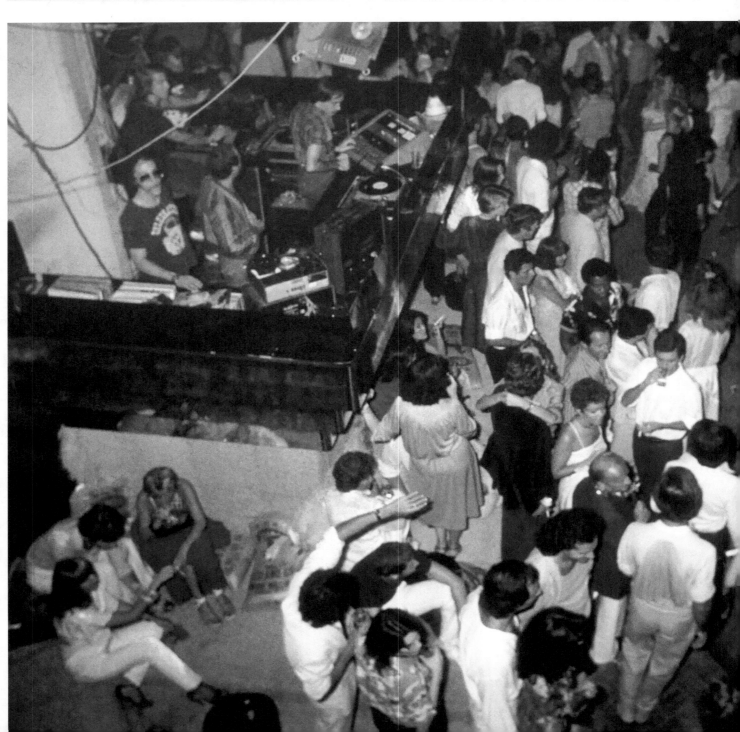

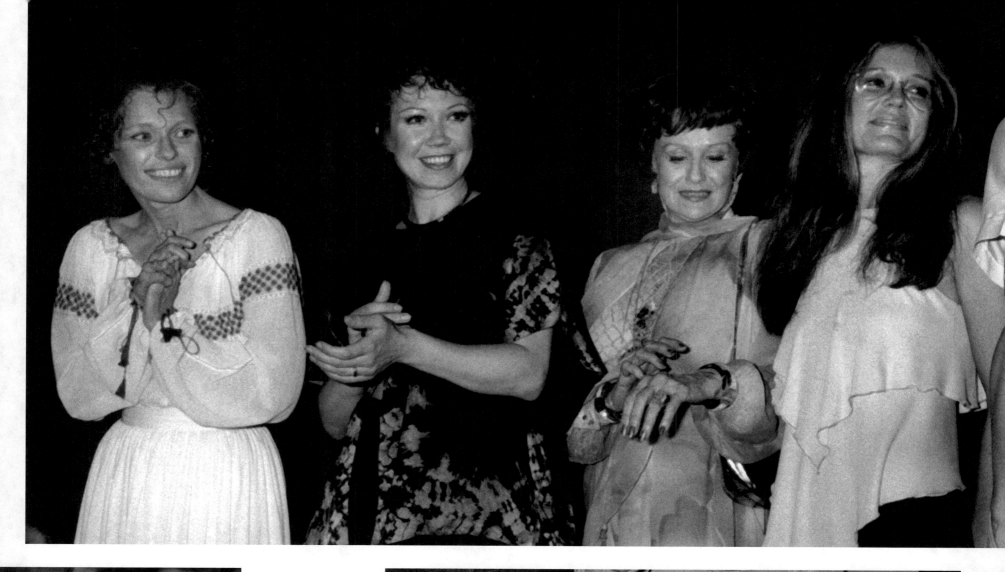

Bottom: Ron Galella (American, born 1931). *Shirley MacLaine and Bella Abzug Attend Bella Abzug's Birthday Party at Studio 54, July 25, 1977.* Gelatin silver print, 8 1/2 x 11 in. (21.6 x 27.9 cm). Courtesy of the artist. © Ron Galella

Top: Ron Galella (American, born 1931). *Louise Lasser, Donna McKechnie, Ruth Warrick, and Gloria Steinem at Bella Abzug's Birthday Party at Studio 54, July 25, 1977.* Gelatin silver print, 8 1/2 x 11 in. (21.6 x 27.9 cm). Courtesy of the artist. © Ron Galella

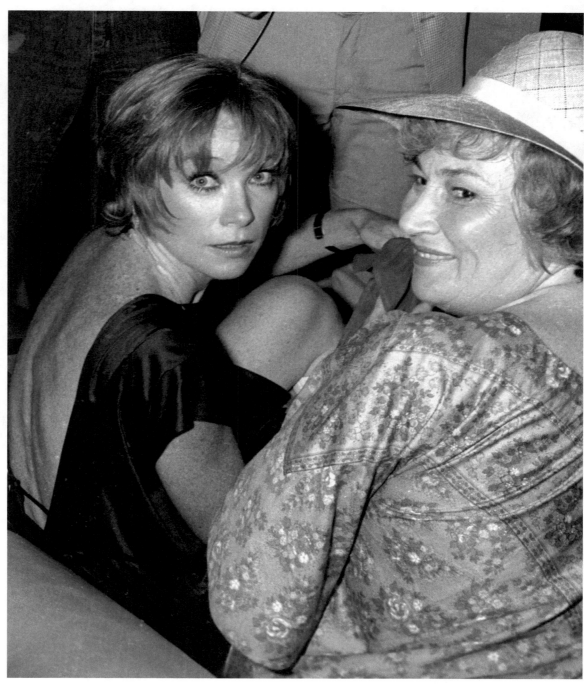

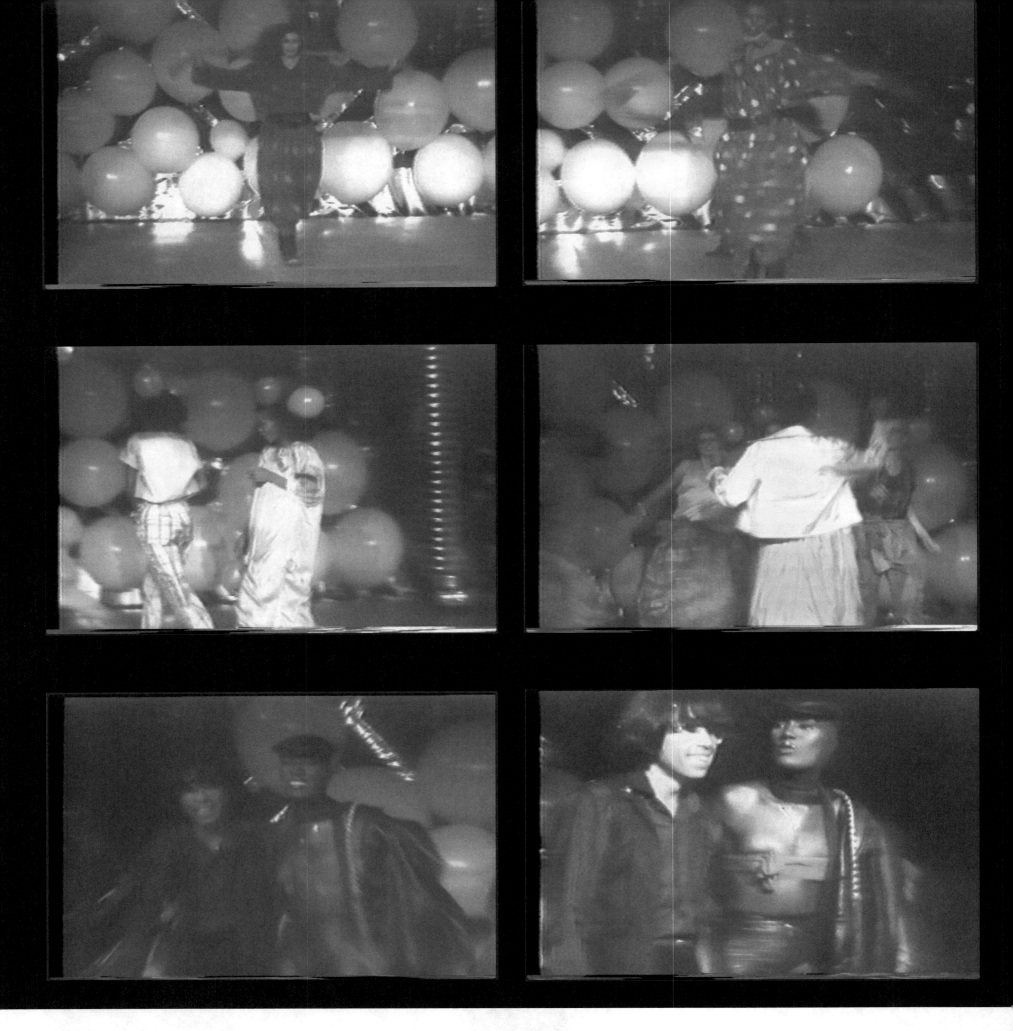

Kenzo
Fashion Show

Anton Perich (American, born
Croatia, 1945). *Anton Perich
Presents R. Couri Hay Reporting:
Kenzo, Studio 54* (stills),
September 14, 1977. Videotape,
color, sound; 28 minutes.
Courtesy of the artist.
© Anton Perich

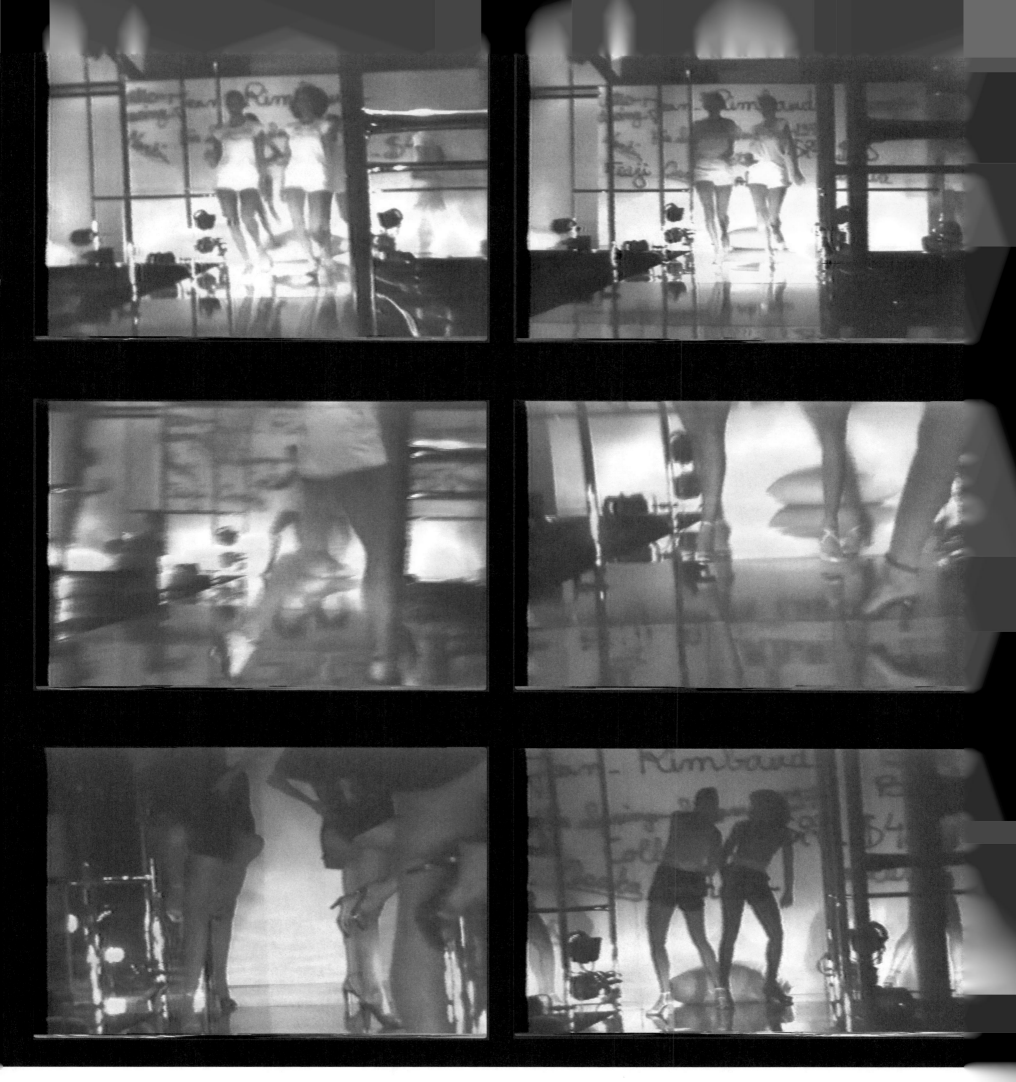

Charles Jourdan
Shoe Show

Anton Perich (American, born
Croatia, 1945). *The Anton Perich
Movies: Charles Jourdan, Studio
54* (stills), October 13, 1977.
Videotape, color, sound; 39
minutes. Courtesy of the artist.
© Anton Perich

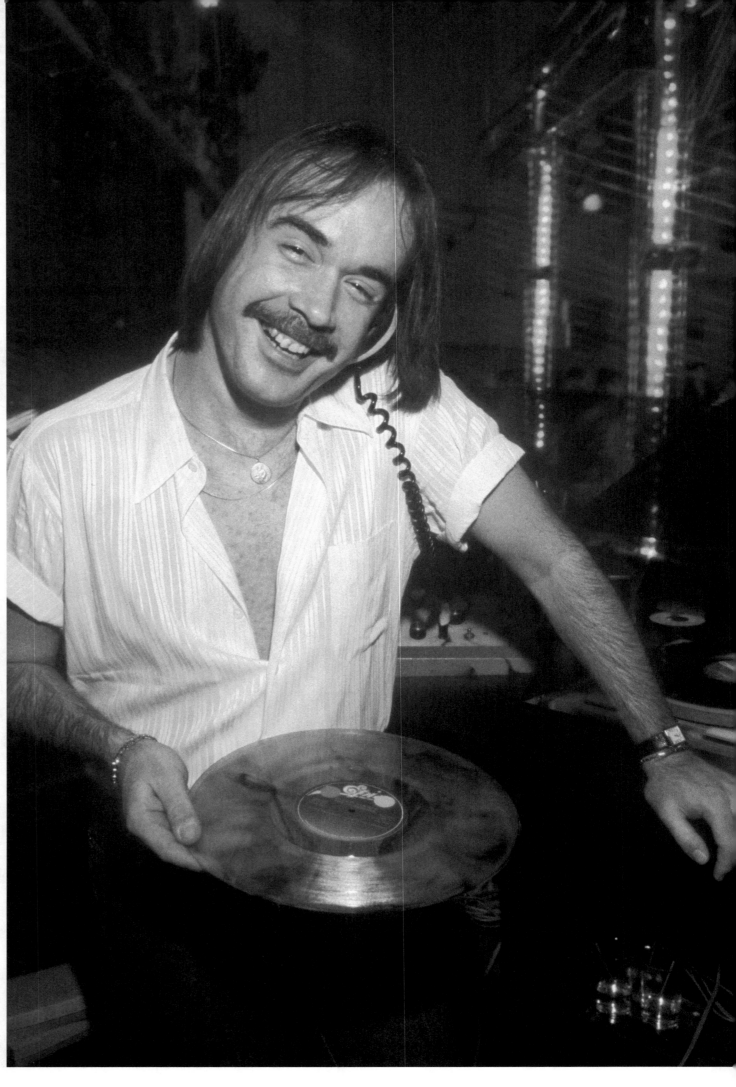

DJ Superstars

In the 1970s the art of DJing was primarily a manual activity—with a DJ alternating between two or three turntables, segueing between songs, to create a continuous soundscape for dancers. Small improvements, such as the ability to adjust turntable speed to bridge tempos across records, were seen as groundbreaking. The DJ's intuition and creativity were crucial to keeping the beats flowing on the dance floor, and a few DJs, including Richie Kaczor and Roy Thode at Studio 54, developed celebrity status.

Before electronic technology could "count" the bpms (beats per minute) of a record, disco DJs did this manually with a stopwatch. DJ Roy Thode compiled these timings, ranging from a slow tempo at 80 bpms to 140, in a "BPM Bible," which he consulted during gigs. This information allowed Thode to musically segue from one song to the next seamlessly without losing momentum. A new innovation at the time (the direct-drive turntable) also enabled the DJ to speed up and slow down the speed of a turntable, so that the bpms could be matched between songs more fluidly.

Roy Thode (American, 1949–1982). *The BPM (Beats Per Minute) Bible*, circa 1979. Notebook with handwritten entries. Courtesy of Marsha Stern

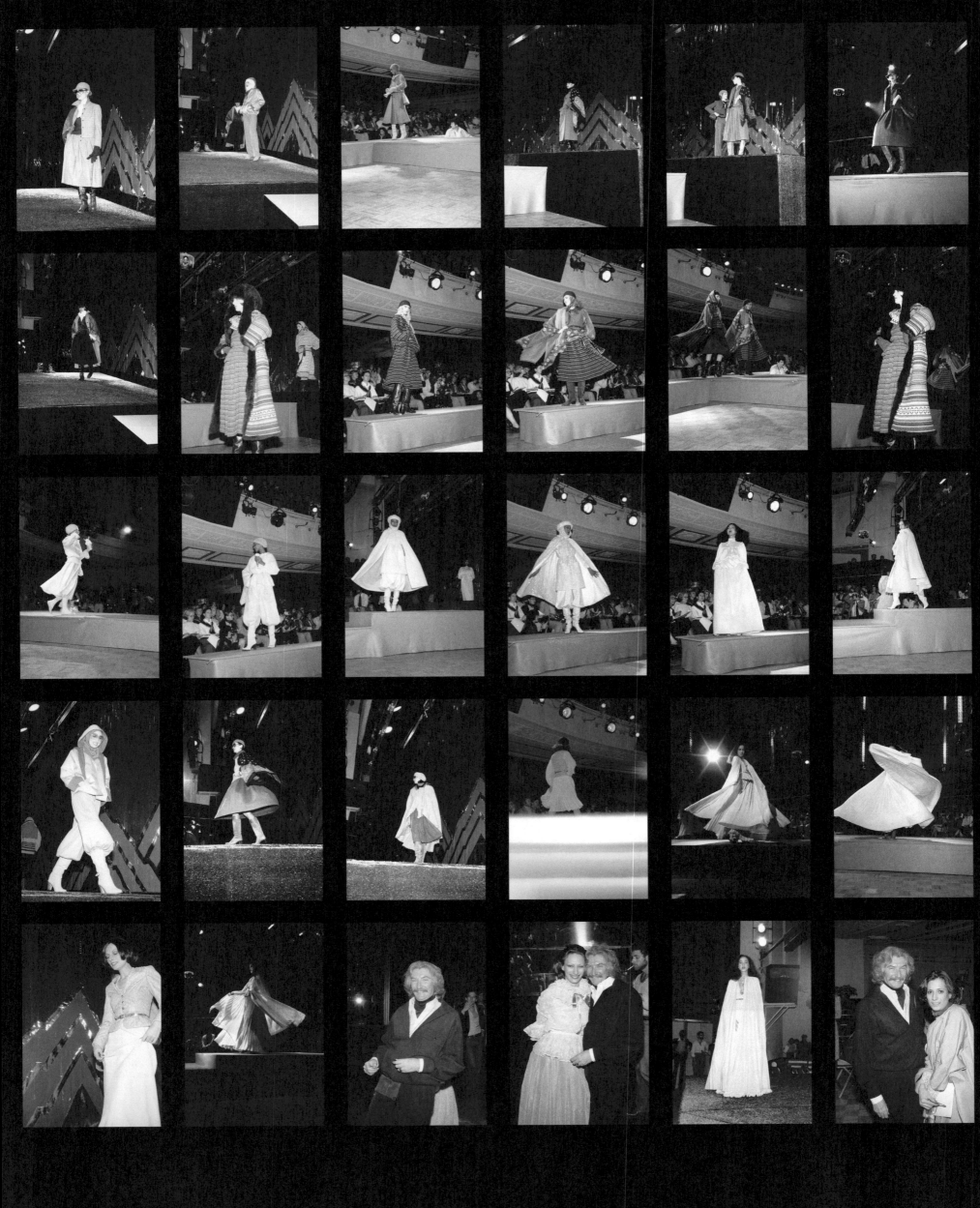

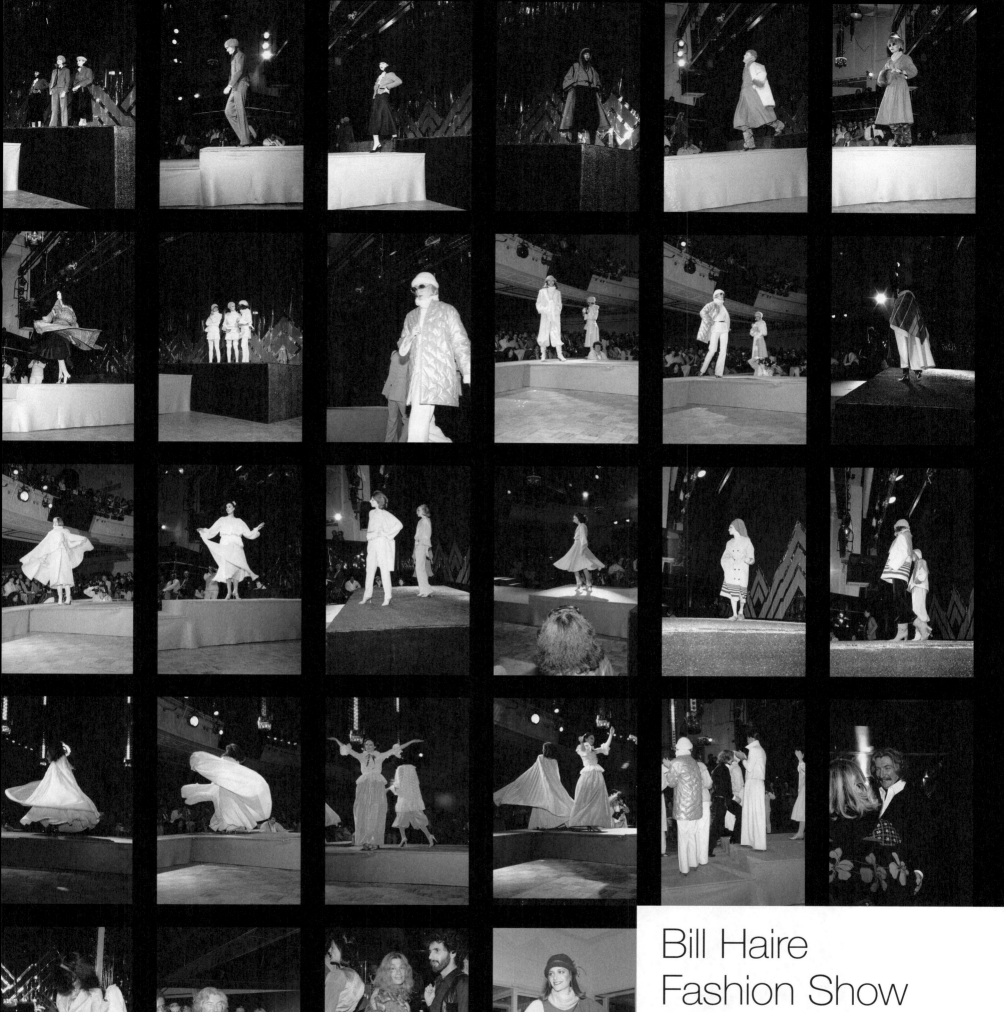

Bill Haire
Fashion Show

Roxanne Lowit (American, born 1958). *Bill Haire Fashion Show*, October 13, 1977. Courtesy of the artist. © Roxanne Lowit

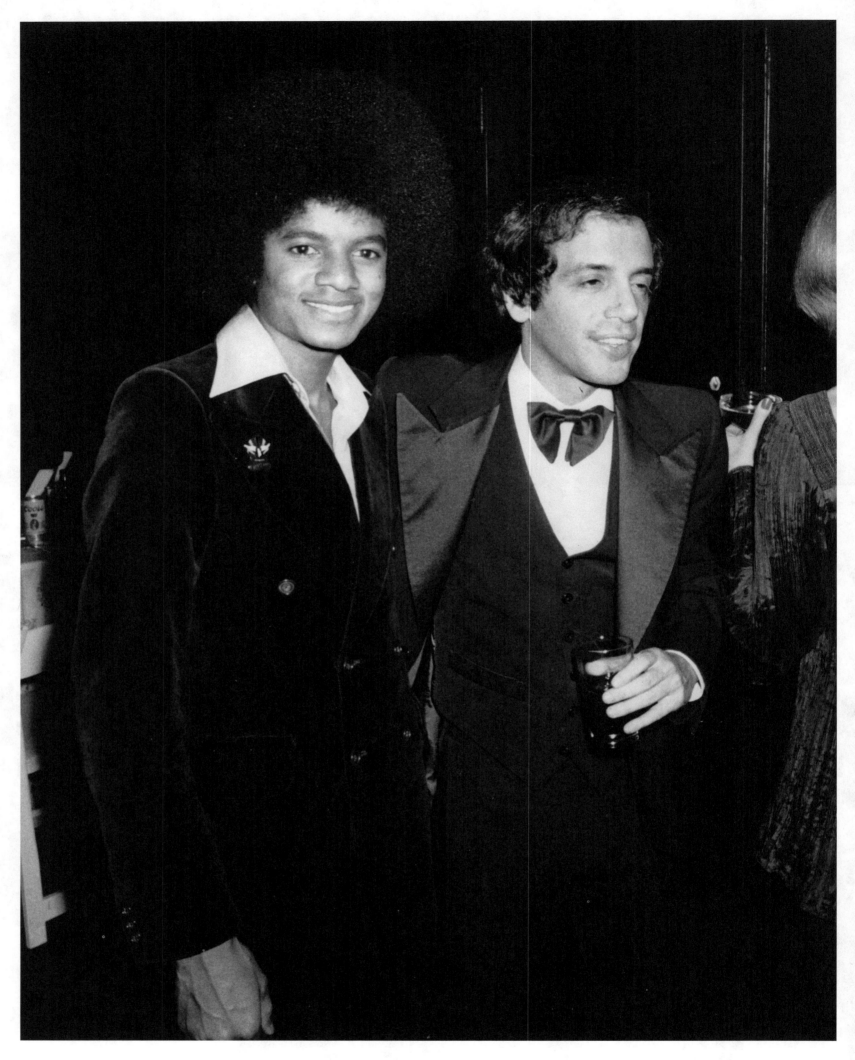

"Did I experience that, or did someone tell me about that?"

—Richie Williamson

Ron Galella (American, born 1931). New York City, Premiere Party for "The Turning Point" at Studio 54, Michael Jackson and Steve Rubell, November 14, 1977. Gelatin silver print, 11 x 8 1/2 in. (27.9 x 21.6 cm). Courtesy of the artist. © Ron Galella

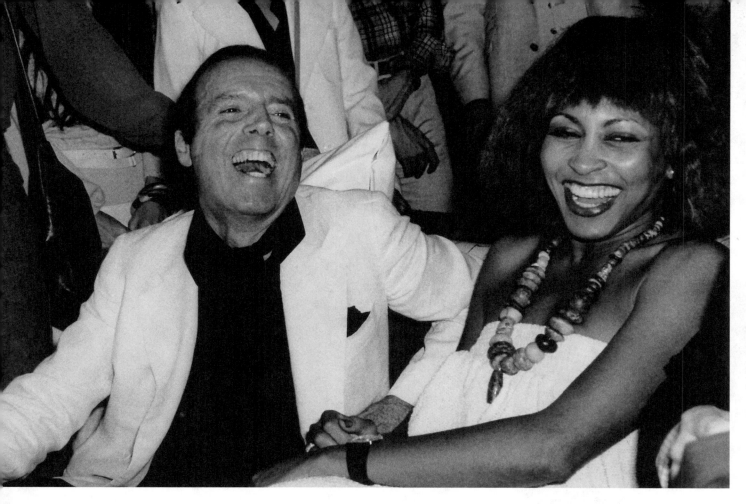

Top: Rose Hartman (American, born 1937). *Francesco Scavullo and Tina Turner*, May 18, 1978. Courtesy of the artist. © Rose Hartman

While most photographers at Studio vied for the best shot, famed studio photographer Francesco Scavullo never took his camera to the nightclub, though he was often the subject for other photographers. For one birthday party at Studio, Rubell and Schrager lined the entrance hallway with photobooths, and presented Scavullo with a cake in the shape of a camera.

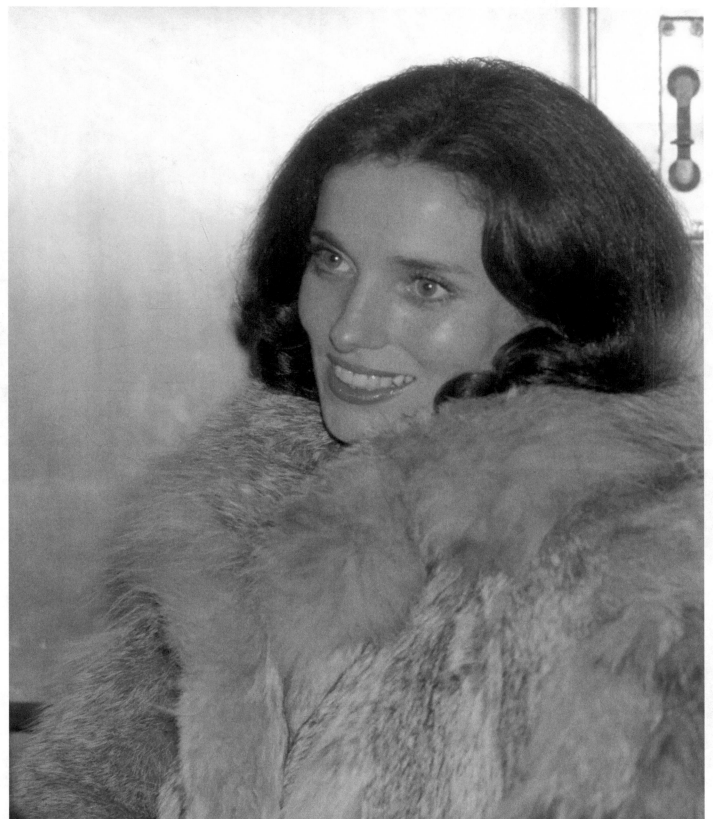

Bottom: Ron Galella (American, born 1931). *Margaret Trudeau at Tennis Benefit Party at Studio 54*, November 21, 1977. Courtesy of the artist. © Ron Galella

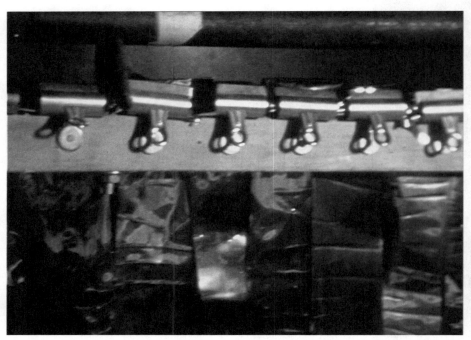

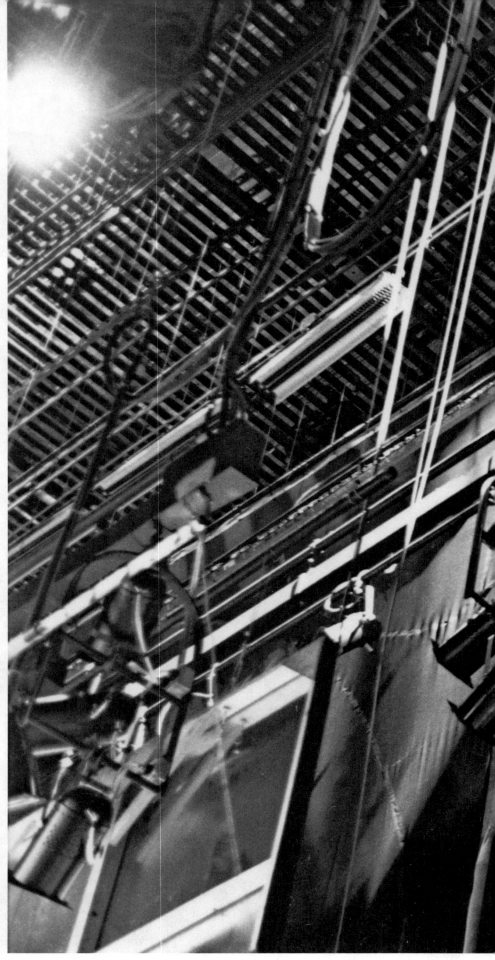

The Rigging behind the Scenes

When Studio 54 opened its doors at night, the huge dance floor was usually divided in half by a curtain drop. Once the night-club became crowded—typically after midnight—the drop would be lifted. In the hours before midnight, Studio began to have "behind the curtain" parties, and Steve Rubell's December 2, 1977, birthday celebration is said to have been the first. On that occasion Bianca Jagger jumped out of a cake, continuing a Rubell birthday tradition born at Enchanted Garden, where Divine jumped out of the cake.

Four-inch Mylar strips were frequently used as a dance floor "event." Clipped onto a thirty-foot-long bar, the curtain of Mylar strips would drop from above the dancers and jump back up. Sometimes the dancers would pull strips off the rod and wear them like scarves. Paul Mathieson, the stage and technical head, would refresh the Mylar every evening as a part of the evening preset. Bestek Theatrical built the drop mechanism for the Mylar.

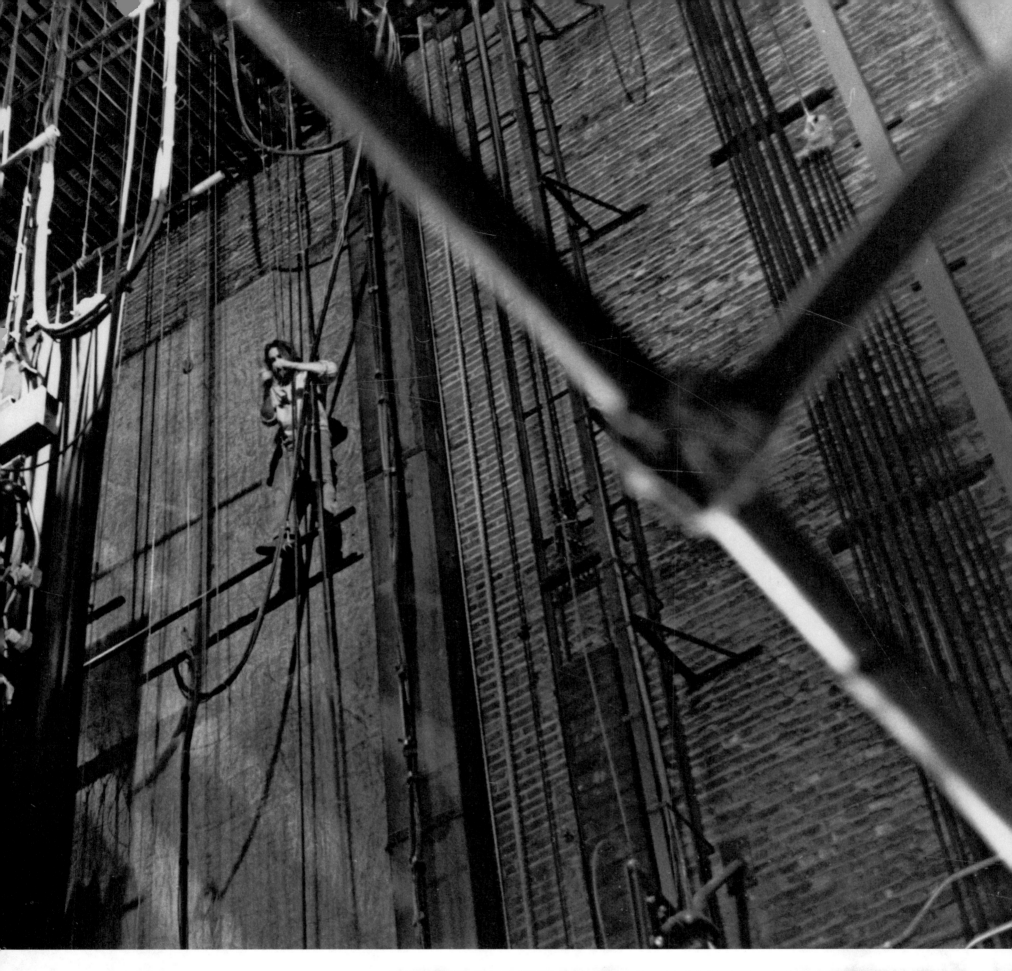

Above: Adam Scull (American).
Renovation. The rigging from
several stories up. Photo by
© Adam Scull/PHOTOlink.net

Right: Adam Scull (American).
Renovation. Photo by © Adam
Scull/PHOTOlink.net

Opposite: Susan Hillary Shapiro
and Glenn Albin, filmmakers. *Mylar
drop* (still), 1979. 16mm film,
color, silent. Courtesy of the
filmmakers. © Glenn Albin and
Susan Hillary Shapiro

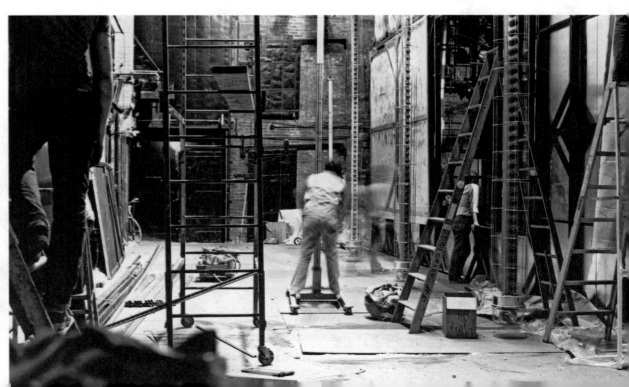

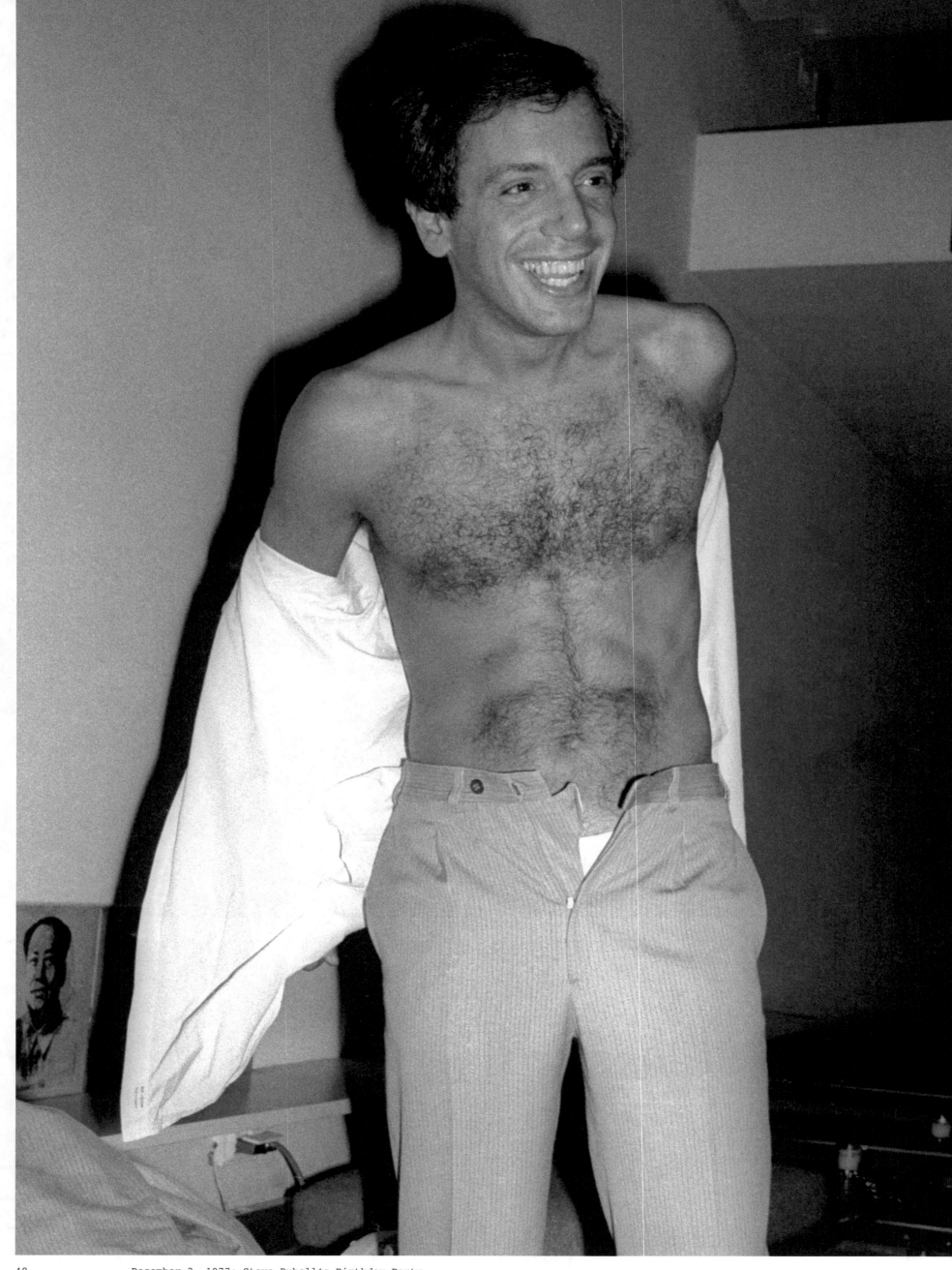

December 2, 1977: Steve Rubell's Birthday Party

Birthday Party Steve Rubell Style

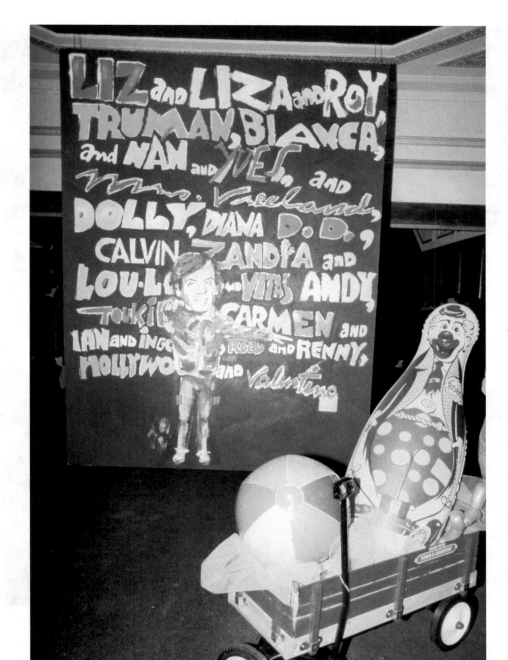

"When you walked in, they would give you party favors . . . handkerchiefs, or cowboy hats, or sheriff's badges, so everyone was a part of the party."

—Roxanne Lowitt

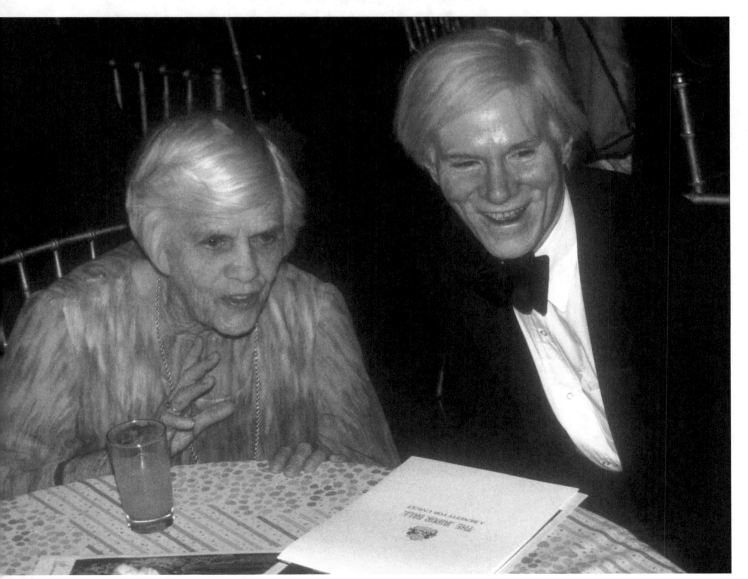

Opposite: Adam Scull (American). *Steve Rubell*, 1978. Courtesy of the artist. © Adam Scull

Top: Dustin Pittman (American). *Entrance to Steve Rubell's Birthday Party*, December 2, 1977. Courtesy of the artist. © Dustin Pittman

Bottom: Adam Scull (American). *Lillian Carter and Andy Warhol*, December 5, 1977. Photo by Adam Scull/PHOTOlink.net. © Adam Scull

The Jaipur Ball, to benefit UNICEF, was the first sit-down dinner at Studio 54. Lillian Carter received the Indo-American Peace and Friendship Award.

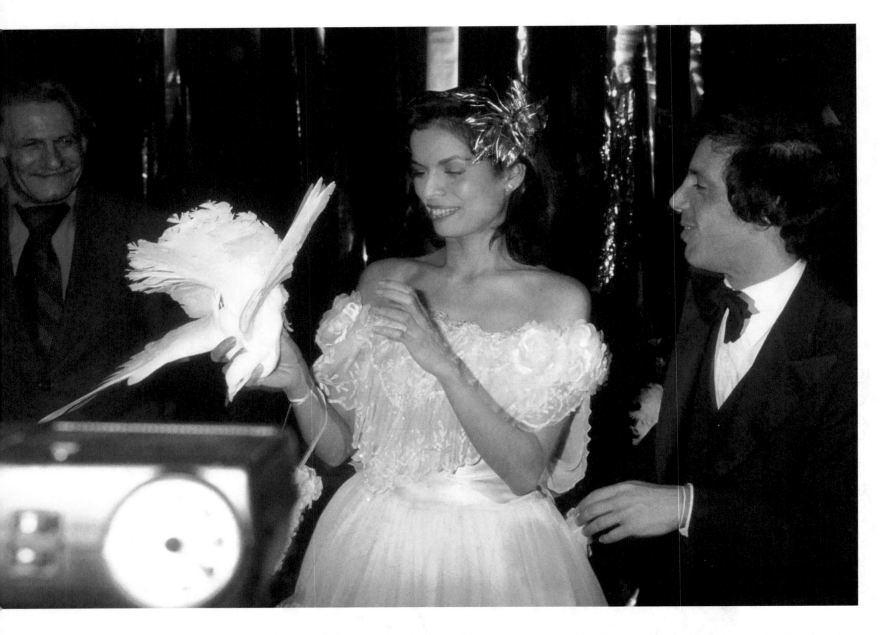

"Disco Bash" for Bianca Jagger, Hosted by Halston, 1977

Halston's circle of famous and beautiful friends and his visionary style would infuse Studio 54 with glamour and originality that had not been seen in New York since the days of El Morocco and the Stork Club. He maintained long and successful relationships with such Hollywood celebrities and socialites as Doris Duke, Liza Minnelli, and Elizabeth Taylor, among many. Others in his orbit included the model and jewelry designer Elsa Peretti, Halston house model Chris Royer, illustrator and art director Joe Eula, and his companion and muse, Venezuelan artist and window designer Victor Hugo. His coterie of American models, known as the Halstonettes, included Karen Bjornson, Alva Chinn, Pat Cleveland, and Nancy North. Individually or in groups, they frequently accompanied Halston to special events at Studio 54.

Top: Ron Galella (American, born 1931). *New York City, Studio 54, Party for Bianca Jagger Hosted by Halston, Bianca Jagger with Doves and Steve Rubell*, 1977. Courtesy of the artist. © Ron Galella

Bottom: Ron Galella (American, born 1931). *New York City, Studio 54, Party for Bianca Jagger Hosted by Halston, Bianca Jagger with Doves*, 1977. Courtesy of the artist. © Ron Galella

Opposite, top: Robin Platzer (American, b. 1953). *Bianca Jagger with Dove*, 1978. Film. Courtesy of the artist. © Robin Platzer / Twin Images

Opposite, bottom: Ron Galella (American, born 1931). *New York City, Studio 54, Party for Bianca Jagger Hosted by Halston, Bianca Jagger with Doves*, 1977. Courtesy of the artist. © Ron Galella

Opposite, bottom right: Ron Galella (American, born 1931). Party for Bianca Jagger hosted by Halston, Allan Greenspan and Barbara Walters, December 12, 1977. Courtesy of the artist. © Ron Galella

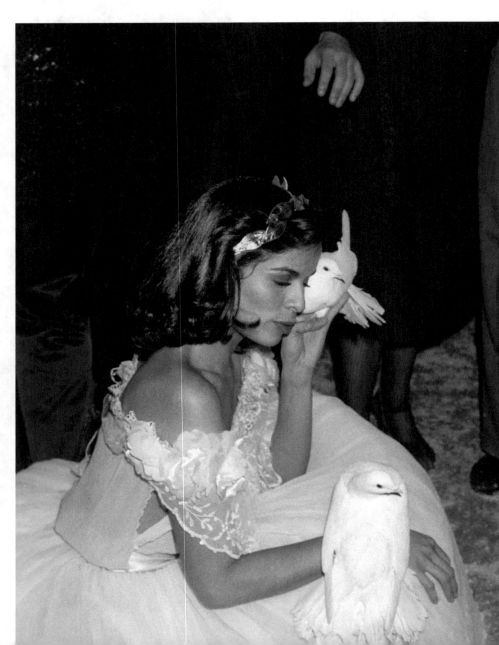

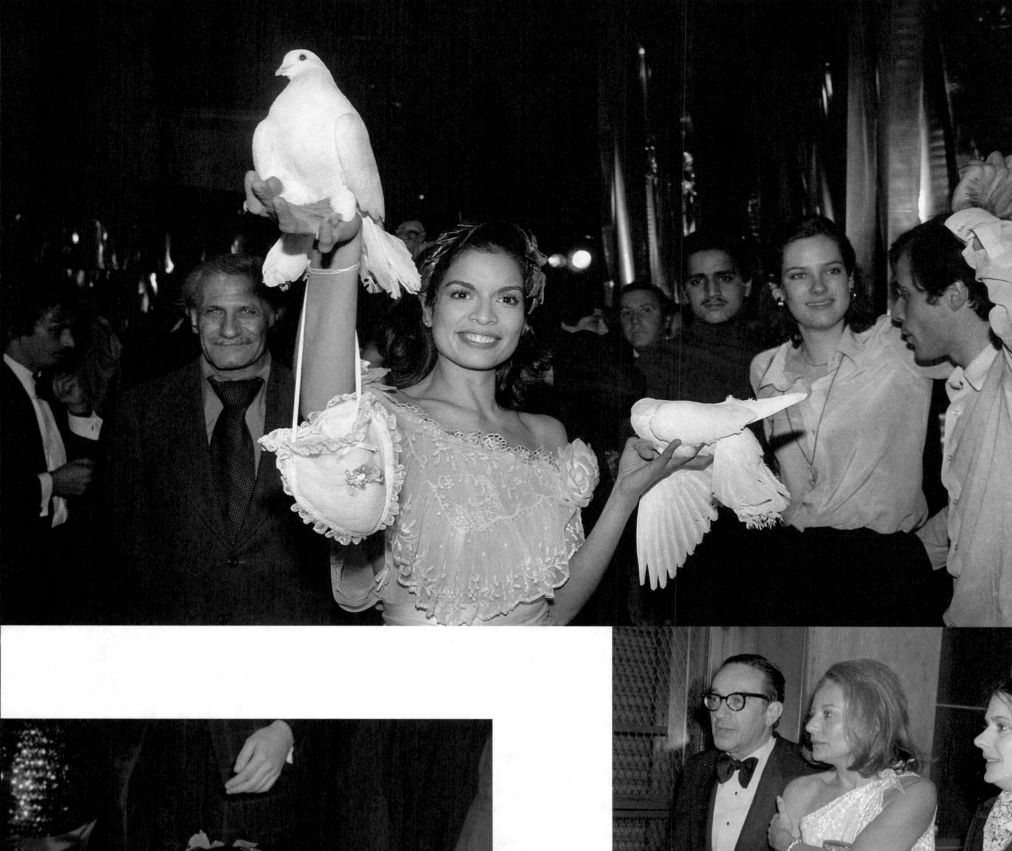
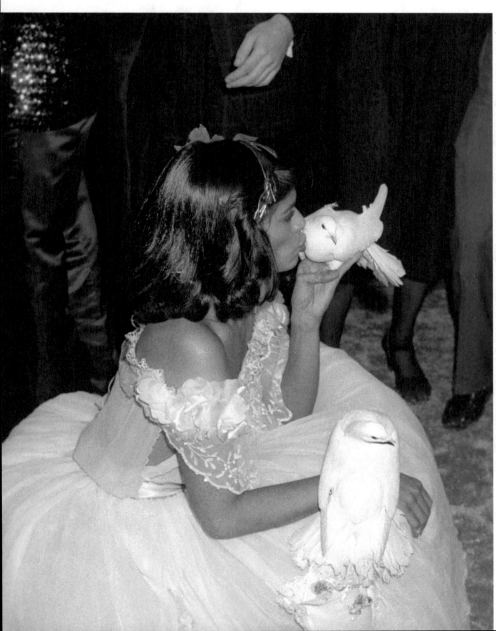
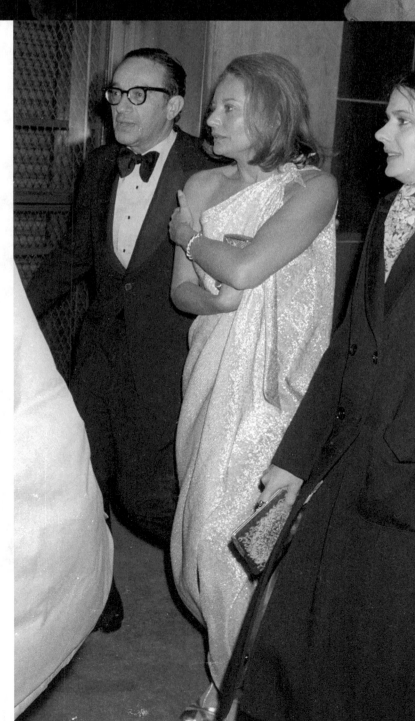

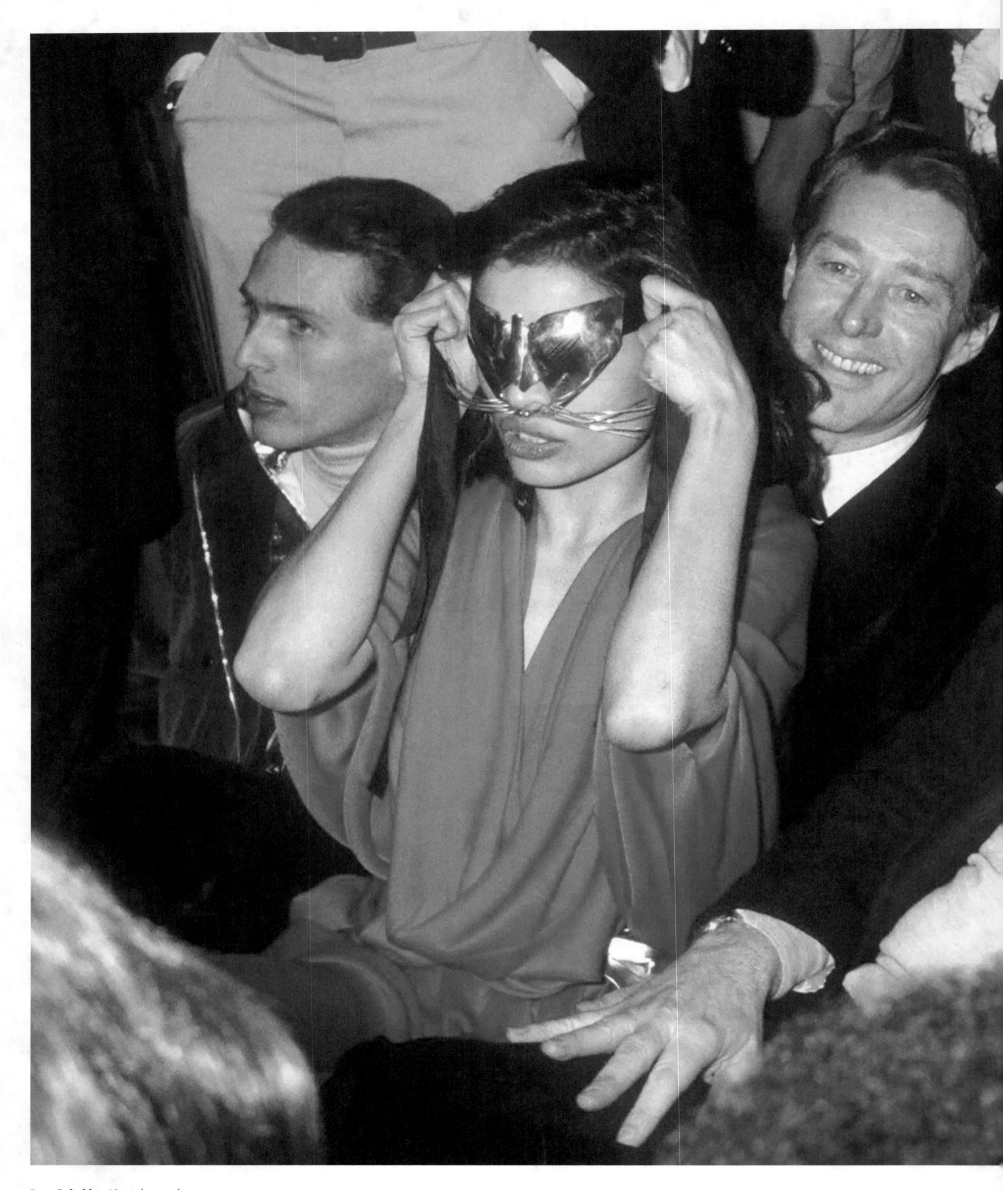

Ron Galella (American, born
1931). *Bianca Jagger, Halston,
Jack Haley, Jr., and Liza
Minnelli*, New Year's Eve, 1977–
78. Courtesy of the artist.
© Ron Galella

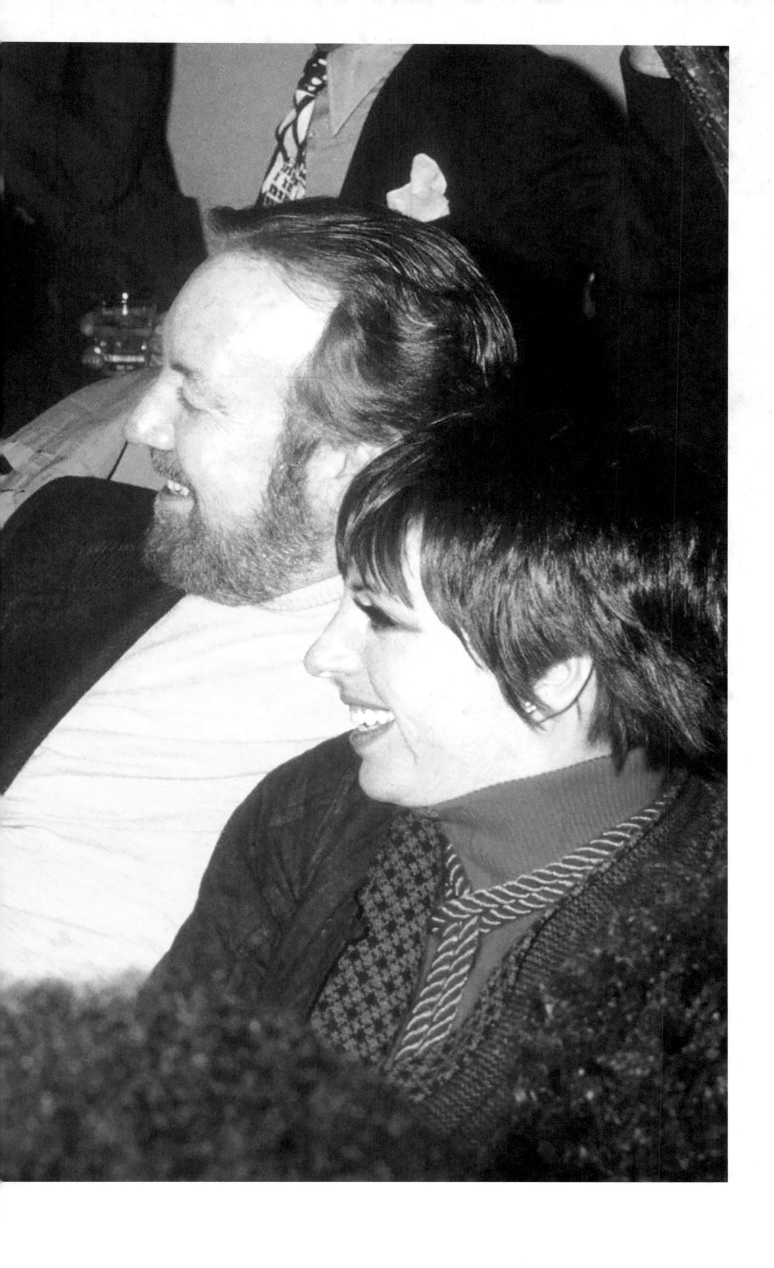

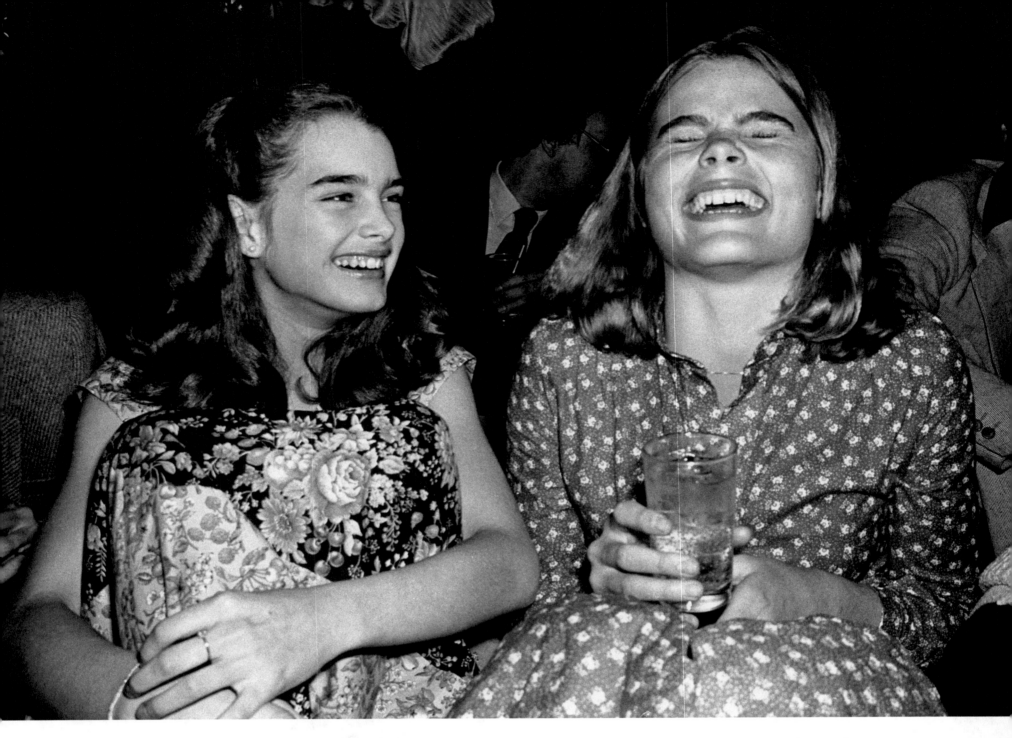

New Year's Eve 1977

Adam Scull (American). *Brooke Shields and Mariel Hemingway*, 1977. Courtesy of the artist. Photo by Adam Scull/ PHOTOlink.net. © Adam Scull

Opposite: Tod Papageorge (American, born 1940). *New Year's Eve, Studio 54*, 1978—79. Gelatin silver photograph, 19 7/8 x 15 3/4 in. (50.5 x 40 cm). Brooklyn Museum, Gift of Robert L. Smith and Patricia L. Sawyer, 1999.127.4. © Tod Papageorge

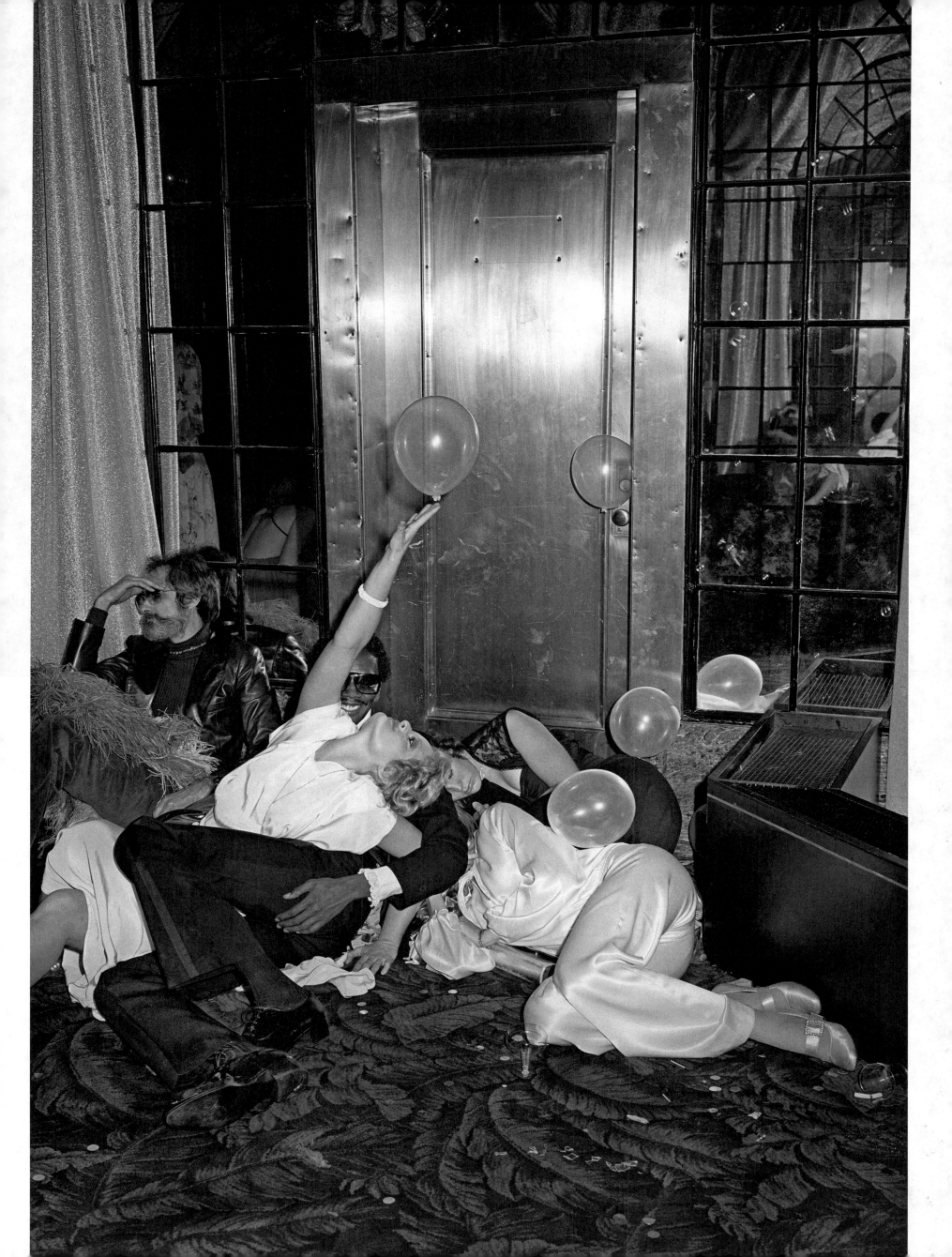

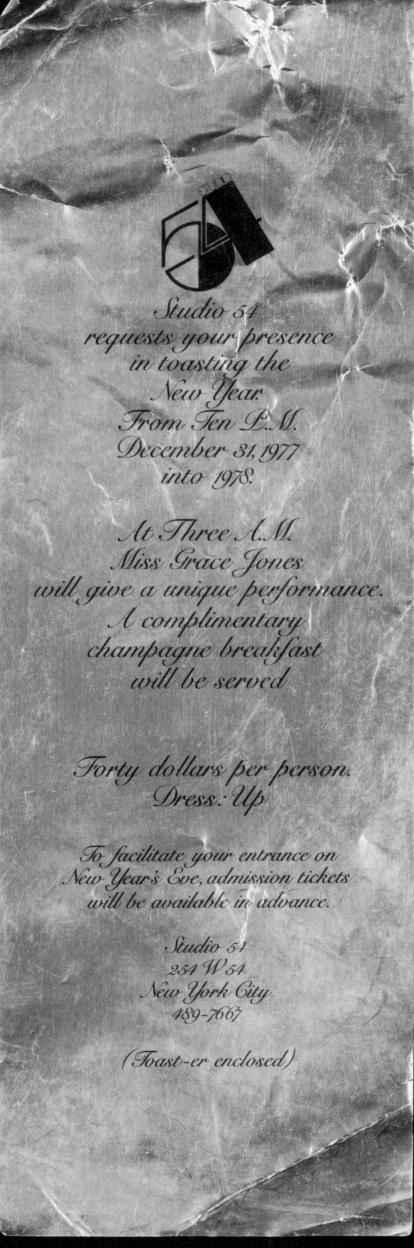

*Studio 54
requests your presence
in toasting the
New Year.
From Ten P.M.
December 31, 1977
into 1978.*

*At Three A.M.
Miss Grace Jones
will give a unique performance.
A complimentary
champagne breakfast
will be served*

*Forty dollars per person.
Dress: Up*

*To facilitate your entrance on
New Year's Eve, admission tickets
will be available in advance.*

*Studio 54
254 W 54
New York City
489-7667*

(Toast-er enclosed)

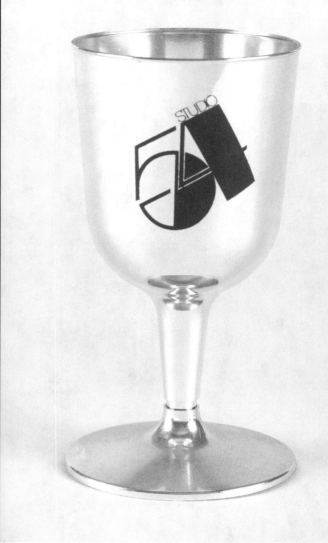

For the 1977-78 New Year's Eve party at Studio, Grace Jones was dressed by Norma Kamali, who created a gold-dusted brown leotard with attached gold lame unitard and leggings, armbands, and a dramatic cloak. At 3 a.m. New Year's Eve, Grace Jones emerged from the cobra's mouth behind a white fox blanket and over the next twenty minutes removed layers of her ensemble and her ten male dancers' break-away pants. Jones performed four songs from her album *Portfolio*.

Left: Gil Lesser (American, 1935–1990). *Invitation to Grace Jones' New Year's Eve Party*, 1977. Printed invitation. Courtesy of Ian Schrager Archive (Photo: Jonathan Dorado)

Top: Gil Lesser (American, 1935–1990). *Invitation to Grace Jones' New Year's Eve Party*, 1977. Metal cup in paper mailing tube. Museum of the City of New York. Gift of Steve Desroches, 2013

Opposite: Aerographics: Richie Williamson (American, born 1947) and Dean Janoff (American, born 1948), set designers. Dress Rehearsal for New Year's Eve Performance, December 31, 1977. Courtesy of Richie Williamson

Pages 58–61: Ron Galella (American, born 1931). *Grace Jones's New Year's Eve performance*, 1978–79. Courtesy of the artist. © Ron Galella

Page 62–63: Richard Bernstein (American, 1939–2002). Grace Jones's *Fame* inner gatefold, 1978. Gouache, pastel, and acrylic. 21 x 15 in. (53.3 x 38.1 cm). © 2020 The Estate of Richard Bernstein / Artists Rights Society (ARS), New York

Page 64: Ron Galella (America, born 1931). *Grace Jones' New Year's Eve performance*, 1978–79. Courtesy of the artist. © Ron Galella

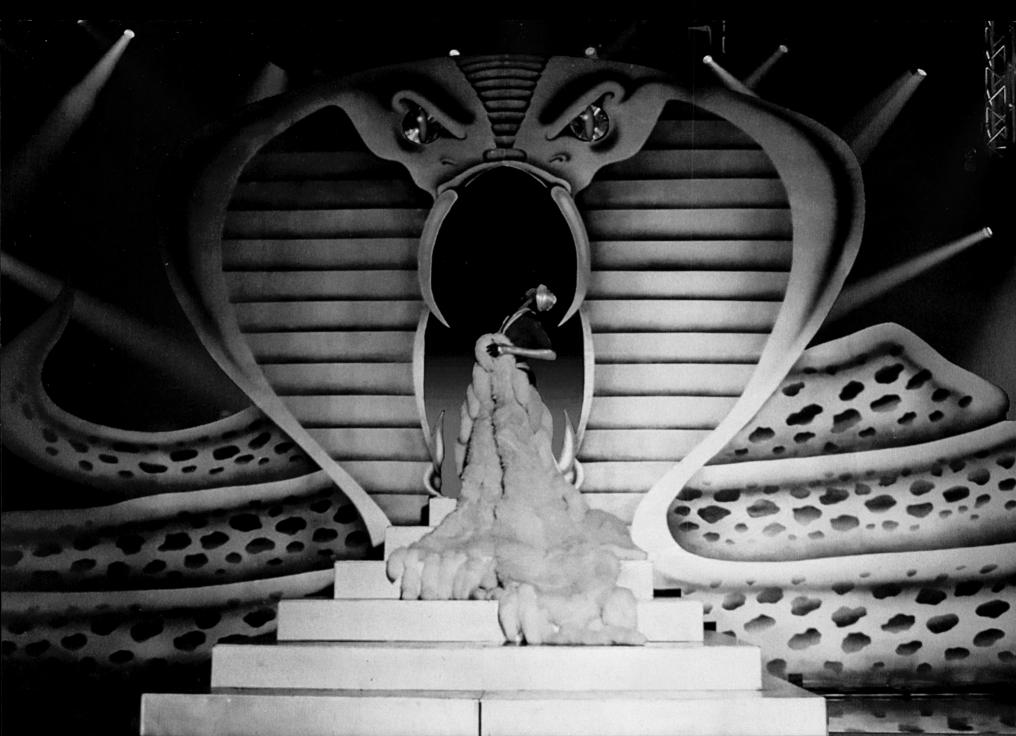

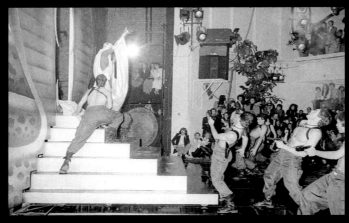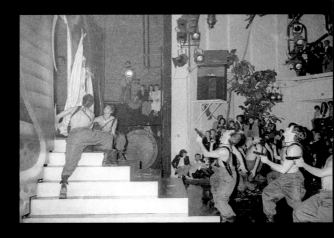
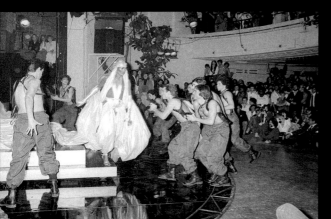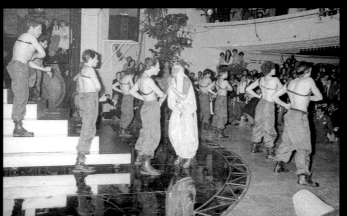

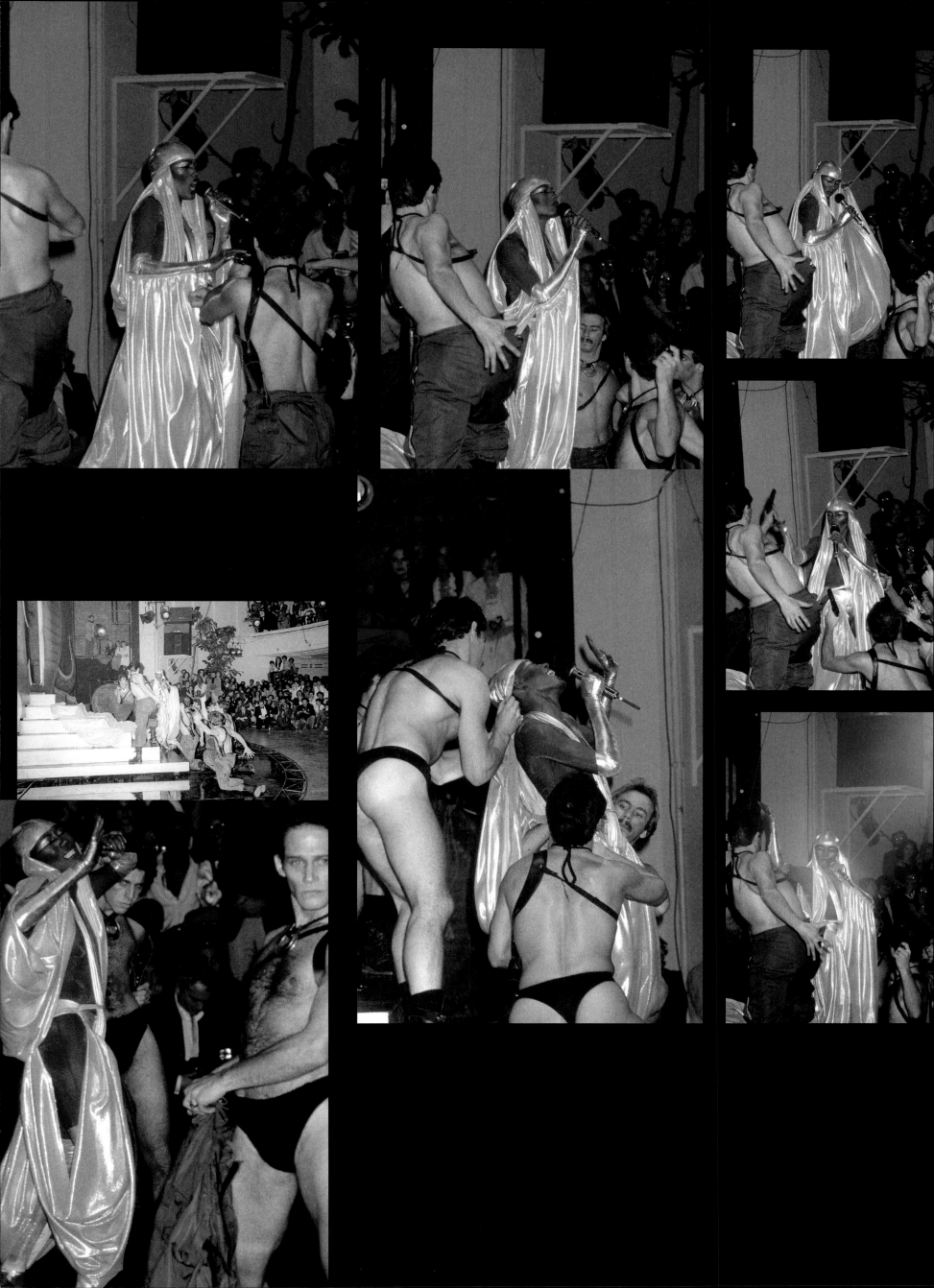

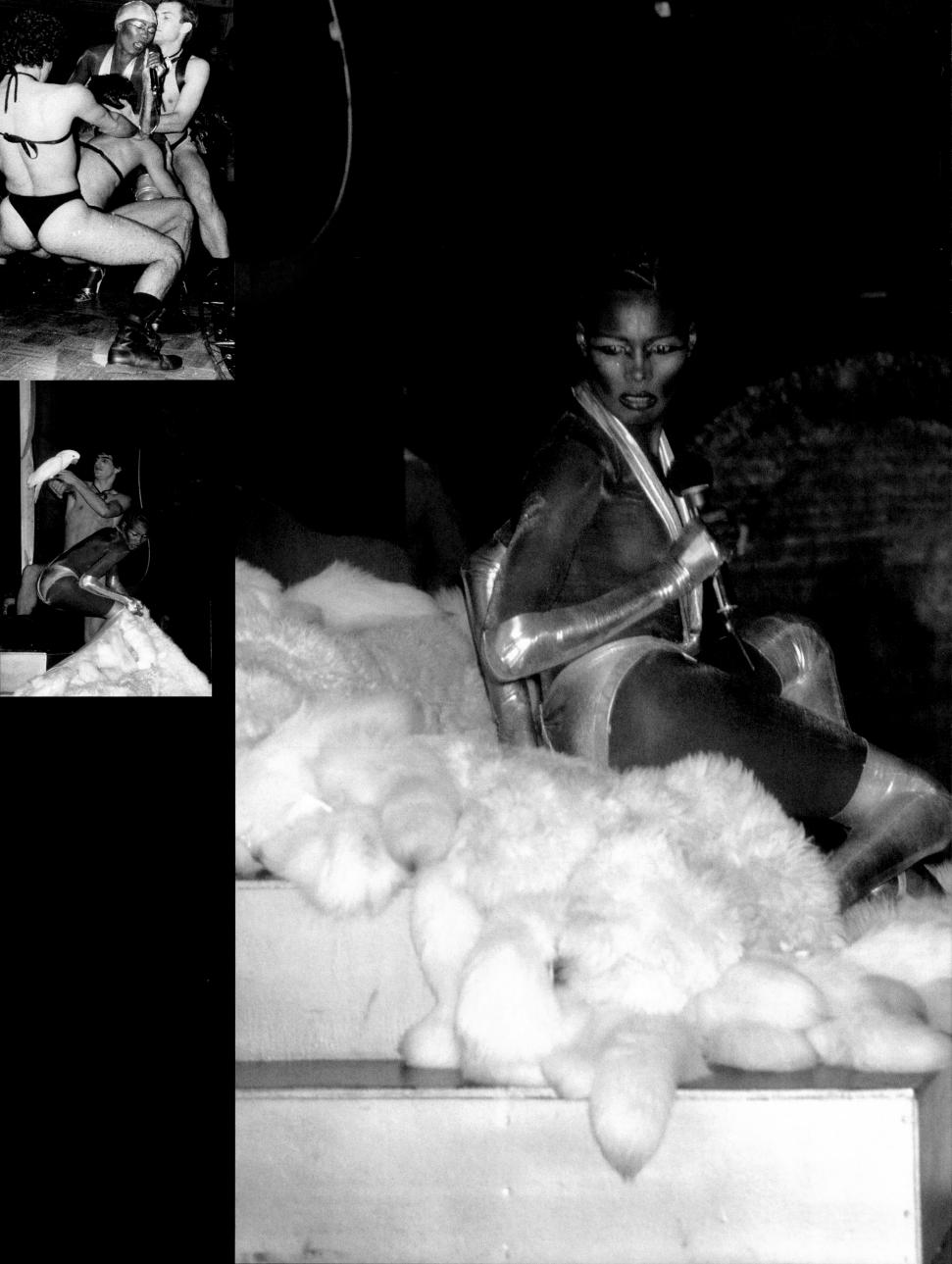

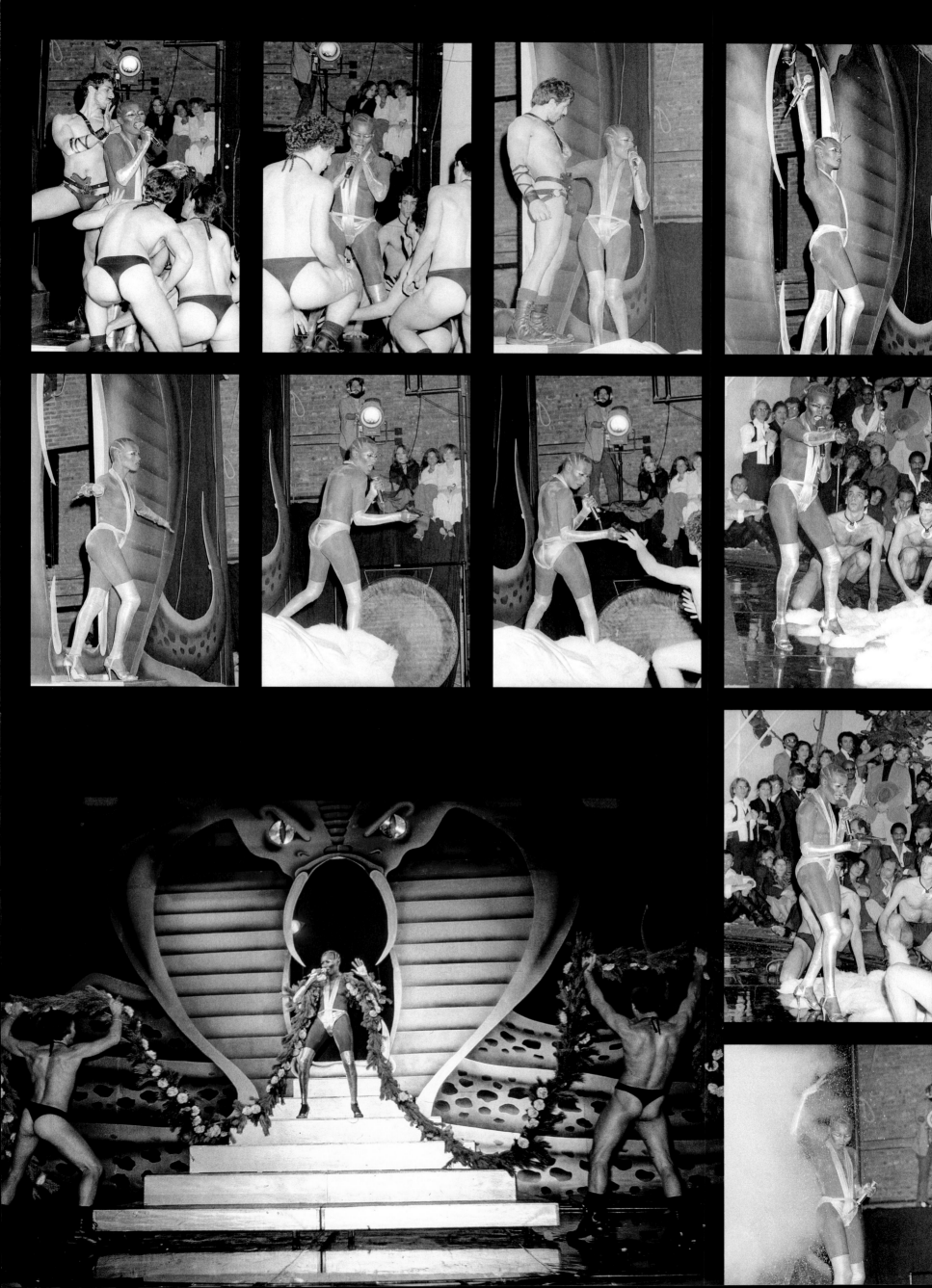

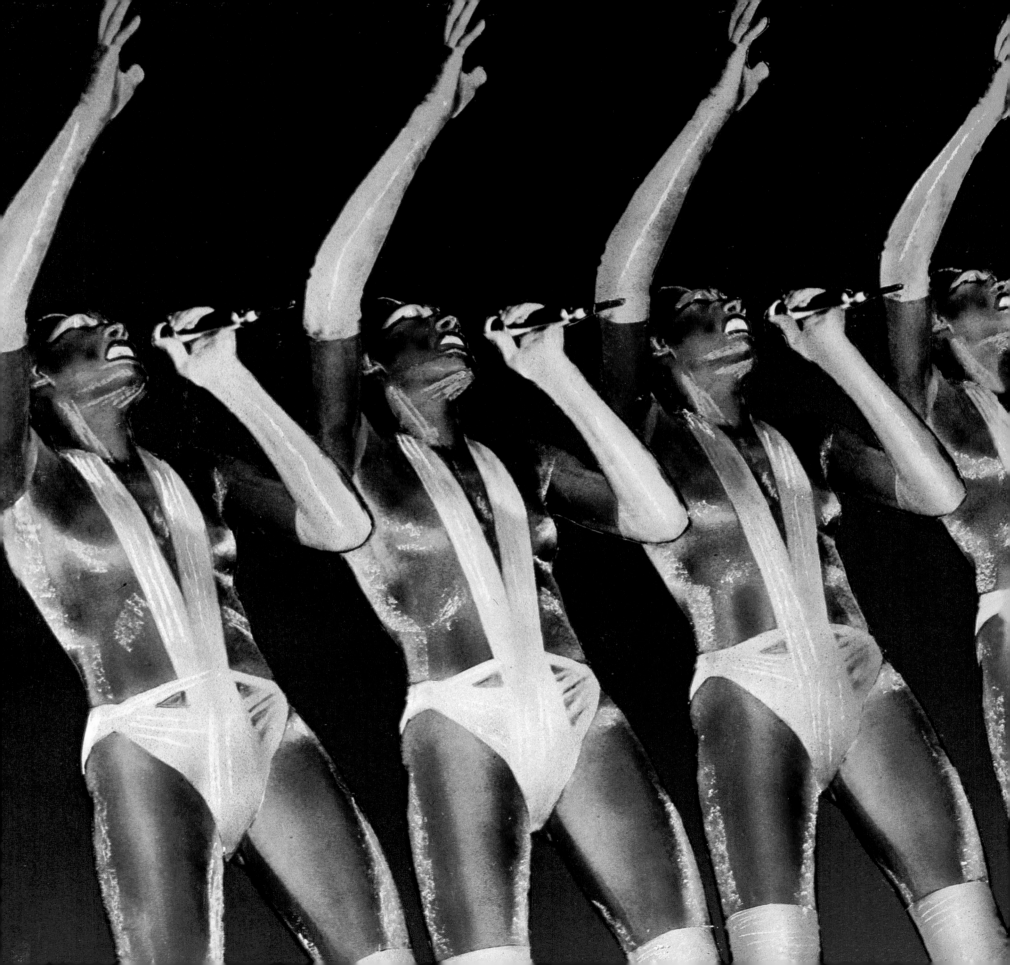

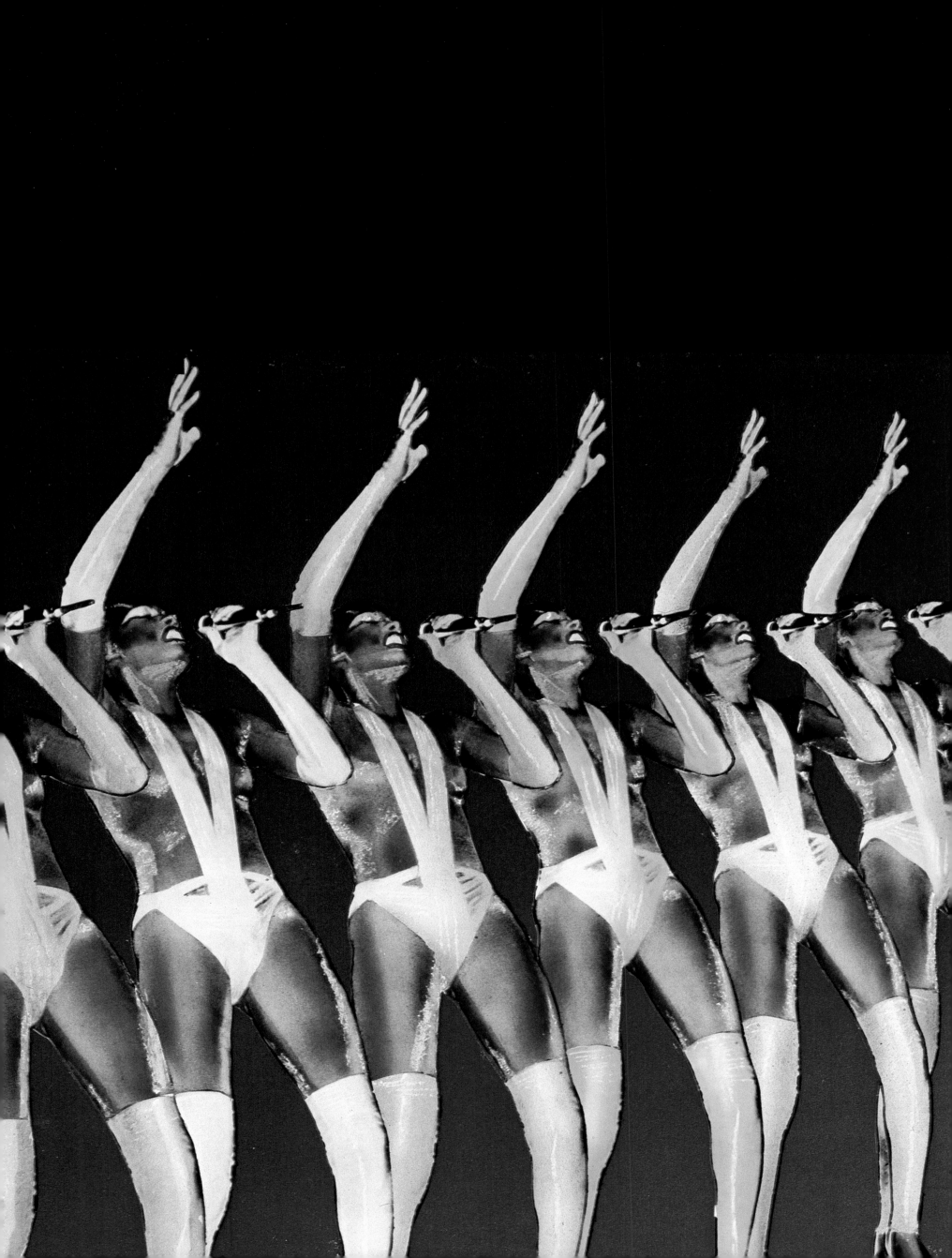

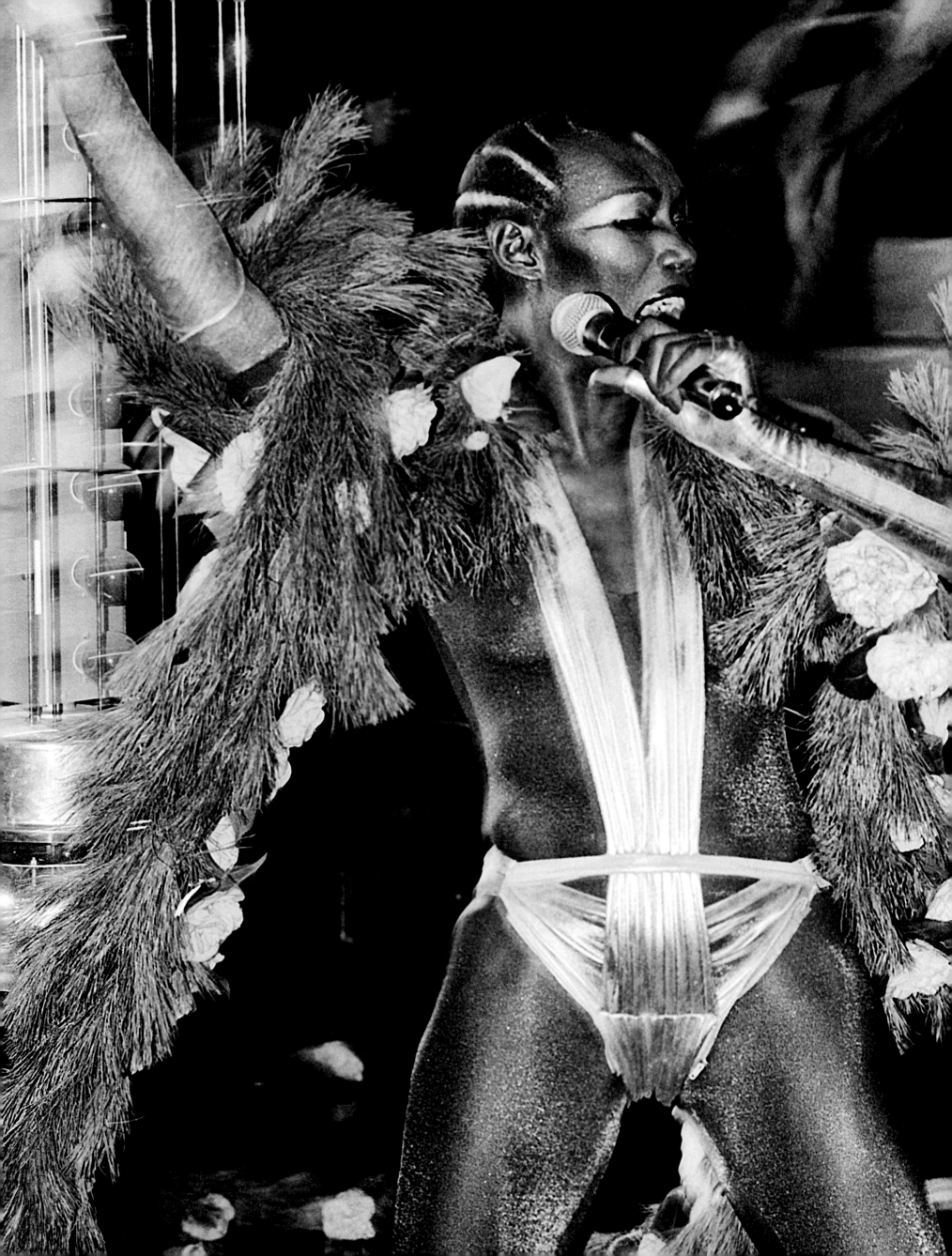

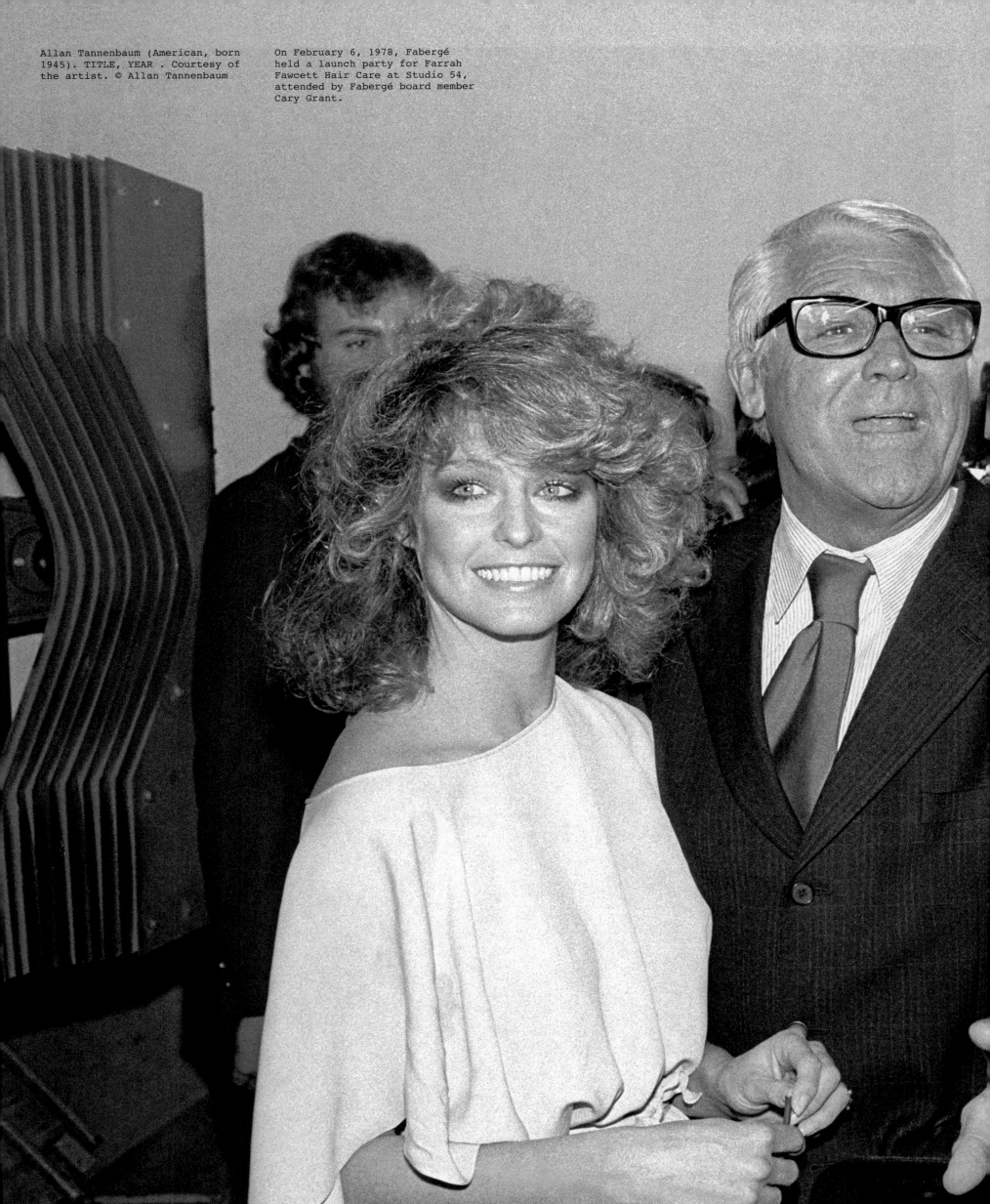

On February 6, 1978, Fabergé held a launch party for Farrah Fawcett Hair Care at Studio 54, attended by Fabergé board member Cary Grant.

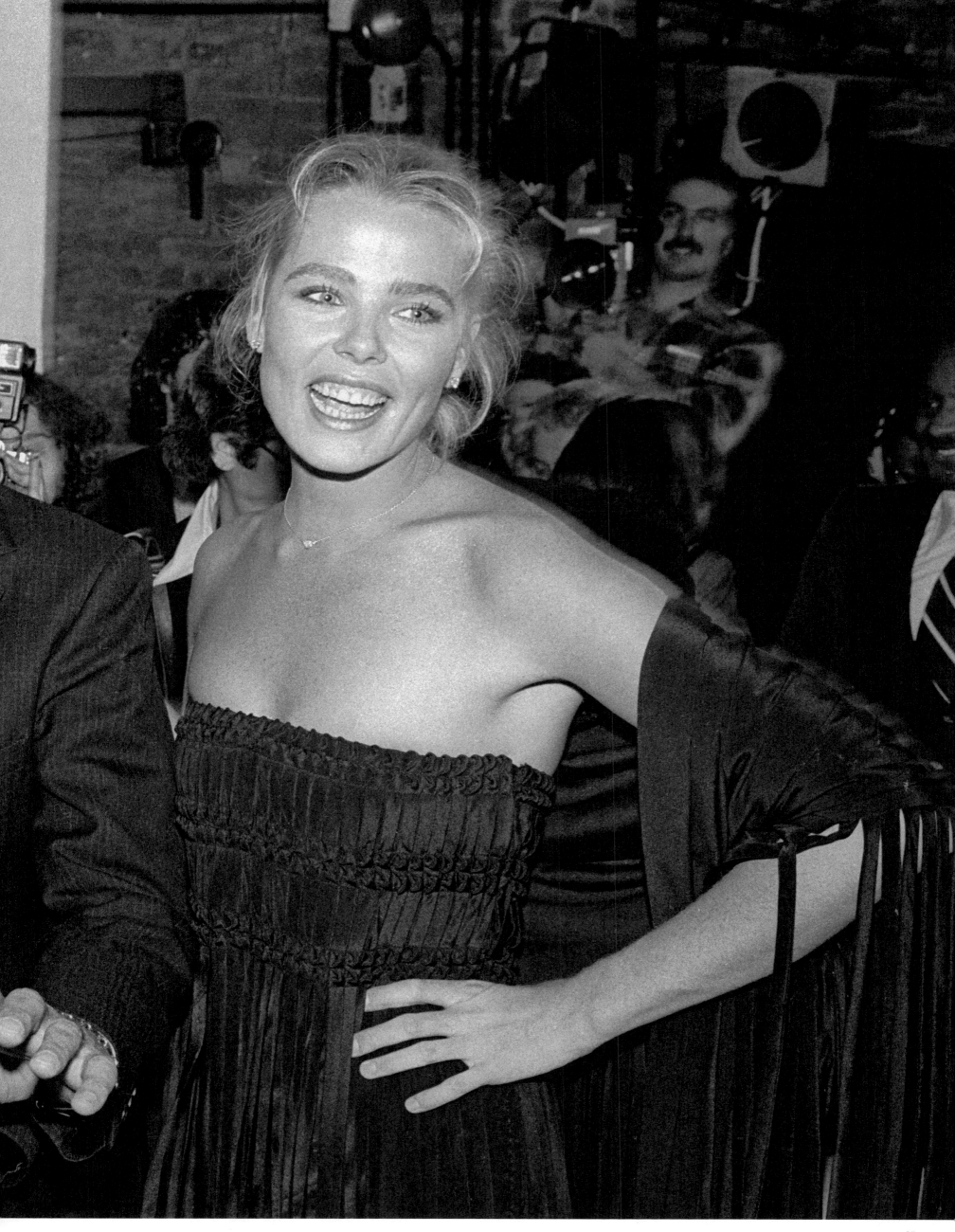

Valentine's Day 1978

Gil Lesser (American, 1935–1990).
*Invitation to Valentine's Day
Party*, 1978. Printed invitation

"Very cold night. As you walked in there were two long troughs of water, with Styrofoam lily pads, gold fish, and gardenias. The bar areas were filled with cherry trees in full bloom, St. Augustine grass, and white wicker furniture on sod. The busboys had white shorts and wings. Two hours after opening, the fire department declared that the ponds were blocking egress and insisted that the ponds were emptied."

—Richie Williamson, 2018,
recalling Studio's 1978
Valentine's Day party

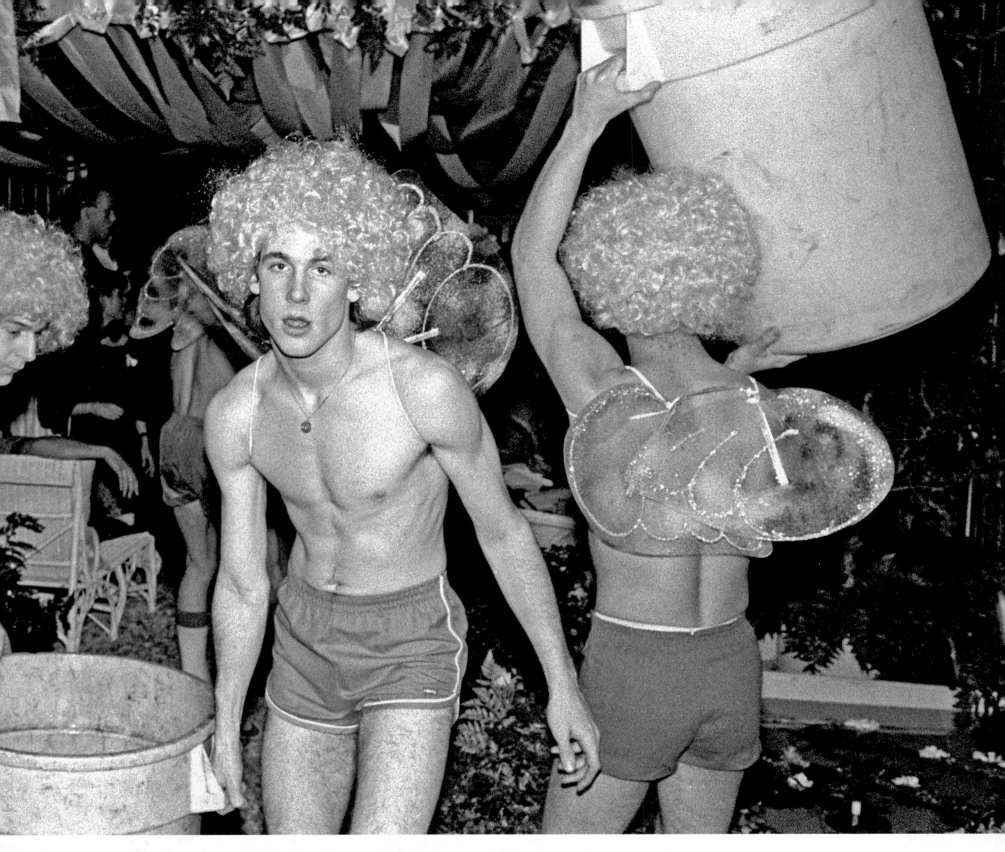

Adam Scull (American). *Cupid Busboys*. Photo by © Adam Scull/ PHOTOlink.net

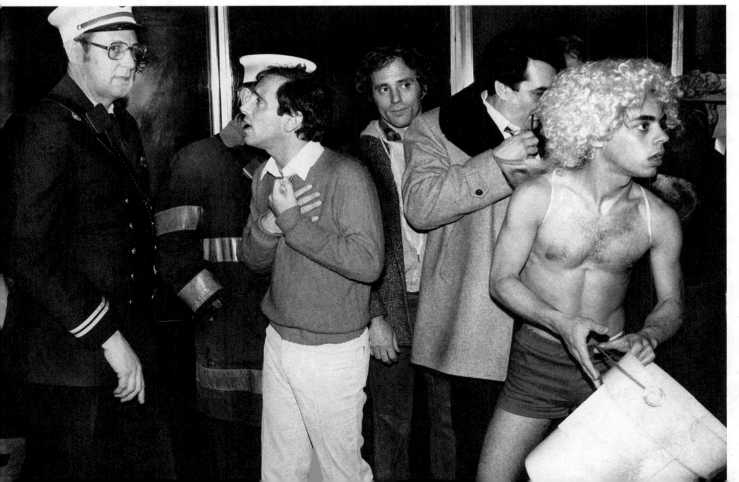

Liz Taylor's Birthday Party Featuring the Radio City Rockettes, 1978

At her birthday party on the evening of March 6, 1978, Elizabeth Taylor was greeted in the grand Studio 54 hallway by an eight-foot-square portrait created by Michaele Vollbracht earlier in the day. Vollbracht dramatically painted Taylor's eyes, lips, and beauty mark, much in the style of his famous Bloomingdale's shopping bag. Installed, the painting was lit by Brian Thomson with a blue light from one angle and a white light from another, making the portrait glow at the end of the hallway. Taylor was said to have gasped and frozen upon seeing the portrait, which was subsequently gifted to her.

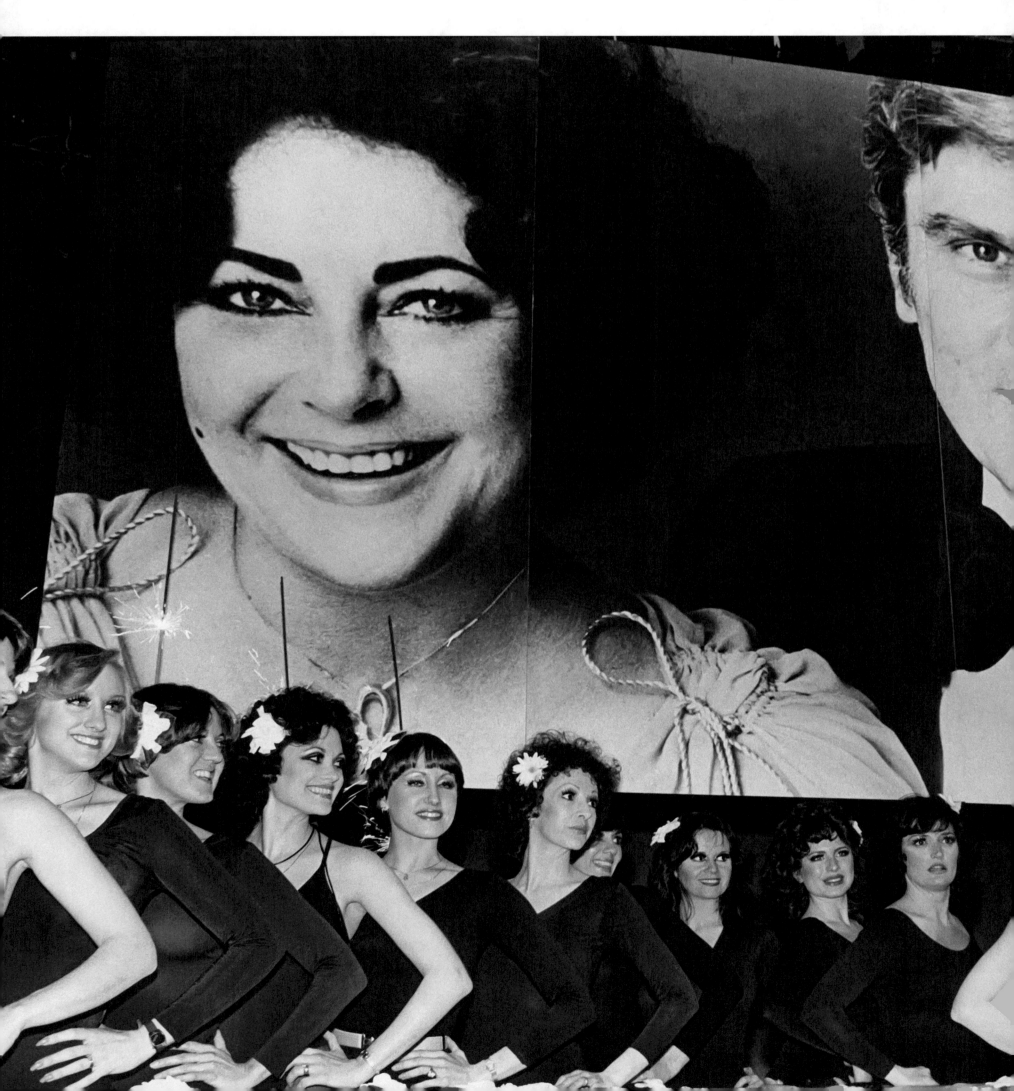

Birthday party for Elizabeth Taylor at Studio 54, 1978 (Photo by Images Press/IMAGES/Getty Images)

Top: Michaele Vollbracht (American, 1947–2018). *Painted Portrait of Elizabeth Taylor*, 1978. Current location unknown

Bottom: Halston (American, 1932–1990) (host) Andy Warhol (American, 1928–1987) (former owner). *Envelope with Western Union Mailgram (to Andy Warhol, March 2, 1978)*, 1978. Typewritten ink on pre-printed paper, 7 × 8 1/2 in. (17.8 × 21.6 cm). The Andy Warhol Museum, Pittsburgh; Founding Collection, Contribution The Andy Warhol Foundation for the Visual Arts, Inc.

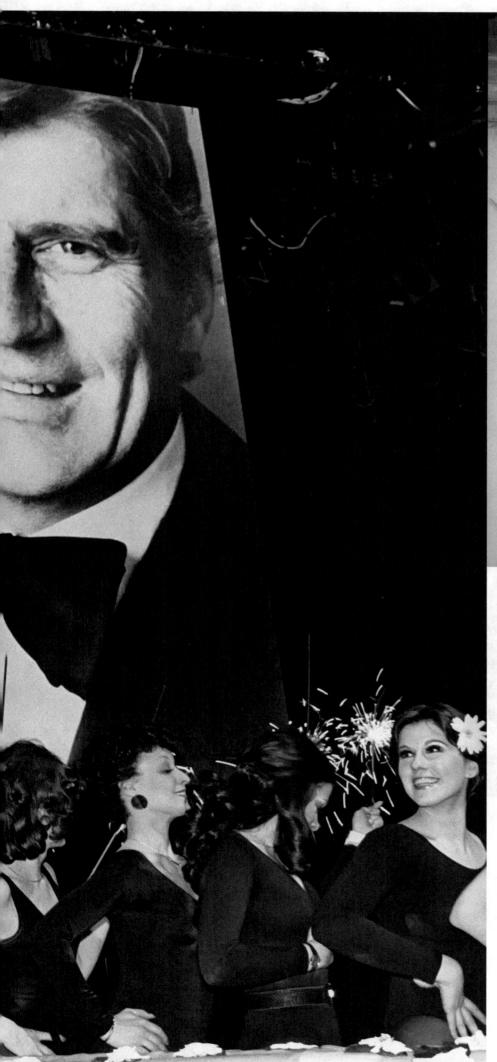

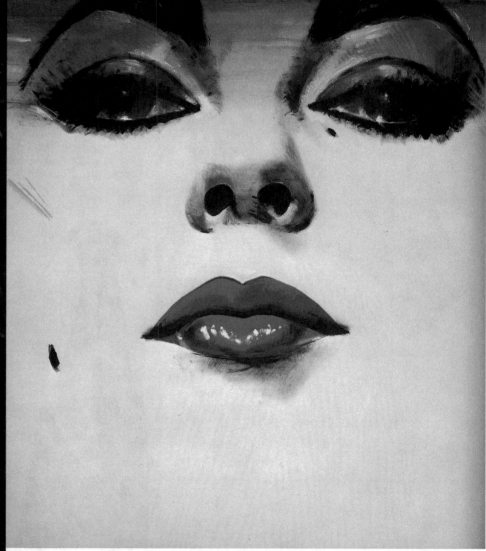

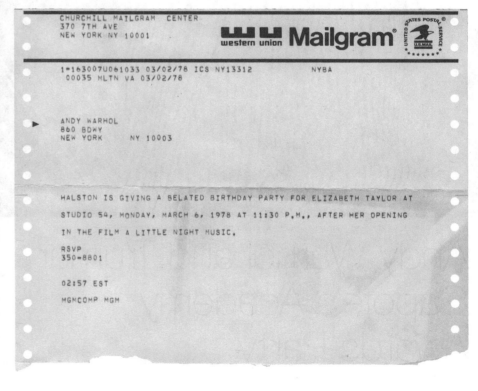

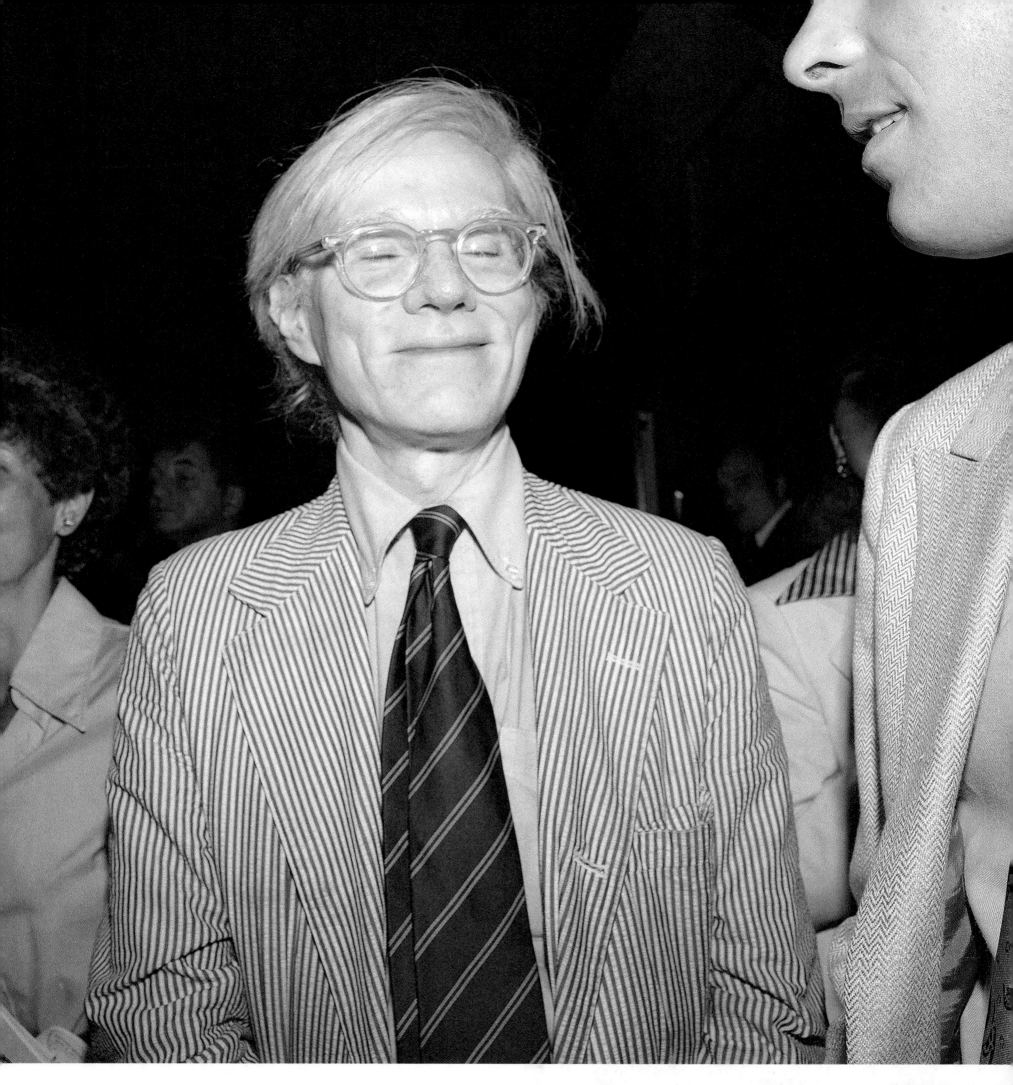

Andy Warhol and Truman Capote's Academy Awards Party

For an Academy Awards party hosted Andy Warhol and Truman Capote, the nightclub was designed to feel like Hollywood, with giant gold Oscar sculptures and groves of palm trees, and waiters serving huge bowls of caviar. The televised Academy Awards program was shown on then state-of-the-art video projectors and screens, though the television signal was still received through an antenna on the roof (personally adjusted by Ian Schrager).

TRUMAN CAPOTE
ANDY WARHOL
INVITE YOU
TO AN
ACADEMY AWARDS PARTY
AT STUDIO 54
MONDAY
APRIL 3RD
FROM 9 PM
RSVP REGRETS:
(212) 826-0892

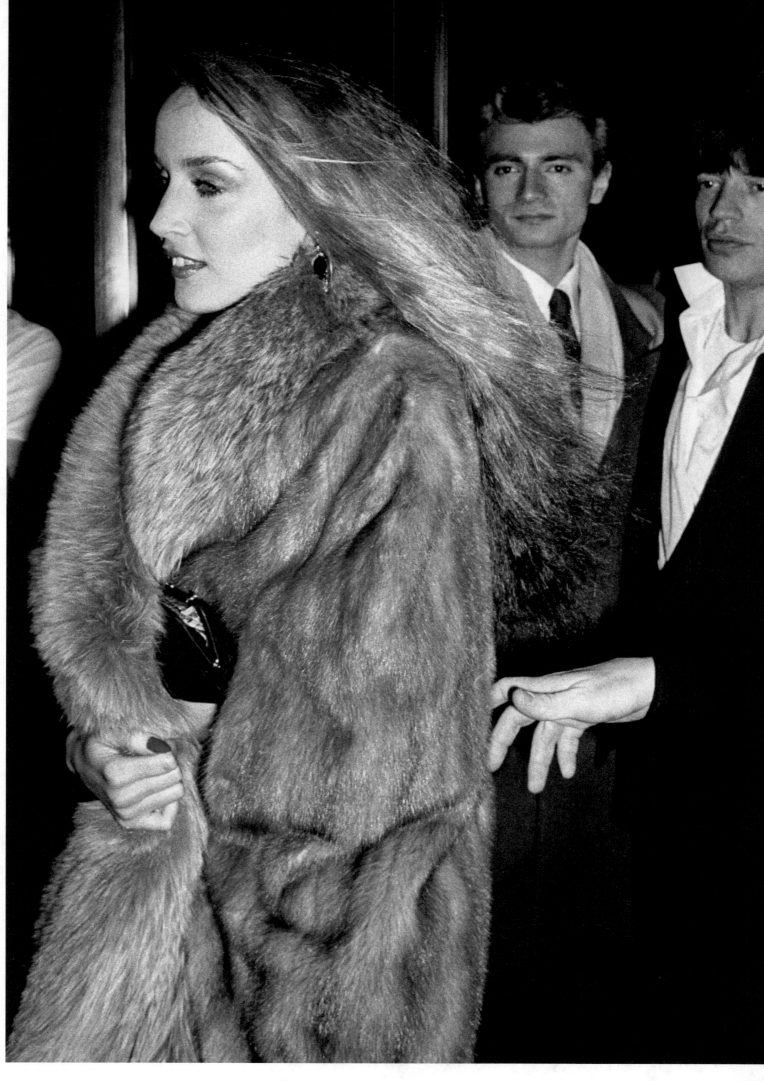

Opposite, top: Meryl Meisler (American, born 1951). *Warhol Eyes Closed Between His Friend and Judi Jupiter*, 1977; printed 2019. Gelatin silver print, 14 x 14 in. (35.6 x 35.6 cm). Courtesy of the artist. © Meryl Meisler

Opposite, bottom: Gil Lesser (American, 1935–1990). *Academy Awards Party Invitation*, 1978. Printed paper, 6 x 6 in. (15.2 x 15.2 cm). Courtesy of Ian Schrager Archive. (Photo: Brooklyn Museum)

Adam Scull (American). *Jerry Hall, Marc Benecke, and Mick Jagger*, April 3, 1978. Photo by Adam Scull/PHOTOlink.net. © Adam Scull

Following spread: Allan Tannenbaum (American, born 1945). *Miyake*, 1977. Courtesy of the artist. © Allan Tannenbaum

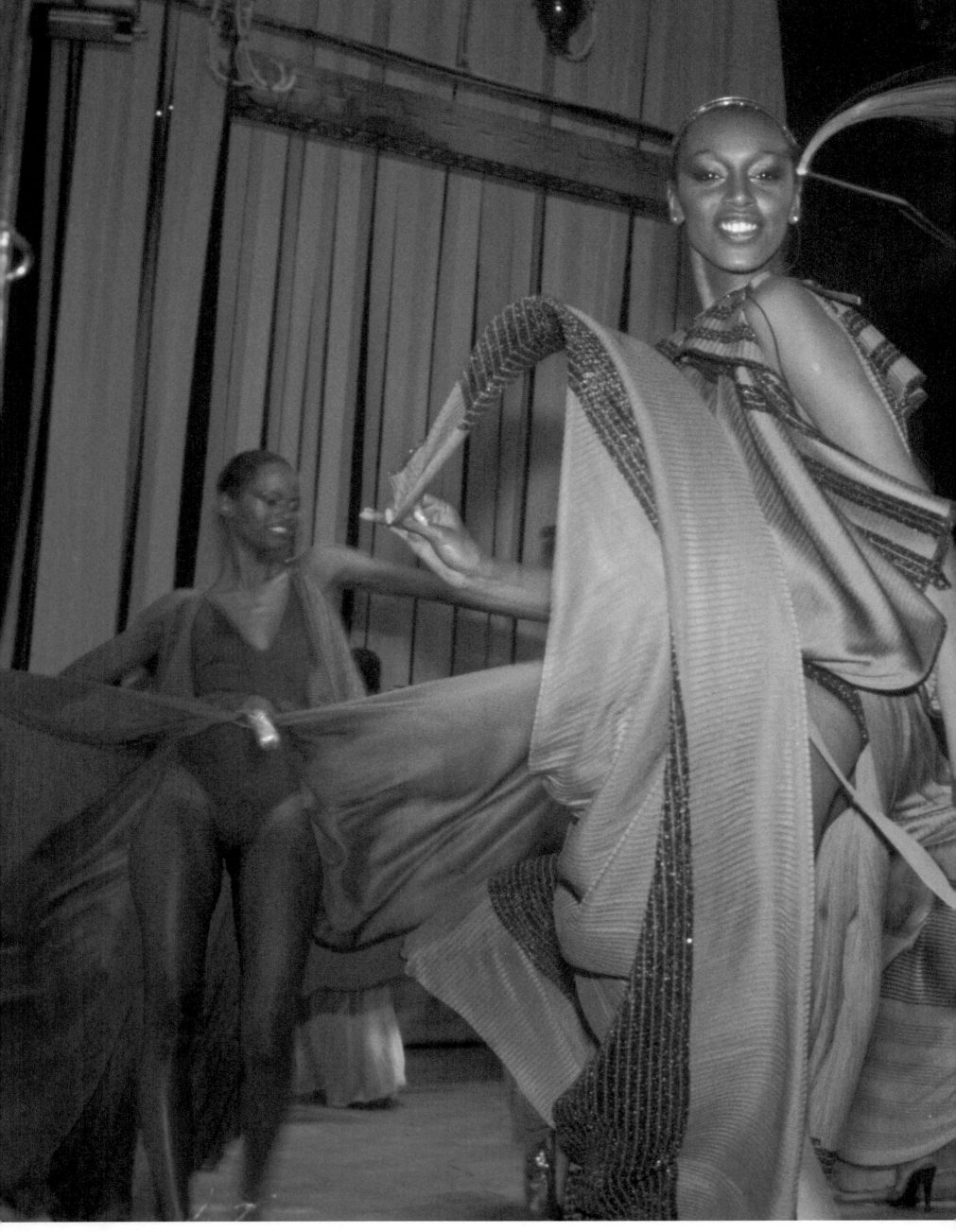

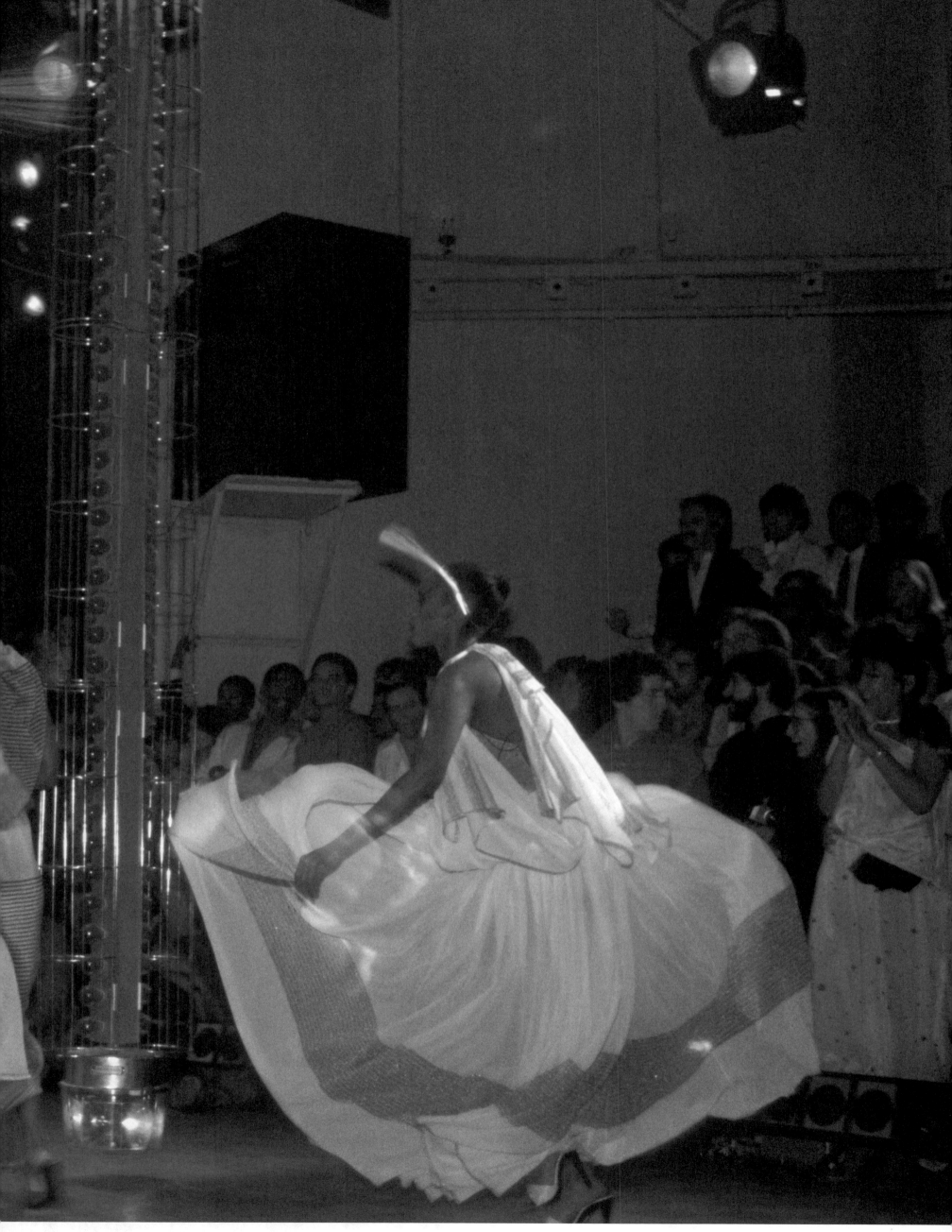

Studio's First Anniversary 1978

For Studio's first anniversary on April 26, 1978, Issey Miyake conceived "East Meets West," a performance that was an extension of his 1976 runway presentation in Japan called *Issey Miyake and Twelve Black Girls*, featuring Grace Jones and Toukie Smith. On the dance floor, two mirror balls were added, animating the space with moving dots and streams of light. (Though disco is often represented with mirrored disco balls, they were not part of Studio's permanent decor.) The brass and glass-block deco-style bar was masked with gold paper screens, and elsewhere there were walls of real exotic pines.

"I think Studio 54 brought glamour back to New York that we haven't seen since the sixties—it made New York get dressed up again."

—Liza Minelli, at Studio 54's first anniversary in 1978

Opposite, top: Adam Scull (American). *Liza Minnelli and Halston*, 1977. Photo by Adam Scull/PHOTOlink.net. © Adam Scull

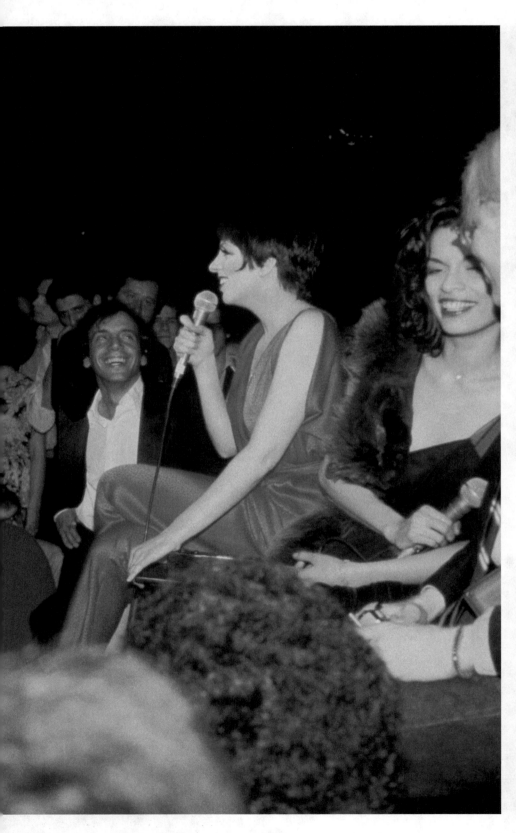

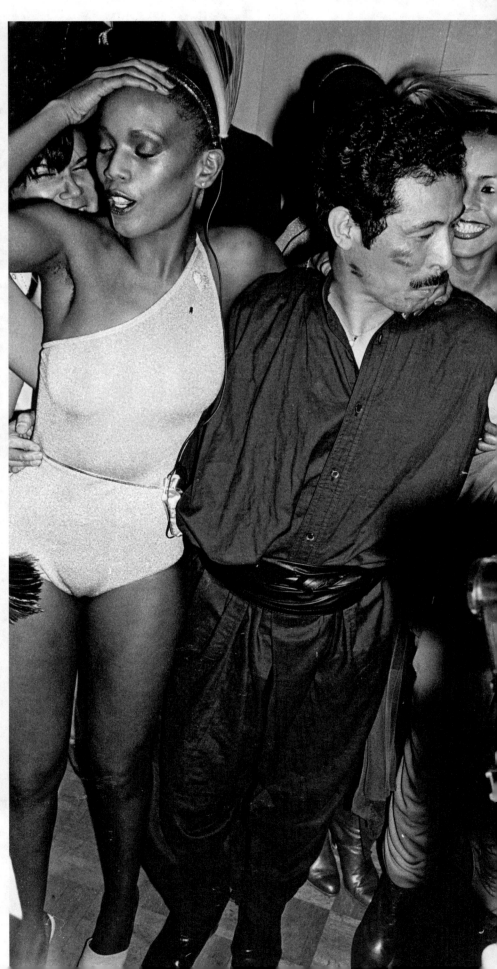

Left: Adam Scull (American). *Liza Minnelli and Halston*, 1977. Photo by © Adam Scull/PHOTOlink.net

Right: Adam Scull (American). *Issey Miyake and Toukie Smith*. Image courtesy of the artist. Photo by © Adam Scull/ PHOTOlink.net

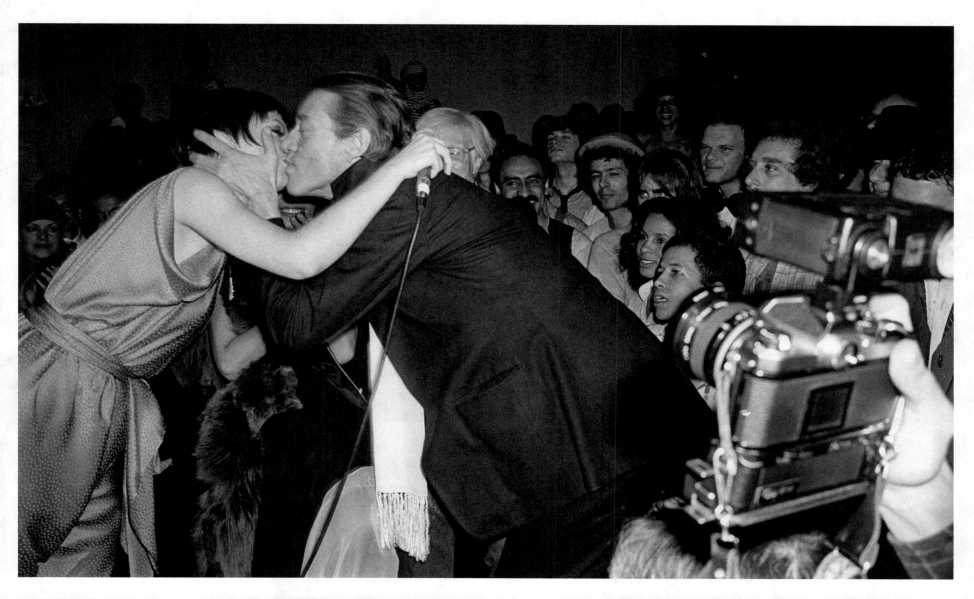

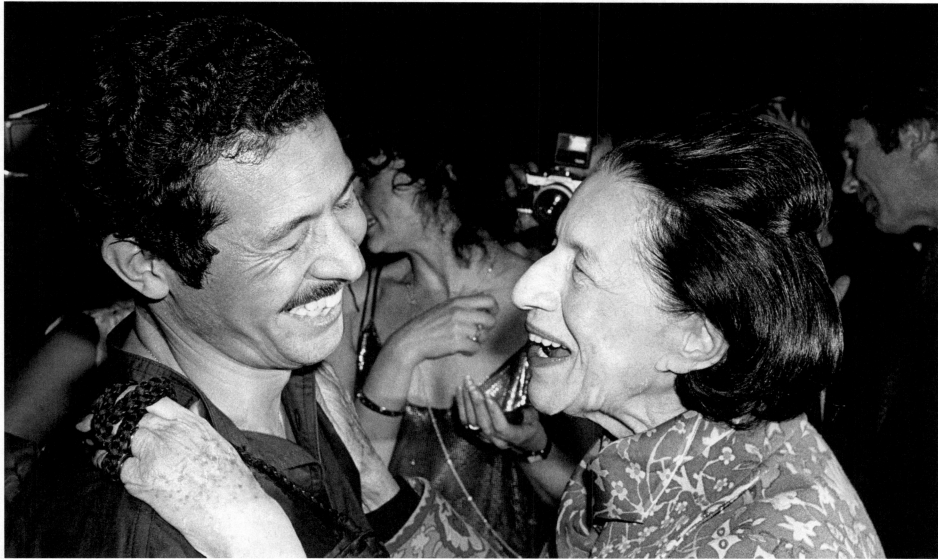

Adam Scull (American). *Issey
Miyake and Diana Vreeland*, 1978.
Photo by Adam Scull/
PHOTOlink.net. © Adam Scull

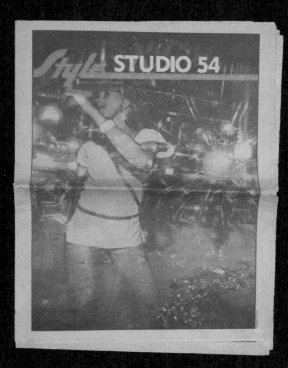

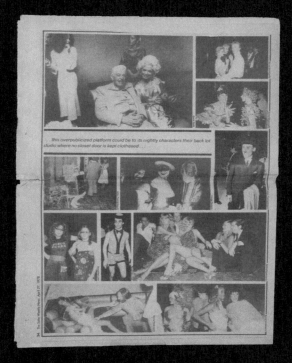

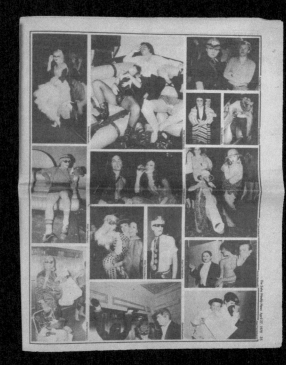

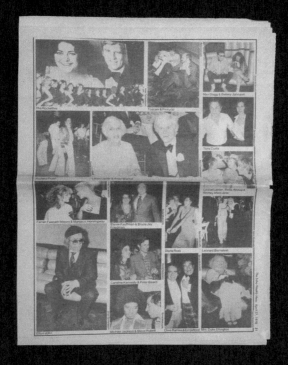

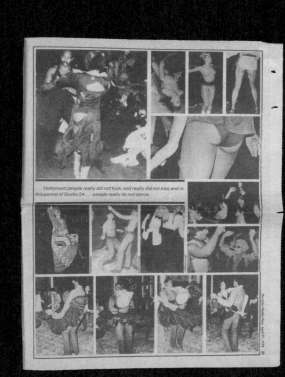

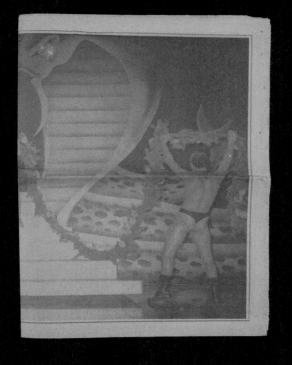

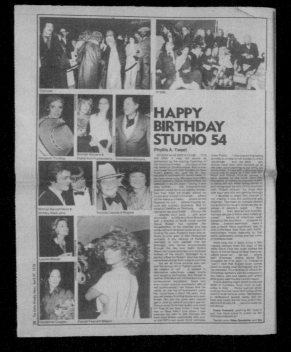

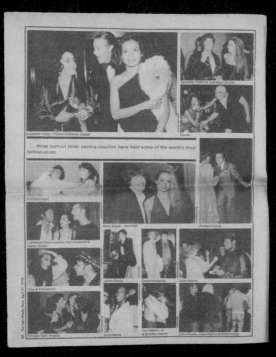

"Style Soho Weekly News: Studio 54," special issue, *Soho Weekly News*, April 28, 1978. Printed newspaper. Courtesy of Tony Walton (Photos: Jonathan Dorado)

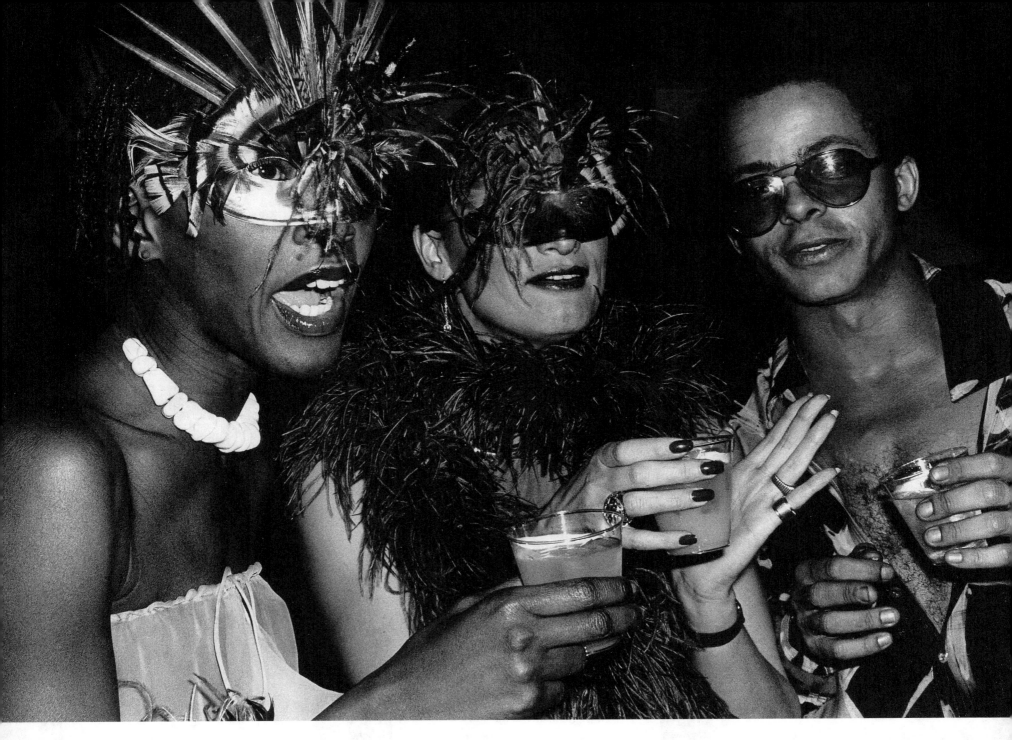

Rose Hartman (American, born 1937). *Bethann Hardison, Daniela Morera, and Stephen Burrows at Valentino's Birthday Party*, May 12, 1978. Courtesy of the artist. © Rose Hartman

Opposite: Roxanne Lowit (American, born 1958). *Giancarlo Giammetti, Studio 54*, May 12, 1978. Courtesy of the artist. © Roxanne Lowit

Birthday Party for Valentino 1978

For designer Valentino's forty-sixth birthday, his business partner Giancarlo Giammetti and Ian Schrager staged a "circus," complete with costumes from Federico Fellini's film *The Clowns* (1970). In this photograph Giammetti wears one of Fellini's longtime collaborator Danilo Donati's costumes, which were constructed by the Roman costume house Sartoria Farani. Valentino himself wore a ringmaster's red jacket, white breeches, and black leather boots, while Marina Schiano dressed as a fortune teller, Giorgio di Sant'Angelo as a lion, and others wore Donati's spectacular creations. The decor included enlargements of drawings by Joe Eula, and trapeze artists performed.

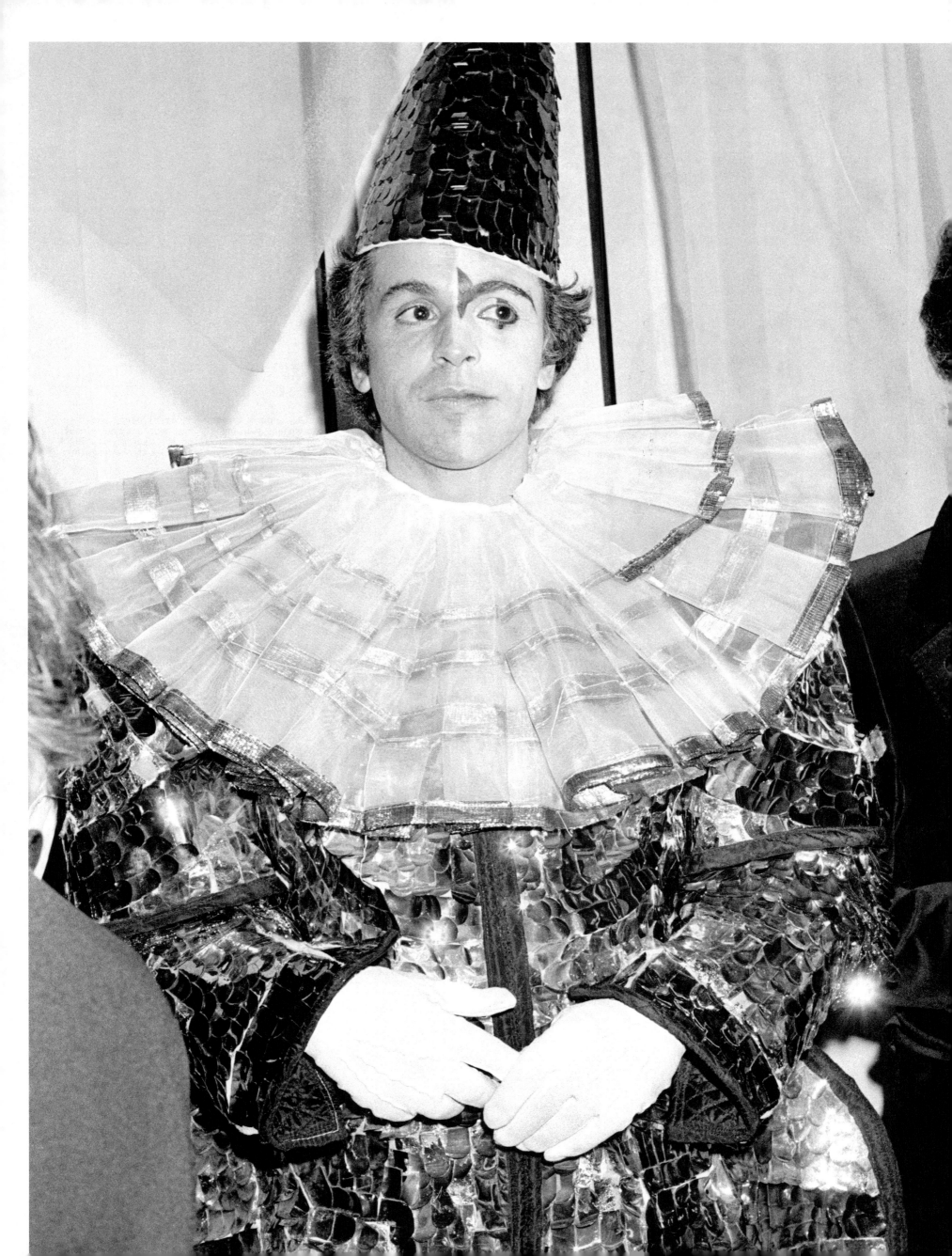

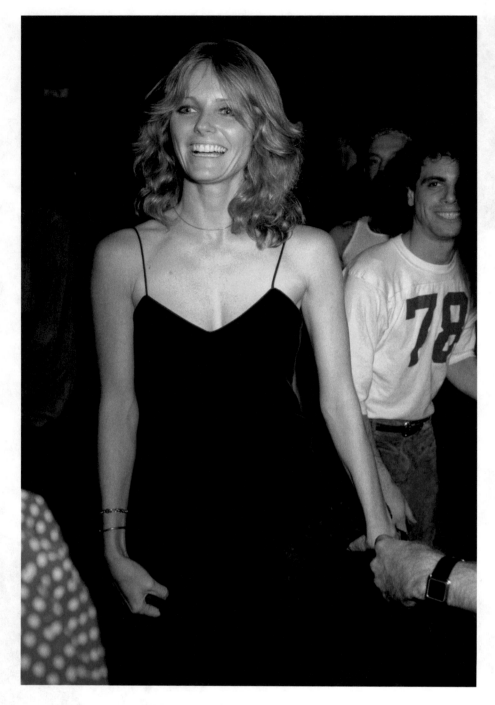

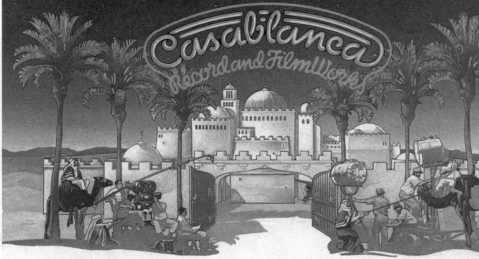

NEIL BOGART
President

May 25, 1978

Mr. Ian Schrager
STUDIO 54
254 West 54th Street
New York, New York

Dear Ian:

I can't thank you enough for the wonderful party and the
delightful atmosphere you and all the people at Studio 54
created for us last week celebrating the opening of "THANK
GOD IT'S FRIDAY." I shall never forget that spectacular
evening.

Most of all, thank you for being such a good friend.

Best regards,

Neil Bogart,
President

NB/jb

Casablanca Record and FilmWorks, Inc.
Main Office: 8255 Sunset Boulevard, Los Angeles, California 90046 • (213) 650-8300
Studio: The Burbank Studios, Burbank, California 91505 • (213) 843-6000

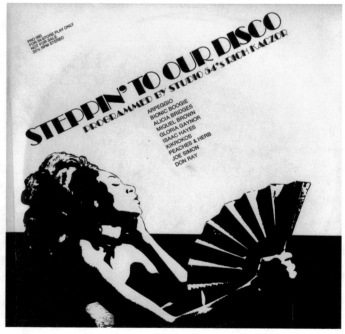

Thank God
It's Friday

Robert Kline's film *Thank God
It's Friday* (1978) was promoted
as a West Coast answer to John
Badham's *Saturday Night Fever*
(1977). The story line centers
around the character of Nicole
(played by singer Donna Summer),
whose dream was to become a disco
star. Although its soundtrack
did not produce the multiple
hits that *Saturday Night Fever*
enjoyed, the film did feature the
now-classic "Last Dance." Written
by Brooklyn-born Paul Jabara, the
song received two Grammy Awards,
a Golden Globe, and an Academy
Award in 1979.

Top left: Dustin Pittman
(American). *Cheryl Tiegs*, 1978.
Courtesy of the artist.
© Dustin Pittman

Top right: *Thank-You Letter from
Neil Bogart to Ian Schrager for
"Thank God It's Friday" party*,
1978. Printed paper, 10 1/2 x
7 1/4 in. (26.7 x 18.4 cm).
Courtesy of Ian Schrager Archive

Bottom: *Steppin' to Our Disco*
cover, 1978. Polydor Records

Opposite: Anton Perich (American,
born Croatia, 1945). *Patti Hansen
in a metal mesh top by Stephen
Burrows*. © Anton Perich

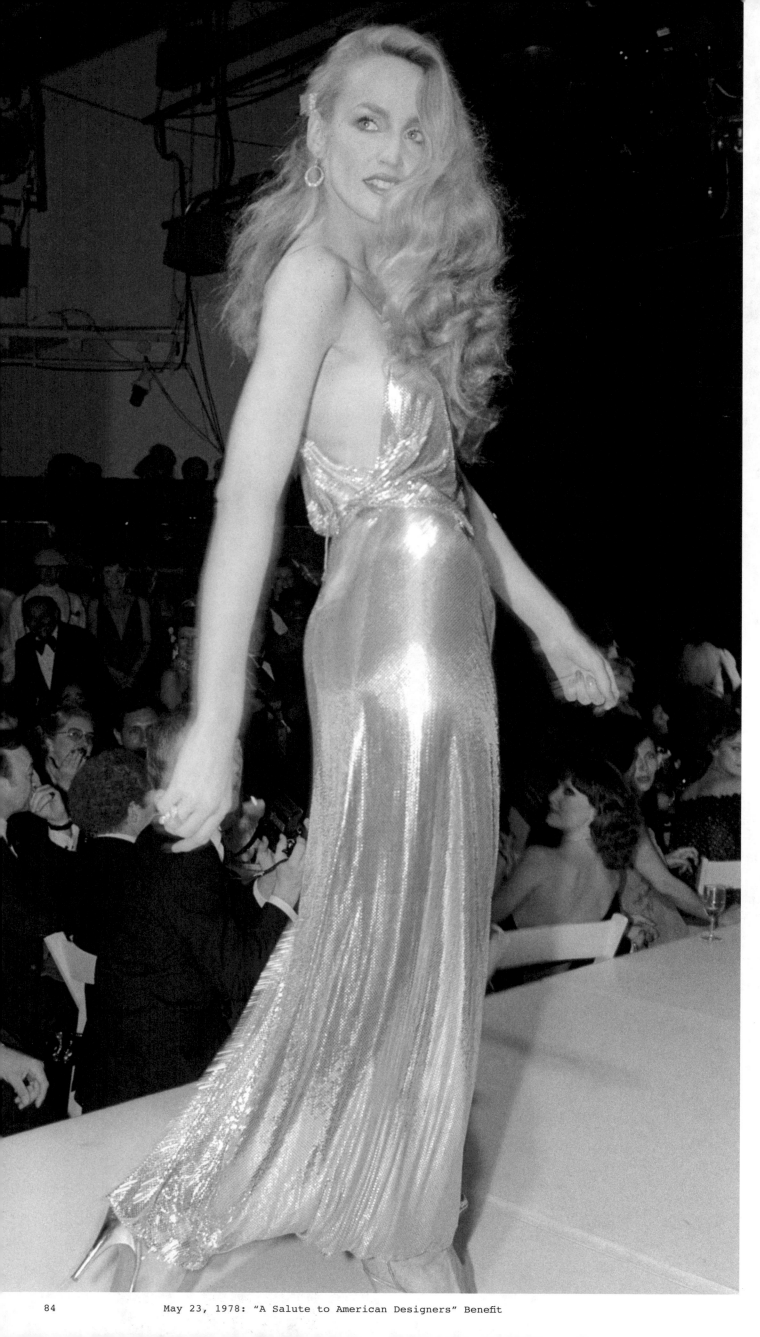

Allan Tannenbaum (American,
born 1945). *"Fashion Maker's"
Show*, *Jerry Hall*, May 23, 1978.
Courtesy of the artist.
© Allan Tannenbaum

Jerry Hall appeared as a model
for the presentation of Stephen
Burrows's collection at "A
Salute to American Designers"
in May 1978. Several designers
participated in the presentation,
including Geoffrey Beene and Perry
Ellis. It was at this fashion
show that Mick Jagger first saw
and met Jerry Hall, his future
partner. That evening, Jerry
Hall also drew the attention of
several photographers, including
Anton Perich, Ron Galella,
and Allan Tannenbaum. Perich—
who had recently created an
electric painting machine, a
precursor of the inkjet printer,
from Army surplus parts found
on Canal Street—chose an image
of Hall for one of his first
machine paintings. The image was
projected onto paper or canvas,
and the machine's photocell
attachment moved across and down
this surface. When the photocell
received light, it stopped
painting, and when it read dark
or black areas, it painted,
thereby re-creating the projected
photograph in paint or ink.

A Salute to American Designers

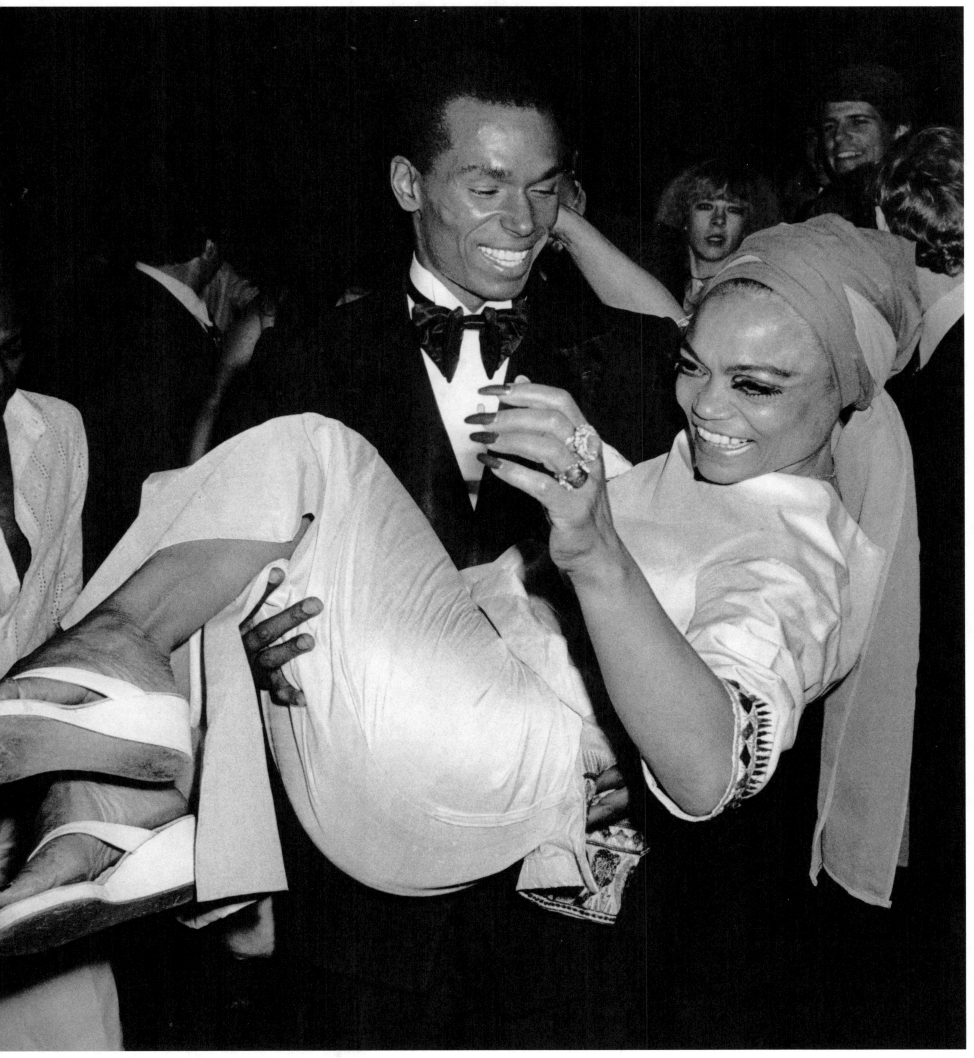

Top: Ron Galella (American, born 1931). *Olivia Newton-John at the Premiere of "Grease" at Studio 54*, June 13, 1978. Courtesy of the artist. © Ron Galella

Bottom left: Ron Galella (American, born 1931). *Elton John and Divine at the Premiere of "Grease" at Studio 54*, June 13, 1978. Courtesy of the artist. © Ron Galella

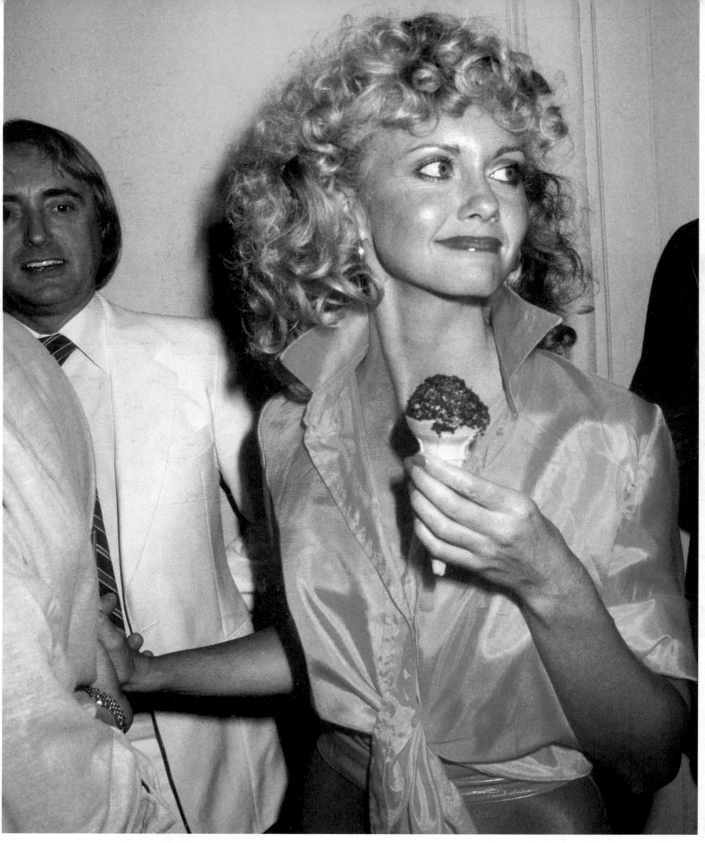

Grease Premiere

Grease, John Travolta's next film after *Saturday Night Fever*, was set in the 1950s. For the premiere party at Studio 54, the entrance hall was lined with high school lockers, and attendants doled out pomade for guests to slick their hair. Designer Renny Reynolds parked six vintage cars on Studio 54's dance floor, along with two large painted portraits of Newton-John and Travolta on easels. Ice cream cones were served at the bar, below an airbrushed sign reading "FROSTY."

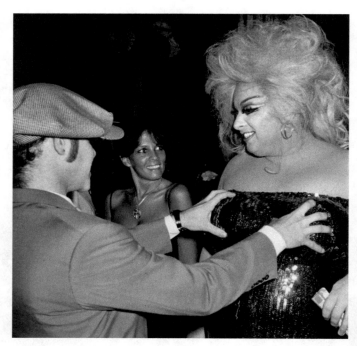

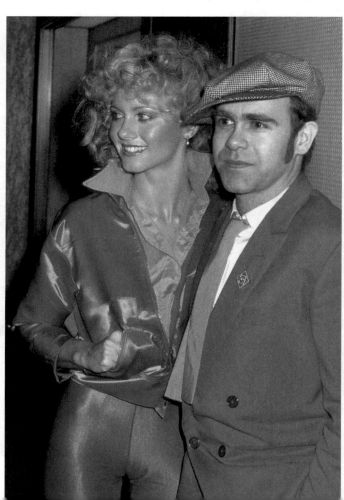

Bottom right: Ron Galella (American, born 1931). *Elton John and Olivia Newton-John at the Premiere of Grease at Studio 54*, June 13, 1978. Courtesy of the artist. © Ron Galella

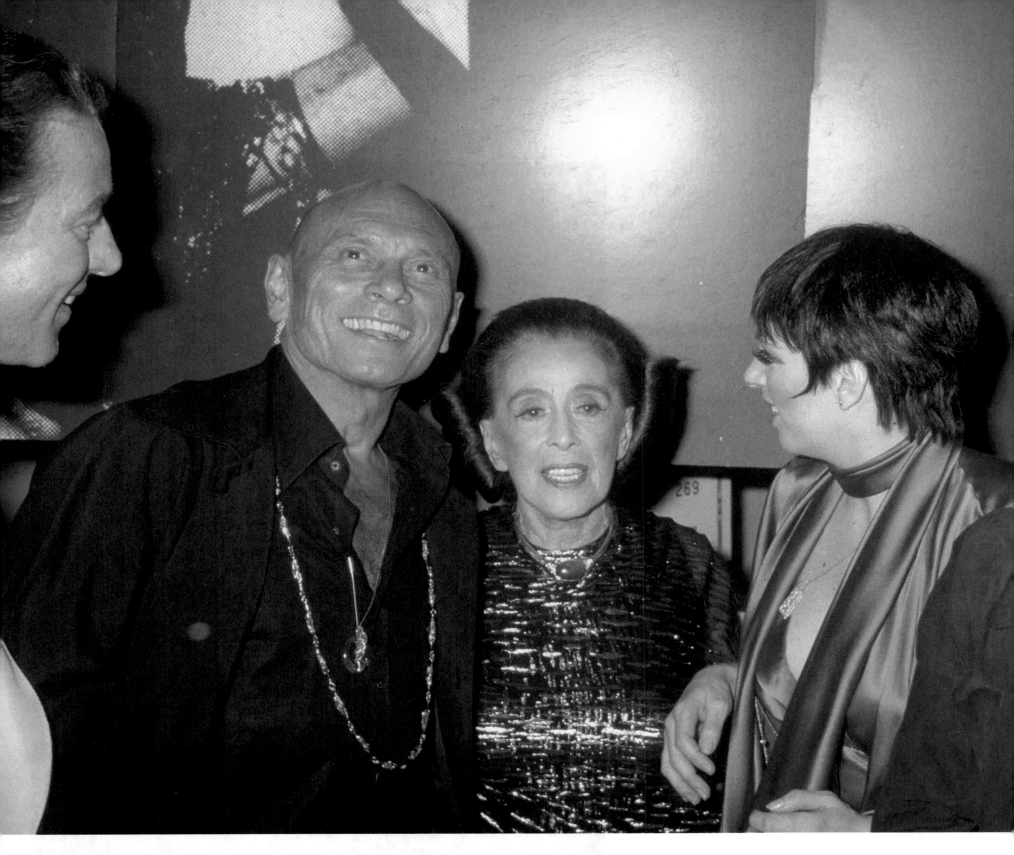

The Stars Come Out for Martha Graham, 1978

On June 22, 1978, Liza Minnelli, dancer Mikhail Baryshnikov, and Halston hosted a gala benefit for the Martha Graham Center of Contemporary Dance at Studio 54. Minnelli had been a student of Graham's in the late 1960s, and Halston was an ongoing supporter who began to design and reimagine costumes for the Graham company. This was the first of several benefits held at Studio for Graham, who would stay on afterward to watch the dancers—once even from the DJ booth, accompanied by former student and former First Lady Betty Ford.

Ron Galella (American, born 1931). *Halston, Yul Brynner, Martha Graham, Liza Minnelli, and Mikhail Baryshnikov*, June 22, 1978. Courtesy of the artist. © Ron Galella

A *Night at Studio 54* (1979) was
executive-produced by Schrager
and Rubell. Studio's best DJs,
Roy Thode and Marc Paul Simon,
sequenced the double album so
the songs on *A Night at Studio
54* segued seamlessly from one to
the next, instead of the standard
silent gaps.

A Night at Studio 54, 1979.
Record sleeve with double 12-inch
vinyl album, 12 1/2 x 12 1/2 in.
(31.8 x 31.8 cm). Courtesy of Ian
Schrager Archive

Top left: Miestorm (American, born 1958). *Studio 54 Busboy*, December 1, 1979. Courtesy of the artist. © Miestorm

Top right: Miestorm (American, born 1958). *Studio 54 Busboy "Fierce" Jones*, December 20, 1979. Courtesy of the artist. © Miestorm

Bottom: Miestorm (American, born 1958). *Esme and Bartender Eddie Packen*, December 13, 1979. Courtesy of the artist. © Miestorm

The bartenders and busboys had to have a clean-shaven face and body, and maintain a stylish haircut. To maintain their appearance, many of them had gym memberships, while others took dance classes. The interviews were often handled by Rubell, who hired busboys Lenny 54 (aka photographer Miestorm), and Patrick 54 (future actor Patrick Taylor, who worked as a busboy and bartender before being cast in the 1981 film *Endless Love* along with Studio 54 regular Brooke Shields).

Top left: Miestorm (American, born 1958). *Studio 54 Doorman Marc Benecke*, December 20, 1979. Courtesy of the artist.
© Miestorm

Top right: *Calliope Nicholas and Bartender*, circa 1980.
© Calliope Nicholas

Calliope Nicholas began working at Studio 54 in September 1978. She soon eschewed anti-disco punk looks for glamorous dresses by Betsey Johnson and Norma Kamali. Eventually, Nicholas would develop her own signature look, wearing a metal clamshell bra.

Bottom: Allan Tannenbaum (American, born 1945). *Bartender*, 1977. Courtesy of the artist.
© Allan Tannenbaum

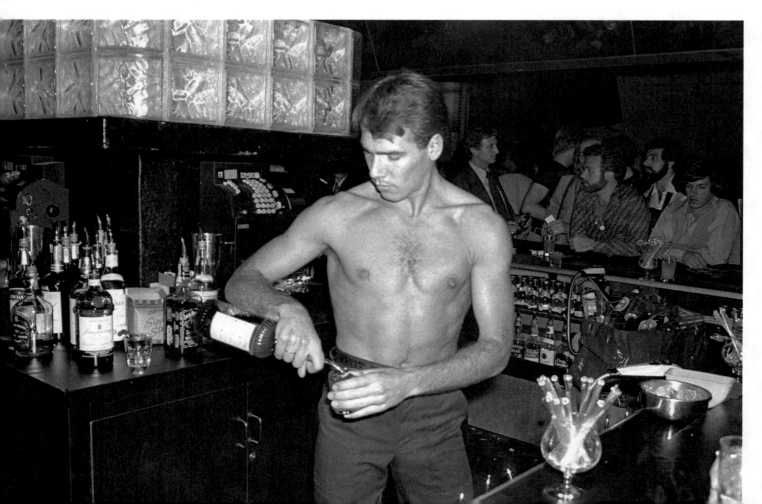

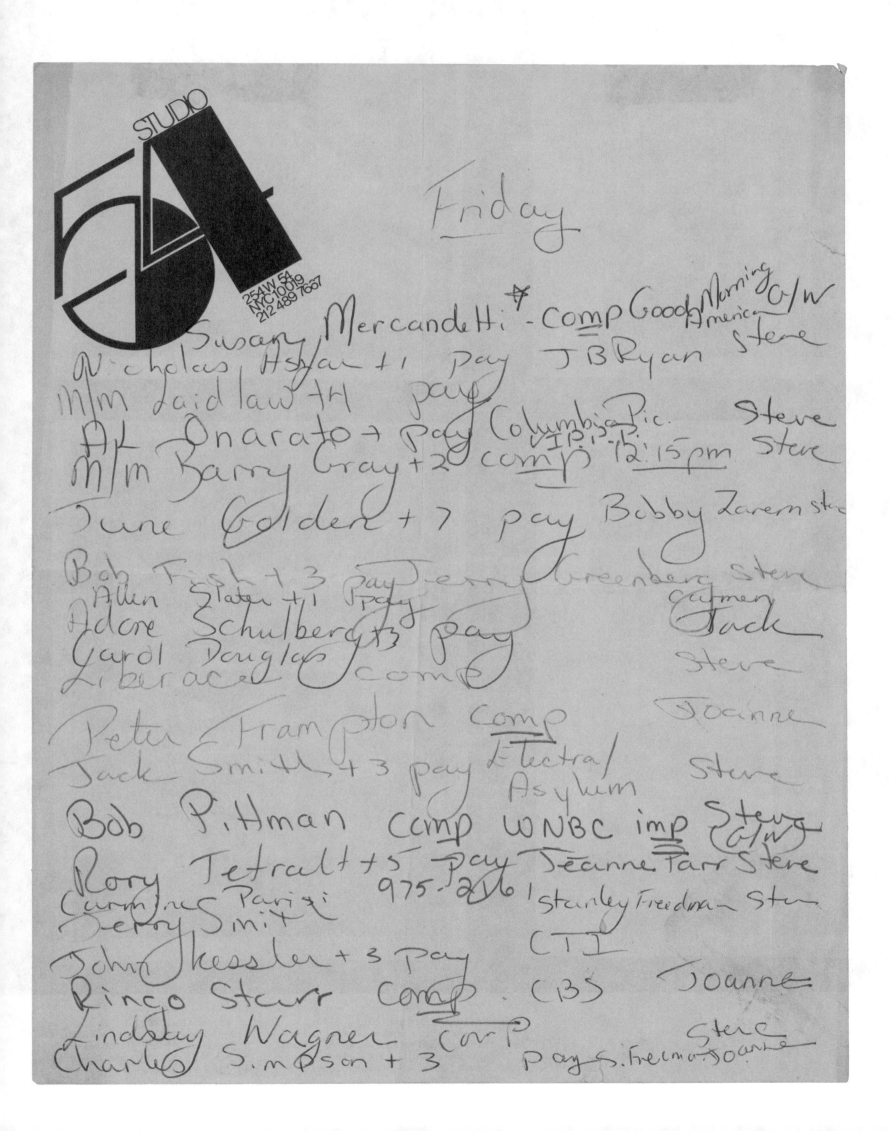

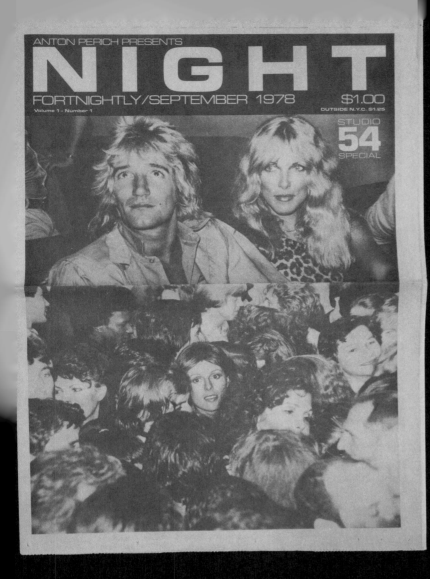

ANTON PERICH PRESENTS

NIGHT

FORTNIGHTLY/SEPTEMBER 1978 $1.00

Volume 1 - Number 1 OUTSIDE N.Y.C. $1.25

STUDIO
54
SPECIAL

NIGHT

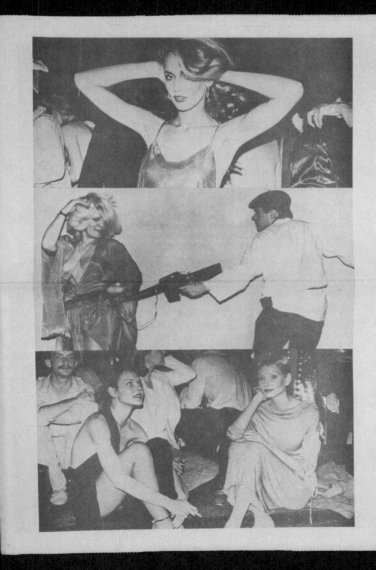

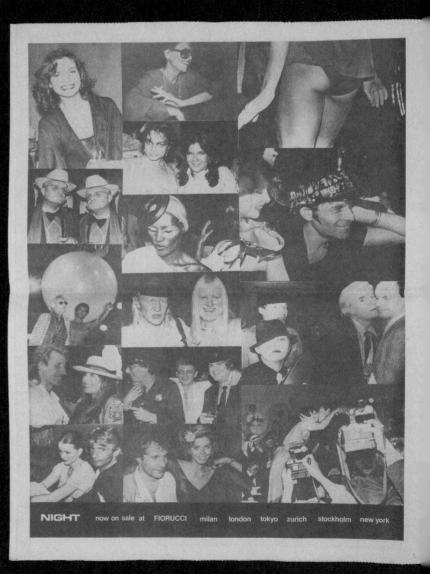

NIGHT now on sale at FIORUCCI milan london tokyo zurich stockholm new york

Beginning in the early 1970s,
Anton Perich screened many of
his film and video works on local
New York cable television, which
he saw as a more modern outlet
than traditional screening rooms.

By the late 1970s, he would
occasionally assemble a video
version of NIGHT, which was
televised on Manhattan Cable at
11 p.m. on Sundays.

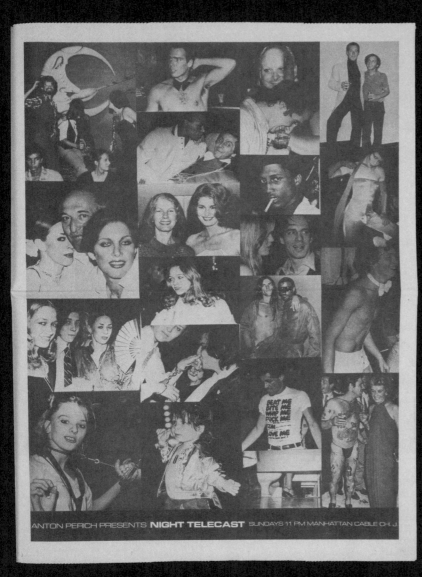

Anton Perich (American, born Croatia, 1945), founder and cover photographer. *NIGHT*, vol. 1, no. 1 (with second cover and pages 2, 4, 13, 6, 10, and 10), September 1978. Printed newsprint magazine. Courtesy of Tony Walton (Photo: Jonathan Dorado)

Anton Perich (American, born Croatia, 1945). Stills from printing NIGHT, the First Issue (Second Cover), August 1978. Video, color, sound. Courtesy of the artist

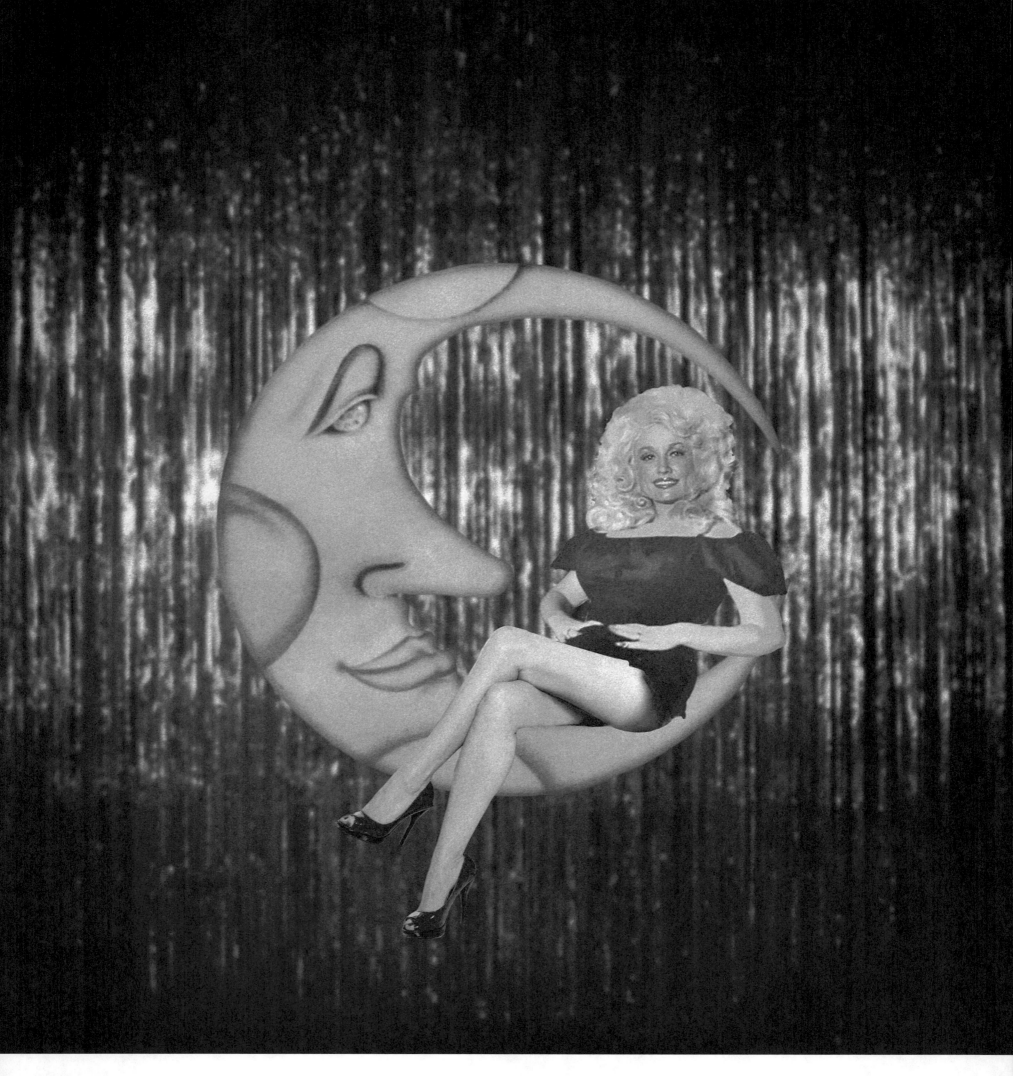

Richie Williamson (American, born 1947). *Dolly Parton on Moon*, 1978. Courtesy of the artist. © Richie Williamson

For the Dolly Parton after-party, Studio 54 was transformed with a country theme and paintings of the singer. Parton posed in front of a large portrait of her in the entrance hallway, and then encountered a second version inside. Richie Williamson combined an existing image of Parton (who was originally sitting on a bale of hay) with a new photograph of artist and friend Gae Atchinson's legs, and posed the resulting cutout on the famous crescent moon. It is the only time a figure was placed sitting on the crescent moon, referencing iconic images such as Hedy Lamarr in *The Heavenly Body* (1944) and, more recently, Ryan O'Neal in the poster for *Paper Moon* (1973).

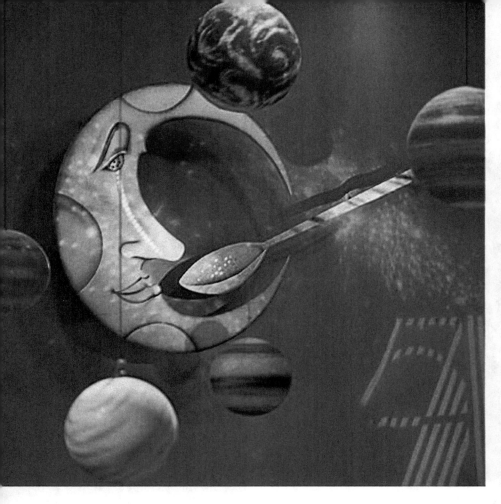

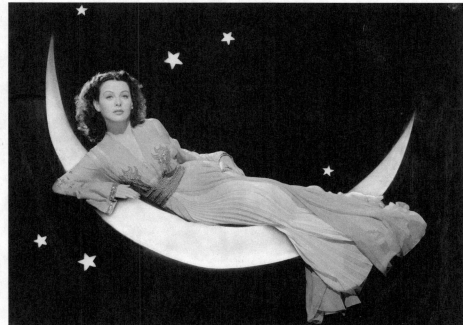

> "When the spoon was coming down . . .
> it was like being inside a pinball machine."

—Judy Licht, 2018

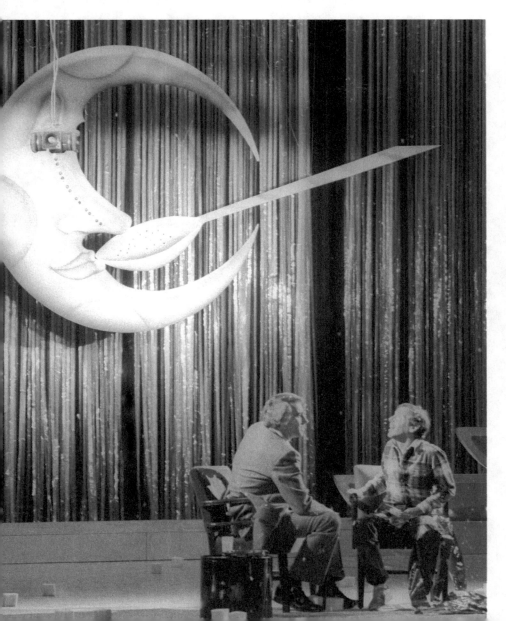

The Moon and Spoon

The Moon and Spoon was Studio 54's well-known logo—which was initially chosen for its audaciousness and an arrogance which manifested Studio's spirit. When Ian Schrager met with designer Richie Williamson in 1977 to discuss decor for Studio 54, Schrager referenced Busby Berkeley musicals of the 1930s and suggested the idea of having just a visual of a nose and spoon, acknowledging the popularity of cocaine. Williamson and partner Dean Janoff subsequently designed the "old moon" and spoon, with a galaxy of planets. That year outer space was capturing the popular imagination, with the release of *Star Wars* and *Close Encounters of the Third Kind*.

Williamson made a small drawing, which Van Rice at Bestek Theatrical, a production and rigging company in Queens, gridded to enlarge the moon to an eight-foot diameter, with a proportionally monumental spoon. Williamson airbrushed details on the plywood moon and spoon and on the planets, which were made from cardboard balls and varnished. Paul Marantz added the twinkling lights on the spoon, the zip light up the nose, and the red lights in the eye.

The cinderblock wall at the back of the theater was painted black, and the comets, stars, and galaxies were added in paint that was only visible under ultraviolet light. The planets were dismantled two weeks later, as they took up too much fly space.

Roxanne Lowit (American, born 1958). *Victor Hugo*, Studio 54, September 12, 1978. Courtesy of the artist. © Roxanne Lowit

Top: Studio 54 nightclub in New York City, circa 1978. (Photo by John Kelly/Ebet Roberts/Redferns/ Getty Images)

Bottom: Gil Lesser (American, 1935–1990). *Studio 54 invites you to throw caution to the wind and confetti in the air to celebrate its gala reopening*, 1978. Printed Plexiglas invitation box, black confetti. Courtesy of Ian Schrager Archive

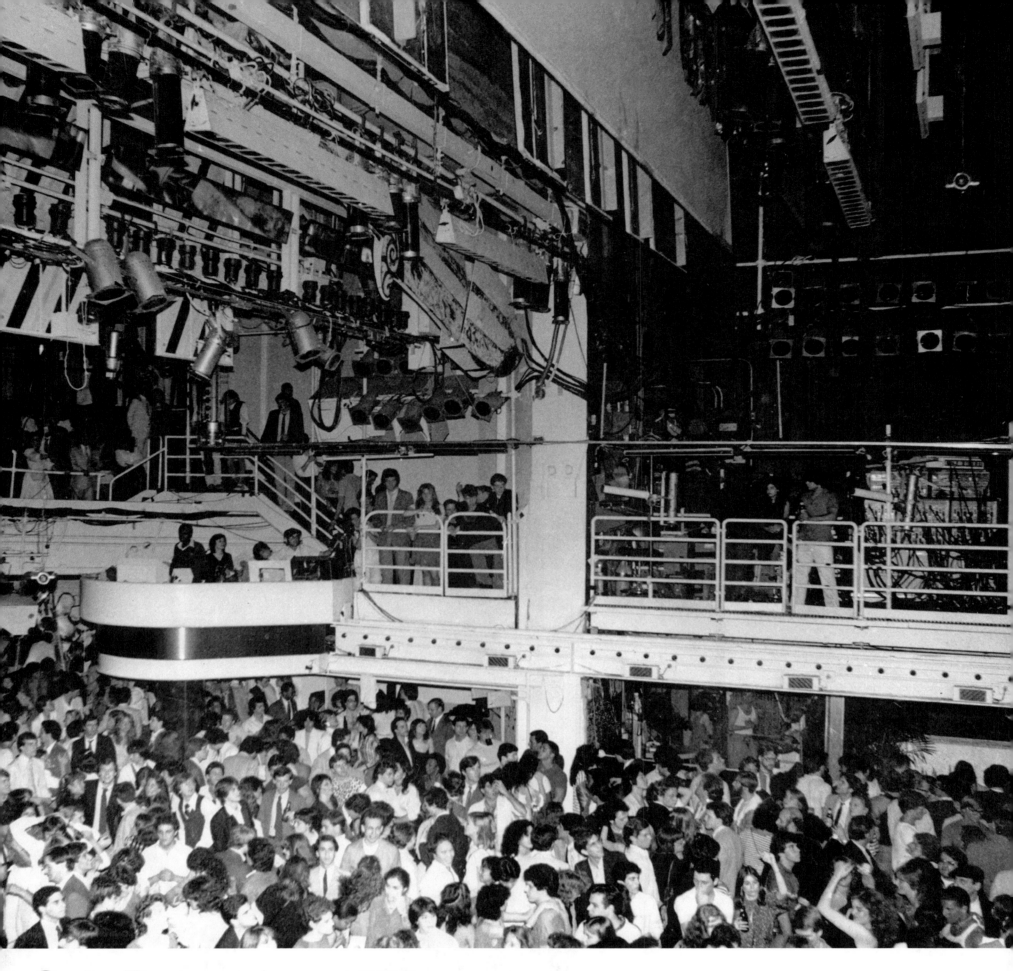

Gala Reopening, 1978

"7-10 get ready to go out . . . disco naps
. . . 11-12 go to Studio, and stay until
4 or 5 you'd carry a pair of sunglasses,
because you'd leave and the sun
was coming up."

—Edward Tricomi

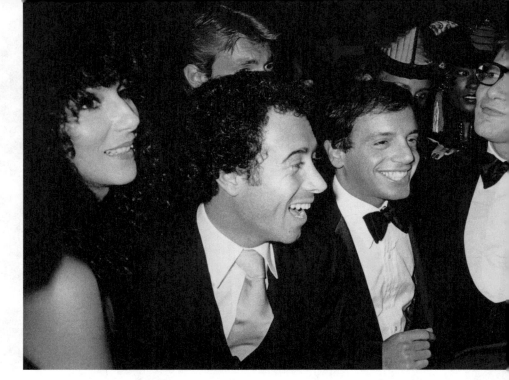

Top: Ron Galella (American, born 1931). *New York City, Opium Perfume Party at Studio 54, Cher, David Geffen, Steve Rubell and Yves Saint Laurent*, September 20, 1978. Color print, 8 x 10 in. (20.3 x 25.4 cm). Courtesy of the artist. © Ron Galella

Bottom: Roxanne Lowit (American, born 1958). *Yves Saint Laurent, Opium Party*, Studio 54, September 20, 1978. Courtesy of the artist. © Roxanne Lowit

Opium Launch After-Party, 1978

On September 20, 1978, Yves Saint Laurent launched his new fragrance, Opium, with an event followed by an after-party at Studio 54. The main launch took place on a junk off southern Manhattan and was designed by Studio 54 florist and event designer Renny Reynolds. The sails were to be replaced with gold, red, and purple lamé spotlighted in soft pink, and the gangway to be lined with caged live animals such as jaguars and pumas. The interior design featured an area built from huge bamboo stalks covered in thousands of orchids, with seating in purple and red. The executives at Squibb, the parent company of Yves Saint Laurent, balked at the expense of the proposed event, but with Saint Laurent's support, the design was ultimately approved, except for the live animals. Despite protest from the Chinese American community over the use of the ancient ship, as well as the name of the scent, the perfume met with abundant sales.

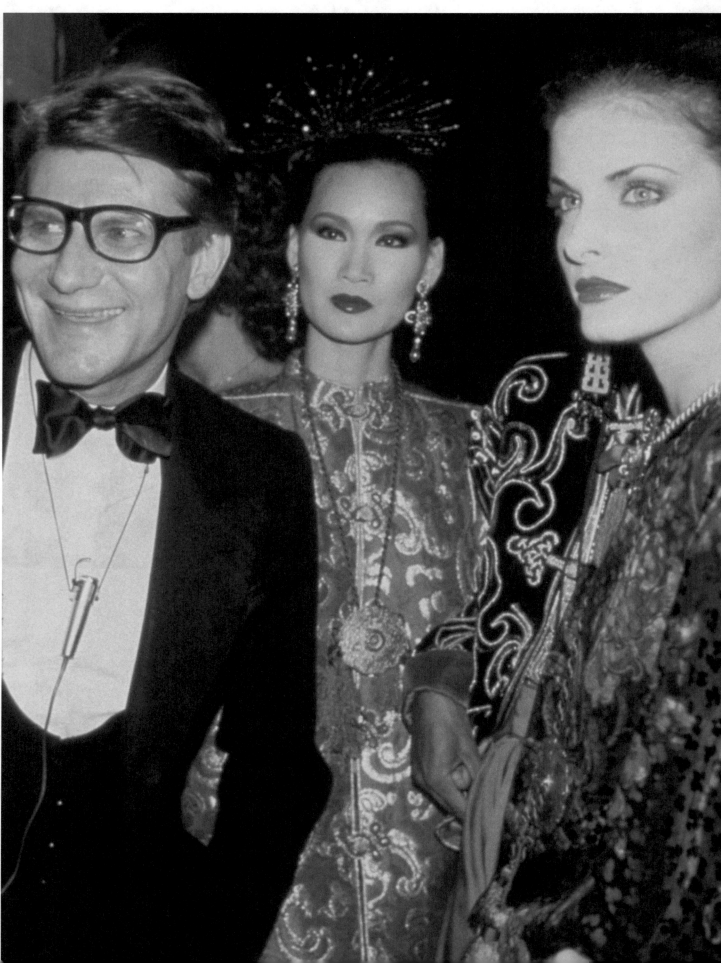

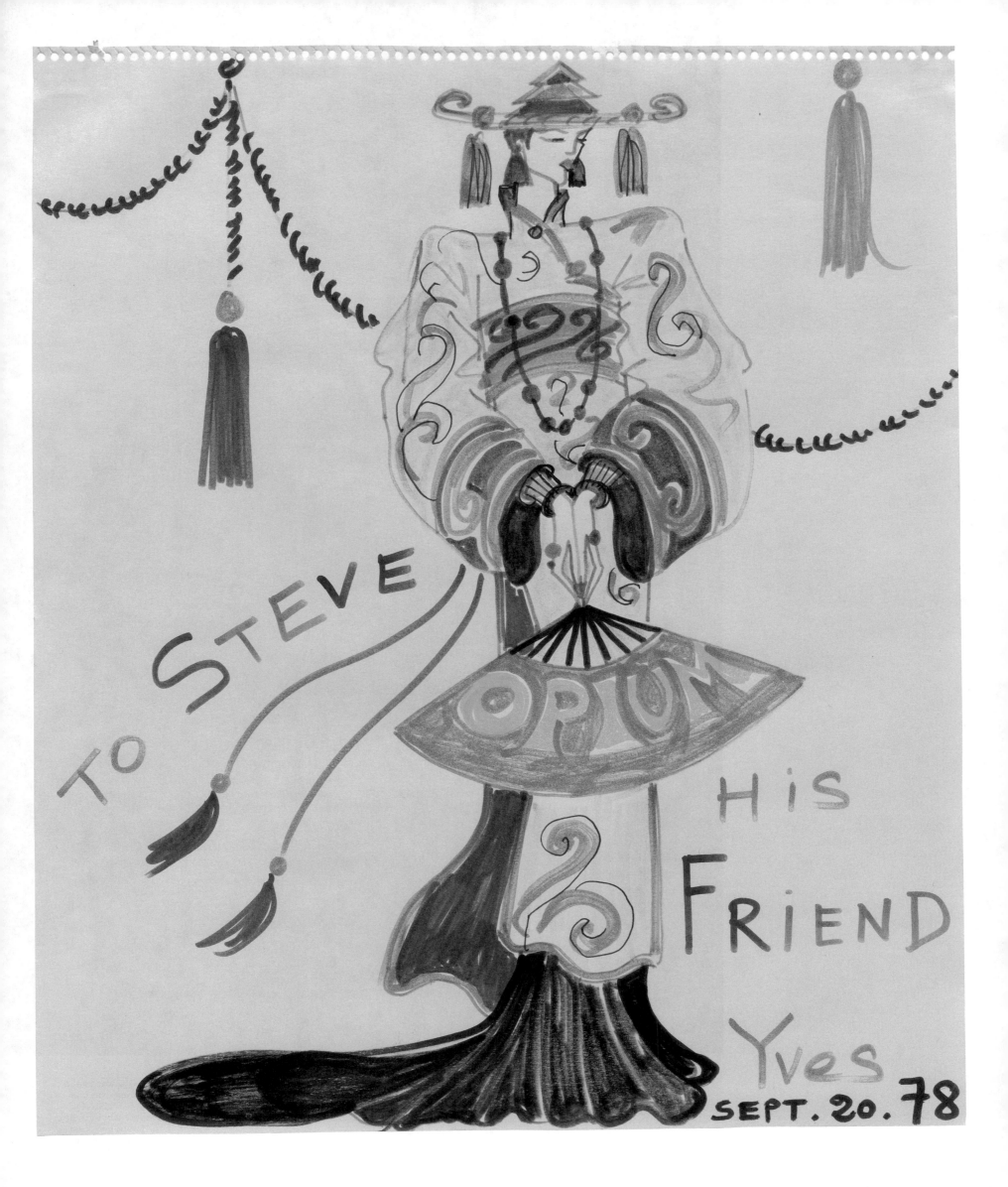

Yves Saint Laurent (1936—2008).
*Sketch Dedicated to Steve Rubell
for the Opium Launch in New York*,
1978. Felt pen on paper, 17 x 14
in. © Fondation Pierre Bergé-Yves
Saint Laurent

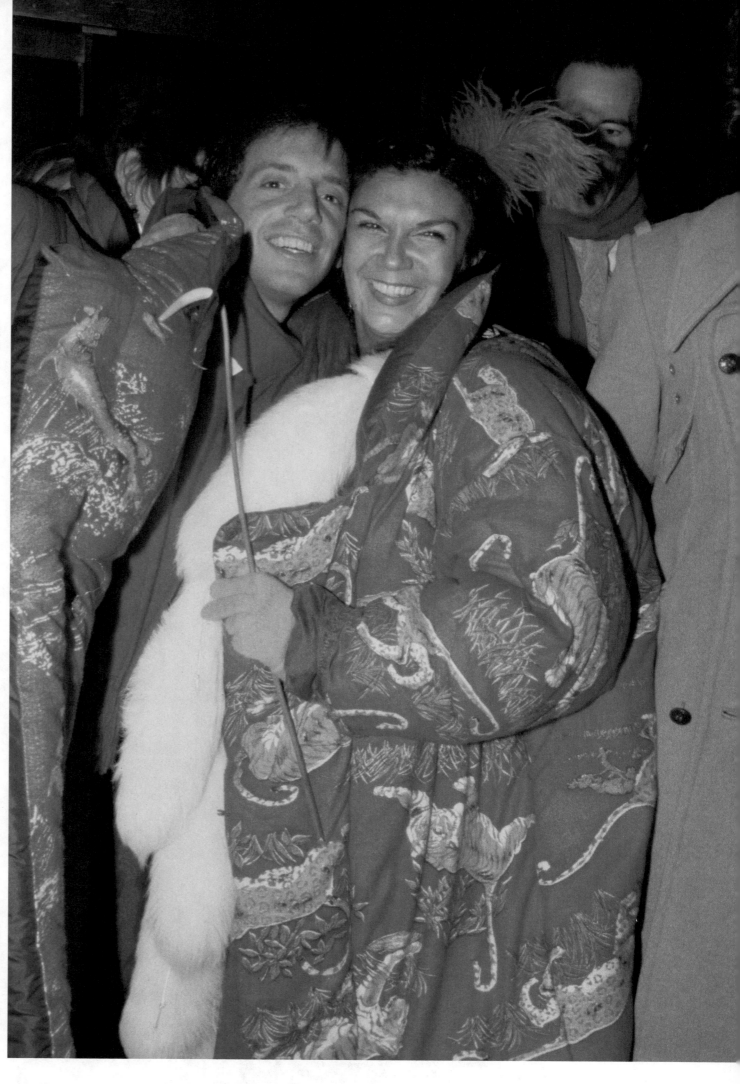

Dustin Pittman (American). *Steve Rubell and Carmen D'Alessio in Norma Kamali Coats*, 1977. Courtesy of the artist. © Dustin Pittman

In 1974 Norma Kamali was on a camping trip and rose in the middle of the night with a sleeping bag draped around her. This experience inspired her now-iconic sleeping-bag coat. Originally constructed from ready-made sleeping bags, the garments featured traditional woodland prints. The sleeping-bag coat would be a staple "uniform" for Steve Rubell, Carmen D'Alessio, and Myra Scheer as they oversaw the velvet rope on winter nights from 1977 to 1980.

Top: Rose Hartman (American, born 1937). *Steve Rubell and Giorgio di Sant'Angelo*, 1978. Courtesy of the artist. © Rose Hartman

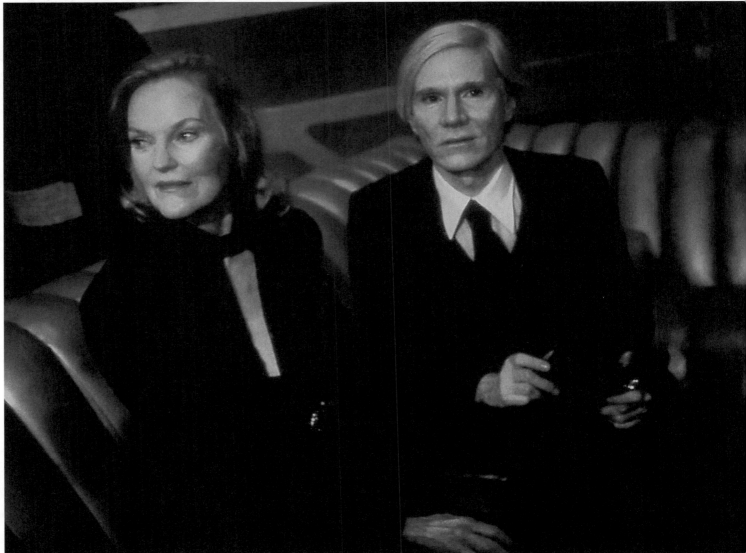

Bottom: Rose Hartman (American, born 1937). *Doris Duke and Andy Warhol at Studio 54*, circa 1978. Courtesy of the artist. © Rose Hartman

"Someone came up to me one night at 4 o'clock in the morning at Studio 54 and asked me if I'd be interested in doing jeans, blue jeans. . . . I wore jeans every day of my life. Levi 501s. Very American. And so [I knew that] the back pocket was important. The signature needed to be identifiable, and recognized from a distance. The loop—infinity—felt like it could be identified with me."

—Calvin Klein

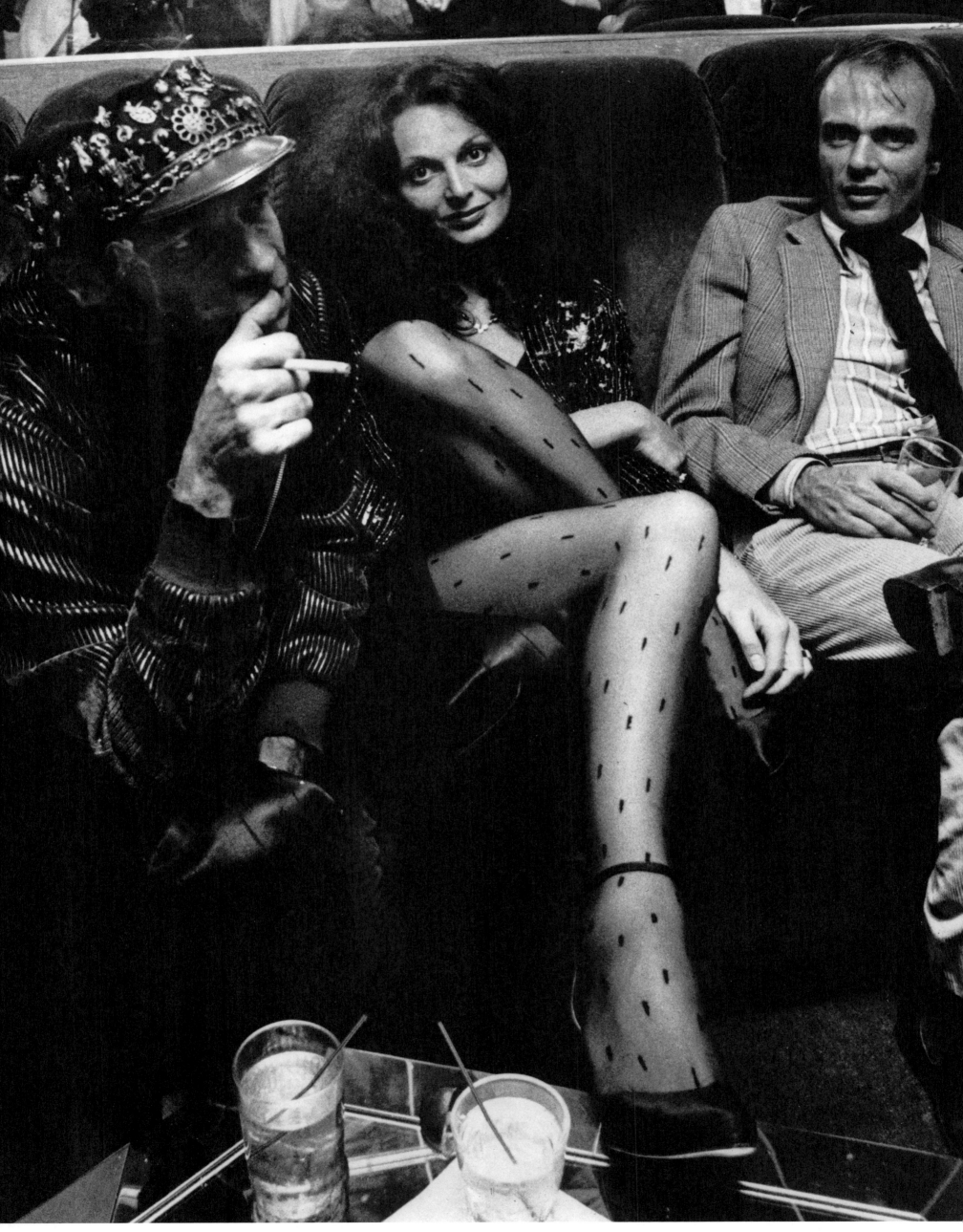

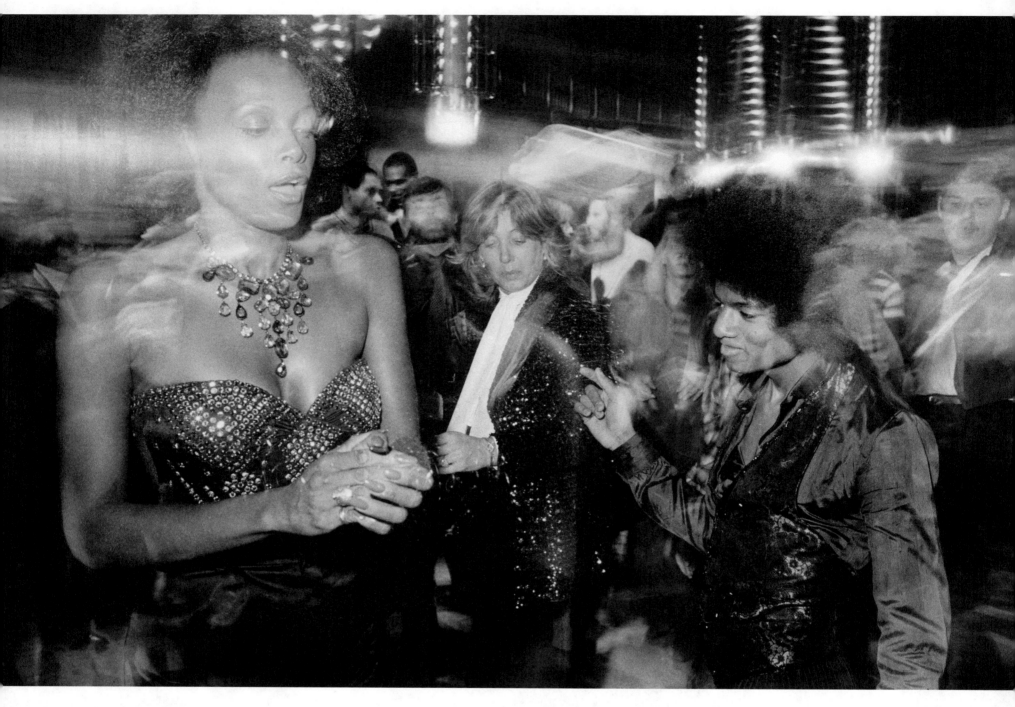

Top: Hasse Persson (Swedish, born 1942). *Halloween, (Potassa and Michael Jackson)*, 1977. Gelatin silver print. 27 9/16 x 39 3/8 in. (70 x 100 cm). Courtesy of Hasse Persson and Embassy of Sweden. © Hasse Persson

"After much experimenting, I finally found a way to capture the Studio 54 ambience on camera by using a flash to freeze the subject at the same time as I kept the shutter open for up to 30 seconds. This allowed me to catch movement on the dance floor, and the colored light and other details that characterized disco culture."
—Hasse Persson, *Studio 54* (Stockholm: Bokforlaget Max Strom, 2014), p. 6

"Boo . . . Come As You Are or Aren't" Halloween Party

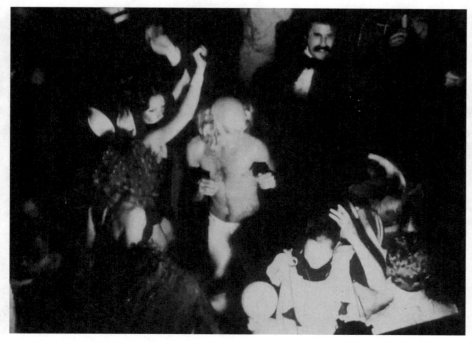

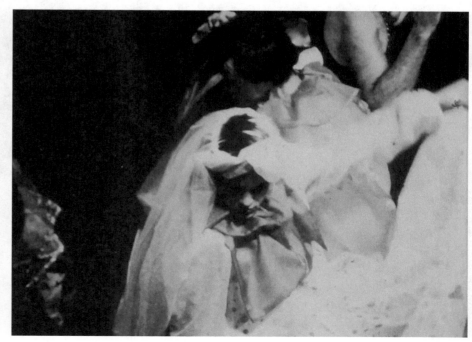

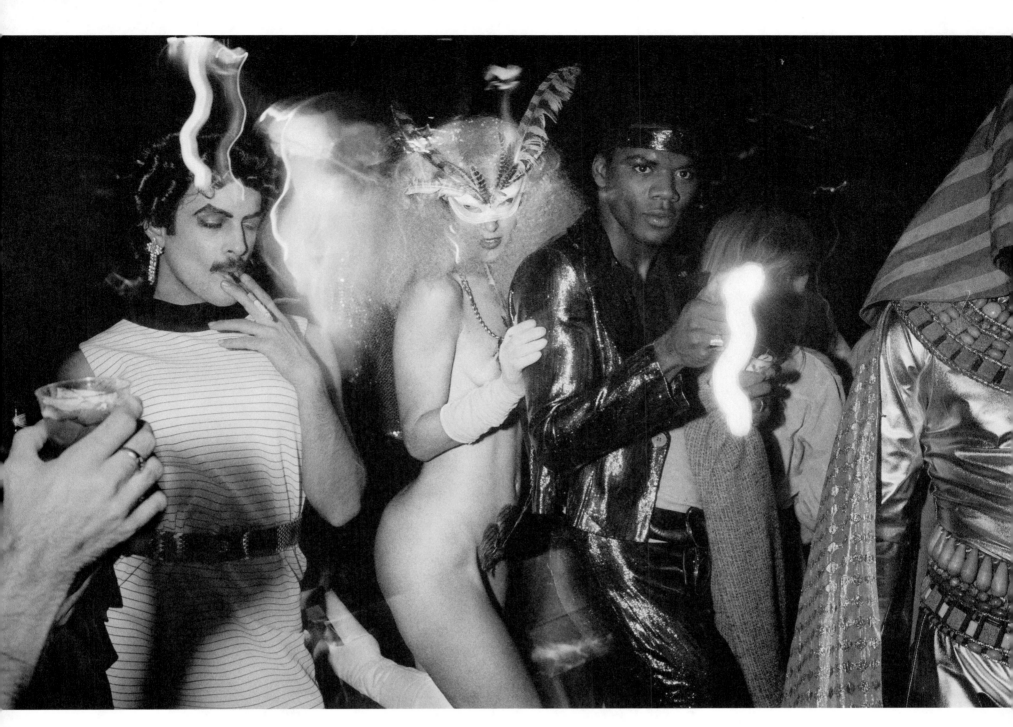

Hasse Persson (Swedish, born
1942). *Party Time*, 1978. Gelatin
silver print. 27 9/16 x 39 3/8
in. (100 x 70 cm). Courtesy of
Hasse Persson and Embassy of
Sweden. © Hasse Persson

"If you can remember it,
you weren't there."

—Dustin Pittman

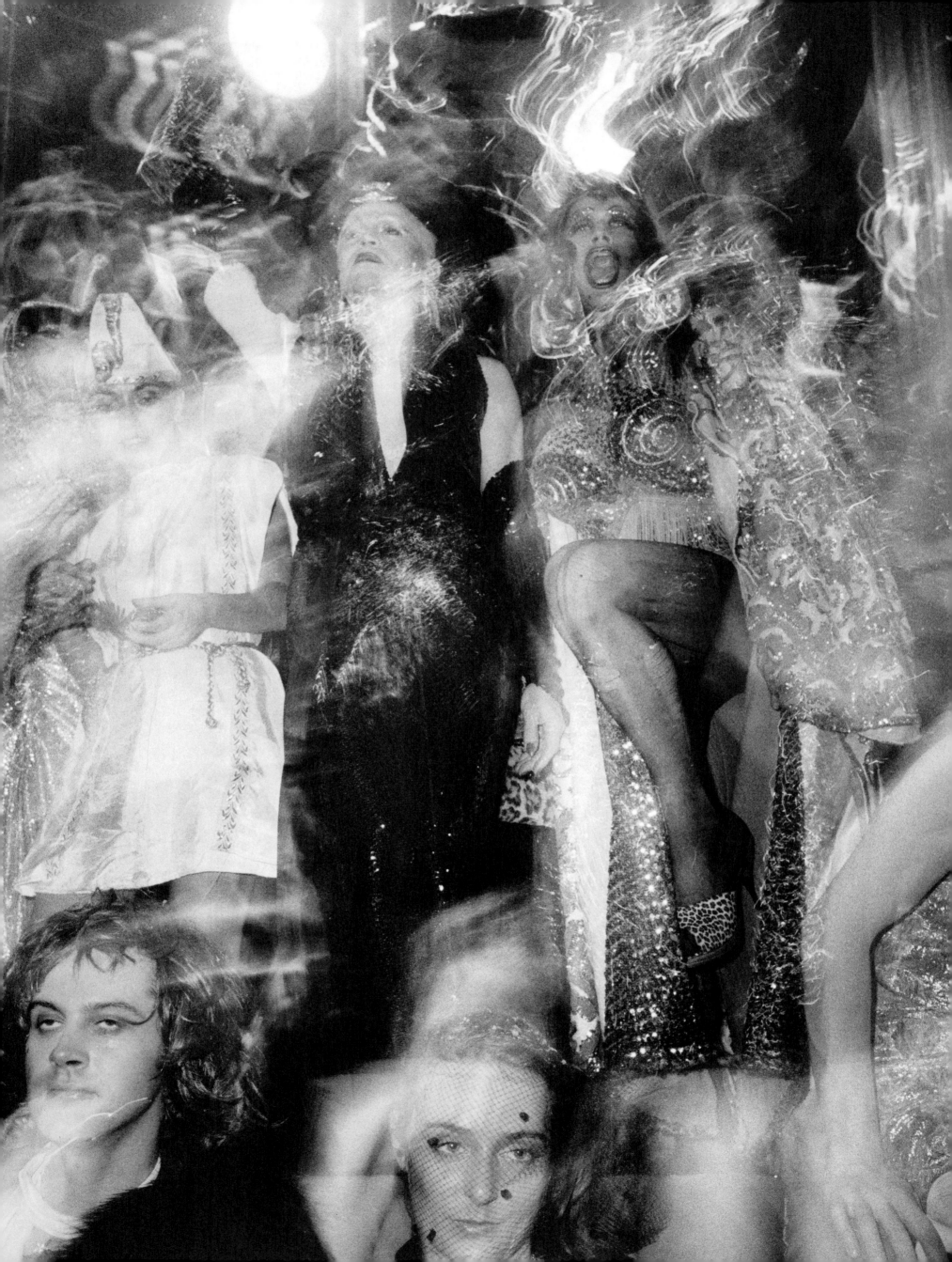

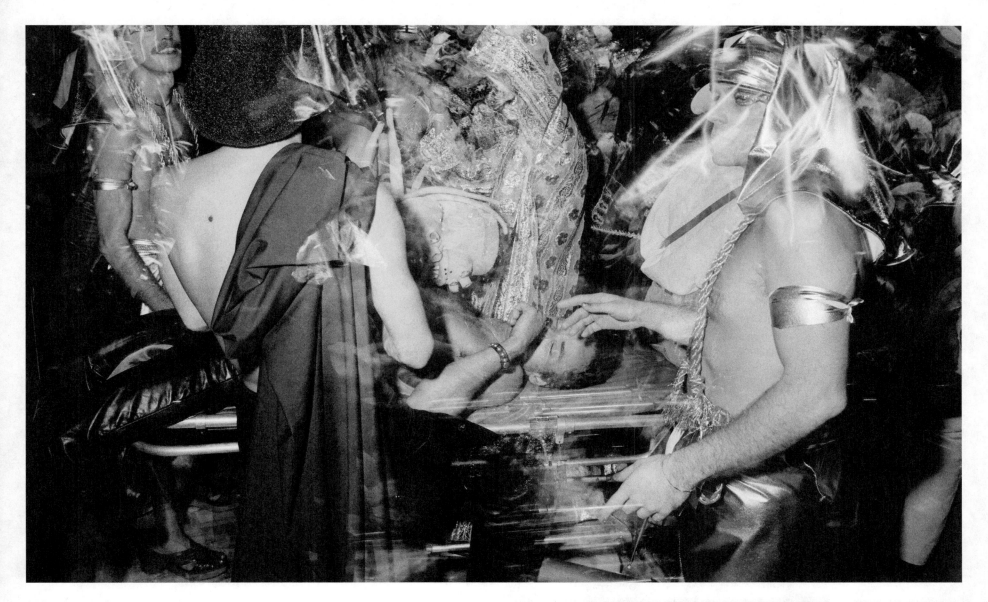

Opposite: Hasse Persson (Swedish, born 1942). *Halloween*, 1978. Gelatin silver print. 39 3/8 x 27 9/16 in. (100 x 70 cm). Courtesy of Hasse Persson and Embassy of Sweden. © Hasse Persson

Top: Hasse Persson (Swedish, born 1942). *Fashion Artist Victor Hugo on a Stretcher on the Dance Floor*, 1978. Gelatin silver print, 39 3/8 x 27 9/16 in. (100 x 70 cm). Courtesy of Hasse Persson and Embassy of Sweden. © Hasse Persson

Bottom: Susan Hillary Shapiro and Glenn Albin, filmmakers. Susan Hillary Shapiro, cinematographer. Still from *Halloween*, 1978. 16mm film, black-and-white, silent; excerpt 1 min. 30 sec. © Glenn Albin and Susan Hillary

"Great salon in 54 was the bathrooms. People would bring out full makeup kits. Best salon in the city."

—Edward Tricomi

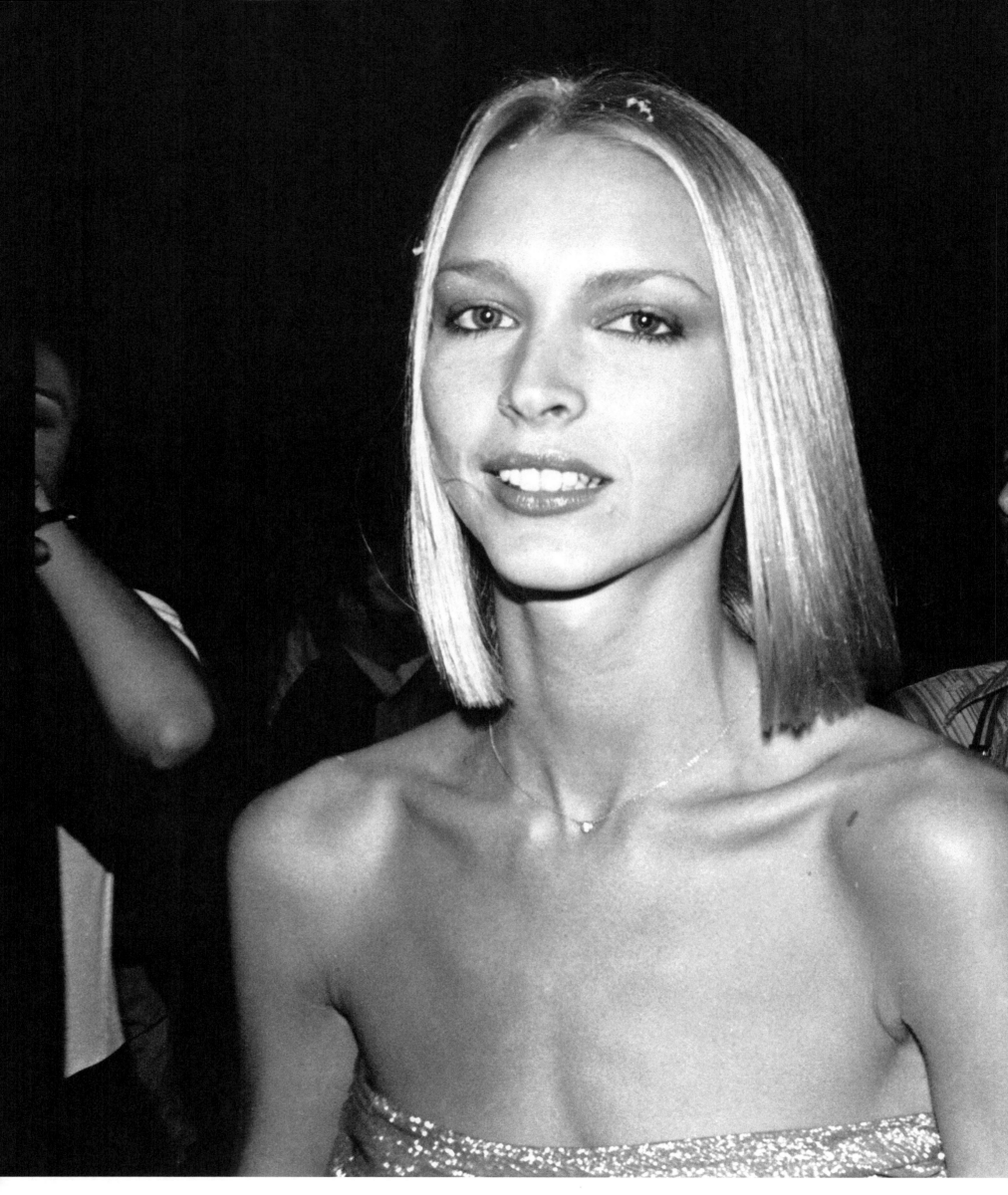

Anton Perich (American, born
Croatia, 1945). *Karen Bjornson at
Studio 54*, 1978. Gelatin silver
print, 20 x 24 in. (50.8 x 61
cm). Courtesy of the artist.
© Anton Perich

"I finally decided what I'm going to give all the Halston family for Christmas—Halston and Steve and Dr. Giller and Bianca—paintings of a free drink ticket from 54."

—*The Andy Warhol Diaries*
(New York, Warner, 1989),
December 19, 1978

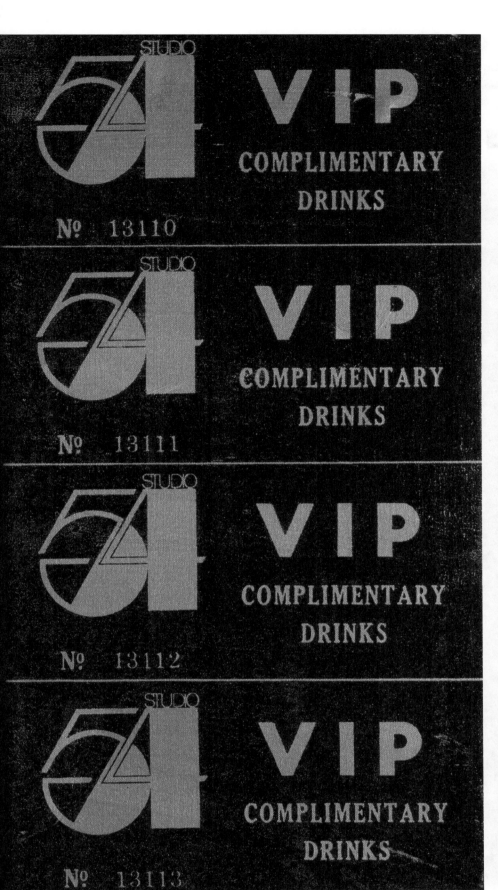

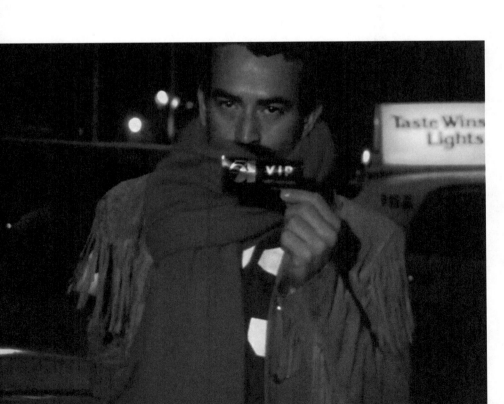

Top left: Andy Warhol (American, 1928–1987). Studio 54, 1978. Acrylic and silkscreen ink on linen, 26 x 14 in. (66 x 35.6). The Andy Warhol Museum, Pittsburgh; Founding Collection, Contribution The Andy Warhol Foundation for the Visual Arts, Inc. © 2020 The Andy Warhol Foundation for the Visual Arts, Inc. / Licensed by Artists Rights Society (ARS), New York

Top right: Andy Warhol (American, 1928–1987) Studio 54, 1978. Acrylic and silkscreen ink on linen. Ian Schrager Archive

Bottom: Susan Hillary Shapiro and Glenn Albin, filmmakers. Susan Hillary Shapiro, cinematographer. Still from Victor Hugo performance in front of and inside Studio 54 (holding Studio 54 VIP ticket), 1979. 16mm film, black-and-white, silent; excerpt 3 min. 20 sec. © Glenn Albin and Susan Hillary Shapiro

The back of this print bears two inscriptions: "Merry Christmas, Halston. Love Andy. '78" "Merry Xmas Ian. With love. It must be yours! Halston, 1988" In 1978, Ian Schrager arrived too late to the party and all of the Warhol paintings had been distributed; In 1988, Halston sent this painting to Schrager with the above second inscription. Both inscriptions are on the verso.

Andy Warhol (American, 1928—1987). Studio 54, 1978. Screen prints on vellum, 40 x 27 in. (101.6 x 68.6 cm). The Andy Warhol Museum, Pittsburgh; Founding Collection, Contribution The Andy Warhol Foundation for the Visual Arts, Inc. © 2020 The Andy Warhol Foundation for the Visual Arts, Inc. / Licensed by Artists Rights Society (ARS), New York

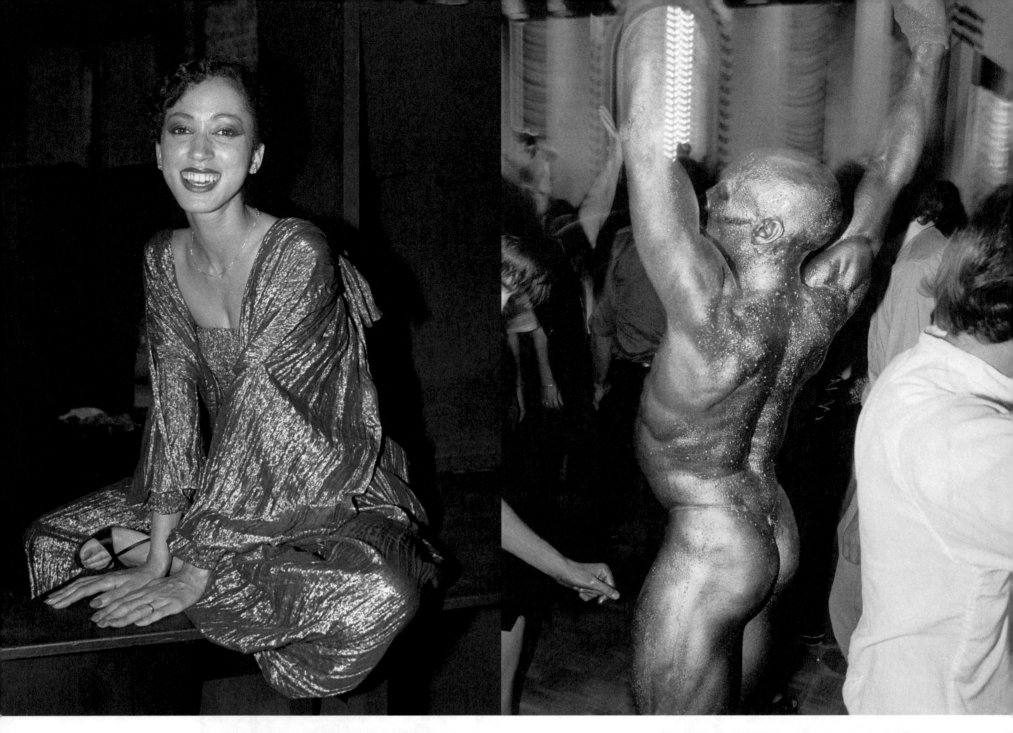

Top left: Dustin Pittman
(American). *Pat Cleveland,
New Year's Eve*, 1978-79.
Courtesy of the artist.
© Dustin Pittman

Top right: Hasse Persson
(Swedish, born 1942). *New
Year's Eve*, 1978-79. Gelatin
silver print, 39 3/8 x 27 9/16
in. (100 x 70 cm). Courtesy of
Hasse Persson and Embassy of
Sweden. © Hasse Persson

Bottom: Dustin Pittman
(American). *Studio 54 Entrance
Hallway*, New Year's Eve, 1978-
79. Courtesy of the artist.
© Dustin Pittman

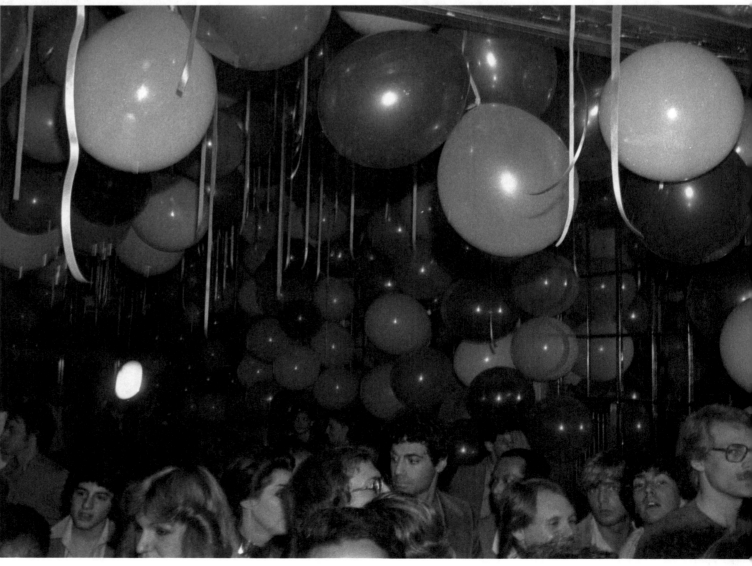

Dustin Pittman (American).
Diana Ross, New Year's Eve,
1979. Courtesy of the artist.
© Dustin Pittman

Standing on Stardust

Ian Schrager considered the
decor for Studio 54's New Year's
Eve 1978–79 party the best of
the club's thirty-three months,
describing it as "standing on
stardust." Florist and event
designer Renny Reynolds bought
barrels of diamond dust—not
glitter—in different sizes. The
floor was covered with two tons
of it, and another two tons was
sprinkled onto the crowd through-
out the evening. Many claimed
that they would see people with
diamond dust twinkling on their
clothes months later.

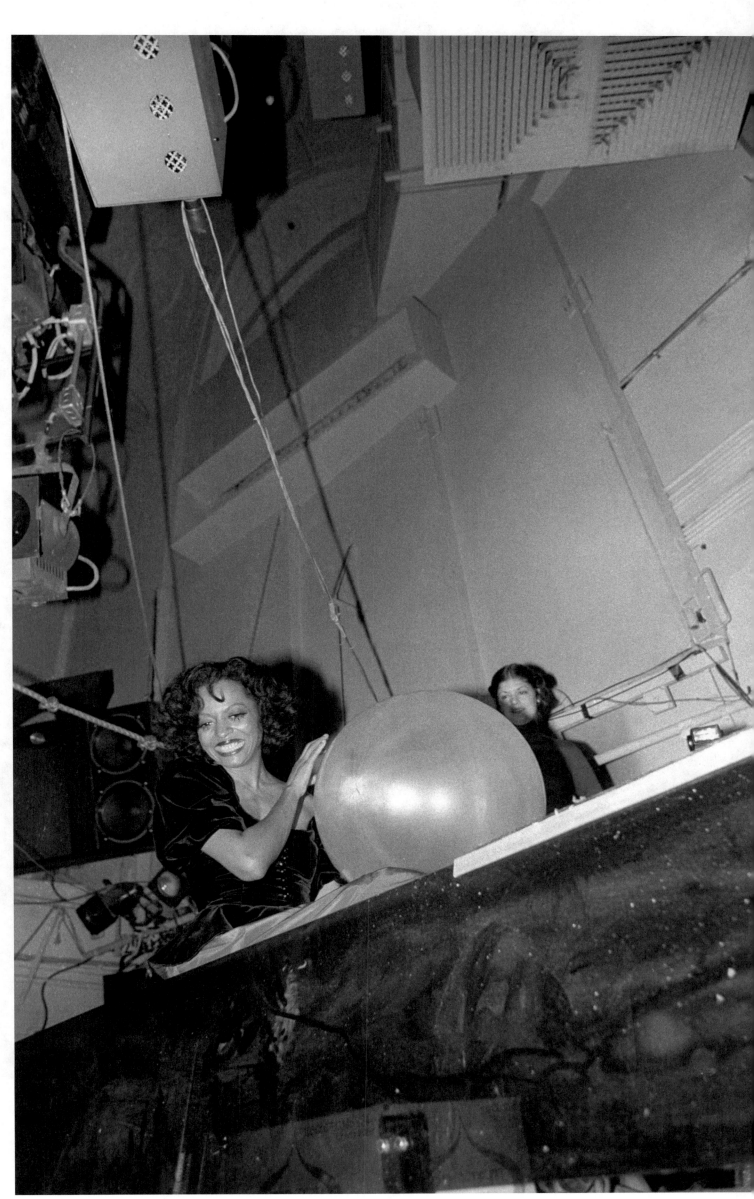

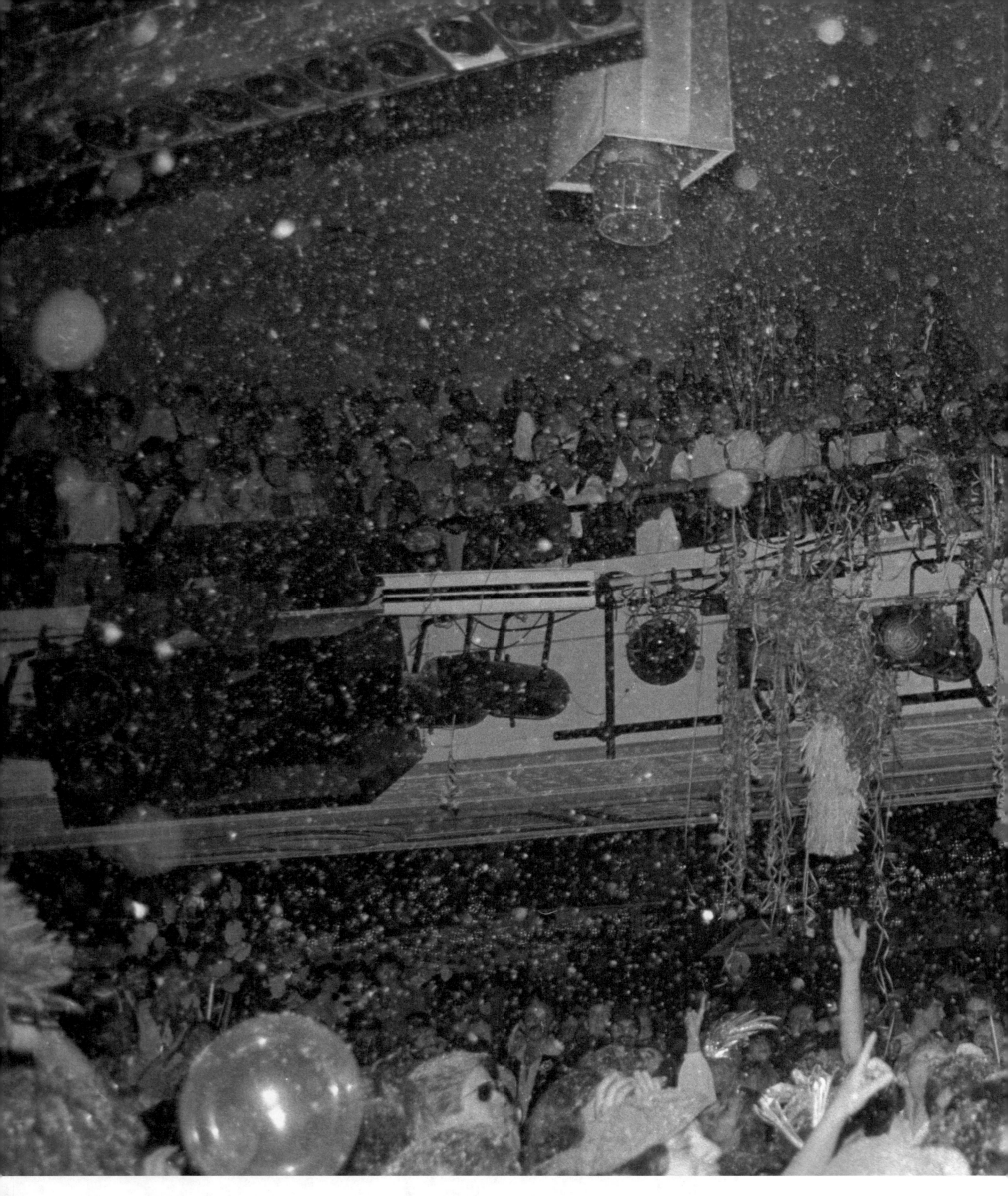

Dustin Pittman. *Stroke of Midnight at Studio*, 1978–79. Photograph, 15 x 20 in. (38.1 x 50.8 cm). Courtesy of the artist. © Dustin Pittman

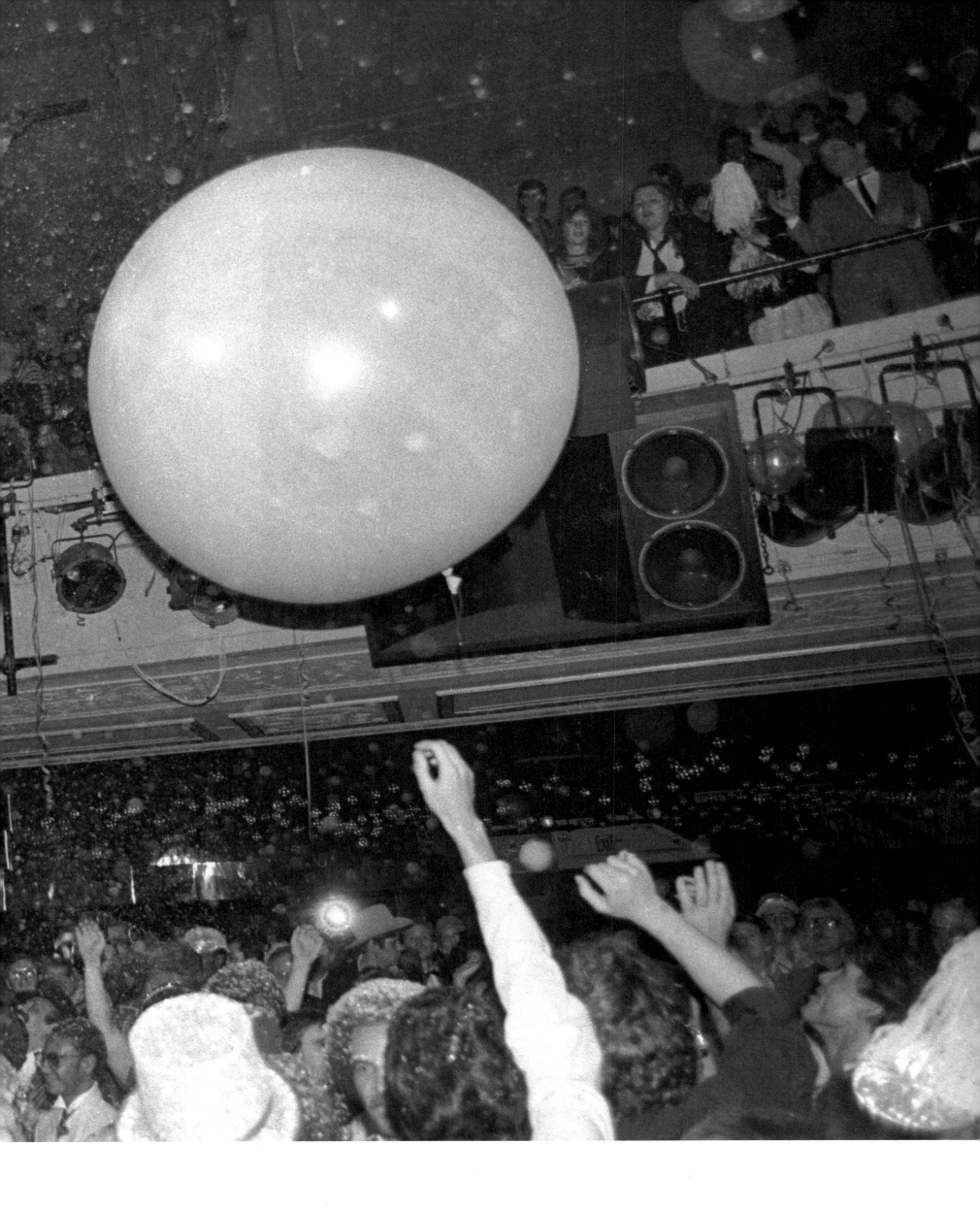

Valentine's Day, 1979

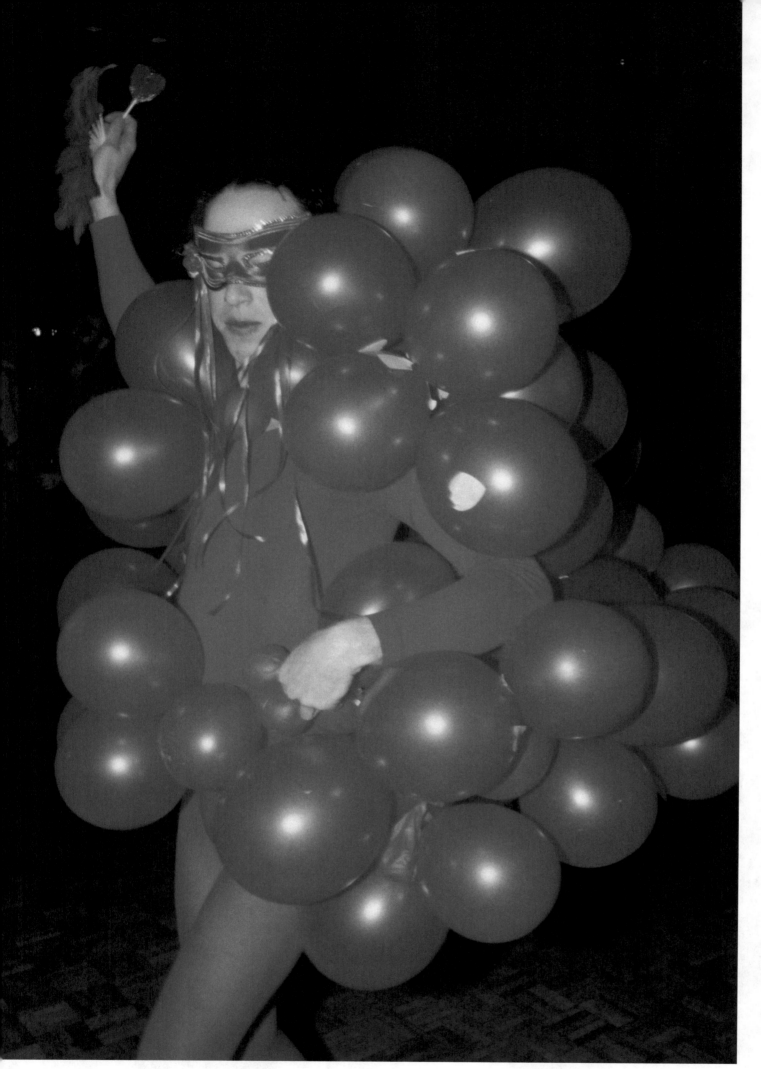

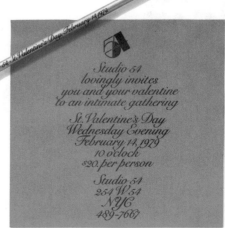

Top: Dustin Pittman (American).
Red Balloons, Valentine's Day
1979. Courtesy of the artist.
© Dustin Pittman

Bottom: Gil Lesser (American,
1935–1990). *St. Valentine's Day
invitation*, 1979. Printed paper,
8 x 8 in. (20.3 x 20.3 cm).
Courtesy of Ian Schrager Archive

Opposite: Miestorm (American,
born 1958). *Marianne and Friend*,
February 23, 1978. Courtesy of
the artist. © Miestorm

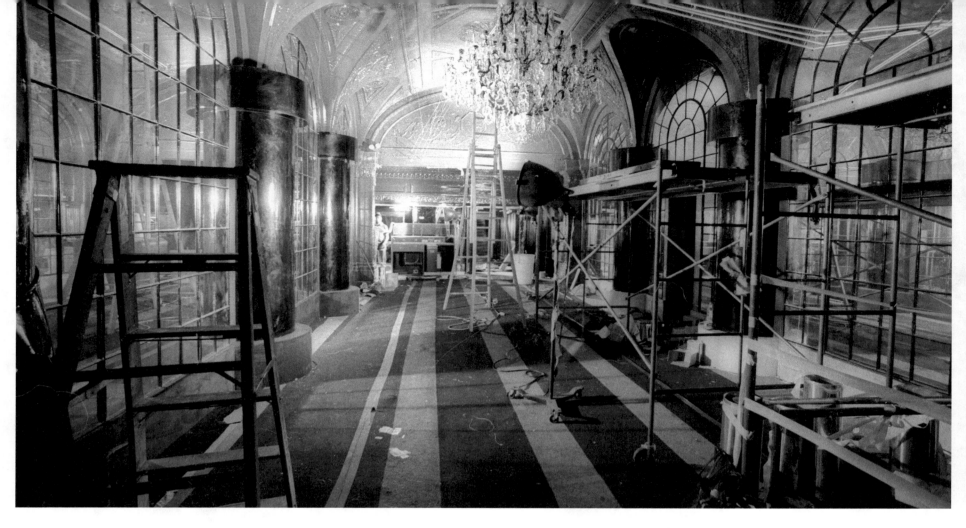

Top: Adam Scull (American). *Michael Overington Renovation*, 1981. Photo by © Adam Scull/ PHOTOlink.net

Bottom: Adam Scull (American). Balcony Renovation, 1978. Color photograph, 8 x 10 in.(20.3 x 25.4 cm). Courtesy of Ian Schrager Archive. Photo by Adam Scull/PHOTOlink.net. © Adam Scull

Opposite, bottom: Adam Scull (American). *Re-opened Studio 54 for Architectural Digest*, 1978. Color photograph, 8 x 10 in. (20.3 x 25.4 cm). Courtesy of Ian Schrager Archive. Photo by © Adam Scull/PHOTOlink.net

"In 1978 during Studio 54's ren- ovation, Jules Fisher and Paul Marantz were asked to 'update' the lighting at Studio 54. At that time, the Broadway produc- tion of *Chicago* was closing, and so they suggested moving the neon fan from the theater to Studio. *Chicago*, designed by Tony Walton, was set in the jazz-age 1920s, the same era when the Gallo Opera was built. *Chicago* is a satire on the celebrity of criminals. Because *Chicago* began out of town, the neon tubing was encased in plastic tubing to protect the delicate glass tubes filled with gases. Over the plastic and glass was a third layer of chrome mesh, so that it looked like metal until the lights were turned on." —Tony Walton

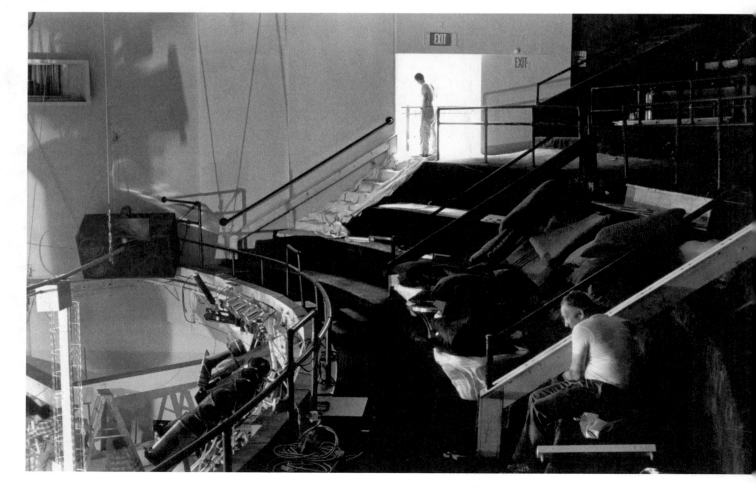

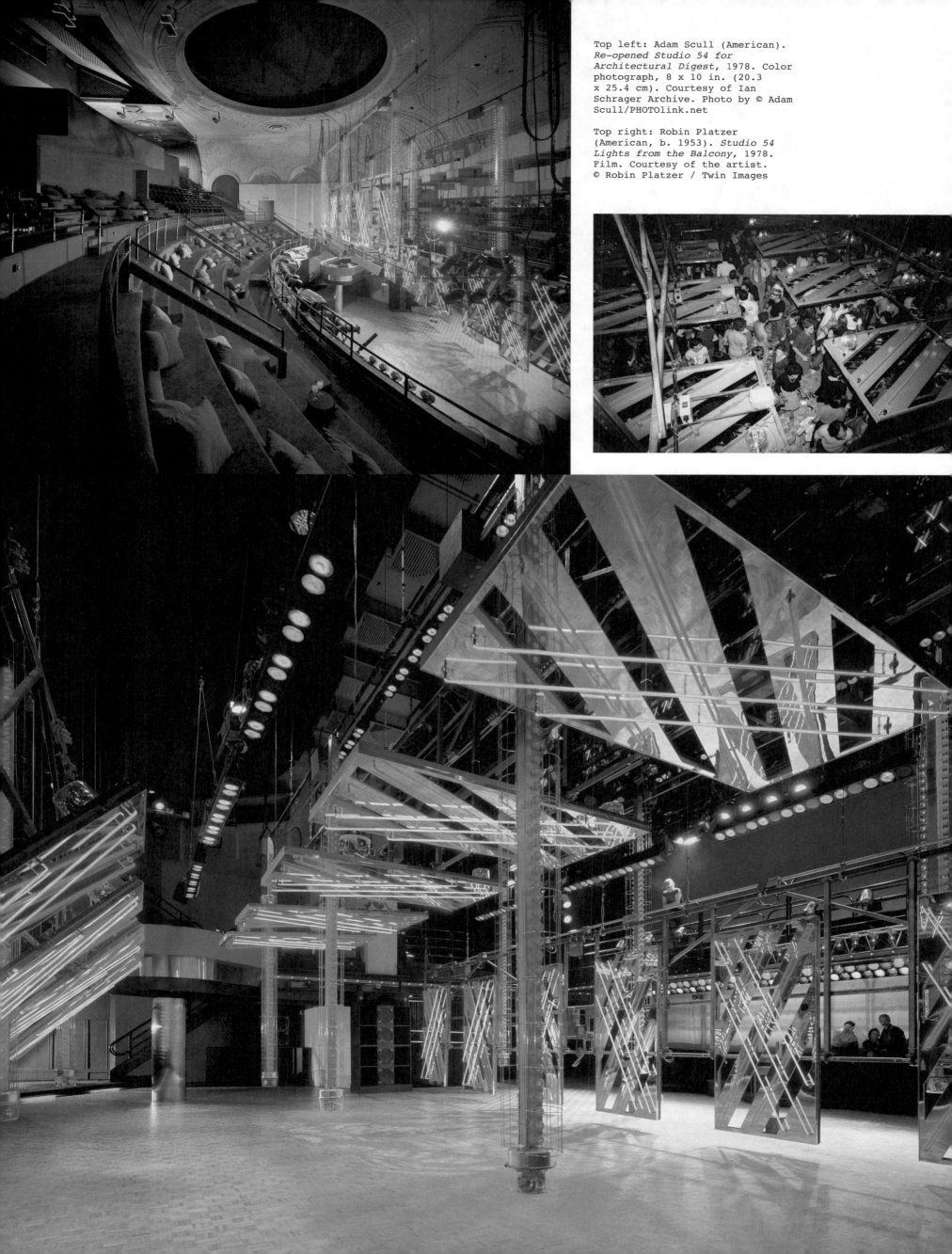

Top left: Adam Scull (American).
*Re-opened Studio 54 for
Architectural Digest*, 1978. Color
photograph, 8 x 10 in. (20.3
x 25.4 cm). Courtesy of Ian
Schrager Archive. Photo by © Adam
Scull/PHOTOlink.net

Top right: Robin Platzer
(American, b. 1953). *Studio 54
Lights from the Balcony*, 1978.
Film. Courtesy of the artist.
© Robin Platzer / Twin Images

Richie Williamson (American, born 1947). *Realized Sets at Studio 54*, 1977–80; 2020. Animation, color, silent; 8 minutes. Courtesy of the artist

The original 1977 pyramid was also painted and airbrushed; the revised 1978 pyramid was painted so that it could only be seen under huge ultraviolet lights. The "Mandala cut drop curtain" from 1978 was made of black velvet with pierced holes, backed by sheets of frosted plastic. Behind the curtain was a series of moving lights. The "shimmer disc" and "striped back panel" of 1979 were both created by attaching red spangles onto sheets of metal mesh. The disc, eight feet in diameter, was covered solid with spangles, and the stripes were created by alternating solid strips of spangles with "blank" strips. At this time the "bridge," a moving balcony with a line of purple airport runway lights along its side, had also been installed.

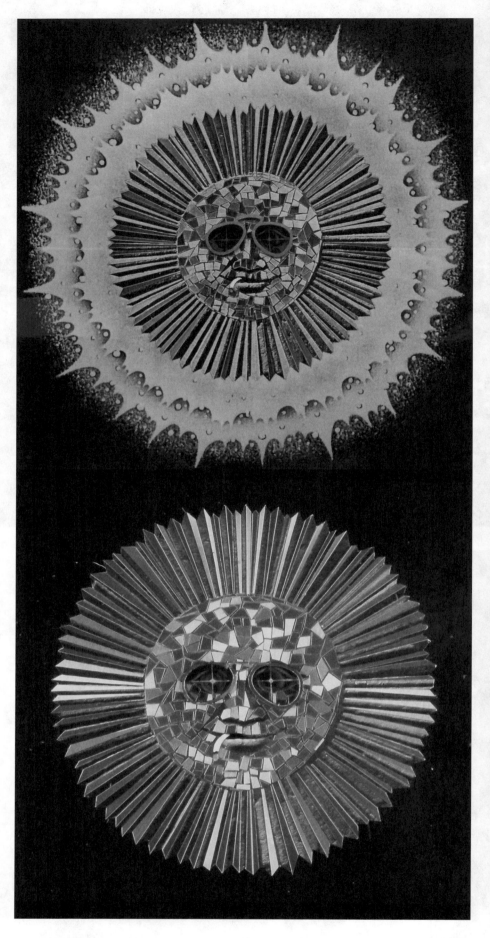

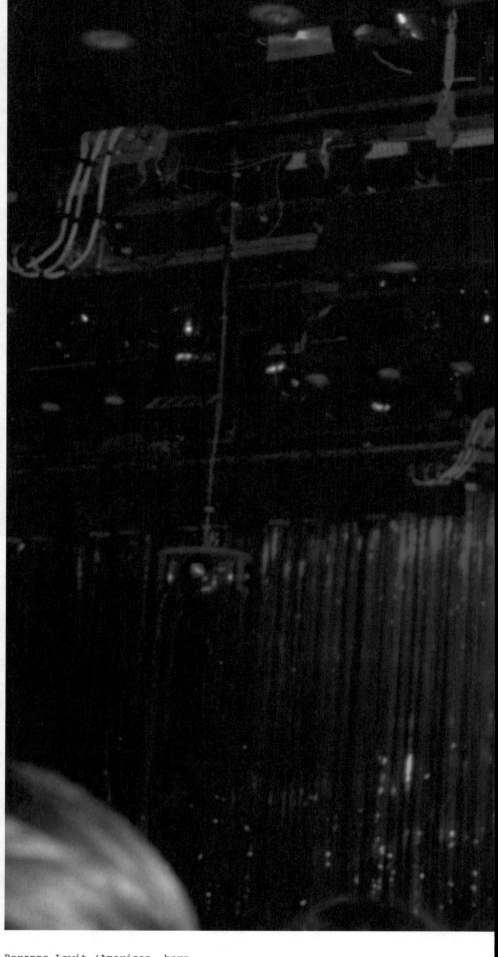

Top: Tony Walton (British, born 1934). *Moon Madness (Frost)*, 1979. Collage, 12 1/2 x 12 in. (31.8 x 30.5 cm). Courtesy of the artist. © Tony Walton

Bottom: Tony Walton (British, born 1934). *"Smoking Sun" model for Studio 54*, 1979. Collage, 11 1/2 x 11 in. (29.2 x 27.9 cm). Courtesy of the artist. © Tony Walton

Roxanne Lowit (American, born 1958). *Sunburst Decor at Studio 54*, circa 1978. Courtesy of the artist. © Roxanne Lowit

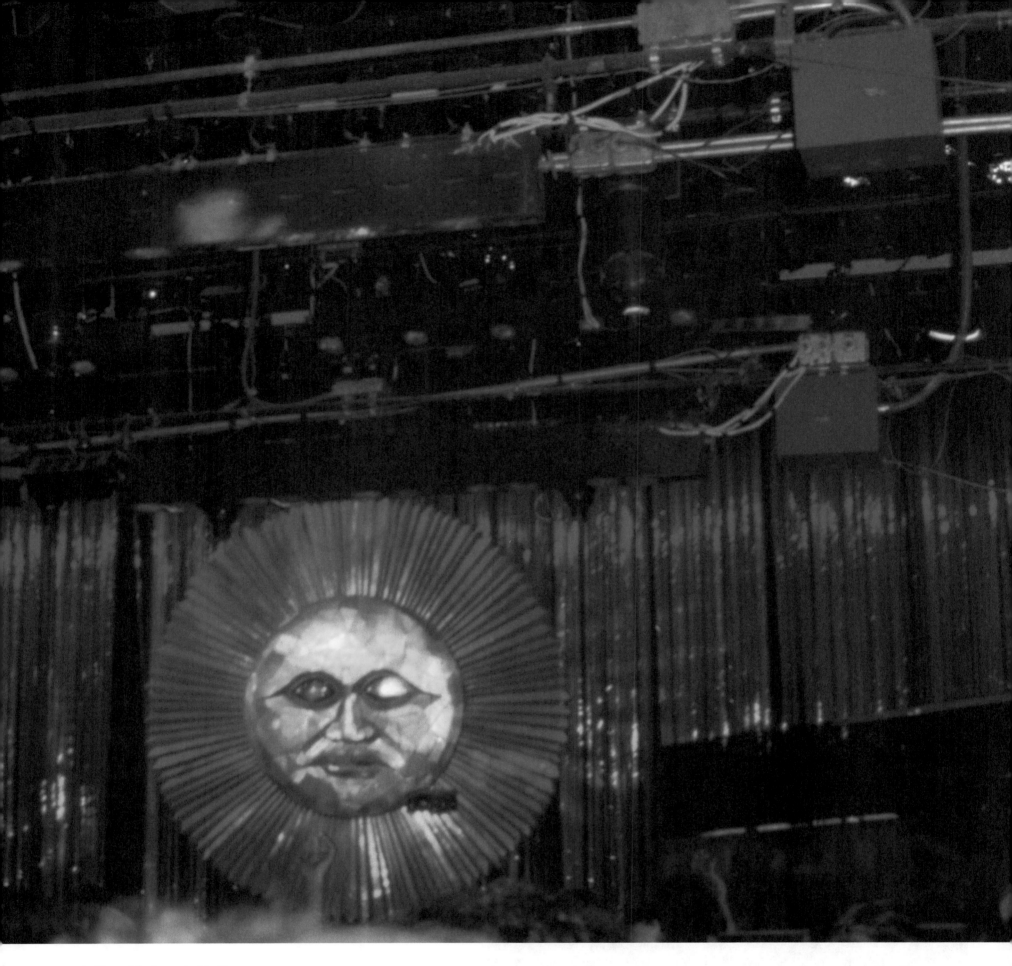

Steve Rubell said that at Studio
54 there would be sunrises and
sunsets, snow storms and rain,
all in one night—bringing the
theatrical drama of the natural
world indoors, though on a much-
accelerated time frame.

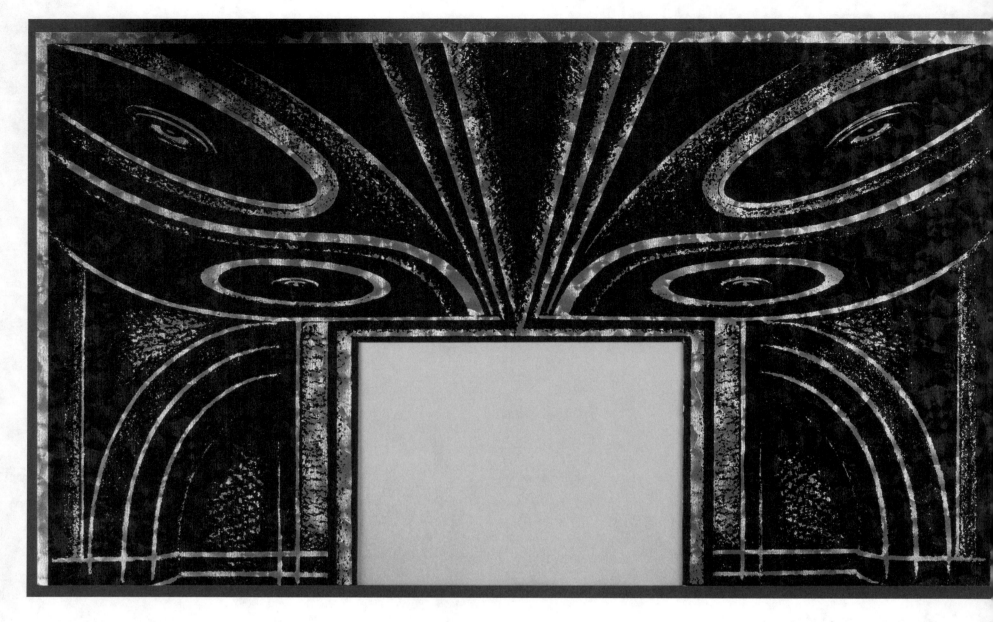

Tony Walton's proposal for the moving proscenium set was related to his design for Bette Midler's 1975 Broadway production, *Clams on the Half Shell Revue*, which featured scenery that moved vertically behind the proscenium.

Top: Tony Walton (British, born 1934). *Deco Drop with Proscenium*, 1979. Print on silver ground, mounted on black card stock, 16 3/4 x 24 1/2 in. (42.5 x 62.2 cm). Courtesy of the artist. © Tony Walton (Photo: Jonathan Dorado)

Bottom: Tony Walton (British, born 1934). *Pearl Drapery*, 1979. Photograph, 7 1/4 x 9 in. (18.4 x 22.9 cm). Courtesy of the artist. © Tony Walton (Photo: Jonathan Dorado)

Opposite: Tony Walton (British, born 1934). *Twin Elvises*, 1979. Photo-collage, 35 1/2 x 13 3/4. (90.2 x 34.9 cm). Courtesy of the artist. © Tony Walton (Photo: Jonathan Dorado)

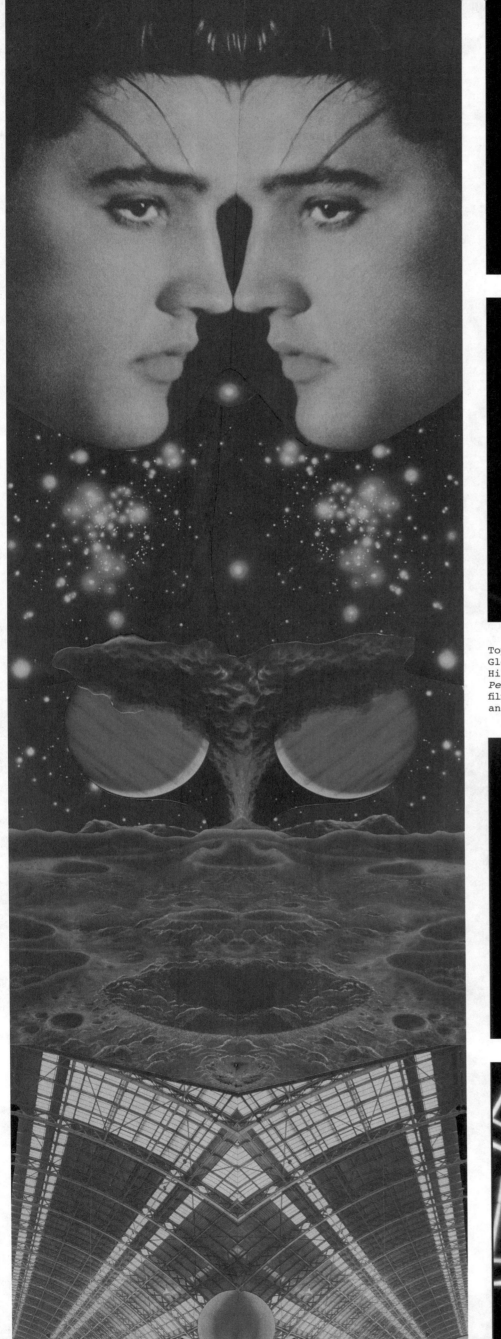

Top: Susan Hillary Shapiro and Glenn Albin, filmmakers. Susan Hillary Shapiro, cinematographer. *Pendulum heart* (still), 1979. 16mm film, color, silent. © Glenn Albin and Susan Hillary Shapiro

Bottom: Susan Hillary Shapiro and Glenn Albin, filmmakers. Susan Hillary Shapiro, cinematographer. *Neon fan* (still), 1979. 16mm film, color, silent. © Glenn Albin and Susan Hillary Shapiro

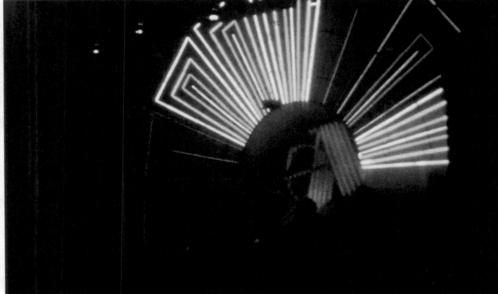

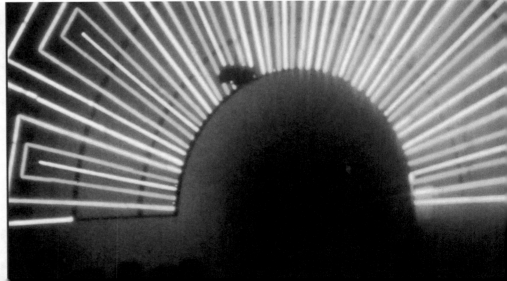

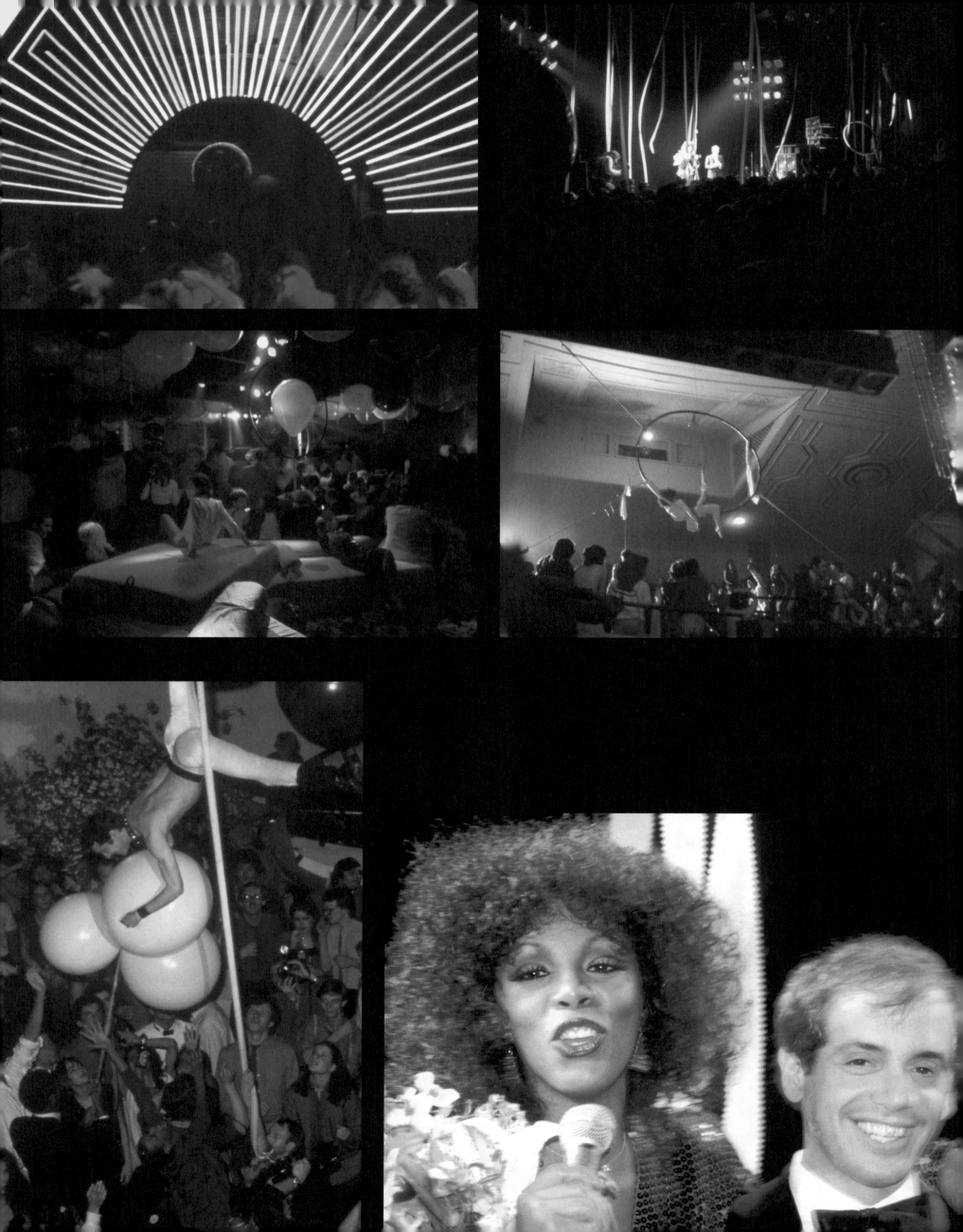

Second-Anniversary Party

Top: Allan Tannenbaum (American, born 1945). *Donna Summer Sings*, April 26, 1979. Courtesy of the artist. © Allan Tannenbaum

Opposite top four and bottom left: Nina Meledandri (American, born 1957), photographer Karin Bacon (American, born 1940), event designer and producer. *Second Anniversary Party*, April 26, 1979. Slideshow of 35mm color slides. Courtesy of Karin Bacon

Opposite bottom: Allan Tannenbaum (American, born 1945). *Donna Summer and Steve Rubell*, April 26, 1979. Courtesy of the artist. © Allan Tannenbaum

"We had the best music."

—Carmen D'Alessio

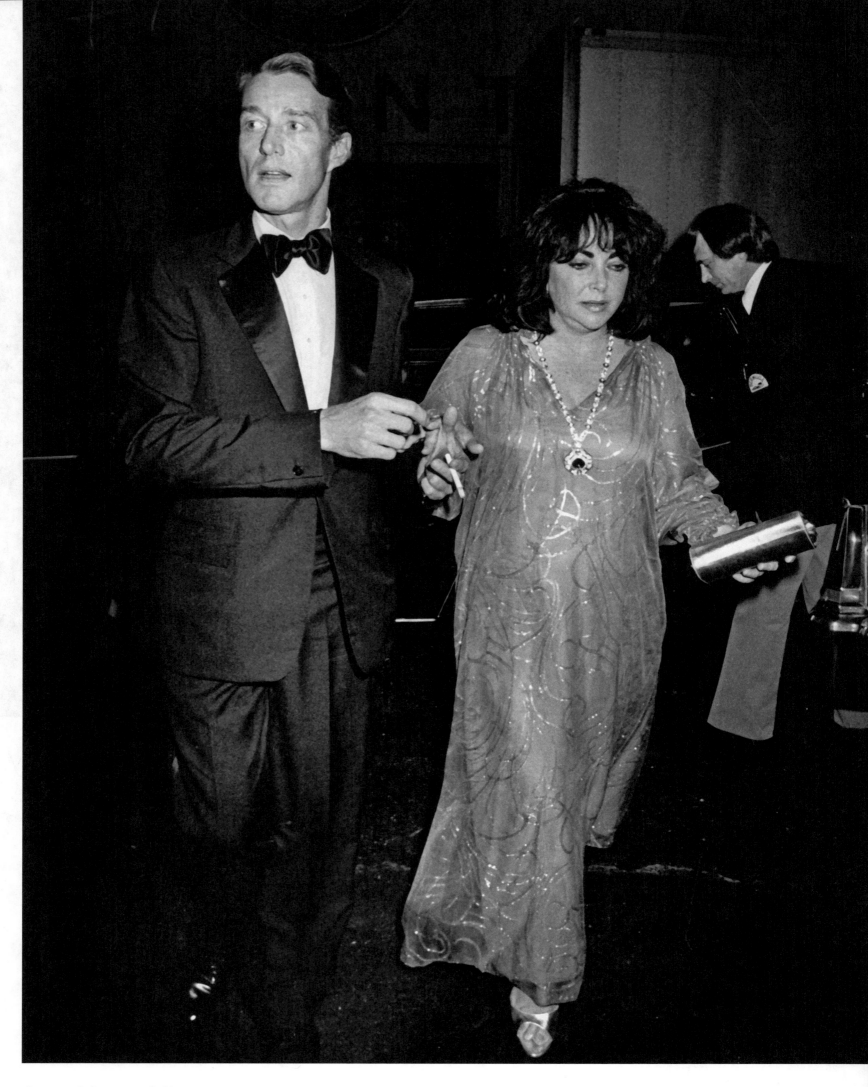

Photograph by Ron Galella.
Halston and Elizabeth Taylor,
Martha Graham Award to Halston,
May 21, 1979. Vintage gelatin
silver print. Courtesy of the
artist. © Ron Galella

Opposite, bottom: *Liza Minnelli,
Elizabeth Taylor and Betty Ford
at Studio 54 in New York City,*
circa 1979. (Photo by Robin
Platzer/IMAGES/Getty Images)

Letter from Liza Minnelli to
Elizabeth Taylor, March 15, 1979.
Typed stationery, with signature
and notations. The Elizabeth
Taylor Archive

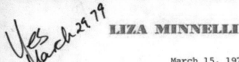

LIZA MINNELLI

March 15, 1979

Dear Liz:

I am delighted to tell you that I have
accepted the chairmanship of this year's Annual
Martha Graham Award Dinner which will be held
on Monday evening, May 21st. I am especially
pleased to serve as chairman since the Third
Annual Award will be presented by Mrs. Gerald
Ford to my dear friend, Halston.

The award is given annually to an individual
who has helped establish a deep recognition of
the arts in the culture of the United States and
of the world. The first award was presented to
Mrs. Gerald R. Ford in 1977. Miss Alice Tully
was the recipient of the Second Annual Award at
a special presentation and dinner held last May.

The dinner will be limited to 150 guests,
all friends of Halston's, Martha's and mine. As
in the past, the proceeds from the evening will
be used to enable the Graham Company to con-
tinue their work which Halston and I have come to
so deeply admire. I hope that you will plan to
be with us on the 21st and that you will also
agree to serve on the Committee for the Third
Annual Martha Graham Award.

I shall look forward to hearing from you.

Sincerely,

Halston, Liza, Liz and Martha Graham, 1979

At the invitation of Liza
Minnelli, Elizabeth Taylor
attended Martha Graham's ben-
efit honoring their longtime
friend Halston. Halston designed
Taylor's ensemble to set off her
fabled Bulgari sautoir necklace,
featuring a 62-carat sugarloaf
cabochon Burmese sapphire. The
sapphire can also be detached
from the necklace to be worn as
a brooch.

The necklace was presented to
Taylor by her husband Richard
Burton, on her fortieth birthday,
February 27, 1972. Taylor wore it
to many special events, including
Burton's fiftieth birthday party
in London in 1975 and the opening
night of Lena Horne's Broadway
revue *The Lady and Her Music*
in 1981.

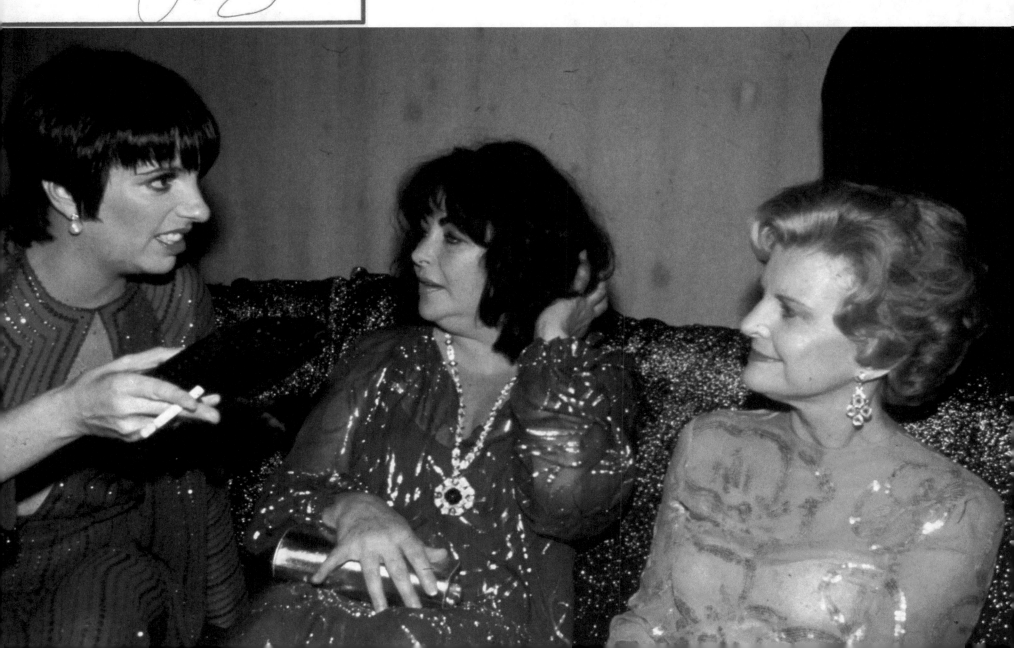

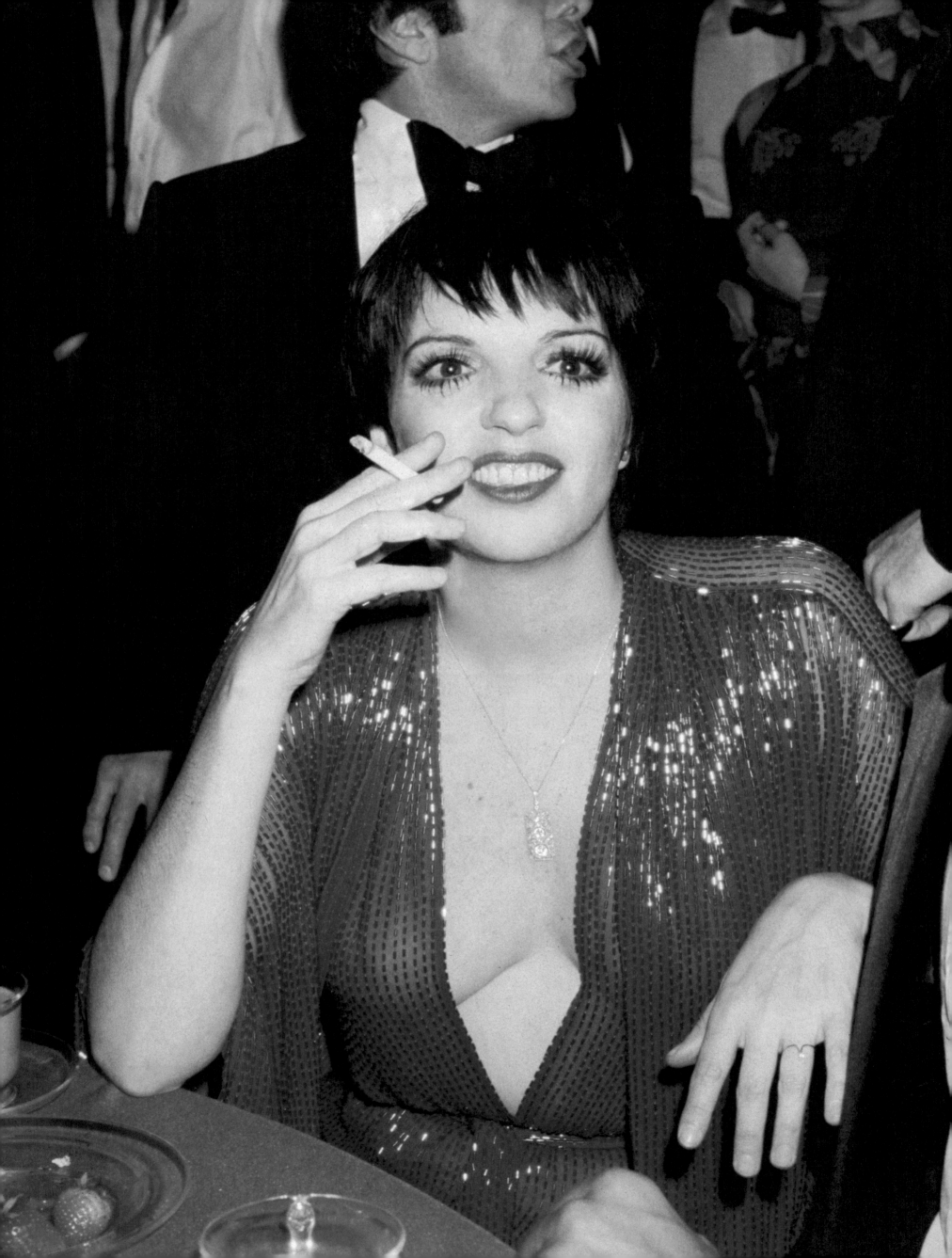

A CELEBRATION FOR HALSTON

BETTY FORD
and
LIZA MINNELLI

cordially invite you to a

GALA CELEBRATION FOR

HALSTON

RECIPIENT OF THE
THIRD ANNUAL MARTHA GRAHAM AWARD

STUDIO 54
254 West 54th Street

Monday Evening, May 21st
nine o'clock

Tax Deductible
Donation
Twenty Dollars Reply Card Enclosed

Joe Eula (American, 1925–2004) *Invitation (Sent to Andy Warhol for Presentation of Martha Graham Award, posted May 8, 1979, New York)*, 1979. The Andy Warhol Museum, Pittsburgh; Founding Collection, Contribution The Andy Warhol Foundation for the Visual Arts, Inc., TC242.59.1–.4

Bottom right: Doris Duke during Martha Graham Award to Halston at Studio 54 in New York City. (Photo by Ron Galella/Ron Galella Collection via Getty Images)

Doris Duke, who over the decades frequented Birdland and other New York nightclubs, was also a regular at Studio 54. A statuesque fashion icon, Duke visited Halston's salon for ensembles "made to measure"—which is how Halston described his one-of-a-kind couture designs.

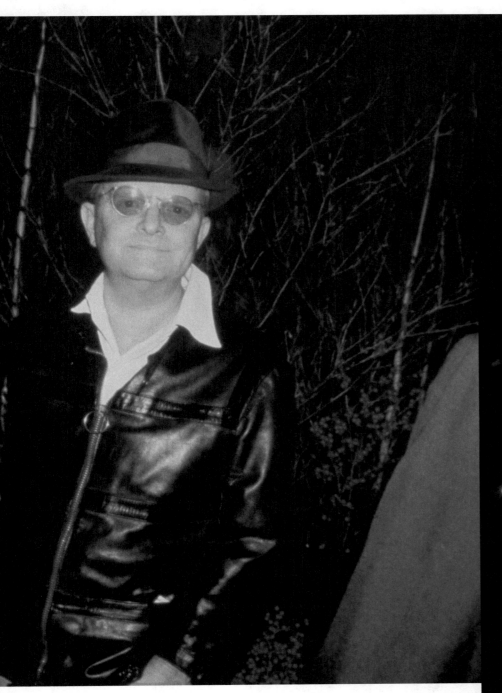

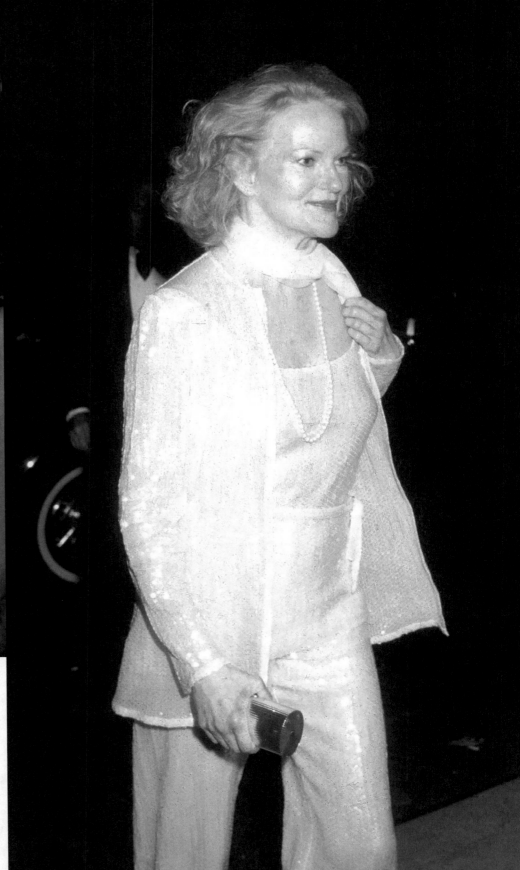

Opposite: Roxanne Lowit (American, born 1958). *Liza Minnelli*, Studio 54, 1978. Courtesy of the artist. © Roxanne Lowit

Bottom left: Roxanne Lowit (American, born 1958). *Truman Capote*, Studio 54, 1979. Courtesy of the artist. © Roxanne Lowit

May 21, 1979: Presentation of Martha Graham Award to Halston 133

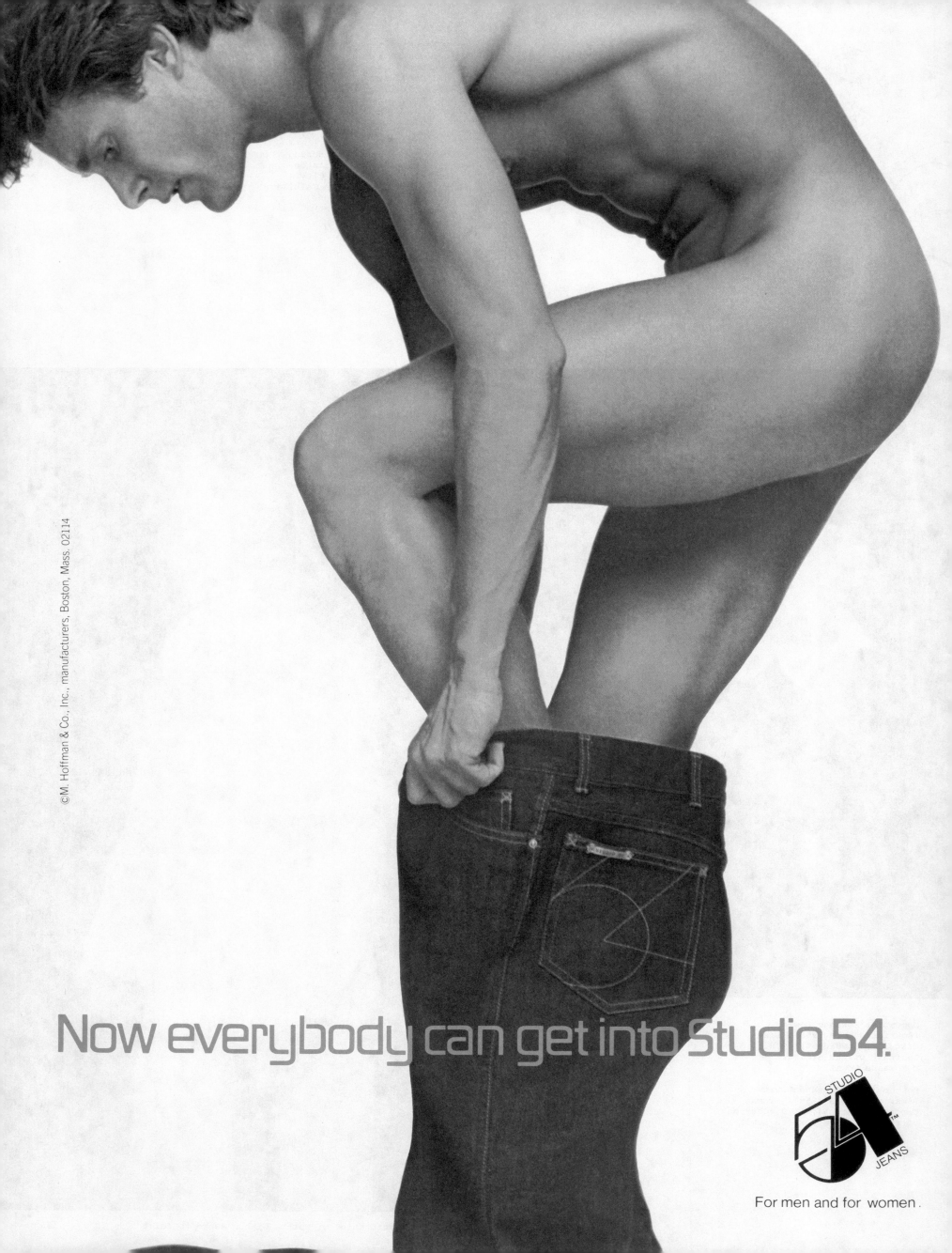

Now everybody can get into Studio 54.

STUDIO 54 JEANS

For men and for women .

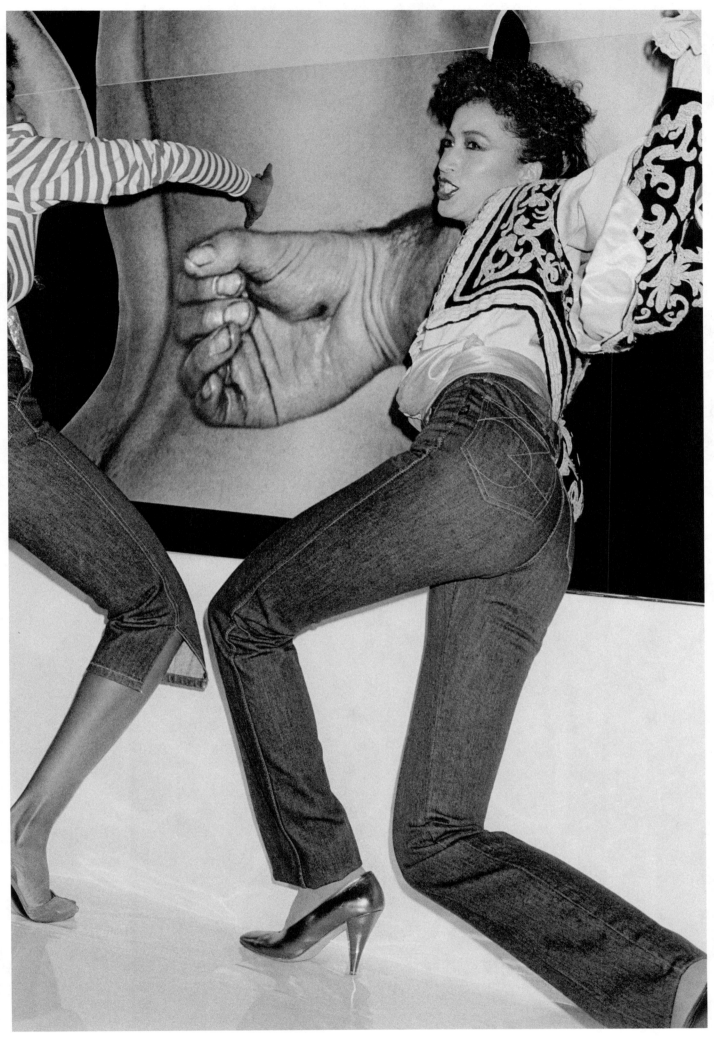

Joining the designer jeans competition in 1979 was Studio 54 jeans, a collaboration with Landlubber and Studio 54 friend Norma Kamali. The designer spent months taking apart a variety of jeans and reworking her pattern for a great fit. The jeans were promoted in an ad campaign with the tagline "Now everybody can get into Studio 54," which riffed on the by-then-infamous red-rope door policy. The tagline was written by legendary adman Peter Rogers who coined "Blackglama: What Becomes a Legend Most".

Opposite: Gordon Munro (American, born 1938) and Peter Rogers (American, born 1934) for Studio 54 (nightclub). *Now everybody can get into Studio 54*, circa 1980. Poster, 22 x 17 in. (55.9 x 43.2 cm). Museum of the City of New York, 2013.8.9. © Gordon Munro, photographer

Roxanne Lowit (American, born 1958). *Pat Cleveland Wearing Studio 54 Jeans*, 1979. Courtesy of the artist. © Roxanne Lowit

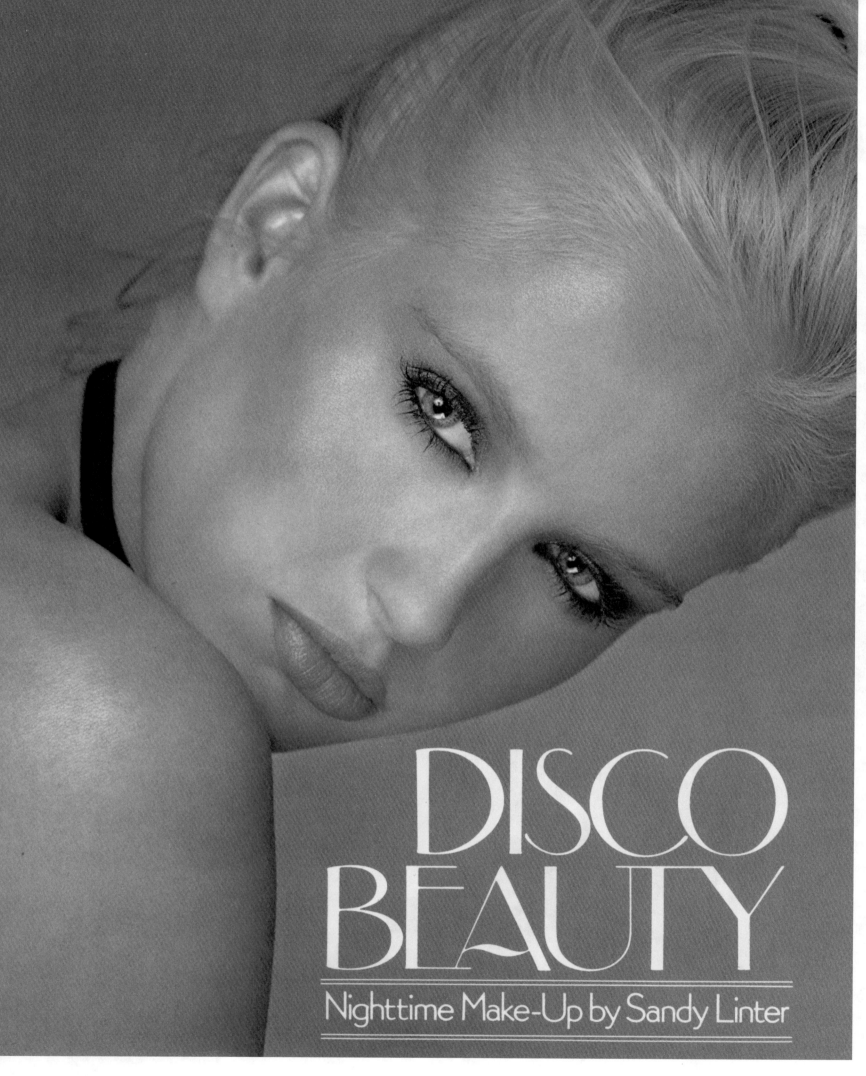

DISCO BEAUTY

Nighttime Make-Up by Sandy Linter

Sandy Linter (American, born
1947). *Disco Beauty: Nighttime
Make-Up* (cover), 1979. New York:
Simon and Schuster. Printed book.
Courtesy of Sandy Linter

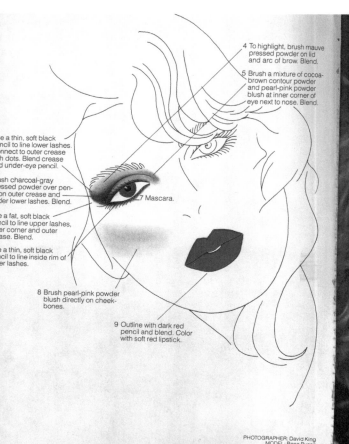

4 To highlight, brush mauve pressed powder on lid and arc of brow. Blend.

5 Brush a mixture of cocoa-brown contour powder and pearl-pink powder blush at inner corner of eye next to nose. Blend.

se a thin, soft black encil to line lower lashes. onnect to outer crease ith dots. Blend crease nd under-eye pencil.

rush charcoal-gray ressed powder over pen- on outer crease and der lower lashes. Blend.

se a fat, soft black encil to line upper lashes. ter corner and outer ease. Blend.

7 Mascara.

se a thin, soft black encil to line inside rim of ver lashes.

8 Brush pearl-pink powder blush directly on cheek-bones.

9 Outline with dark red pencil and blend. Color with soft red lipstick.

PHOTOGRAPHER: David King
MODEL: Rene Russo
HAIR: Harry King

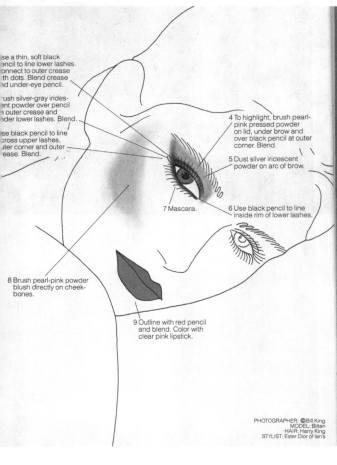

se a thin, soft black encil to line lower lashes. onnect to outer crease th dots. Blend crease nd under-eye pencil.

rush silver-gray irides- ent powder over pencil outer crease and der lower lashes. Blend.

se black pencil to line cross upper lashes. ter corner and outer ease. Blend.

7 Mascara.

4 To highlight, brush pearl-pink pressed powder on lid, under brow and over black pencil at outer corner. Blend.

5 Dust silver iridescent powder on arc of brow.

6 Use black pencil to line inside rim of lower lashes.

8 Brush pearl-pink powder blush directly on cheek-bones.

9 Outline with red pencil and blend. Color with clear pink lipstick.

PHOTOGRAPHER: ©Bill King
MODEL: Bitten
HAIR: Harry King
STYLIST: Ester Dior of Ian's

Left: Sandy Linter (American, born 1947). Pages from *Disco Beauty: Nighttime Make-Up*, 1979. New York: Simon and Schuster. Printed book. Courtesy of Sandy Linter

Anton Perich (American, born Croatia, 1945). Stills from *Anton Perich Presents Grace Jones, Cinandre*, 1978. Featuring Grace Jones and Andre Martheleur. Video, color, sound; excerpt 13 min. 45 sec. Courtesy of the artist

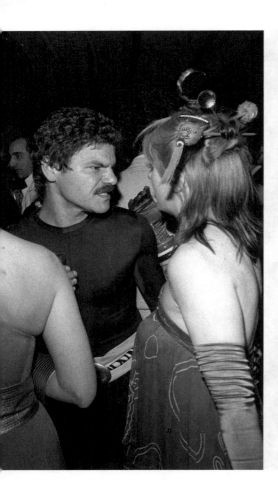

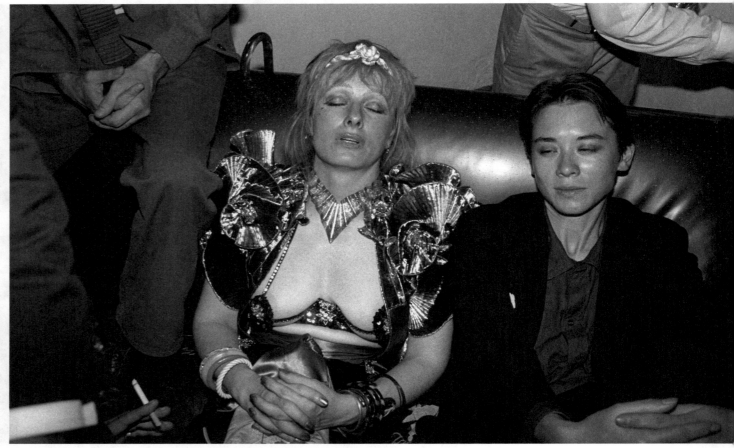

Dustin Pittman (American).
*Valerie LeGaspi, Larry LeGaspi,
and Zandra Rhodes*, 1979. Courtesy
of the artist. © Dustin Pittman

Dustin Pittman (American). *Zandra
Rhodes and Tina Chow*, 1979.
Courtesy of the artist.
© Dustin Pittman

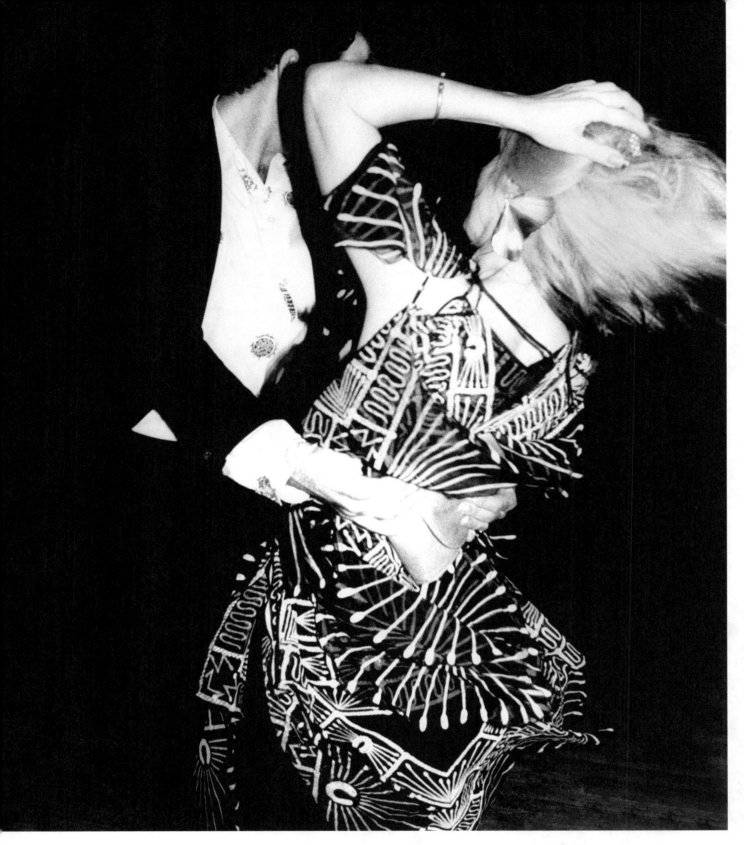

"If you wanted to dance, that's where you went."

—Bruce Suldano

Rose Hartman (American, born 1937). *R. Couri Hay and Zandra Rhodes*, circa 1977. Courtesy of the artist. © Rose Hartman

"The best expression of freedom."
—Tommy Mattola

Toby Old (American, born 1945).
Studio 54, 1980. Courtesy of
the artist

Opposite: Dustin Pittman (American).
Shinzei, 1978. Courtesy of the
artist. © Dustin Pittman

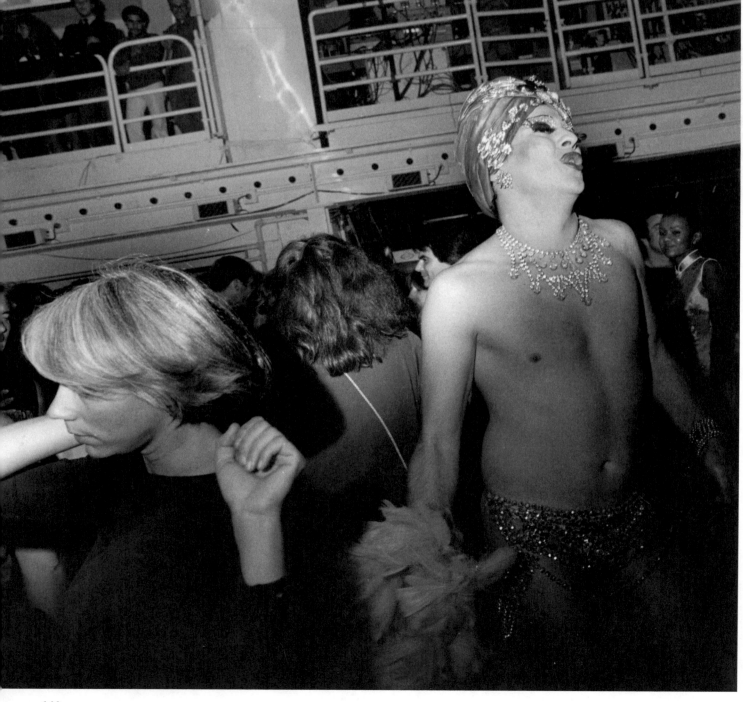

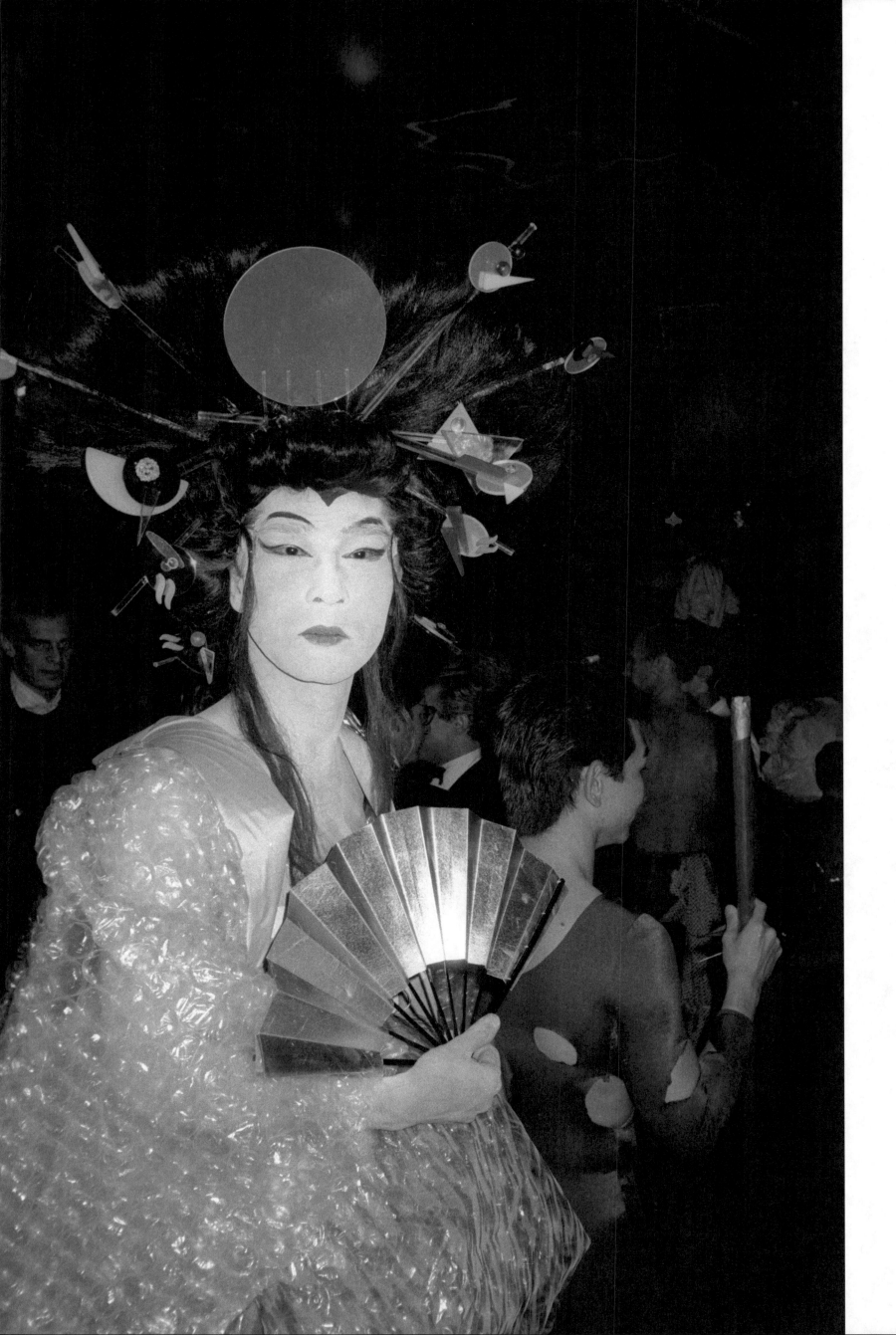

141

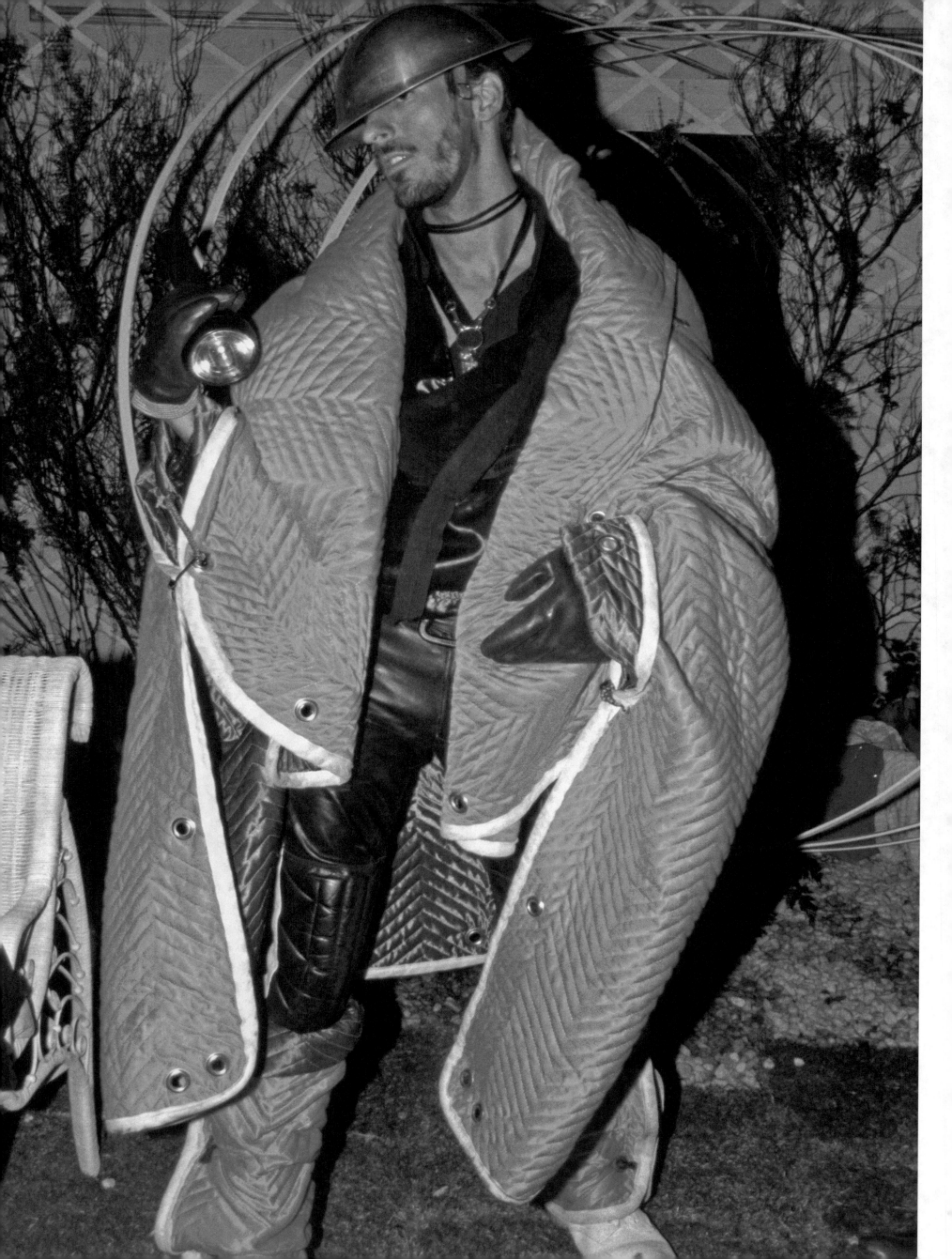

Known for his street performances on Fifth Avenue and his work onstage with Robert Wilson in the early 1970s, Richard Gallo turned to performance art on the dance floor later in the decade at nightclubs such as Studio 54 and Bond International Casino. When Gallo was not wearing his signature rhinestone glove, he would often improvise and hold a butter knife in the air to sparkle under Studio 54's lighting. His other props included two flashlights and a ball of yarn, which friends such as performance artist Sheryl Sutton would pull from his waders and use to bind people together on the dance floor.

As scholar Scott Rollins has noted, "When Gallo performed, he was more like an art object rather than a stage actor. At Studio 54, he would find the best lighting on the dance floor, and stand under it without speaking or moving. Because of his muscled body and provocative costumes, he didn't have to move or speak to get attention. His costume designer, Phillip Haight, described Gallo's presence in Studio 45 as 'a performance of stillness and strangeness.'"

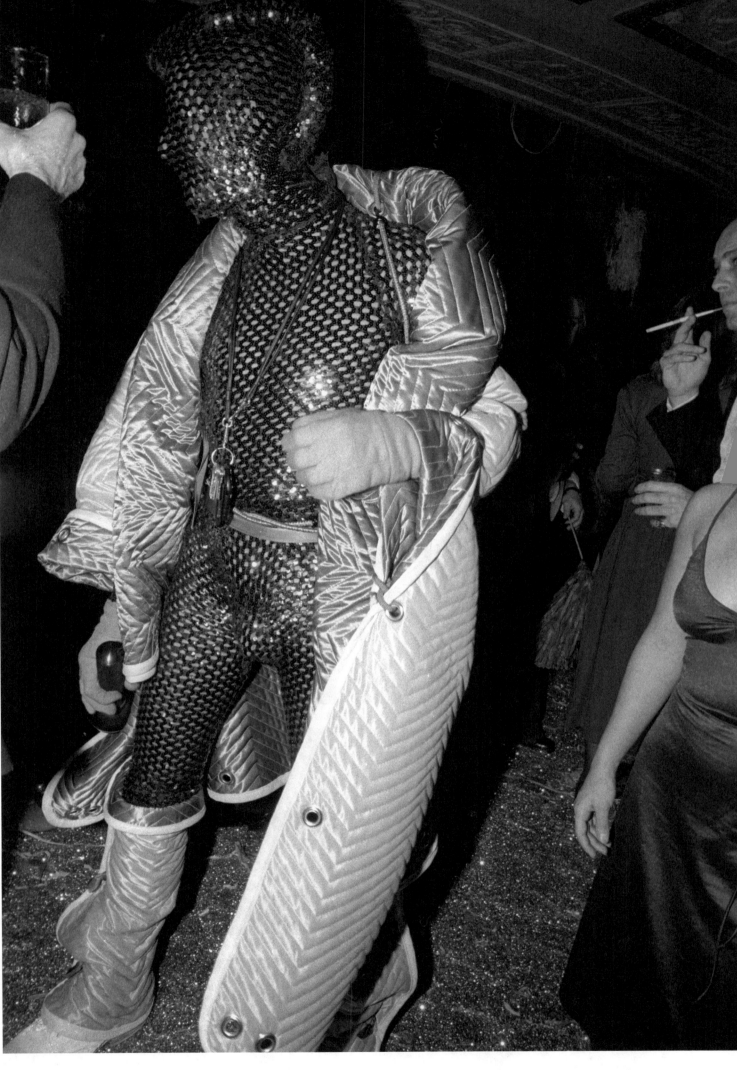

Opposite: Dustin Pittman (American). *Richard Gallo*, 1979. Courtesy of the artist. © Dustin Pittman

Dustin Pittman (American). *Richard Gallo*, New Year's Eve, 1979. Courtesy of the artist. © Dustin Pittman

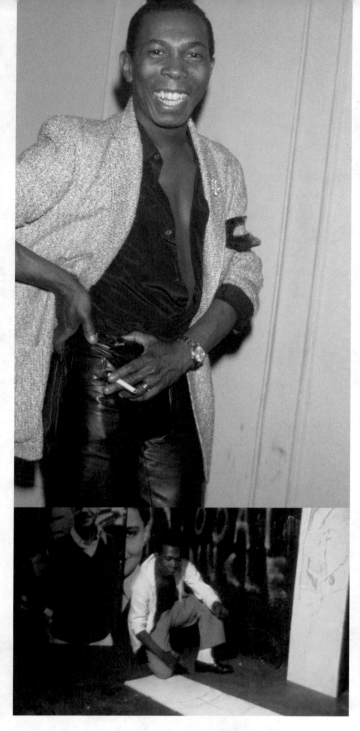

Top: Roxanne Lowit (American, born 1958). *Scott Barrie*, Studio 54, 1979. Courtesy of the artist. © Roxanne Lowit

Bottom: Susan Hillary Shapiro and Glenn Albin, filmmakers. Susan Hillary Shapiro, cinematographer. Stills from *Scott Barrie* drawing. 16mm film, color, silent; 2 min. © Glenn Albin and Susan Hillary Shapiro

Page 145: Richard Bernstein (American, 1939–2002). *Steve Rubell*, 1979. Airbrush, gouache, pencil, and collage on board, 16 x 10 in. (40.6 x 25.4 cm). © The Estate of Richard Bernstein

Pages 146–147: Allan Tannenbaum (American, born 1945). *Debbie Harry, Interview* magazine, June 7, 1979. Courtesy of the artist. © Allan Tannenbaum

Page 148, top left: Barry McKinley (Australian, born New Zealand, ?–1992), photographer. Richard Bernstein (American, 1939–2002), painter. *Debbie Harry*, 1979

Pages 148–151: Richard Bernstein (American, 1939–2002). Courtesy of the artist's estate. © The Estate of Richard Bernstein

Page 148, top right: *Marina Schiano*, 1980. Airbrush, gouache, pencil, and collage on board, 17 x 12 in. (43.2 x 30.5 cm)

Page 148, bottom left: *Farrah Fawcett*, 1978. Mixed media on canvas, 42 x 42 in. (106.7 x 106.7 cm). Commissioned by Farrah Fawcett

Page 148, bottom right: *Diahnne Abbott*, 1977. Airbrush, gouache, pencil, and collage on board, 14 x 10 in. (35.6 x 25.4 cm)

Page 149, top left: *Fran Lebowitz*, 1981. Airbrush, gouache, pencil, and collage on board, 18 x 11 in. (45.7 x 27.9 cm)

Page 149, top right: *Margaret Trudeau*, 1978. Airbrush, gouache, pencil, and collage on board, 16 x 10 in. (40.6 x 25.4 cm)

Page 149, bottom left: *Liz Taylor*, 1976. Airbrush, gouache, pencil, and collage on board, 14 x 10 in. (35.6 x 25.4 cm)

Page 149, bottom right: *Liza Minnelli*, 1975. Airbrush, gouache, pencil, and collage on board, 14 x 10 in. (35.6 x 25.4 cm)

Page 150, top left: *Vitas Gerulaitis*, 1979. Airbrush, gouache, pencil, and collage on board, 16 x 10 in. (40.6 x 25.4 cm)

Page 150, top right: *Tatum O'Neal*, 1980. Airbrush, gouache, pencil, and collage on board, 17 x 11 in. (43.2 x 27.9 cm)

Page 150, bottom left: *Mick Jagger, Iman, and Paul van Ravenstein*, 1977. Airbrush, gouache, pencil, and collage on board, 14 x 10 in. (35.6 x 25.4 cm).

Page 150, bottom right: *Olivia Newton-John*, 1983. Airbrush, gouache, pencil, and collage on board, 17 x 11 in. (43.2 x 27.9 cm)

Page 151, top left: *Mariel Hemingway*, 1978. Airbrush, gouache, pencil, and collage on board, 16 x 10 in. (40.6 x 25.4 cm)

Page 151, top right: *Peter Beard*, 1978. Airbrush, gouache, pencil, and collage on board, 14 x 10 in. (35.6 x 25.4 cm)

Page 151, bottom: *Cher*, 1974. Airbrush, gouache, pencil, and collage on board, 10 x 13 in. (25.4 x 33 cm)

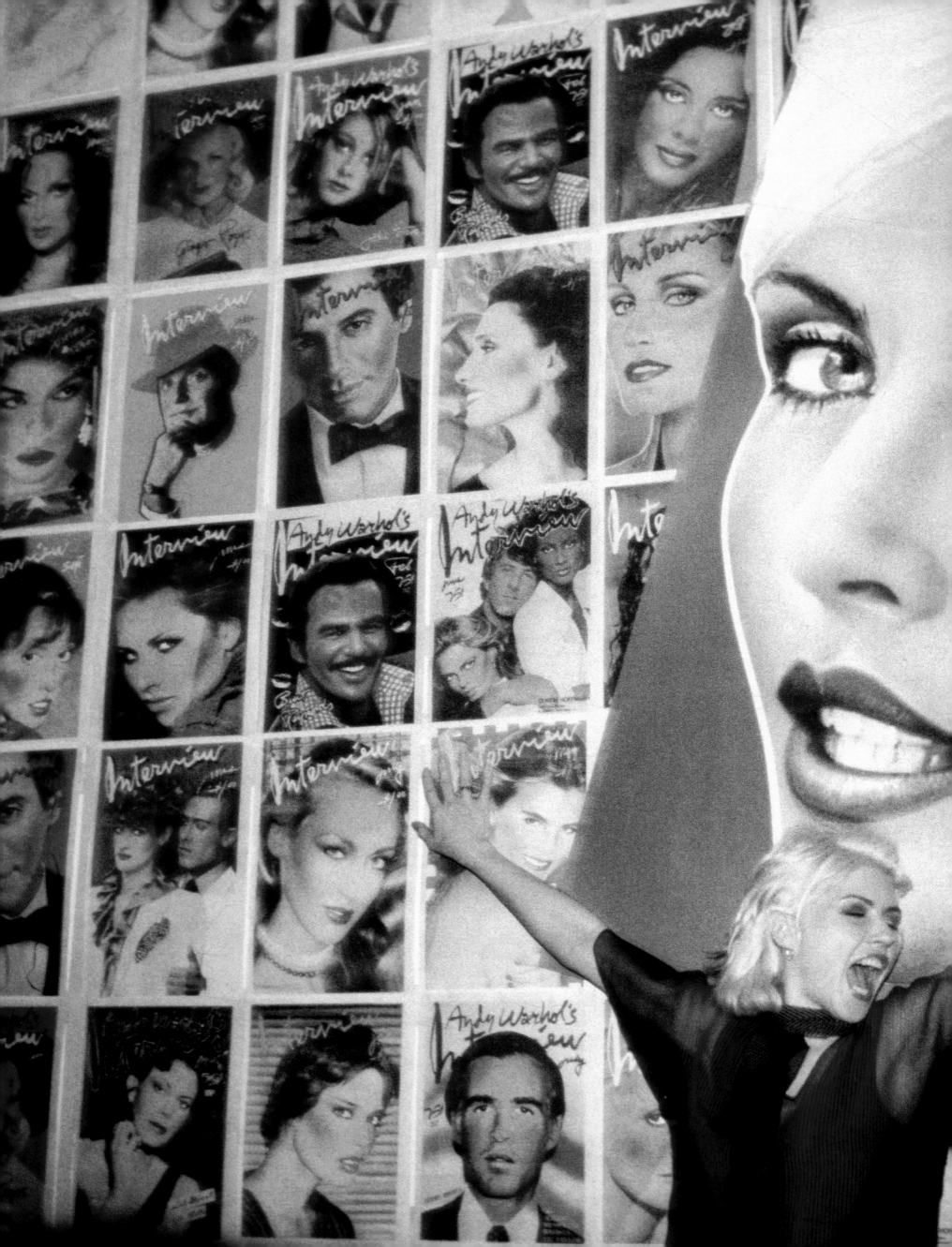

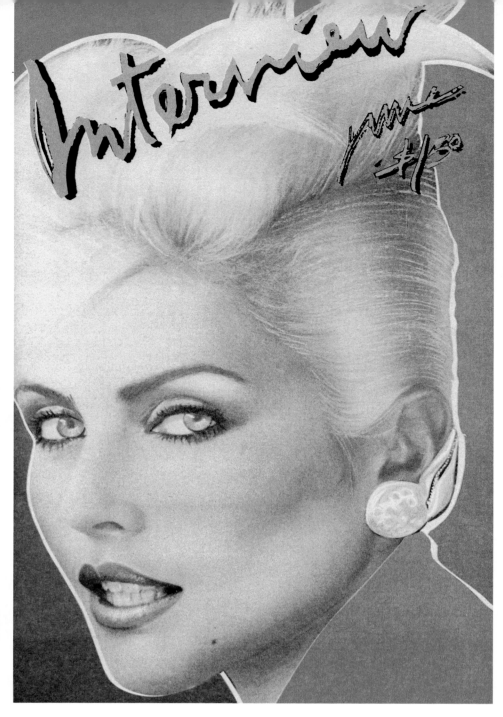

Interview

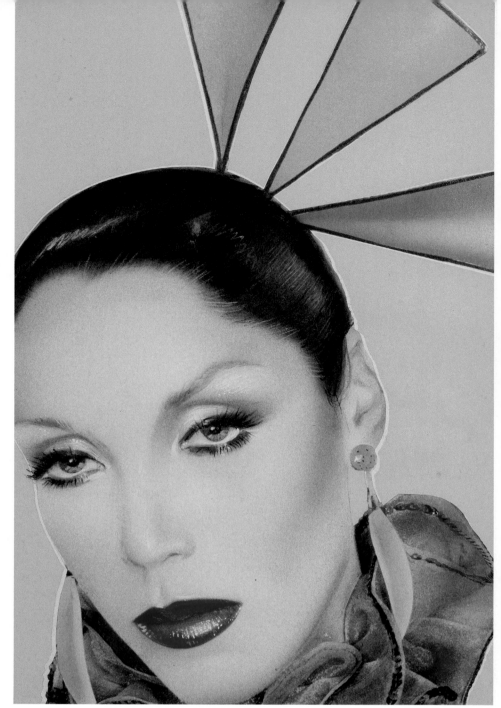

Interview Magazine
10th Anniversary

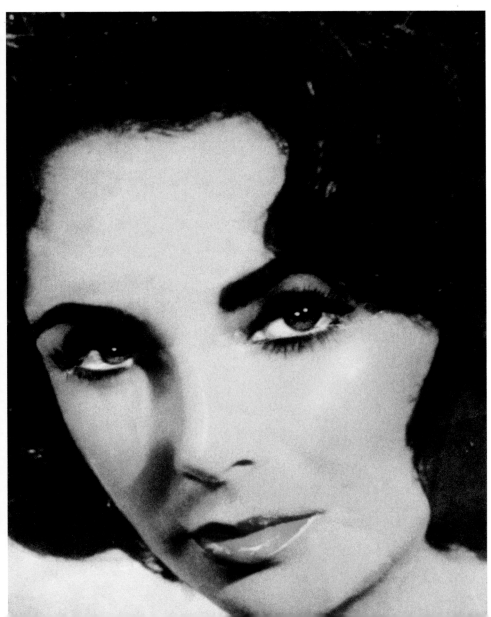

Andy Warhol and Truman Capote signed copies of the tenth anniversary issue of *Interview* at Fiorucci, on East 59th Street, which was also known as the "Daytime Studio 54" because of its moving lights and disco soundtrack. Joey Arias and Klaus Nomi were among the salespeople who frequently performed in the store's front display window.

 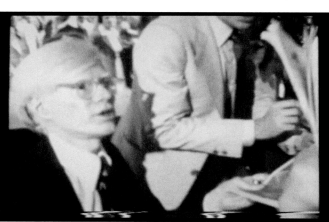

Anton Perich (American, born Croatia, 1945). *Warhol, Capote, Fiorucci*, 1979. Videotape, color, sound; 14 minutes. Courtesy of the artist. © Anton Perich

Actress Marisa Berenson and fashion designer Valentino are seen here at Studio 54, following Halston's birthday party for Steve Rubell at his Olympic Tower offices.

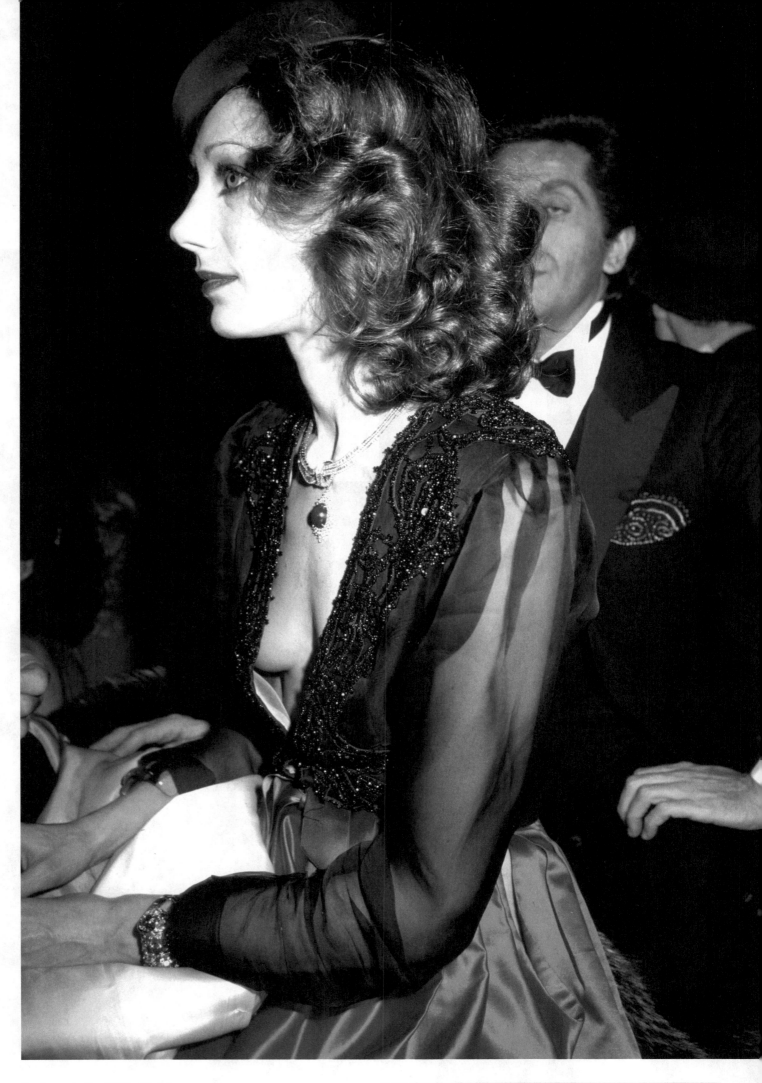

Top: Dustin Pittman (American). *Marisa Berenson and Valentino*, 1979. Courtesy of the artist. © Dustin Pittman

Bottom: *Drink Tickets (Studio 54 VIP)*, circa 1978. Printed ink on coated paper, stapled, with plastic coated ribbon. The Andy Warhol Museum, Pittsburgh; Founding Collection, Contribution The Andy Warhol Foundation for the Visual Arts, Inc. TC249.206

On August 7, 1979, Halston gave Andy Warhol a birthday party at his modernist Paul Rudolph—designed home that was attended by Truman Capote, fashion editor? D. D. Ryan, and Warhol's assistant Ronnie Cutrone. Later, everyone went to Studio 54, where Steve Rubell gifted Andy Warhol with this roll of free drink tickets for his birthday. On another occasion, Rubell presented him with a garbage pail of "a thousand dollars' worth" of one-dollar bills (which Warhol later discovered, to his disappointment, was only $800).

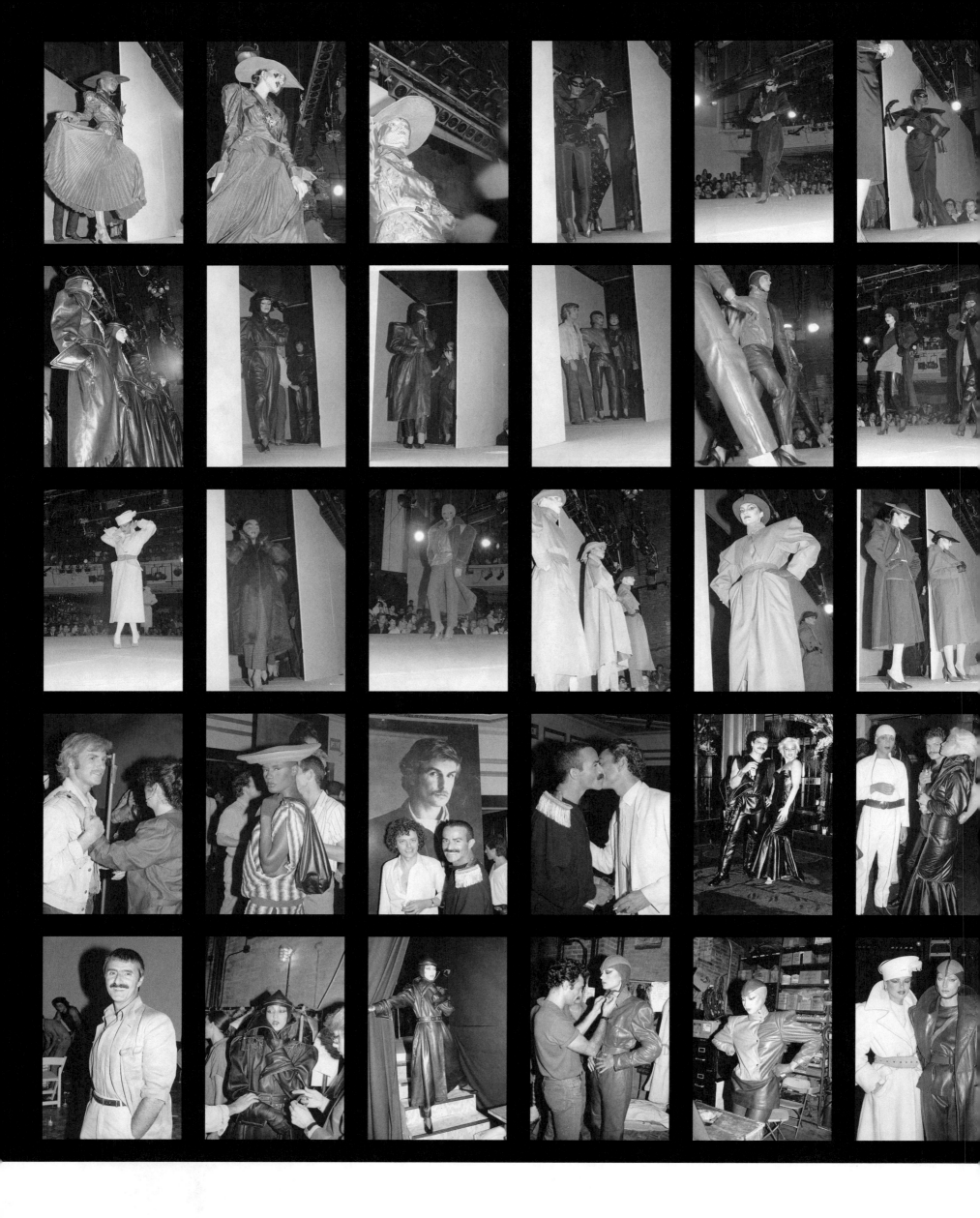

September 6, 1979: Claude Montana Fashion Show

Opposite: Roxanne Lowit
(American, born 1958). *Claude
Montana Fashion Show*, September
6, 1979. Courtesy of the artist.
© Roxanne Lowit

Left: Dustin Pittman (American).
Little Jacques, 1979. Courtesy of
the artist. © Dustin Pittman

Right: Roxanne Lowit (American,
born 1958). *Larry LeGaspi and
Valerie LeGaspi*, Studio 54,
Claude Montana Show, September 6,
1979. Courtesy of the artist.
© Roxanne Lowit

Claude Montana
Fashion Show, 1979

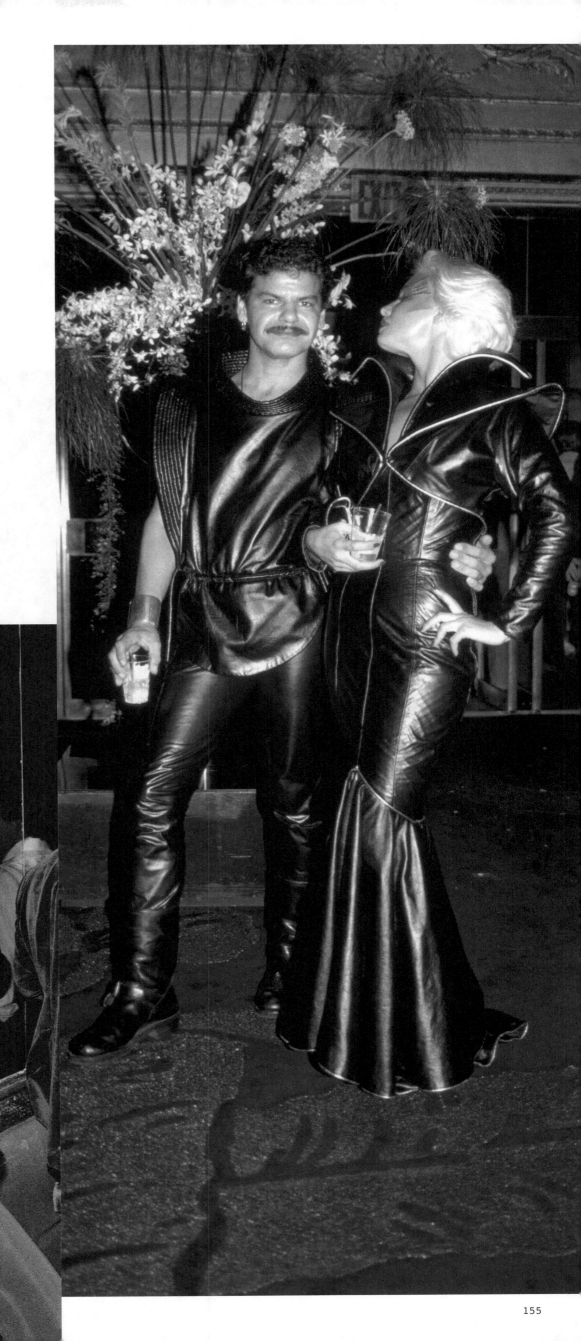

Top left: Gil Lesser (American, 1935—1990). *Invitation Mockup* (Sympathize with the Devil at Studio 54 on Halloween), 1979. Cut and folded Pantone paper. Ian Schrager Archive

Bottom left: Karin Bacon (American). *Halloween*, 1979. Courtesy of the artist

Top right: Hasse Persson (Swedish, born 1942). *New Year's Eve*, 1978. Gelatin silver print, 39 3/8 x 27 9/16 in. (100 x 70 cm). Courtesy of Hasse Persson and Embassy of Sweden. © Hasse Persson

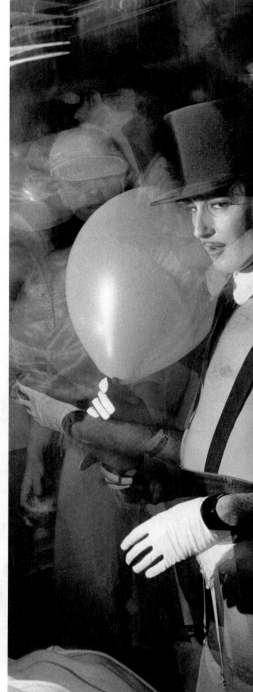

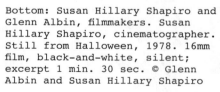

Bottom: Susan Hillary Shapiro and Glenn Albin, filmmakers. Susan Hillary Shapiro, cinematographer. Still from Halloween, 1978. 16mm film, black-and-white, silent; excerpt 1 min. 30 sec. © Glenn Albin and Susan Hillary Shapiro

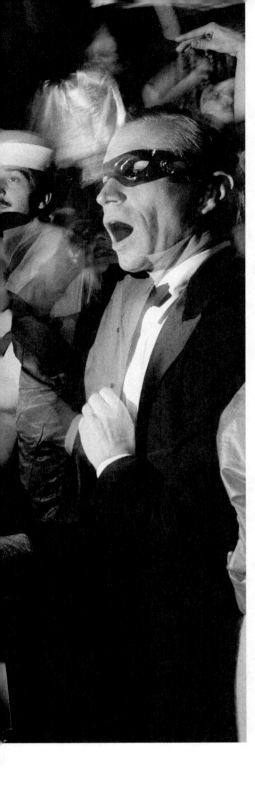

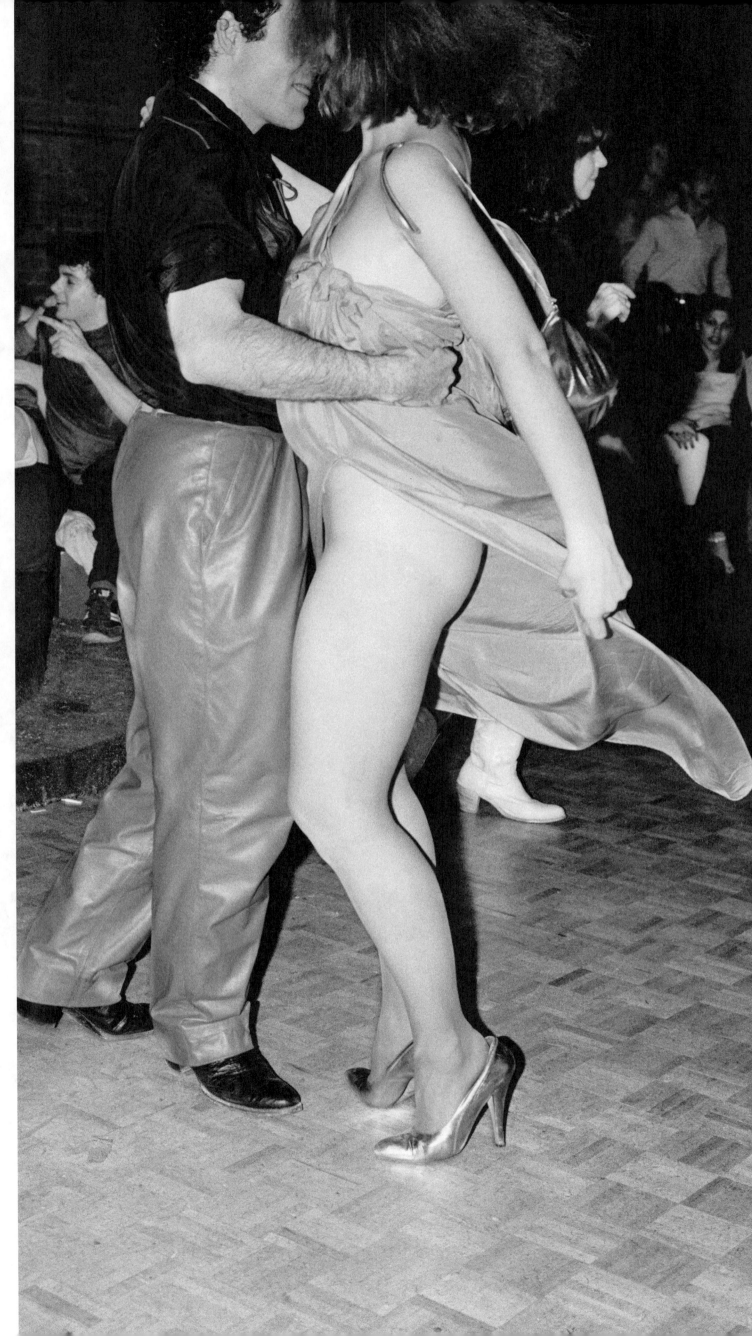

Opposite: Miestorm (American, born 1958). *R. Couri Hay and Alvin Ailey dancer*, December 13, 1979. Courtesy of the artist. © Miestorm

Dustin Pittman (American). *Snow Drop, New Year's Eve*, 1979. Courtesy of the artist. © Dustin Pittman

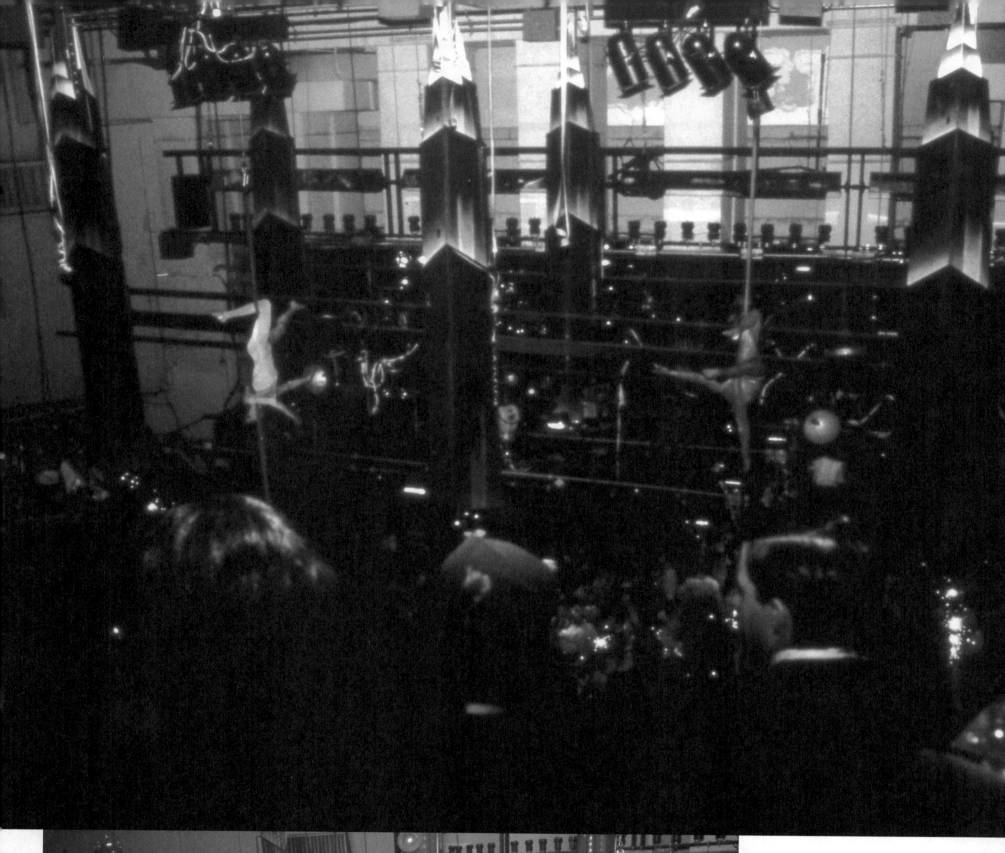

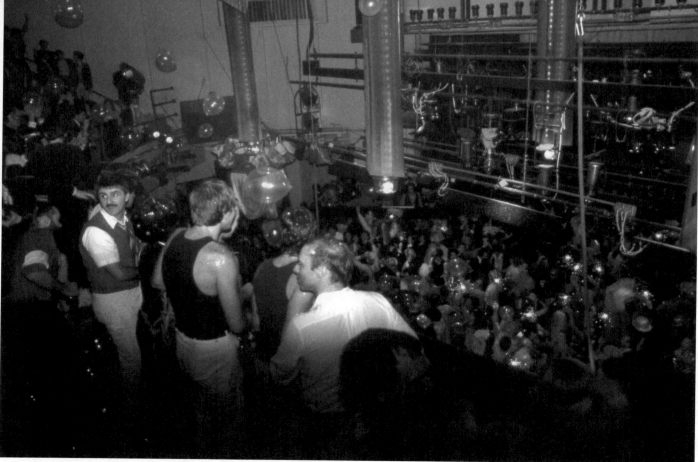

All photographs and previous pages: Karin Bacon (American). *New Year's Eve*, 1978—79. Courtesy of Karin Bacon

December 31, 1979: New Year's Eve Party

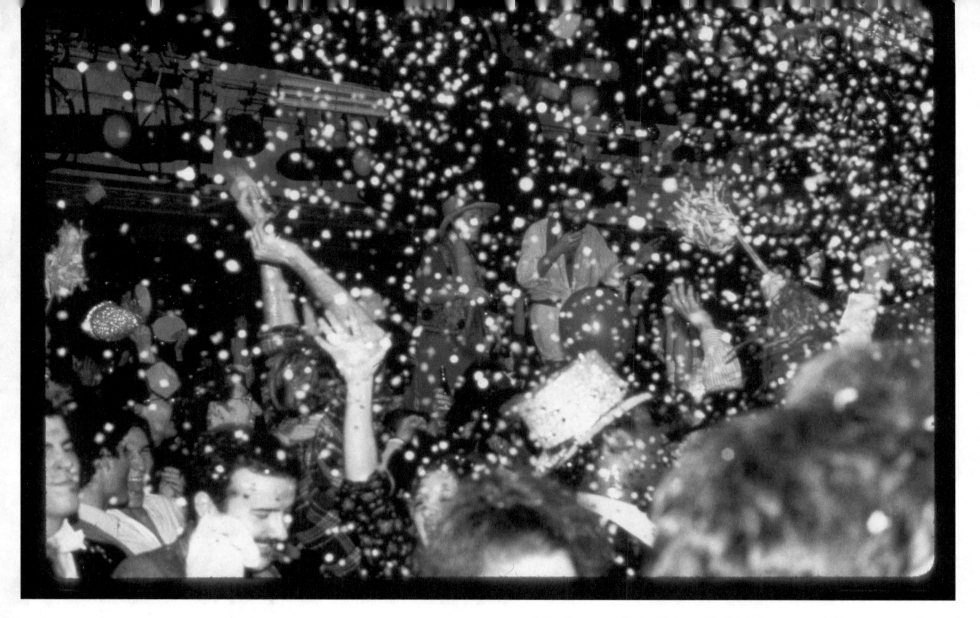

New Year's Eve, 1979

For New Year's Eve 1979—80, the chase poles were covered in skyscrapers designed by Aerographics (Richie Williamson and Dean Janoff), made from airbrushed carpet foam, which fit over the poles like a giant sock. The windows were made using refraction plastic and Mylar.

While the New Year's Eve dance floor featured skyscrapers, the entrance and bar area decor included ice sculptures and ice walls. Troughs lined the walls, and an ice company provided large blocks of ice that were stacked and moored in crushed ice. Brian Thomson used black lights so that the ice appeared blueish. The usual silver couches were moved to the back and they were replaced for the evening with new seating made of foam rubber overlaid with pink fun fur. The floor was covered in a foot of foam peanuts.

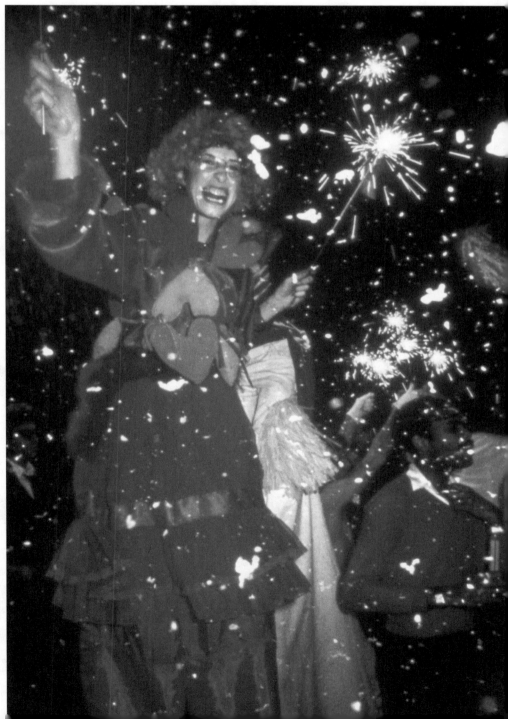

162

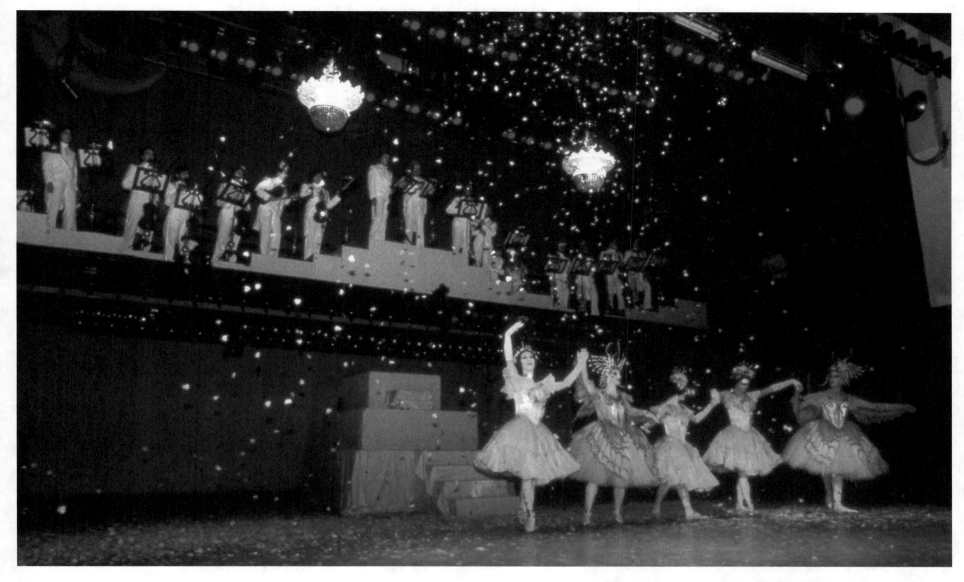

Above and right: Karin Bacon
(American). *Armani*, 1980.
Courtesy of the artist

Armani
Party, 1980

"The designer himself invited
about 400 friends to a Viennese
Waltz Night at, of all places,
Studio 54, which was closed to
the public and transformed with
crystal chandeliers, white slip
covers and 20 violinists in white
tie." *New York Times*, Jan. 22,
1980 (Bernadine Morris)

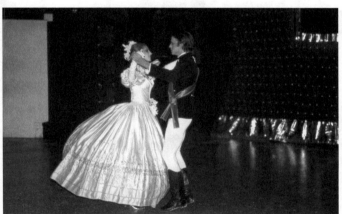

Opposite: Allan Tannenbaum
(American, born 1945). *New Year's
Crotch Hug*, 1979. Courtesy of the
artist. © Allan Tannenbaum

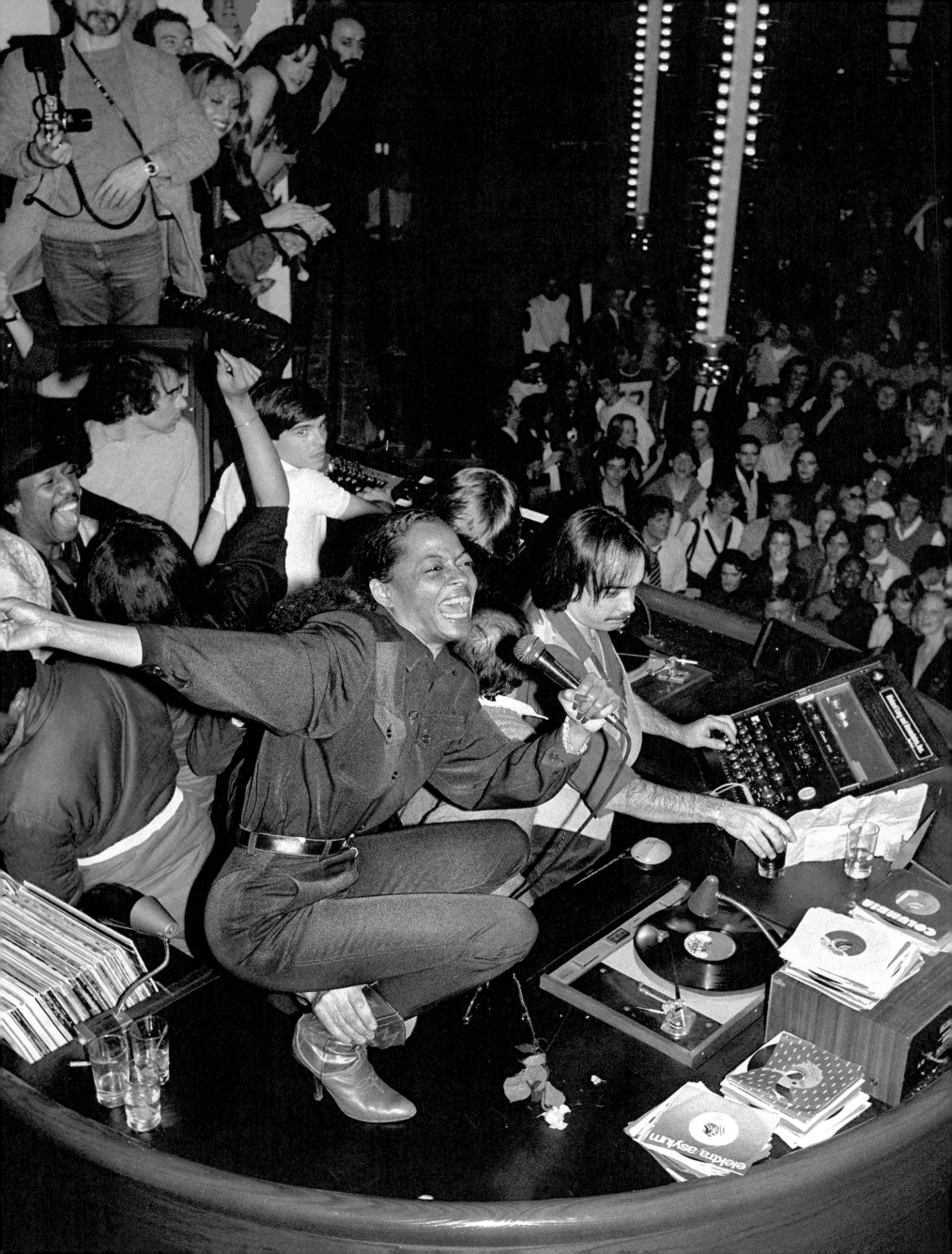

Going-Away Party

Like most nightclubs in the 1970s, Studio 54 was a cash-only business with a manual cash register. Credit cards were used infrequently, and typically not for an entrance fee, coat-check tip, or drink at the bar. From December 1978 through 1979, the club's accounting practices drew scrutiny from the Internal Revenue Service, resulting in an indictment. Even though they were represented by their longtime lawyer, the pugnacious Roy Cohn, Schrager and Rubell did not avoid prison terms. Widely covered in the media at the time, the story was recently reexamined in Matt Tyrnauer's documentary *Studio 54* (2018).

On February 2, 1980, Rubell and Schrager threw an all-night "Going Away" bash at Studio 54; in Tyrnauer's documentary, Schrager exclaimed, "What were we thinking?" From the balcony and DJ booth, Liza Minnelli belted out "New York, New York" and Diana Ross sang one of Rubell's favorite songs, "Come See About Me." Rubell and Schrager reported to the Manhattan Correctional Department two days later and were subsequently transferred to Arkansas.

After their release on January 30, 1981, the "Comeback Kids," as dubbed by *New York* magazine, ventured into boutique hotels and in May 1985 opened one more nightclub, the now-legendary Palladium, designed by Isozaki Arata, one of the architects who later oversaw the renovation of the Brooklyn Museum West Wing galleries.

Ian Schrager was granted a full and unconditional pardon by President Barack Obama on January 17, 2017.

Opposite: Diana Ross belts out a song from atop the disco booth at Studio 54, 1980. (Photo by Richard Corkery/NY Daily News Archive via Getty Images)

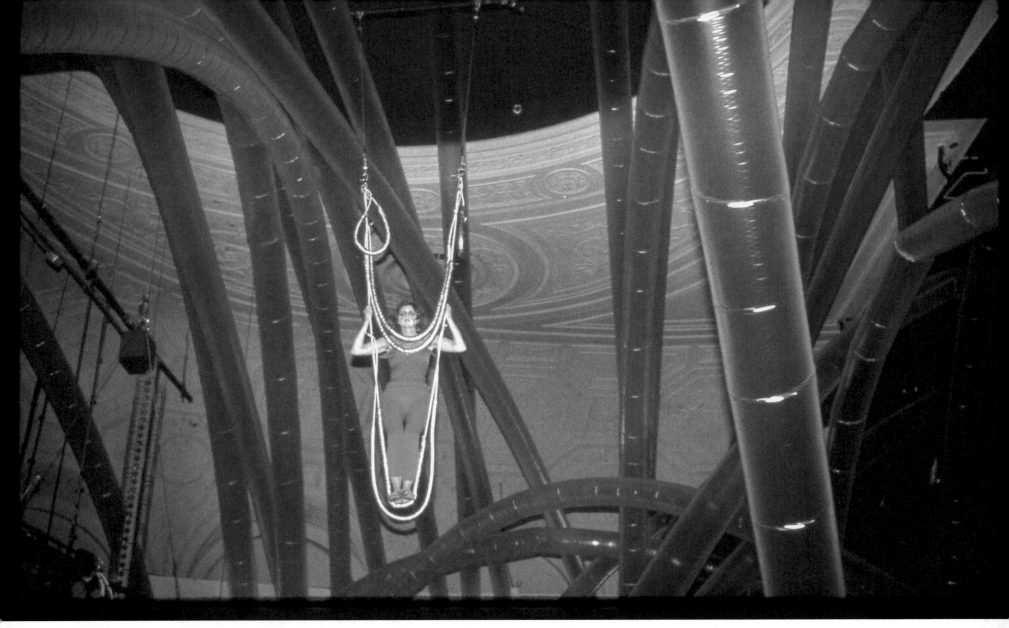

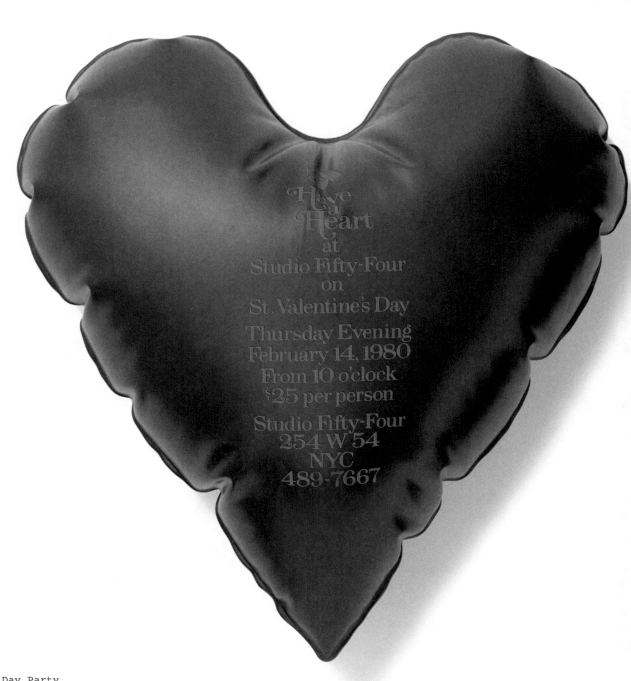

Have a Heart
at
Studio Fifty-Four
on
St. Valentine's Day

Thursday Evening
February 14, 1980
From 10 o'clock
$25 per person

Studio Fifty-Four
254 W 54
NYC
489-7667

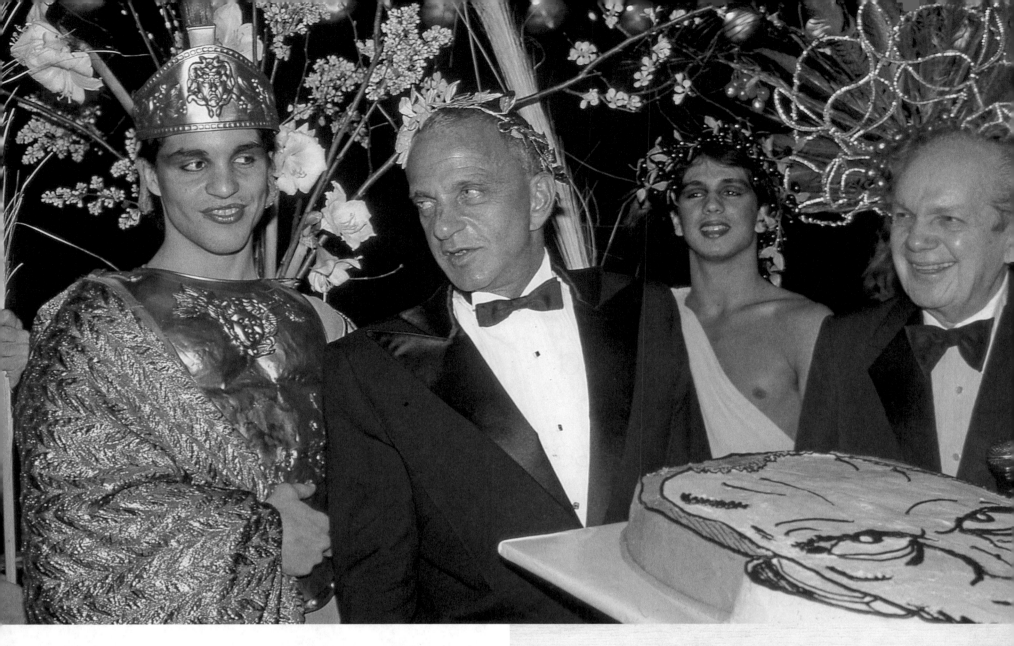

Opposite, top: Mariette Pathy
Allen (Egyptian, born 1940).
Valentine's Day Party, February
14, 1980. Courtesy of Karin Bacon

Opposite, bottom: Gil Lesser
(American, 1935–1990). "Have
a Heart at Studio 54 on St.
Valentine's Day" Invitation,
1980. Printed vinyl, 13 x 3 in.
(33 x 7.6 cm). Collection of
Harry King

Top: Mariette Pathy Allen
(Egyptian, born 1940). *Roy Cohn's
birthday party*, 1980. Courtesy of
Karin Bacon

In the matter of the

BIRTHDAY PARTY OF SUBPOENA

ROY M. COHN

The People of the State of New York

HON. ANDREW STEIN & BRENDA

WE COMMAND YOU, *That all business and excuses being laid aside, you and each of you appear and*
attend

> STUDIO 54
> *Private back entrance*
> *229 West 53rd Street*

on the 22nd day of February, 1980 at 8:30 o'clock in the evening for cocktails followed
by seated dinner at 9 o'clock promptly — black tie.

*Failure to comply with this subpoena is punishable as a contempt and shall make you liable for all dam-
ages sustained by reason of your failure to celebrate, and will make Roy even more vicious than usual.*

R.S.V.P.: Vincent Millard
212-472-1400

Karin Bacon (American). *Michael
Chow Party*, 1980. Courtesy of
Karin Bacon

Bottom: *Roy Cohn Birthday Party
Invitation*, 1980. Printed
invitation. Collection of Myra
Scheer, New York

For thirty-three charged-up months, Studio 54 had infused a depressed New York City with vibrancy, glamour, and a new attitude.

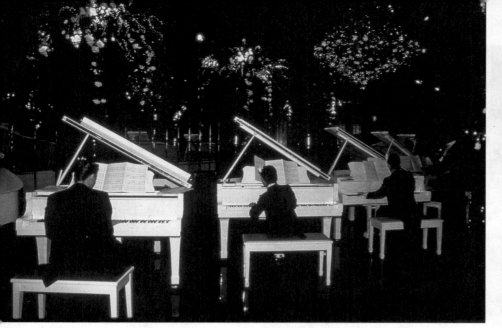

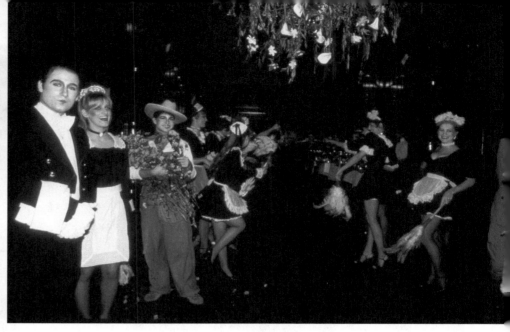

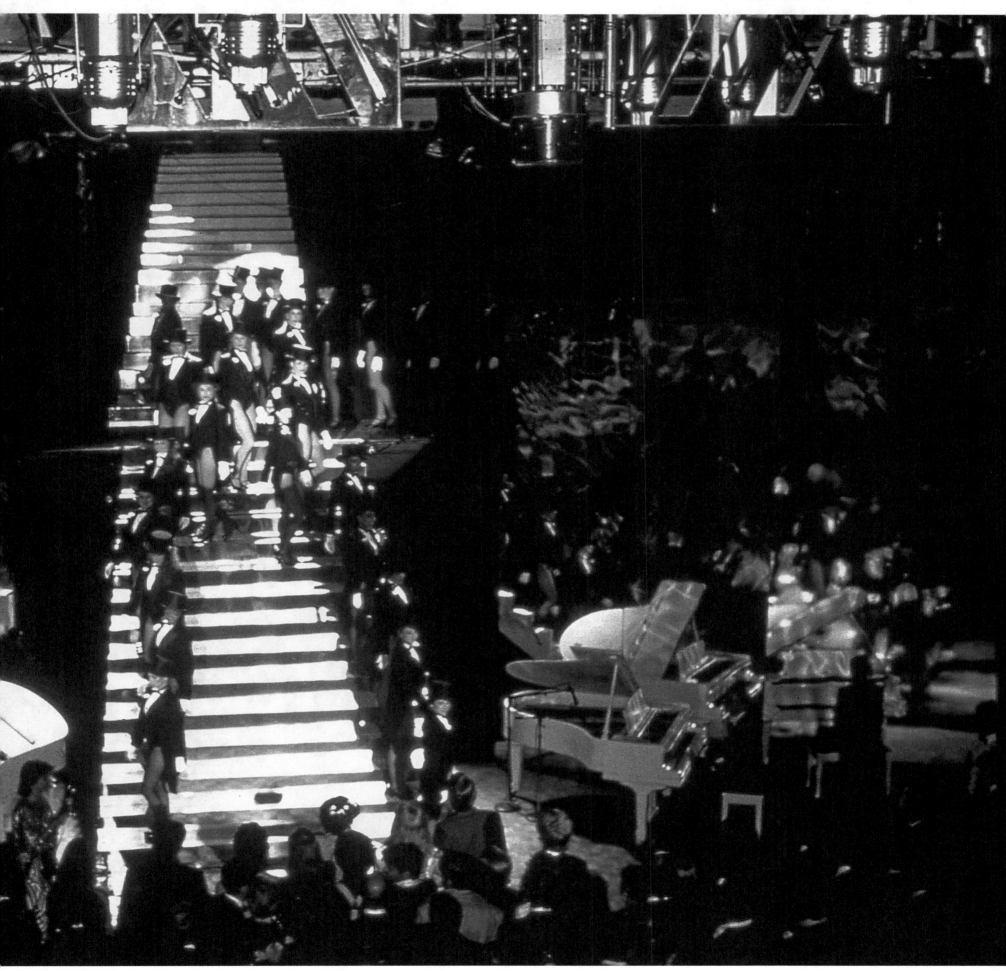

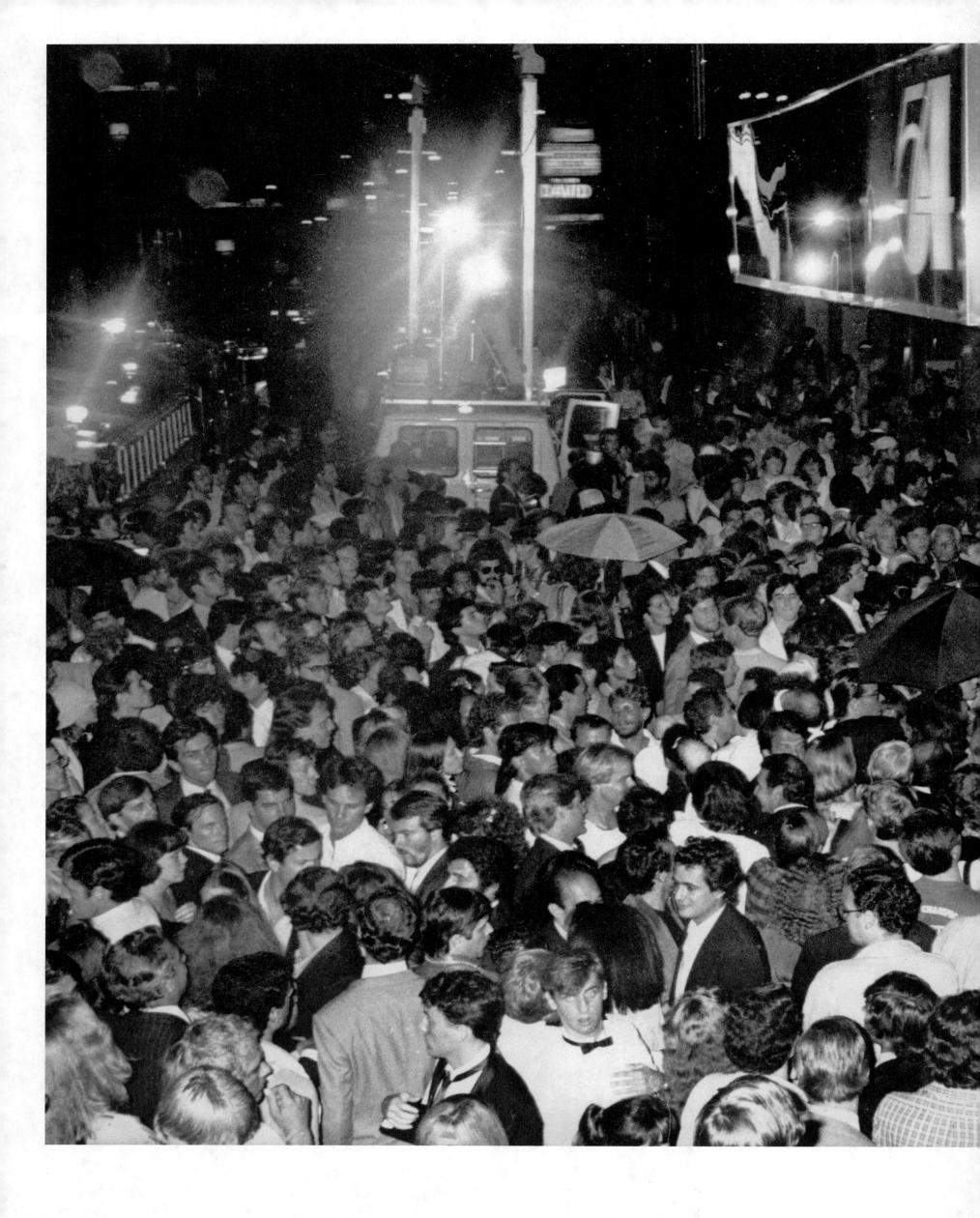

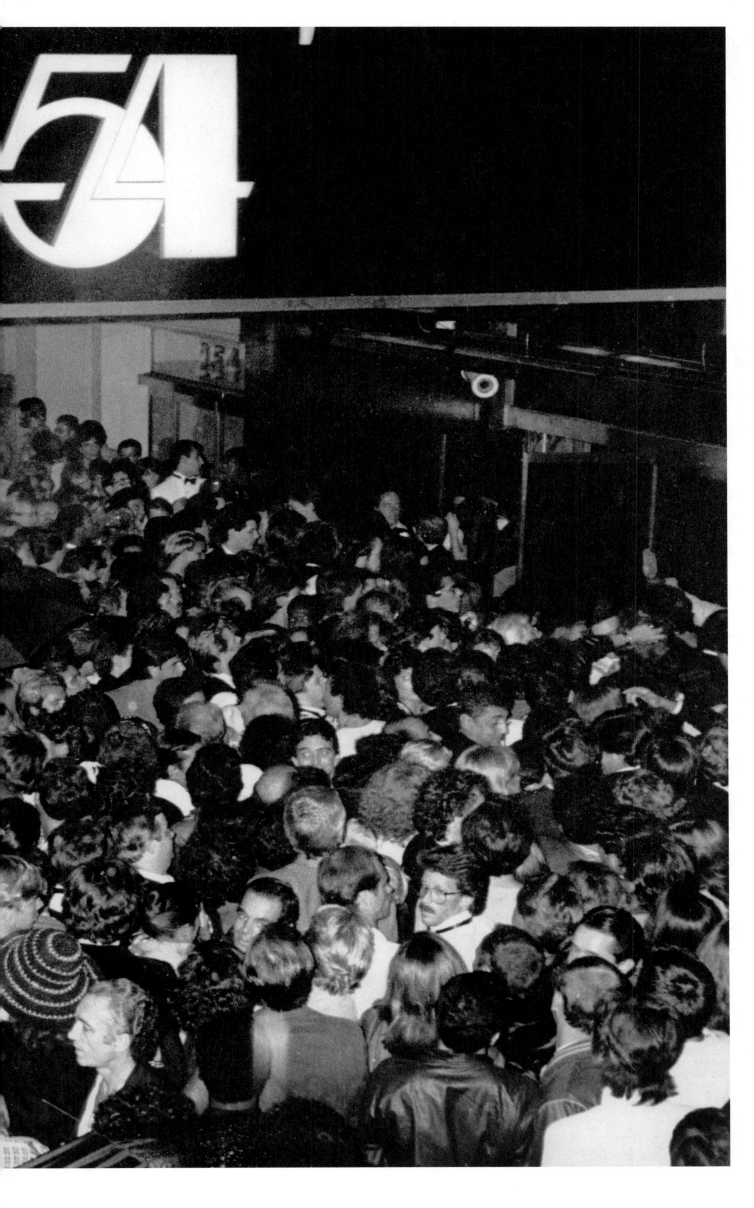

Peter F. Gould (American). *Crowd Outside Studio 54*, 1981. Courtesy of the artist. © Peter L. Gould/ imagespressllcusa@gmail.com

Acknowledgments

Matthew's Thank-you:

Studio 54: Night Magic is the culmination of two years' research, preparation and production. I want to thank Anne Pasternak and David Berliner, for their immediate enthusiasm for this project. Equally, I want to thank Ian Schrager for his openness, good-natured spirit and exquisite sense of design. Together, your support has made this project an extraordinary experience.

I would also like to thank all of the lenders and participating artists for being so generous with your time, knowledge and objects, which are extensive. Additionally, I would like to thank the many wonderful people who spent hours with me in person, on the telephone, and on e-mail, reminiscing about 1977, 1978, 1979, and 1980.

I was a teenager during those years, living in a little town in Pennsylvania. While I had read about and saw photographs of Studio 54 in magazines and on television, the closest I got was buying the double album set *A Night at Studio 54* one Saturday afternoon at the local National Record Mart, and dancing in the living room. It has been a dream to experience Studio 54 through your personal stories, and to create *Studio 54: Night Magic* for everyone.

Brooklyn Museum:

Director of Collections and Curatorial Affairs: Susan Fisher
Director of Exhibitions and Strategic Initiatives: Sharon Matt Atkins
Director of Exhibition Planning: Dolores Farrell
Exhibition Project Manager: Esther Woo
Manager of Touring Exhibitions: Gwen Arriaga

Lenders and Participating Artists:

The Andy Warhol Museum
BVLGARI
Charles Tracy Archive
William and Carol Clements
Pat Cleveland
Barbara Colaciello
Beth Rudin DeWoody
Judy (Licht) Della Femina
Doris Duke, Newport Restoration Foundation, Rhode Island
The Elizabeth Taylor Archive
The Estate of Antonio Lopez and Juan Ramos
Diane von Furstenberg Archives
Fashion and Textile Museum, London
FIDM Museum
FIORUCCI
Ian Schrager Archive
Valerie LeGaspi
Miyake Design Studio
Musée Yves Saint Laurent, Paris
The Museum at FIT
Museum of Contemporary Photography, Columbia College
Museum of the City of New York
Nailya Alexander Gallery
Calliope Nicolas
Pace / MacGill Gallery
Mark Payne
PVH Archives, New York
Richard Bernstein Estate
Richard Gallo Archives
SCAD FASH
Myra Scheer
Marsha Stern
Kay Unger
Vito Schnabel Projects

Glenn Albin
Karin Bacon
Kenny Bonavitacola
Alexander Borodulin
Scott Bromley
Stephen Burrows
Cerrone
Bob Colacello
Fred J. DeVito
Bil Donovan
George DuBose
Larry Fink
Jules Fisher
Ron Galella
Timothy Greenfield-Sanders
Rose Hartman
Norma Kamali
Harry King
Calvin Klein
Amanda Lear
Sandy Linter
Roxanne Lowit
Christopher Makos
Paul Marantz
Guy Marineau
Meryl Meisler
Miestorm
Robert Lee Morris
Gordon Munro
Toby Old
Rick Owens
Tod Papageorge
Elsa Peretti
Anton Perich
Hasse Persson
Dustin Pittman

Mark Ravitz
Renny Reynolds
Zandra Rhodes
Robin Rice
Wayne Scott
Adam Scull
Susan Hillary Shapiro
Allan Tannenbaum
Doug Vann
Tony Walton
Richie Williamson

ABC
BBC
British Pathé, London
Canadian Film Distribution Centre
CBS
Getty Images
Historic Films Archive
NBC News Archives
Warner Music Group

Studio 54: Night Magic Friends:

Jeffrey Anderson
Elliot Azrak
Jessica Barber
Jayce Bartok
Tiffany Bartok
Tommy Beall
Marc Benecke
Barbara Berkowitz
Karin Bjornson
Lucia Boscaini
Claudia Boublil
Oliver Bradbury
Erin Byrne
Jenny Mählqvist Cabezas
Devon Caranicas
Paul Caranicas
George Carr
Vera Cerqueira
Cher
Alva Chinn
Marc Christopher
Ricky Clifton
Kristen Costa
Carmen D'Alessio
Alberto Damian
Franca Dantes
Karen Davidson
William DeGregorio
Jeffrey Deitch
Jose Diaz
Lydia Dolch
Mitch Erzinger
Michael Feinstein
Olivier Flaviano
Vincent Fremont
Leslie Frowick
Chuck Garelick
Katie Garrity
Nancy Gerstman
Giancarlo Giammetti
Sandra Gomez
Jean-Paul Goude
John Granito
Scott Greenstein
Claudette Jabara Hadad
Henry Hadad
Anthony Haden-Guest
Bethann Hardison
Carolina Herrera
Janice Holmes
Paulette Howell
Gale Anne Hurd
Geralyn Huxley
Iman

Beverly Johnson
Paulette Kaczor
Noah Khoshbin
L. J. Kirby
Kathy Lener
Humberto Leon
Holly Lorenzo
Michael Maccari
Phyllis Magidson
Fern Mallis
Thomas Manzi
Melanie Martinez
Tim Mendelson
Liza Minnelli
Thierry Mugler
Nancy North
Michael Overington
Stefano Palumbo
Tristan Perich
Martin Price
Michael Pucci
Ralph Pucci
Barry Ratoff
Paul van Ravenstein
Susan Raymond
Corey Reeser
Van Rice
Tanner Riley
Scott Rollins
Jean-Baptiste Rougeot
Chris Royer
Don Rubell
Anja Rubik
Ralph Rucci
Rosina Rucci
Alexandra Sachs
Aurélie Samuel
Bruce Suldano
Carlos Souza
Valerie Steele
Chris Stein
Marsha Stern
Anna Sui
Theresa Sullivan
Nancy Knox Talcott
Patrick Taylor
Catherine Tharin
Lisa Thompson
Jim Toth
Joyce (Bogart) Trabulus
Edward Tricomi
Rory S. Trifon
Tommy Tune
Matt Tyrnauer
Christian John Wikane
Robert Wilson
Peter Wise
David Wolfson
Linda Zachrison

In memory of the wonderful artist Ron Ferri (1932–2019), who shared great stories about creating light and neon sculptures for nightclubs, stores, and galleries in the 1960s and 1970s.

Photo Credits

Thank you to the following photographers and artists:

Jaime Ardiles-Arce. © Jaime Ardiles-Arce

Karin Bacon (American, born 1940). Courtesy of Karin Bacon

Richard Bernstein (American, 1939-2002). Courtesy of the artist's estate. © The Estate of Richard Bernstein

Martha Cooper (American, born 1942). Courtesy of Karin Bacon

Jules Fisher (American, born 1937). Courtesy of Jules Fisher and Paul Marantz

Ron Galella (American, born 1931). Courtesy of the artist. © Ron Galella

Peter F. Gould (American). Courtesy of the artist. © Peter L. Gould/ imagespressllcusa@gmail.com

Rose Hartman (American, born 1937). Courtesy of the artist. © Rose Hartman

Gil Lesser (American, 1935-1990). Courtesy of Ian Schrager Archive. (Photo: Jonathan Dorado)

Michael Hanulak (American, 1937-2011). Brooklyn Museum, Purchased with funds given by the Horace W. Goldsmith Foundation, Harry Kahn, and Mrs. Carl L. Selden, 1994.129.1. © Michael Hanulak

Sandy Linter (American, born 1947). Courtesy of Sandy Linter

Antonio Lopez (American, born Puerto Rico, 1943-1987). © The Estate of Antonio Lopez and Juan Ramos. (Photo: Jonathan Dorado)

Roxanne Lowit (American, born 1958). Courtesy of the artist. © Roxanne Lowit

Guy Marineau (French, b. 1947). (Photo Credit: Guy Marineau/WWD/Shutterstock)

Meryl Meisler (American, born 1951). Courtesy of the artist. © Meryl Meisler

Nina Meledandri (American, born 1957). Courtesy of Karin Bacon

Miestorm (American, born 1958). Courtesy of the artist. © Miestorm

Gordon Munro and Peter Rogers (1934–) © Gordon Munro, photographer

Callipe Nicholas © Calliope Nicholas

Toby Old (American, born 1945). Courtesy of the artist. © Toby Old

Tod Papageorge (American, born 1940). Brooklyn Museum, Gift of Robert L. Smith and Patricia L. Sawyer, 1999.127.4. © Tod Papageorge

Mariette Pathy Allen (Egyptian, born 1940). Courtesy of Karin Bacon

Anton Perich (American, born Croatia, 1945). Courtesy of the artist. © Anton Perich

Hasse Persson (Swedish, born 1942). Courtesy of Hasse Persson and Embassy of Sweden. © Hasse Persson

Dustin Pittman (American). Courtesy of the artist. © Dustin Pittman

Robin Platzer/ Twin Images.

Ian Schrager Archive

Adam Scull (American). Photo by © Adam Scull/PHOTOlink.net

Susan Hillary Shapiro and Glenn Albin, filmmmakers. Courtesy of the filmmakers. © Glenn Albin and Susan Hillary Shapiro

Neil Slavin © Neil Slavin

Allan Tannenbaum (American, born 1945). © 1977-2020 Allan Tannenbaum

Russell Turiak © Russell Turiak

Tony Walton (British, born 1934). Courtesy of the artist. © Tony Walton

Andy Warhol (American 1928-1987). The Andy Warhol Museum, Pittsburgh; Founding Collection, Contribution The Andy Warhol Foundation for the Visual Arts, Inc. © 2020 The Andy Warhol Foundation for the Visual Arts, Inc. / Licensed by Artists Rights Society (ARS), New York

Richie Williamson (American, born 1947). © Richie Williamson

Wurts Bros. (American, 1894-1979). Museum of the City of New York, Wurst. Bros. Collection. Gift of Richard Wurts, 1956.

Board of Trustees

Published on the occasion of the exhibition Studio 54: Night Magic organized by the Brooklyn Museum and held March 13-July 5, 2020.

Dortmunder U, Center for Arts and Creativity: August 14—November 8, 2020

Art Gallery of Ontario: December 20, 2020—April 11, 2021

First published in the United States of America in 2020 by Rizzoli Electa
A Division of Rizzoli International Publications, Inc.
300 Park Avenue South
New York, NY 10010
www.rizzoliusa.com

In association with
Brooklyn Museum
200 Eastern Parkway
Brooklyn, NY 11238-6052
www.brooklynmuseum.org

For their kind support of the exhibition, we extend our gratitude to our Presenting Sponsor Spotify and our Major Sponsor Perrier. The contributions of sponsors like these are crucial to all that we achieve.

For Brooklyn Museum:
Director of Publications and Interpretation: Audrey Walen
Senior Curator of Fashion and Material Culture: Matthew Yokobosky
Research and Production Assistant: Sarah Jean Culbreth
Head of Digital Collections and Services: Sarah DeSantis
Image Licensing and Media Acquisition Coordinator: Melissa Chase

For Rizzoli Electa:
Publisher: Charles Miers
Associate Publisher: Margaret Rennolds Chace
Editor: Ellen Nidy
Layout: Sarco
Production Manager: Maria Pia Gramaglia
Managing Editor: Lynn Scrabis
Design Coordinator and cover editor: Olivia Russin

Printed in the United States 2020 2021 2022 2023 2024 / 10 9 8 7 6 5 4 3 2 1

ISBN: 978-0-8478-6922-0
Library of Congress Control Number: 2020843617

Visit us online:
Facebook.com/RizzoliNewYork
instagram.com/rizzolibooks
twitter.com/Rizzoli_Books
pinterest.com/rizzolibooks
youtube.com/user/RizzoliNY
issuu.com/rizzoli

Studio 54: Night Magic is curated and designed by Matthew Yokobosky, Senior Curator of Fashion and Material Culture, Brooklyn Museum.

Cover image: Peter F. Gould (American). *Crowd Outside Studio 54*, 1981. Courtesy of the artist © Peter L. Gould/ imagespressllcusa@gmail.com

Opposite title page: Guy Marineau (French, b. 1947). *Pat Cleveland on the Dance Floor During Halston's Disco Bash at Studio 54*, 1977. (Photo Credit: Guy Marineau/WWD/Shutterstock)